U0003077

字體編排設計和語言沒什麼兩樣。
Typography is what language looks like.

圖解字型思考
寫給設計師、寫作者、編輯、以及學生們的重要指南

作　　　者	艾琳‧路佩登（Ellen Lupton）
譯　　　者	林育如
責任編輯	賴曉玲
版　　　權	吳亭儀、翁靜如
行銷業務	莊晏青、王瑜
總編輯	徐藍萍
總經理	彭之琬
發行人	何飛鵬
法律顧問	台英國際商務法律事務所 羅明通律師
出　　　版	商周出版
	台北市中山區104民生東路二段141號9樓
	電話：(02) 2500-7008　傳真：(02)2500-7759
	E-mail：bwp.service@cite.com.tw
發　　　行	英屬蓋曼群島商家庭傳媒股份有限公司城邦分公司
	台北市中山區104民生東路二段141號2樓
	書虫客服服務專線：02-25007718‧02-25007719
	24小時傳真服務：02-25001990‧02-25001991
	服務時間：週一至週五09:30-12:00‧13:30-17:00
	郵撥帳號：19863813　戶名：書虫股份有限公司
	讀者服務信箱：service@readingclub.com.tw
	城邦讀書花園：www.cite.com.tw
香港發行所	城邦（香港）出版集團有限公司
	香港灣仔駱克道193號東超商業中心1樓 / E-mail：hkcite@biznetvigator.com
	電話：（852）25086231 傳真：（852）25789337
馬新發行所	城邦(馬新)出版集團
	Cité (M) Sdn. Bhd. (458372 U)
	11, Jalan 30D/146, Desa Tasik, Sungai Besi, 57000 Kuala Lumpur, Malaysia
	電話：（603）90563833 傳真：（603）90562833
美術設計	張福海
印　　　刷	卡樂彩色製版印刷有限公司
總經銷	聯合發行股份有限公司
地　　　址	新北市231新店區寶橋路235巷6弄6號2樓
	電話：（02）2917-8022　傳真：（02）2911-0053

■2016年10月18日初版　　　　　　Printed in Taiwan
定價／520元
ISBN 978-986-477-087-8

國家圖書館出版品預行編目(CIP)資料

圖解字型思考:寫給設計師、寫作者、編輯、以及學生們的重要指南 / 艾琳.路佩登(Ellen Lupton)著；林育如譯. -- 初版. - 臺北市：商周出版：家庭傳媒城邦分公司發行, 2016.10

譯自：Thinking with type : a critical guide for designers, writers, editors, & students

ISBN 978-986-477-087-8(平裝)

1.平面設計 2.字體

962　　　　　105014659

Thinking with Type, revised and expanded edition
Copyright © Ellen Lupton
First published in the United States by Princeton Architectural Press
Complex Chinese edition copyright © 2016 Business Weekly Publications,
a division of Cité Publishing Ltd.
All Rights Reserved.

thinking with **type**

圖解字型思考

寫給設計師、寫作者、編輯、以及學生們的重要指南

A CRITICAL GUIDE
FOR DESIGNERS,
WRITERS, EDITORS
& STUDENTS

CONTENTS

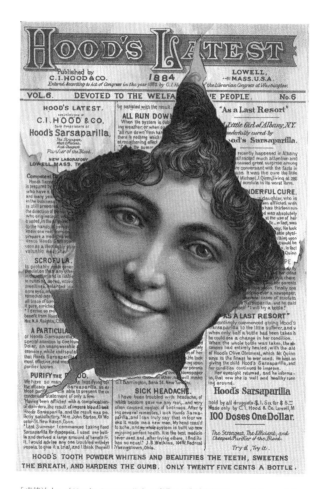

「虎德沙士」（Hood's Sarsaparilla），廣告，平版印刷（lithograph），一八八
四年。依實際尺寸複製。一張女性健康的臉龐穿破紙張上的文字而出，她明亮的好
氣色比任何文字形式的宣稱更能彰顯產品的功效。文字與圖像皆為手繪，以彩色平
版印刷術複製。

INTRODUCTION 序言

自從《圖解字型思考》第一版在二〇〇四年問世以來，這本書便廣受世界各地的設計課程採用。每回在演講或其他活動場合有年輕設計師拿著破爛不堪的《圖解字型思考》請我在書上簽名時，我從頭到腳——從襯線（serif）到豎線（stem）——都因為歡喜而感到無比溫暖。那些磨損的封面和缺角的書頁證明了字體編排設計正在下一個世代的手裡、心裡蓬勃發展著。

　　從二〇〇四年到現在我增加了一些體重，這本書也是。在新版當中，我決定要放鬆束縛，讓內容有更多呼吸的空間。假使你就像大多數的平面設計師一樣，喜歡對小細節斟酌再三、斤斤計較，那麼接下來你將會發現許多讓你愛不釋手、五體投地、焦慮不已的內容。在第一版當中已略有觸及的細瑣問題，例如字距微調（kerning）、小型大寫字（small capitals）、非齊線數字（non-lining numerals）、標點符號、對齊、基線網格（baseline grids）等，在本書中都有更詳細的說明；另外書中也新增了一些之前略過未提的主題，例如首字放大下沉（a drop capital）要如何設計、關於視覺尺寸（optical sizes）你該知道的事、還有在接下來的「美國平面設計協會」（AIGA, American Institute of Graphic Arts）聯誼派對上什麼時候該說「字體」（typeface）而不是「字型」（font）。這本新書裡什麼都多了一點：更多字型、更多練習、更多範例、更壯觀的索引，而最棒的是，還列舉了更多字體編排上的不良設計——讓更多落漆的「囧設計」和得體的「設計準則」兩者相得益彰。

焦慮嗎？
請參考第八十一頁。

　　我從一九九七年起便在馬里蘭藝術學院（Maryland Institute College of Art, MICA）開設字體編排課程，我是在替這門課尋教科書的時候，動了要撰寫這本書的念頭。與字體編排設計相關的書籍，有些聚焦在傳統經典的版面上，有些則大部龐雜、過於鉅細靡遺。有些大量援引作者本身創作的圖文為例，在多樣的實務操作上只能提供狹隘的一家觀點；還有的內容婆婆媽媽、把讀者當白癡，用字遣詞充滿優越屈尊的口吻。

　　我想要找的是一本四平八穩、清晰易懂的書，設計與文字在書中相輔相成，有助於讀者對字體編排設計的了解；我想要找的是一本小而美、簡約但結構扎實的書——一本適合隨手翻閱的手冊；我想要找的是一本能夠反映字體編排設計的各種面向、過去與現今發展的書，讓我的學生們對於相關的歷史、理論、與創意能夠有所領會；最後，我想要找的是一本能夠從印刷紙張到發光螢幕、涵蓋各種視覺設計媒體的書。

　　我發現我沒有選擇的餘地，只能自己動手寫一本。

　　《圖解字型思考》由三個單元組成：字母（letter）、文本（text）、和網格（grid），從最基本的字母樣式開始，一直談到將文字融入條理一致的內容主體、以及可靈活變動的系統當中。每一單元的開頭都有一篇敘事性的短文，探

討在各種媒體上影響字體編排設計的文化性與理論性議題。緊接在短文之後的範例，除了展示字體編排設計「如何」架構之外，同時也說明「為什麼」的理由，以證明設計的慣例有其功能與文化的基礎。在這本書裡，設計實務的範例——展現出字體編排系統的彈性，其中的規則（幾乎）全都是可以打破的。

第一個單元「字母」，揭示了早期鉛字如何透過模仿手寫字與版面主體建立關連性。十九世紀的商業廣告字體編排設計是由新古典土義當中所提取的要素孕育而生的奇妙產物。到了二十世紀，前衛藝術家與設計師將字母視為一套理論系統並加以探討。隨著數位設計工具的興起，字體編排設計也與版面主體重新建立起關連性。

第二個單元「文本」，對於集結文字成為較大的版面主體有深入討論。文本是一個區塊或結構，其中的紋理、色彩、密度、與輪廓都可以被無限制地調整。從金屬活字具體的物質性到數位媒材所賦予的彈性與限制，「技術」造就了版面空間的設計。文本從一個封閉、穩定的主體演變為一個流動、開放的環境。

第三個單元「網格」以空間的組織為研究對象。在二十世紀早期，達達主義與未來主義的藝術家意圖跳脫金屬活字的直線結構限制，揚棄了凸版印刷的機械式網格。一九四〇與一九五〇年代的瑞士設計師將網格系統化，發展出第一套全面性的設計方法論。他們的理論將提綱挈領的思考方式帶入這個一向以品味與慣例掛帥的領域裡，至今也仍然影響著多媒體設計的系統思考方法。

這本書是一本關於運用字體編排設計進行思考的書——到最後，重點還是在「運用」上。字體編排設計是被運用以做事的一種工具：表現內容、賦予語言具象的主體、讓訊息產生社會性的流動。字體編排設計是一項持續發展中的傳統，它讓你與過去和未來的設計師得以連結在一起。不論你到哪裡——大街上、購物中心、網路、住家——字體總是如影隨行跟著你。視覺文字的生命看似有其秩序卻又難以預測，這本書的目的即在於和所有生活與之息息相關的讀者與寫作者、設計師與製造商、老師與學生們深入對話。

ACKNOWLEDGMENTS 致謝

一九八一年至一九八五年間我在古柏聯合學院（Copper Union）學習藝術與設計，身為一名設計師、作家、與視覺思考者，我深深受惠於當年老師們的教導。那時設計界被涇渭分明地分成瑞士風格的現代主義派、與根源於美國廣告與插畫圈的創意方法派兩大塊。我的老師們，包括喬治·薩德克·威廉·貝明頓（William Bevington）、和詹姆士·克雷格（James Craig）等人，在這兩個世界之間畫出一方天地，讓現代主義派對於抽象系統的迷戀能夠與奇特、詩意、流行的一切擦撞出火花。

這本書之所以取名為《圖解字型思考》（Thinking with Type），為的是要向詹姆斯·克雷格撰寫的入門書《活用字型：排印工藝101》（Designing with Type）致敬，那是我們在古柏聯合學院就讀時的實用經典教科書。假使說那本書是寫給技師的基本字體編排設計手冊，這本就是博物學家的田野圖鑑，我將字體視為一種漸進演變的現象，而不是機械化的結果。我受教於老師們的不是規則與論述，而是思考的方法──如何利用視覺文字與口語讓創意概念得以發展。對我而言，探索字體編排設計就像是發現了一座連結藝術與語言的橋樑。

為了要寫出一本屬於二十一世紀的著作，我決定再次進修充實自己。二○○三年，我進入巴爾的摩大學（University of Baltimore）攻讀媒體傳達設計學程博士學位，並且於二○○八年完成學業。期間我與史都華·摩斯洛普（Stuart Moulthrop）和南西·卡普蘭（Nancy Kaplan）兩位在網路媒體與數位介面領域享有盛名的世界級學者、評論家、設計師共事，這本書中隨處可見他們的影響。

我在馬里蘭藝術學院的同事們在學校裡打造了別具特色的設計文化；我要特別感謝雷·艾倫（Ray Allen）、弗瑞德·拉札魯斯（Fred Lazarus）、古納·納達拉真（Guna Nadarajan）、布拉琪特·侯恩（Brockett Horne）、珍妮佛·寇勒·菲利浦、與我所有的學生們。

《圖解字型思考》第一版的編輯馬克·拉姆斯特（Mark Lamster）一直是我最敬重的同事之一。第二版的編輯妮可拉·貝納瑞克（Nicola Bednarek）則是在擴充篇幅的內容均衡與去蕪存菁上出力不少。我要感謝普林斯頓建築出版社（Princeton Architectural Press）的發行人凱文·里佩爾特（Kevin Lippert），多年來一直不斷給予我支持。還有許多一路相挺的設計師與學者們，包括彼德·比拉克（Peter Bilak）、馬提歐·伯洛葛納（Matteo Bologna）、薇薇安·佛肯弗立克（Vivian Folkenflik）、強納森·胡福勒（Jonathan Hoefler）、艾瑞克·卡爾尼斯（Eric Karnes）、艾爾克·蓋索賽德（Elke Gasselseder）、漢斯·里克雷馬（Hans Lijklema）、威廉·諾埃爾（William Noel）、傑佛瑞·澤爾曼（Jeffrey Zeldman）以及其他所有分享他們心血的設計師們。

每一天，我都會從我的孩子們傑（Jay）和露比（Ruby）、我的父母、我的雙胞胎姊妹、以及優秀的米勒家族成員身上學到一些東西。我的朋友們──珍妮佛·托比亞斯（Jennifer Tobias）、愛德華·波頓尼（Edward Bottone）、克勞蒂亞·馬茲柯（Claudia Matzko）、和喬伊·海耶斯（Joy Hayes）──讓我的生命不斷受到鼓舞。我的先生阿勃特·米勒（Abbott Miller）是我所知道最傑出的設計師，能將他的作品收錄在這本書中讓我倍感驕傲。

{LETTER 字母}

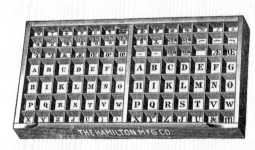

Upper Case.

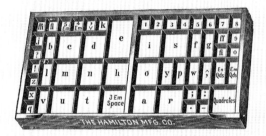

Lower Case.
A PAIR OF CASES.

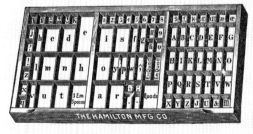

California Job Case.
FIG. 2.—Showing Lay of Cases.

TYPE, SPACES, AND LEADS
活字、字間、與鉛條

示意圖，一九一七年。作者：法蘭克 S. 亨利（Frank S. Henry）。在活版印刷廠裡，活字字型與調節間距的素材會被放在有柵格的盒子當中。大寫字母放置在小寫字母上方的抽屜裡。「大寫字母」（uppercase）和「小寫字母」（lowercase）兩個名詞便是從印刷廠裡的空間使用配置衍生而來的。

LETTER 字母

這不是一本關於字型的書，而是一本關於如何使用字型的書。字體是為平面設計師所運用的一種基本素材，就像玻璃、石塊、鋼鐵、與其他素材之於建築師一樣。平面設計師有時候會自行創作字體與手繪美術字，然而更普遍的情形是，他們會往廣大的現有字體庫裡搜尋，為特定的觀眾或情境挑選並組合出適用的字體。要勝任這份工作、展現個人巧思，必須具備字體如何演變、與為什麼如此演變的相關知識。

文字起源於身體的姿態。第一套字體是直接模仿書法的形式製作出來的。然而「字體」並不是身體的姿態；它們是人造的圖像，為了不斷重複出現的目的而設計的。字體編排設計的歷史反映了手與機械、有機與幾何、人體與抽象系統之間持續的緊張關係。這些緊張關係標誌了五百多年前印刷字母的誕生，時至今日也仍然刺激著字體編排設計的發展。

十五世紀初期，德國的約翰尼斯·古騰堡（Johannes Gutenberg）發明了活字印刷，為西方世界的書寫帶來革命。過去仰賴抄寫員以手寫方式製作書籍與文獻，然而活字印刷的出現讓大量生產成為可能——鑄模可以鑄造出大量的字母，而這些字母可以被組合成各種「形式」。當頁面文字經過校對、修改、印刷之後，這些字母會被收納在有柵格的盒子裡，等待下一次再被拿出來使用。

中國在更早期已有活字的運用，但實際效用並不高。相較於中文書寫系統裡有數以萬計的個別文字，拉丁字母系統則是將口語轉譯為一小組符號群，非常適合機械化。古騰堡最著名的《聖經》是以手抄聖經為藍本。為了模仿「哥德體」（blackletter）緊密、濃黑的手寫風格，他為每一個字母創造不同的變化形，也製作了大量的連字（ligatures，將兩個以上的字母組合在一起），重現哥德體古怪獨特的質感。

本章是根據〈字母的法則〉（Laws of the Letter）一文延伸並修改而成。艾琳·路佩登與J. 阿勃特·米勒，《設計論述研究：平面設計論述》（Design Writing Research: Writing on Graphic Design, New Work; Kiosk, 1966; London: Phaidon, 1999），第五十三頁至六十一頁。

約翰尼斯·古騰堡，印刷文字，一四五六年。

NICOLAS JENSON
尼可拉斯．詹森原本在德國字體編排設計的發源地美因茲（Mainz）學習印刷術，後來大約於一四六五年左右，他在威尼斯（Venice）成立了自己的印刷廠。他的字體有結實的垂直豎線，由粗而細的變化則是模仿了寬頭尖嘴筆的筆跡。

los appellatur mari
euir dicitur frater m
ratriæ appellantur q
mitini fratrum & m
atruelis matrum fra
õſobrini ex duabus
ta ſunt in antiquis a

CENTAUR
一九一二年至一九一四年間由布魯斯．羅傑斯（Bruce Rogers）所設計，重現了特別強調緻帶般筆觸的詹森字體。

Lorem ipsum dolor
consectetuer adipiscing
Integer pharetra, nis
luctus ullamcorper,
tortor egestas ante,
pede urna ac neque.
ac mi eu purus tinci

RUIT
一九九〇年代由荷蘭字型設計師、教師、與理論家伽里特．諾塞（Gerrit Noordzij）所設計。這個以數位方式建構的字掌握了十五世紀的羅馬體與其源頭哥德體（而非人文主義字體）

vanum laboraverur
si Dominus custod
istra vigilavit qui cc
num est vobis ante
rgere postquam sec
i manducatis panei
m dederit dilectis s
ALMI IVXTA LX:

的動感與立體感。就如同諾塞所解釋，詹森「將德文字母融入義大利樣式（圓一點、輕一點），於是便創造出了羅馬體（roman type）。」

the iiii wekis, and hov
lord, yet the chirchem
that is to wete, of that
and of that he cometh
in thoffyce of the chi
tynges that ben in th
one partie, & that oth
cause of the comynge
ben of joye and gladr

Lorem ipsum dolor
consectetuer adipise
Integer pharetra, ni
luctus ullamcorper,
tortor *egestas* ante, v
pharetra pede urna
neque. Mauris ac m

Lorem ipsum dolo
consectetuer adipis
Integer pharetra, n
ullamcorper, augu
ante, vel *pharetra* p
neque. Mauris ac r
tincidunt faucibus.
dignissim lectus. Ni

SCALA
一九九一年由荷蘭字型設計師馬丁．馬約（Martin Majoor）創作。雖然這套完現代感的字體帶有幾何襯線與充滿理性、幾乎可以說是模組化的樣式，但從字母來看，它仍然反映出活字與書法的淵源，例如字母「a」

GOLDEN TYPE
由英國設計界的改革者威廉．莫里斯（William Morris）於一八九〇年創作。這套字體試圖要重新呈現詹森印刷品頁面上濃黑、沉重的緊密感。

ADOBE JENSON
一九九五年由羅伯特．斯林巴赫（Robert Slimbach）設計，他從數位應用的角度重新檢視了歷史上的重要字體。與Centaur相比，Adobe Jenson顯得較不做作與花俏。

HUMANISM AND THE BODY
人文主義與人體

在十五世紀的義大利，哥德體並不為人文主義作家與學者們所喜愛；他們鍾情於樣式較寬鬆、奔放的古典手寫字體lettera antica。這種對於lettera antica的偏愛，與古典藝術和文學的復興（重生）息息相關。法國人尼可拉斯·詹森（Nicolas Jenson）原本在德國學習印刷技術，後來大約一四六九年左右他在威尼斯成立了一間具有影響力的印刷廠。他的字體融合了他在法國與德國時最為熟悉的哥德體、與形式較圓滑輕盈的義大利風格。這套字體被視為是第一套——也是最精緻的——羅馬正體字（roman typefaces）。

我們今天所使用的許多字體，包括Garamond、Bembo、Palatino、和Jenson，都是根據十五、十六世紀的印刷商人名字所命名。這些字體便是眾所周知的「人文主義字體」。今人對於早期經典字體的改作，其設計重點在於讓字體適用於現代科技，以因應目前對於銳利度與均勻度的需求。每一次改作，都是在回應——或反抗——當代的製造方法、印刷風格、與藝術慣習。有些是根據現存的金屬活字、鋼字沖（punches，鋼製的活字原型）、或圖畫改作，然而絕大部份改作只能參考印刷樣本進行。

同樣發源於十五世紀義大利的斜體字（italic letters）則是依風格較為隨興的手寫字鑄造。挺立的人文主義字體通常見於製作成本昂貴的書籍當中，草寫的字體樣式則活躍於較廉價的寫字坊，因為這種字體寫起來要比一板一眼的lettera antica來得快多了。一名威尼斯印刷業者、出版商、兼學者阿爾杜斯·馬努提烏斯（Aldus Manutius）便將他的著作以斜體字印製成一系列成本低廉的小書，在各國之間流通發行。對書法家而言斜體字比較經濟，因為它可以省下一些書寫時間；在印刷上來說，草寫樣式也可以節省一些空間。阿爾杜斯·馬努提烏斯經常將草寫字與正體字搭配使用；然而在當時，這兩種字體風格一向被認為是天差地別的。

到了十六世紀，印刷業者開始藉由比對字體濃淡與「X」高度（x-height，小寫字母主體部份的高度）將正體字與斜體字納入同一個字體家族。今天，大多數字型的斜體字不僅僅是正體字的傾斜版，它同時包含了草寫樣式所具備的弧線、角度、與較細長的比例等特色。

法蘭西斯柯·格里佛（Francisco Griffo）為阿爾杜斯·馬努提烏斯設計了正體與斜體的活字。當時正體與斜體被視為是完全不同類別的字體。

一六四二年，讓·雅農（Jean Jannon）為巴黎皇家印刷廠（Imprimerie Royale）打造了一套正體與斜體活字，並將它們歸放在同一個較大的活字家族裡。

comme i'ay des-ia remarqué, *S. Augu-stin demande aux Donatistes en vne sem-blable occurrence : *Quoy donc ? lors que nous lisons , oublions nous comment nous auons accoustumé de parler ? l'escriture du grand Dieu

關於正體字複雜的源起，可參閱伽里特·諾塞的著作《字母字母》（Letterletter, Vancouver: Hartley and Marks, 2000）。

喬弗魯瓦·托里（Geofroy Tory）主張文字應該要能反映完美的人體比例。以字母A來說，他寫道：「橫劃覆蓋在男性的生殖器上，這表示對於想要探究完美字型的人而言，節制與貞潔是首要必備條件。」

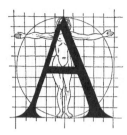

路易斯·希莫努（Louis Simonneau）為路易十四（Louis XIV）的印刷廠設計了一套字體原型。依照皇家委員會的指示，希莫努在精細的網格上設計字體。後來菲力普·格蘭尚（Philippe Grandjean）便根據希莫努的雕版打造了一套皇家字體（romain du roi）。

威廉·凱斯隆（William Caslon）在十八世紀的英格蘭設計了一套清爽的直立字體。一如羅伯特·布靈赫斯特（Robert Bringhurst）所寫的，它們看起來「比文藝復興字體樣式更有立體感、更少了一點手寫味。」

By WILLIAM CASLON, Letter-Founder, in Chif

ABCD
ABCDE
ABCDEFG

DOUBLE PICA ROMAN.
Quousque tandem abutere, Cati-
lina, patientia nostra ? quamdiu
nos etiam furor iste tuus eludet?
quem ad finem sese effrenata jac-
ABCDEFGHJIKLMNOP

GREAT PRIMER ROMAN.
Quousque tandem abutere, Catilina, pa-

Double Pica Itali
Quousque tandem abuter-
na, patientia nostra ?
nos etiam furor iste tuus
quem ad finem sese effren
ABCDEFGHJIKI

Great Primer Italic.
Quousque tandem abutere, Cat

SPECIMEN

By JOHN BASKERVILLE of Birmingham.

I·Am indebted to you for two
Letters dated from Corcyra.

if to mean well to the Interest of my
Country and to approve that meaning

約翰·巴斯克維爾（John Baskerville）是一七五〇與一七六〇年代活躍於英格蘭的印刷商人。為了超越凱斯隆，他創造了一套細節更銳利的字體，將粗細對比做得更分明。儘管當時凱斯隆的字體相當普遍，但對於巴斯克維爾的字體，許多同時期的人們卻給予「外行」、「偏激」的負面評價。

AUSTERLITI

RELATAM A GALI

DUCE

詹巴提斯塔·波多尼（Giambattista Bodoni）在十八世紀末期設計了一套字體，它的粗細對比極端、沒有緩衝，極細的襯線下方也沒有弧型的字托支撐。同一時期，法國的弗蘭索瓦·安布魯瓦茲·狄多（François Ambroise Ddidot）（1784）與德國的尤斯圖斯·埃里希·瓦爾鮑姆（Justus Erich Walbaum）（1800）也分別創作出相似的字體。

ENLIGHTENMENT AND ABSTRACTION
啟蒙與抽象

Aabcdef

ABCD

aabbccddee

ABCD

NOPQ

喬治·畢克漢（George Bickham），一七四三年。「羅馬正體」與「義大利書寫體」的範例。

巴斯克維爾的崇拜者班傑明·富蘭克林（Benjamin Franklin）在寫給巴斯克維爾的信中提及坊間對他的指控。信件全文請見 F. E. 帕爾多（F. E. Pardoe），《伯明罕的約翰·巴斯克維爾：鑄字師與印刷商》（John Baskerville of Birmingham: Letter-Founder and Printer, London: Frederick Muller Limited, 1975），第六十八頁。同時可參考羅伯特·布靈赫斯特（Robert Bringhurst），《字體編排設計風格的要素》（The Elements of Typographic Style, Vancouver: Hartley and Marks, 1992, 1997）。

文藝復興時期的藝術家們希望在完美的人體體型當中找出標準比例。法國設計師與字型設計師喬弗魯瓦·托里（Geofroy Tory）在一五二九年出版了一系列將字母的結構與男性人體結構連結在一起的圖解。拋開字母與人體連結的新觀點是在科學與哲學的啟蒙時期（Enlightenment）出現的。

法王路易十四於一六九三年任命成立一個委員會，他們要以精細的網格打造出一套羅馬正體字。之前托里的圖解是以木刻印刷方式印製；以網格設計出來的 romain du roi（法王的全套字母）字體，其圖示與說明則是透過雕版印刷方式─也就是以雕刻刀工具在銅版上雕刻──印製。根據這些大比例尺的圖解製作而成的鉛字除了反映出雕刻的線條特色之外，也展現了皇家委員會的科學態度。

雕版印刷的字母它們流動的線條不會受到活版印刷機器網格的限制，因而為講求形式的手繪美術字提供了相當合適的媒介。十八世紀有許多偉大書法家的傑出作品都是透過雕版印刷加以複製傳播的。喬治·畢克漢（George Bickham）的著作《世界書法家》（The Universal Penman, 1743）裡除了介紹帶有圓弧的手寫體之外，羅馬正體字也因為雕刻製版後每個字母都有其獨一無二的特色而獲得青睞。

十八世紀的字體編排設計受到新樣式的手寫體與其雕版印刷品的影響。一些印刷商，例如一七二○年代的威廉·凱斯隆（William Caslon）和一七五○年代的約翰·巴斯克維爾（John Baskerville），他們捨棄了人文主義字體慣用的鋼硬筆尖，改用筆頭可彎曲的蓄水鋼筆與尖頭鵝毛筆，這些書寫工具可以寫出流暢、圓鼓的筆跡。本身就是書法大師的巴斯克維爾非常欣賞雕版印刷書籍當中細細雕刻出來的線條。他創造了一套強調銳利感與對比的字體，當時的人們紛紛指責他「弄瞎全國讀者的雙眼；因為你寫出來的字母筆劃又細又窄，太過傷眼。」為了讓他印刷品頁面驚人的清晰度更為增強，巴斯克維爾自行製作油墨，並且對印製好的紙張加以熱壓。

在十八、十九世紀之交，義大利的詹巴提斯塔·波多尼（Giambattista Bodoni）和法國的弗蘭索瓦·安布魯瓦茲·狄多（François Ambroise Ddidot）將巴斯克維爾正經嚴肅的字體風格推往新的極致境界。他們的字體──完全垂直的軸線、粗細明顯的對比、以及看起來似薄餅般鬆脆的襯線──與書法分道揚鑣，開啟了字體編排設計爆發性的視野。

romain du roi 字體不是由某位字體設計師獨力設計出來的；該字體是由政府派任的委員會所設計，委員會成員包括有兩名教士、一名會計師、與一名工程師。

P. VIRGILII MARONIS

BUCOLICA

ECLOGA I. cui nomen TITYRUS.

MELIBOEUS, TITYRUS.

TITYRE, tu patulæ recubans fub tegmine fagi
Silveftrem tenui Mufam meditaris avena:
Nos patriæ fines, et dulcia linquimus arva;
Nos patriam fugimus: tu, Tityre, lentus in umbra
5 Formofam refonare doces Amaryllida filvas.
 T. O Melibœe, Deus nobis hæc otia fecit:
Namque erit ille mihi femper Deus: illius aram
Sæpe tener noftris ab ovilibus imbuet agnus.
Ille meas errare boves, ut cernis, et ipfum
10 Ludere, quæ vellem, calamo permifit agrefti.
 M. Non equidem invideo; miror magis: undique totis
Ufque adeo turbatur agris. en ipfe capellas
Protenus æger ago: hanc etiam vix, Tityre, duco:
Hic inter denfas corylos modo namque gemellos,
15 Spem gregis, ah! filice in nuda connixa reliquit.
Sæpe malum hoc nobis, fi mens non læva fuiffet,
De cœlo taĉtas memini prædicere quercus:
Sæpe finiftra cava prædixit ab ilice cornix.
Sed tamen, ifte Deus qui fit, da, Tityre, nobis.
20 *T.* Urbem, quam dicunt Romam, Melibœe, putavi
Stultus ego huic noftræ fimilem, quo fæpe folemus
Paftores ovium teneros depellere fœtus.
Sic canibus catulos fimiles, fic matribus hœdos
 A Noram;

LA THÉBAÏDE,

OU

LES FRERES ENNEMIS,

TRAGÉDIE.

~~~~~~~~~~~~~~~~~~~~~~~~~~~~~~~~~~~~~~~~

## ACTE PREMIER.
——

### SCENE I.

JOCASTE, OLYMPE.

#### JOCASTE.

Ils sont sortis, Olympe? Ah! mortelles douleurs!
Qu'un moment de repos me va coûter de pleurs!
Mes yeux depuis six mois étoient ouverts aux larmes,
Et le sommeil les ferme en de telles alarmes!
Puisse plutôt la mort les fermer pour jamais,
Et m'empêcher de voir le plus noir des forfaits!
Mais en sont-ils aux mains?

VIRGIL（左圖），書頁，一七五七年。約翰‧巴斯克維爾印製。巴斯克維爾創作的字體以其銳利、直立的樣式與粗細筆劃明顯的對比在當時引起極大的關注——甚至是震驚。除了羅馬正體之外，這一頁還使用了斜體大寫字、人型大寫字（字間加大）、小型大寫字（比例縮小到與小寫字大小相同），和非齊線與舊體數字（依上伸部、下伸部、和小字母字高而設計，搭配小寫字母使用）。

RACINE（右圖），書頁，一八〇一年。由佛爾明‧狄多（Firmin Didot）印製。法國狄多家族所設計的字體有更為細長且沒有字托的襯線、以及粗細筆劃更分明的對比，比巴斯克維爾的字體更偏離寫實、更端正嚴肅。十九世紀的印刷商與字體設計師說這些光彩奪目的字體「很摩登」。

以上兩頁均複製自威廉‧達納‧歐爾卡特（William Dana Orcutt）的著作《完美書本的探尋》（In Quest of the Perfect Book, New York: Little, Brown and Company, 1926）；附圖的邊界裁切並不精準。

440 *Plan for the Improvement of the Art of Paper War.*
whilſt a paſſionate man, engaged in a warm controverſy
would thunder vengeance in

# French Canon

It follows of courſe, that writers of great iraſcibility ſhould
be charged higher for a work of the ſame length, than meek
authors; on account of the extraordinary ſpace their perfor
mances muſt neceſſarily occupy; for theſe gigantic, wrath
ful types, like ranters on the ſtage, muſt have ſufficient
elbow-room.

For example: Suppoſe a newſpaper quarrel to happen be
tween * M and L. M begins the attack pretty ſmartly in

Long Primer.

L replies in

Pica Roman.

M advances to

Great Primer.

L retorts in

Double Pica.

And ſo the conteſt ſwells to

# Raſcal,
# Villain

* Leſt ſome ill-diſpoſed perſon ſhould miſapply theſe ini
tials, I think proper to declare, that M ſignifies Merchant,
and L Lawyer.

Coward.

# Cow-
# ard,

in five line Pica; which, indeed, is as far as the art of printing, or a modern quarrel can well go.

A philosophical reason might be given to prove that large types will more forcibly affect the optic nerve than those of a smaller size, and are therefore naturally expressive of energy and vigour. But I leave this discussion for the amusement of the gentlemen lately elected into our philosophical society. It is sufficient for me, if my system should be found to be justified by experience and fact; to which I appeal.

I recollect a case in point. Some few years before the war, the people of a western county, known by the name of Paxton Boys, assembled, on account of some discontent, in great numbers, and came down with hostile intentions against the peace of government, and with a particular view to some leading men in the city. Sir John St. Clair, who assumed military command for defence of the city, met one of the obnoxious persons in the street, and told him that he had seen the manifesto of the insurgents, and that his name was particularised in letters as long as his fingers. The gentleman immediately packed up his most valuable effects, and sent them with his family into Jersey for security. Had sir John only said that he had seen his name in the manifesto, it is probable that he would not have been so seriously alarmed: but the unusual size of the letters was to him a plain indication, that the insurgents were determined to carry their revenge to a proportionable extremity.

I could confirm my system by innumerable instances in fact and practice. The title-page of every book is a proof in point. It announces the subject treated of, in conspicuous characters; as if the author stood at the door of his edifice, calling

H

5

〈紙上戰爭藝術的改善計畫〉（Plan for the Improvement of the Art of Paper War），法蘭西斯．霍普金森（Francis Hopkinson）的諷刺文章，收錄於《美國博物館》（The American Museum），第一冊（1987），波士頓公共圖書館館藏。這篇十八世紀的文章是早期關於透過字體編排設計表情達意的代表作品。作者提到坊間發生了一起律師與商人的「紙上戰爭」，藉此大開新興的新聞媒體玩笑。隨著這兩位男士不斷攻訐對方，所用的字體也愈來愈大。「Long Primer」、「Pica Roman」、「Great Primer」、「Double Pica」、和「Five Line Pica」在當時都用以指稱字型大小。「f」的符號代表「s」。霍普金斯並不是設計門外漢；美國國旗上星星與橫條的意象便出自霍普金斯之手。

FAT FACE是指十九世紀早期膨脹、特別粗黑的字體風格，它們將波多尼與狄多字體樣式中的粗細元素誇張化到極致。

EXTRA CONDENSED字體設計用於狹窄的空間中。十九世紀的廣告通常會在單一頁面上混搭不同風格與比例的字型。然而這種誇張的字體通常在排版時會被擺放在固定、置中的位置。

EGYPTIAN，或粗襯線字體，把襯線從細緻的線條轉化為荷重的厚板。加粗的襯線獨立成為字體的結構要素，有其重量與質感。這種風格在一八○六年問世後立刻遭到純粹主義者同聲譴責為「字體編排設計的畸形怪物」。

GOTHIC在十九世紀用以統稱無襯線的字體。Gothic字體立面的厚實感非常引人注目。雖然無襯線字體後來多用於表達理性與中立的概念，但它們確實為早期廣告帶來了情感面的衝擊。

我的樣子面目可憎，身高巨大得嚇人。這表示了什麼？我是誰？我又是幹什麼的？……可恨的創造者！你為什麼要製造出一個連你自己都覺得噁心嫌棄的醜陋怪物呢？── 瑪麗·雪萊（Mary Shelley），《科學怪人》（Frankenstein），一八三一年。

## MONSTER FONTS
### 怪物字型

雖然波多尼與狄多的字體設計是受到當時書寫慣例的影響，但他們所創造出來的字體樣式確實衝撞了字體編排設計傳統，開啟了前所未見的新世界，讓文字的結構——襯線和豎線、粗細筆觸、垂直與水平對稱軸線——成為各種奇妙實驗的對象。為了追求理性與莊嚴兼具的美感，波多尼和狄多創造出一隻怪物：一種抽離現實且去人性化的字體設計方法。

隨著十九世紀工業化與大量消費的興起，廣告業也隨之爆發，這種新型態的傳播媒體需要運用新的字體編排設計。字型設計師利用粗大的筆劃裝飾並填滿文字的主體部份。於是有著驚人的高度、寬度、和深度的各種字型便出現了——有膨脹的、收縮的、加陰影的、穿線的（inlined）、加粗的、多面的、和加上花卉圖案裝飾的。襯線拋棄了原本負責收尾修飾的角色，成為文字裡獨立的結構元素，傳統字體的垂直應力也往新的方向傾斜。

原本用以鑄造金屬活字的「鉛」，因其質地太軟，無法在印刷加壓的過程中撐住較大的字型。相較之下，木刻活字就適合用於印刷巨大的字型。一八三

| ANTIQUE | CLARENDON | LATIN / ANTIQUE TUSCAN | TUSCAN |

字體歷史學家羅伯・洛伊・凱利（Rob Roy Kelly）針對十九世紀為了製造各種不同變化的展示文字而採用的機械化設計手法進行研究。這張圖顯示了基本的方形襯線樣式——一般被稱為埃及體或粗襯線字體——被切割、修整、拉伸、彎曲，以製造出新的裝飾圖樣。襯線從原本書法的收尾筆畫轉變為可以任意調整變形的獨立幾何元素。

四年，縮放刻模機的問世為木刻活字的製作帶來革命。縮放儀（pantograph）是一種描繪設備，將縮放儀與刻模機相連，就可以根據母本大量製作出各種不同比例、濃淡、與裝飾圖案的變化。

這種機械化的設計手法讓字母脫離書法，成為一個可靈活運作的系統。人們放下了過去對於完美比例原型字體的追求，轉而視字體編排設計為一個由各種樣式特色所組成的彈性系統（濃度、應力、豎線、橫線、襯線、角度、弧線、上伸部、下伸部）。在一套字體當中，字母之間的關係要比字母的個體性來得重要。

關於裝飾性字體進一步的解析與範例，請參考羅伯・洛伊・凱利（Rob Roy Kelly）的著作《美國木刻活字：一八二八－一九〇〇，關於裝飾性與大型字體發展的筆記》（American Wood Type: 1828-1900, Notes on the Evolution of Decorated and Large Letters, New York: Da Capo Press, 1969）。也可參閱羅瑞・麥克林（Ruari McLean）的文章〈埃及體研究〉（An Examination of Egyptians），《關於字體的文本：字體編排設計的批判文章》（Texts on Type: Critical Writings on Typography），史帝文・海勒（Steven Heller）與菲力普 B. 梅格斯（Philip B. Meggs）編，（New York: Allworth Press, 2001），第七十至七十六頁。

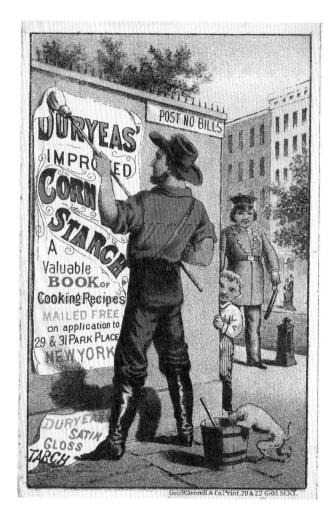

杜里耶牌改良玉米澱粉（Dureas' Improved Cornstarch）（左圖）

平版印刷廣告卡，一八七八年。十九世紀廣告業興起，為了能夠在都會地區引起注目，大型字體的需求隨之產生。在這張卡片中，一名男子無視於法律規定公然張貼海報，而警察正從街角另一頭走近。

滿月（Full Moon）（右圖）

活版印刷海報，一八七五年。這張蒸汽遊輪的海報使用了十二種不同的字型。每一行的字體都有其大小與風格，好讓文字盡量填滿該行的空間。雖然這些字體各有風情，但置中的排版方式讓版面看起來有如墓碑般單調傳統。

印刷文字原本在書籍的庇護下自成一方天地，現在卻被廣告毫不留情地拖到大街上……印刷品就像成災的蝗蟲蔽日般遮蓋了都市居民們的思考能力，而這種情形只會一年糟過一年。——瓦爾特‧班傑明（Walter Benjamin），一九二五年。

# FULL MOON.

## ST. MICHAEL'S

# TEMPERANCE BAND !

Prof. V. Yeager, Leader, will give a

# GRAND
# MOONLIGHT
# EXCURSION

On the Steamer

# BELLE !

## To Osbrook and Watch Hill,

## On Saturday Evening, July 17th,

Leaving Wharf at 7½ o'clock.   Returning to Westerly
at 10½ o'clock.   Kenneth will be at Osbrook.

## TICKETS, - FORTY CENTS.

G. B. & J. H. Utter, Steam Printers, Westerly, R. I.

荷蘭風格派運動（De Stijl movement）的創立者與主要倡議者戴歐・凡・杜斯伯格（Theo Van Doesburg）在一九一九年設計了這套帶有直角元素的字體。該字體被使用在「革命社會主義者聯盟」（Union of Revolutionary Socialists）的信紙信頭上。手寫字母的寬度不一，好填滿整個長方形的空間。風格派運動主張將繪畫、建築、物件、與字體簡化為基本的組件。

**BOND VAN REVOLUTIONNAIR-SOCIALISTISCHE INTELLECTUEELEN**

**DE STIJL**

維爾摩斯・胡札（Vilmos Huzár）於一九一七年為《風格派》雜誌（De Stijl）設計了這個識別標誌。凡・杜斯伯格的字體筆劃是相連的，胡札的字體則包含了一個個像素般的組件。

abcdefghi jklmnopqr s tuvwxyz a dd

一九二五年，赫伯特・拜耶（Herbert Bayer）在包浩斯（Bauhaus）創作出universal字體。這套由直線與圓構成的字體裡只有小寫字母。

**FETTE FUTURA**

**GOETH STOFF**

保羅・倫納（Paul Renner）一九二七年於德國設計了Futura字體。雖然這套字體帶有強烈的幾何色彩，例如它的「O」是一個正圓形，但經過巧妙設計的Futura實用性極高，直到今日仍被廣泛使用著。

# REFORM AND REVOLUTION
## 改革與革命

愛德華・強斯頓（Edward Johnston）一九〇六年根據古羅馬的刻印文字製作了這份「基本」字體的圖解。強斯頓接納帶有中世紀風格的裝飾性字體，而對商業字體抱持嗤之以鼻的態度。

關於Futura字體，請參閱克里斯多佛・柏爾克（Christopher Burke）的著作，《保羅・倫納：字體編排設計的藝術》（Paul Renner: The Art of Typography, New York: Princeton Architectural Press, 1988）。關於一九二〇年代與一九三〇年代的實驗性字體，請參閱羅賓・金洛斯（Robin Kinross）的著作，《不齊行的內文：透視字體編排設計》（Unjustified Texts: Perspectives on Typography, London: Hypress, 2002），第兩百三十三頁至兩百四十五頁。

有些設計師認為將字母變形是一種粗鄙、傷風敗俗的行為，正和具有破壞性、冷酷無情的工業系統沆瀣一氣。愛德華・強斯頓（Edward Johnston）在一九〇六年的著作中意圖重新振興對基本、標準字母字體的追求，並且對誇張變體的「危險性」提出警告。他受到十九世紀美術與工藝運動（Arts and Crafts Movement）的啟發，嘗試著回頭往文藝復興時期與中世紀找尋單純、不受污染的字體。

雖然像強斯頓這樣的改革者對過去的歷史仍然抱有浪漫的情懷，他們將設計師重新定義為遠離商業主流的知識份子。現代的設計改革人士是社會的批判者，他們致力於創造出能夠挑戰、修正大眾習性與慣例的物件與圖像。

二十世紀早期的前衛藝術家排拒傳統的表現形式，但他們卻以前人旁觀批判的作法為範。荷蘭的風格派（De Stijl）成員將字母簡化為直角構成的元素。在包浩斯（Bauhaus），赫伯特・拜耶（Herbert Bayer）和約瑟夫・亞伯斯（Josef Albers）以基本的幾何樣式，如圓形、正方形、三角形來建構字體，他們認為這些是通用視覺語言的組成要素。

這種實驗性的作法把字母視為一個抽象關係的系統。就如同十九世紀最受歡迎的印刷商，這些前衛設計師們也排拒以人類雙手與身體為據而設計出來的基本字體；他們提出簡樸、理論性的選項，以替代主流廣業熱衷使用的新奇字體。

這些實驗性的設計模仿工廠的生產方式，將字體像機械的模組件般組合起來。然而這些字體大部份不是機械字體，而是由手工創作出來的（雖然很多字體現在都已經數位化了）。保羅・倫納在一九二七年設計的Futura便是一套充份展現前衛派信念的多用途商業字體。雖然倫納偏愛「平靜」抽象的樣式而對書法的動感多所嫌棄，但他也在Futura的筆觸、弧度、與比例上做了細緻的變化，調和字體的幾何感。倫納為Futura設計了幾套粗細不同的字型，他將這個字體家族視為建構灰階頁面的繪圖工具。

這些新字體平靜、抽象的樣式與手寫運筆的線條漸行漸遠，它們提供字體編排設計師可以與版面完調和、全新樣貌的粗細濃淡變化。這些字體可以是細體、半粗體，也可以是色調飽和的粗黑體。
——保羅・倫納（Paul Renner），一九三一年。

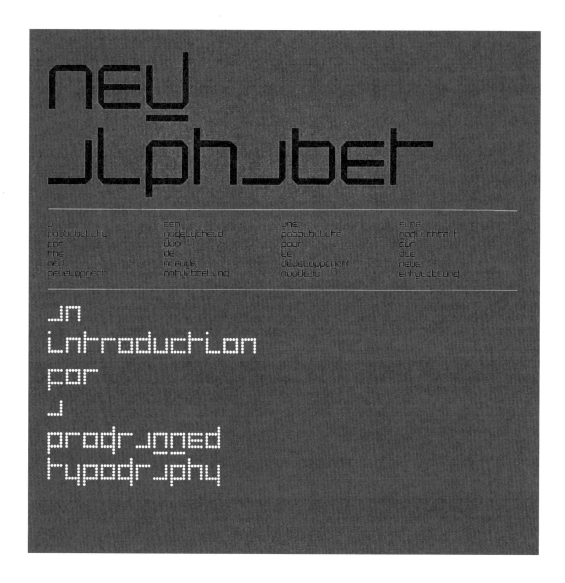

維姆・克勞威爾（Wim Crouwel）在一九六七年發表了一套完全沒有斜線與圓弧線的「新字母」（new alphabet）字體。倫敦「鑄造廠」公司（The Foundry）自一九九七年開始釋出克勞威爾字體的數位版本。

## TYPE AS PROGRAM
## 程式字體

為回應電子通訊的興起，荷蘭設計師維姆‧克勞威爾（Wim Crouwel）於一九六七年發表了一套由直線構成的「新字母」（new alphabet）字體。由於當時電視顯示器（映像管電視）上的弧線與角度都是以水平掃描的線條所繪，於是他拋棄了數百年來的字體編排設計傳統，設計出一套可於電視上作視覺展示的字體。在一篇寫著「程式風格的字體編排設計問世」字眼的新字體文宣手冊裡，他提倡循規蹈矩與理性決策的設計方法論。

維姆‧克勞威爾（Wim Crouwel）以Garamond字體當中字母「a」的「掃描版」與他自己的「新字母」對照，他的新字體可以與螢幕上的網格結構相容。請見維姆‧克勞威爾，《新字母》（New Alphabet, Amsterdam: Total Design, 1967）。

一九八五年，祖札娜‧里柯（Zuzana Licko）為桌上型電腦螢幕與印表機設計了粗解析度的字型。這些為印刷與數位媒體所設計的字型全部被整合在「僑人」字型公司龐大的低解析度字型家族裡。

請參閱魯迪‧范德蘭斯（Rudy VanderLans）與祖札娜‧里柯的著作，《僑人：跨入數位範疇的平面設計》（Emigre：Graphic Design into the Digital Realm, New York: Van Nostrand Reinold, 1993）和《僑人雜誌第七十期：回顧篇，僑人雜誌精選集1984－2009》（Emigre No. 70: The Look Back Issue, Selections from Emigre Magazine, 1984-2009, Berkeley: Gingko Press, 2009）。

一九八〇年代中期，個人電腦與低解析度印表機讓更多社會大眾得以擁有字體編排設計的工具。一九八五年，祖札娜‧里柯（Zuzana Licko）利用早期桌上型電腦顯示器的粗大顆粒設計出新字體。大部份的數位字型是將顯示器螢幕與點陣式印表機粗大的網格套用在傳統的字體樣式上，但里柯則是全然擁抱了數位設備的語言。她與她的先生魯迪‧范德蘭斯（Rudy VanderLans）——他同時也是「僑人」字型公司（Emigre Fonts）與《僑人》雜誌（Emigre）的共同創辦人——稱他們自己是「新原始人」（new primitives），在科技時代扮演開路先鋒的角色。

到了一九九〇年代早期，高解析度的雷射印表機與外框字技術如PostScript問世，字型設計師便不再受限於輸出成品解析度過低的問題。雖然時至今日確實有部份招牌系統與數位輸出設備仍然必須仰賴點陣字型，但點陣字型在印刷與數位媒體上已然因為人們對於程式與幾何結構的迷戀而演化成為一種風格要素。

**真心擁抱電腦會帶給你許多異想天開的點子。**
**——維姆‧克勞威爾（Wim Crouwel），一九六七年。**

CURATOR : JOSEPH WESNI
Linda Ferguson

Steve Handschu
James Hay

Matthew Holland SCULPTU
Gary Laatsch
Brian Liljeblad
Dora Natella
Matthew Schellenberg
Richard String

Michell Thomas

Robert Wilhelm

Opening Reception : Friday June 8, 5:30—8:30 p

SCULPTURE

JUNE 8—JULY 7, 1990

Detroit Focus Gallery (313) 962-902!
743 Beaubien, Third Floor
DETROIT, MICHIGAN 48226
Hours: Noon to 6 pm WEDNESDAY · SATURDA

ALSO IN THE AREA: THE MARKET PRESENTS Peter Gilleran · Gordon Orear Opening 5 · 7:30 pm. Friday, June 8.

艾德‧費拉（Ed Fella）以實驗性的字體編排手法所創作的版面，對一九九〇年代的字體設計產生深刻的影響。他利用直接手寫的方式、或者從第三代的複印件或印有轉印文字的紙張上選字，以看起來受損、有缺陷的字體樣式為底特律「焦點藝廊」（Focus Gallery）設計了一系列海報。古柏－惠特國立設計博物館（Cooper-Hewitt, National Design Museum）館藏。

## TYPE AS NARRATIVE
### 敘事字體

一九九○年代早期，數位設計工具開始支援各種媒體間完美無縫的複製與整合，許多設計師不滿足於簡潔、乾淨的版面，試圖將字體投入粗糙化、腐蝕等物理程序當中。幾百年來人們不斷以精益求精的技術追求完美的字體，現在面臨了被刮擦、彎曲、碰挫、污染的遭遇。

# Template Gothic: flawed technology
### 不完美的技術

貝瑞・戴克（Barry Deck）於一九九○年創作的字體Template Gothic是根據以塑膠模具繪製的字母所設計的，因此這套字體的設計過程同時牽涉了機械與手工。戴克設計這套字體時還是艾德・費拉（Ed Fella）的學生，艾德・費拉的的實驗風格海報啟發了一整個世代的數位字體編排設計師。當僑人字型公司將Template Gothic字體商品化並釋出市場之後，它便在全世界被廣泛使用，成為一九九○年代數位字體編排設計的象徵。

# Dead History: feeding on the past
### 以過往為養份

P. 史考特・馬凱拉（P. Scott Makela）的字體Dead History同樣創作於一九九○年，是由兩種既存的字體揉合而成──傳統襯線字體Centennial和經典的POP字體VAG Rounded。馬凱拉透過操控現成字型的向量，採取了現代繪畫與音樂所運用的取樣策略。他也欣然接受過去歷史與慣例的包袱，這在所有字體編排設計的變革上幾乎都扮演了重要的角色。

# CcDdEeFfGgHhIiJjKkLl ᵗᵣ

荷蘭字體設計師艾瑞克・凡・布拉克蘭德（Erik van Blokland）和賈斯特・凡・羅森姆（Just van Rossum）結合了設計師與程式人員兩種角色，創作了能夠掌握住機會、改變、與不確定感的字體。他們一九九○年設計的Beowulf是第一套有著隨意變化的輪廓與程式設計行為的字體。

**以工業方法進行字體編排設計代表了所有字母都必定是清晰可辨的……現在字體編排設計所使用的設備更為先進，因此這項慣例不再是必然。現在，限制只存在於我們的期望當中。──艾瑞克・凡・布拉克蘭德（Erik van Blokland）和賈斯特・凡・羅森姆（Just van Rossum），二○○○年。**

## BACK TO WORK
## 回到工作面

雖然一九九〇年代混亂與腐敗的影像最為深植人心，但嚴肅正經的字體設計師仍然在持續創作能與各種不同文本版面自在相容的通用字體。這些能操耐用的字體家族讓平面設計師們有了許多可靈活運用的字體組合。

## Mrs Eaves: WORKING *woman* **seeks** *reliable* **mate**

（職業婦女找尋可靠的夥伴）

除了實驗性的顯示器字體之外，里柯在一九九〇年代也設計了帶有歷史復舊色彩的字體。她在一九九六年發表的Mrs Eaves受到十八世紀的Baskerville字體啟發，問世後便成為當代最受歡迎的字體之一。二〇〇九年，Mrs Eaves多了Mr Eaves相伴，它是這套深受女性喜愛的字體的無襯線版本。

## Quadraat: *all-purpose* hard**core** BAROQUE

（全方位的鐵桿子巴洛克）

弗瑞德・斯梅耶爾斯（Fred Smeijers）的Quadraat（上列文字字體）和馬丁・馬約（Martin Majoor）的Scala（本書內文字體）為字體編排設計的傳統做了清爽、生氣勃勃的詮釋。從這些字體簡潔的筆畫、俐落的幾何襯線可以看出它們是從現代的觀點回顧十六世紀的印刷字體。Quadraat家族自一九九二年問世之後，很快便納入了不同字重與風格的無襯線字體。

## Gotham: Blue-Collar **Curves**

（藍領階級的弧線）

二〇〇〇年，托比亞斯・弗萊勒・瓊斯（Tobias Frere-Jones）從他在紐約公車客運總站（Port Authority Bus Terminal, New York City）看到的手繪美術字衍生設計出了Gotham字體。Gotham字體極具特色卻又帶有實用風格，因而成為巴拉克・歐巴馬（Barack Obama）二〇〇八年美國總統大選競選活動的識別字體。到了二〇〇九年，字體界的「第一家庭」（First Family）已經擁有五十種以上不同字重與風格的成員了。

在挑選字體的時候，平面設計師會針對字體的歷史、它們在現代的意義、以及它們的樣式特質一併加以考量。他們的目標在於使字體風格能夠與手邊個案所反映的特定社會情境以及文本作適當的搭配。沒有一套劇本會載明所有字體的特定意義或功能；每一位設計師都必須根據個案獨有的情況，親自探尋蘊藏有各種可能性的字體庫。

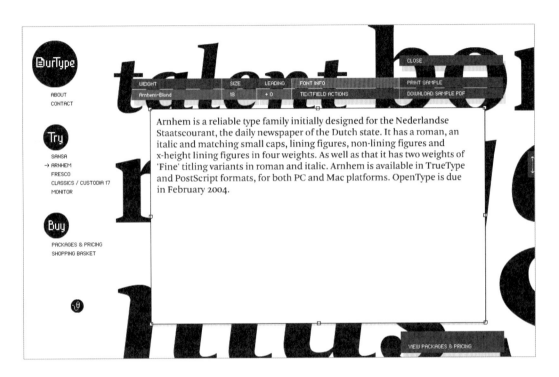

OURTYPE.COM，網頁，二〇〇四年。設計：弗瑞德・斯梅耶爾斯（Fred
Smeijers）和魯迪・吉瑞爾茲（Rudy Geeraerts）。這個以Flash技術製作的
數位字型公司讓使用者可以在短時間內測試他們設計的字型。設計師們在
創作字體之後可以放上他們自己的「標籤」，例如「國際字型坊的
Quadraat」（Quadraat for FontShop International）。這裡的範例是
Arnhem字體。

Can we envision

1. a font that asks more questions than

2. a font that has projective memory that reminds you to

3. a font with a limited

4. a font with an e

5. a font that's

6. a font without temporal inflection, without the imprint of

7. an apolitical font, a font that do

8. a font unaffected by the force of gravity and the weight of human

9. a font without family, without

10. a Marshall McLuhan font that stubbornly persists in bidding farewe

11. a font that takes advantage of all that promised "processin

12. a font that does something other than sit on its ass in a digital

13. a font with the capacity to breed with ot

14. a recombinant font — every letterform the unruly child of a predictable but random

15. a font that sounds as good as

16. a font that writes its o

17. a font that thickens

18. a font that responds and reacts to the meaning it carries and

19. a font that assumes the intelligence of it

20. a font that might sense your level of agitation, fear, or ag

21. a font prone to sudden outbursts and t

22. a font that exceeds the typographic

23. a font whose parents are Father Time and the Mother of In

24. an ambient font, a font without

25. an everyday font, a font of commo

310

ont that slows the pace of reading for the difficult passages (and skips along through easy bits)

ont that writes between the lines

ont that refuses to utter imperatives or commands

karaoke font, a lip-synching font, a font without a voice of its own

font that listens while it speaks

font that toggles effortlessly between languages

font for speaking in tongues

font that speaks in dialects

metropolitan font for uptown, the ghetto, and suburbia alike

font that simultaneously translates

font that sings the plaintive songs of lonely whales

font that grows

font that learns

an evolutionary font

an entropic font

a "live" font

a promiscuous font, a font that fucks fonts, a font-fucking-font

a font that emerges, unfolds, performs, evolves, and passes away

a font of youth

twin fonts, identical but distinct

a generative font that renders itself according to behavioral tendencies

a font that is something other than a recording

a font that is different every time you "play" it

a font with the metabolism of a fly

a font with a demographic algorithm that projects itself onto you, the average reader

311

《生活風格》（Life Style），書本，二〇〇〇年。設計：布魯斯‧莫
（Bruce Mau），出版社：Phaidon，攝影：丹‧梅爾斯（Dan Meyers）
。平面設計師布魯斯‧莫在這本後工業（postindustrial）的宣言當中想像
有一種字體能仿效人類的智能般生動活躍著。

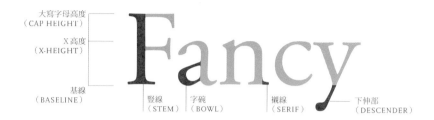

大寫字母高度
（CAP HEIGHT）

X 高度
（X-HEIGHT）

基線
（BASELINE）

豎線
（STEM）

字碗
（BOWL）

襯線
（SERIF）

下伸部
（DESCENDER）

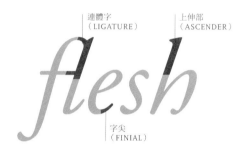

連體字
（LIGATURE）

上伸部
（ASCENDER）

字尖
（FINIAL）

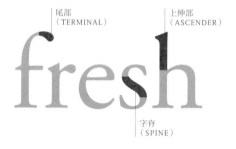

尾部
（TERMINAL）

上伸部
（ASCENDER）

字脊
（SPINE）

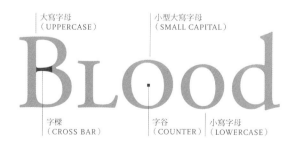

大寫字母
（UPPERCASE）

小型大寫字母
（SMALL CAPITAL）

字樑
（CROSS BAR）

字谷
（COUNTER）

小寫字母
（LOWERCASE）

ASCENDER HEIGHT
上緣線
有些要素的延伸部可能會
稍微高過大寫字母高度。

CAP HEIGHT
大寫字母高度
大寫字母由基線到頂端的距
離決定了這個字母的字級
（point size）。

DESCENDER HEIGHT
下緣線
一個字母的下伸部長度會影
響文字的整體風格與姿態。

# skin, Body

X-HEIGHT
高度
「X」高度是小寫字母去掉上伸部與下伸
部後的主體高度（或小寫X的高度）。

THE BASELINE
基線
基線是所有字母放置的位置。在一
整行文字當中，基線是最穩定的軸
線，也是在排列文字與圖像或文字
與文字時最重要的參考邊線。

OVERHANG
突出部
字母底部的圓弧會略微突出於基線
之外；逗號與分號也會穿過基線。
假使沒有如此擺放，字體看起來會
搖晃不穩，缺乏安定感。少了突出
部，圓形字母看起來會比其它底部
扁平的同伴們略小。

# Bone

雖然孩童們在學習寫字時所使用的練
習紙張上都會畫有將字母精準分為兩
半的直線，但大部份字體並不是如此
設計的。「X」高度通常會高於大寫字
母的一半；「X」高度對應於大寫字母
高度愈高，這套字型看起來就愈大。
在整個文字區塊當中，緊密度最高的
地方在於基線與「X」高度之間。

Hey, look!
They supersized
my x-height.

兩個文字區塊通常會沿著一條共
享的基線對齊排列。這個例子是
以14 / 18　Scala Pro（14 pt字型
與18 pts行距，左圖）和7 / 9
Scala Pro（右圖）兩相對比。

12點等於1派卡
6派卡（72點）
等於1英吋

60點SCALA
字體的大小是從大寫字母的頂端量至下伸部的底部，再加上一點點緩衝空間。

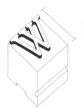

以金屬活字來說，點數大小指的是活字鉛條的高度。

HEIGHT 高度

人們將字體測量標準化的企圖始於十八世紀。我們今日所使用的標準是「點系統」（point system）。一點（point）等於1/72英吋或0.35公釐。12點等於一派卡（pica），這個單位經常用於測量欄寬。字體編排設計中常用的單位還包括有英吋（inches）、公釐（millimeters）、或像素（pixels）。大部份的軟體應用程式會讓設計師自行選擇想使用的測量單位；派卡與點通常是標準預設的單位。

書呆子警報：
派卡（picas）與點（points）的相關縮寫
8派卡＝8p
8點＝p8, 8pts
8派卡．4點＝8p4
8點大小的Helvetica字體加上9點行距＝8/9 Helvetica

# WIDE LOAD

（大肚能容）

INTERSTATE BLACK
字寬（set width）指的是字母本身寬度加上旁邊的空間。

# TIGHT WAD

（一毛不拔）

INTERSTATE BLACK COMPRESSED
在這個字體壓縮版裡的字母字寬較窄。

# WIDE LOAD
# TIGHT WAD

囧設計
水平與垂直比例
為了製造出較寬或較窄的字母，這些字體的長寬比例在數位化的操作方式下已經變形了。

WIDTH 寬度

字母也有水平測量的基準，稱為「字寬」（set width）。「字寬」指的是字母本身的寬度再加上將自己與其它字母分隔開來的些微距離。字母的寬度與字體的比例以及視覺印象有關。有些字體的字寬較窄，有些則較寬。

你可以調整字體的水平或垂直比例來改變字寬。然而這會改變字母的線條重量，讓粗的地方變細、細的地方變粗。為了避免字型扭曲，你可以依照你想要的比例挑選字體，例如窄體（condensed）、壓縮體（compressed）、寬體（wide）、或特寬體（extended）。

30-PT SCALA PRO    30-PT INTERSTATE REGULAR    30-PT BODONI    30-PT MRS EAVES

# Do I look fat in this paragraph?

（我在這一段裡看起來胖嗎？）

當兩種字體設定為同樣點數相比較時，其中一種往往看起來比另一種大。
不同的 x 高度、線重、和字寬都會影響字母的外觀大小。

Mrs Eaves字體不採用二十世紀慣用的大尺寸X高度。
這套字體的設計受到十八世紀字體設計師巴斯克維爾
的啟發，其命名來自於巴斯克維爾的情婦、管家、兼
工作夥伴──莎拉・伊芙絲（Sarah Eaves）。他們在
一七六四年結婚之前同居了十六年。

（大先生對小倆口）

# Mr. Big versus *Mrs. & Mr. Little*

30-PT HELVETICA                        30-PT MRS EAVES    30-PT MR EAVES

The x-height of a typeface affects its apparent size, its space efficiency, and its overall visual impact. Like hemlines and hair styles, x-heights go in and out of fashion. Bigger type bodies became popular in the mid-twentieth century, making letterforms look larger by maximizing the area within the overall point size.

10/12 HELVETICA

字體的「X」高度會影響它的外觀大小、空間的利用率、以及整體的視覺效果。就像裙襬
長度與髮型一樣，「X」高度也有其時尚潮流。二十世紀中期，在字級範圍內讓字型極大
化，好讓字可看起來較大的大型字體便蔚為流行。

Because of its huge x-height, Helvetica can remain legible at small sizes. Set in 8 pts for a magazine caption, Helvetica can look quite elegant. The same typeface could look bulky and bland, however, standing 12 pts tall on a business card.

6/8 HELVETICA

Helvetica有較大的「X」高度，因此即便將字級縮小，字體仍然清晰可辨。以8 pts大小作
為雜誌內文的helvetica看起來相當優雅；然而相同字體若以12 pts大小放置在名片上，看
起來便可能顯得笨重乏味。

在許多軟體程式當中，字體大小的預設值為12 pts。雖然這讓螢幕顯示
器上的字體易於閱讀，但12 pts的文字放在印刷品上看起來通常會顯得
過於笨重、高頭大馬。9 pts到11 pts是印刷品上普遍常用的字級。本段
文字的大小是7.5 pts。

Typefaces with small x-heights, such as MRS EAVES, use space less efficiently than those with big lower bodies. However, their delicate proportions have lyrical charm.

10/12 MRS EAVES

「X」高度較小的字體，例如Mrs Eaves，在空間的利用上不如下盤較大的字體來得有效
率。然而它們雅致的比例卻帶有一種抒情的魅力。

Like his lovely wife, MR EAVES has a low waist and a small body. His loose letterspacing also makes him work well with his mate.

10/12 MR EAVES

就和他可人的太太一樣，MR EAVES也有較低的腰身和嬌小的身軀。較鬆散的字距讓它
得以完美搭配它的伴侶。

The size of a typeface is a matter of context. A line of text that looks tiny on a television screen may appear appropriately scaled in a page of printed text. Smaller proportions affect legibility as well as space consumption. A diminutive x-height is a luxury that requires sacrifice.

6/8 MRS AND MR EAVES

字體的大小和它出現的脈絡背景有關。在電視螢幕上看起來過小的一行文字，很可能在
印刷品頁面上看起來大小適中。較小的X高度會影響版面的易讀性與空間消耗，極小的
「X」高度可以說是必須被犧牲性掉的奢侈品。

以下所有字體都是受到十六世紀印刷字體Claude Garamond啟發而設計的，但每一種字體又各自反映了它們所屬的時代風格。纖細的Garamond 3出現於經濟大蕭條時期（the Great Depression），而有著膨脹的X高度的ITC Garamond則成為一九七〇年代浮華世界的代表。

（憤怒的葡萄）

# Grapes of Wrath

30-PT GARAMOND 3    30-PT ITC GARAMOND

二十世紀的GARAMOND字體：同一主題的各種變化

## 1930s: Franklin D. Roosevelt, SALVADOR DALÍ, Duke

一九三〇年代：（富蘭克林 D. 羅斯福，薩瓦多爾·達利，艾靈頓公爵，《疤面煞星》，炸雞與鬆餅餐，墊肩，收音機）
17-PT GARAMOND 3，莫里斯·富勒·本頓（Morris Fuller Benton）與湯瑪斯·麥特蘭·克雷藍（Thomas Maitland Cleland）為ATF所設計，一九三六年。

Ellington, *Scarface*, chicken and waffles, shoulder pads, radio.

## 1970s: Richard Nixon, Claes Oldenburg, Van Halen,

一九七〇年代：（理查·尼克森，克雷斯·歐登伯格，范·海倫，《教父》，喇叭褲，酪梨醬、情境喜劇）
17-PT ITC GARAMOND，東尼·史丹（Tony Stan）設計。

*The Godfather*, bell bottoms, guacamole, sitcoms.

## 1980s: Margaret Thatcher, BARBARA KRUGER, Madonna,

一九八〇年代：（瑪格麗特·柴契爾，芭芭拉·克魯格，瑪丹娜，《藍絲絨》，墊肩，通心粉沙拉，桌面排版）
17-PT ADOBE GARAMOND，羅伯特·斯林巴赫設計，一九八九年。

*Blue Velvet*, shoulder pads, pasta salad, desktop publishing.

## 2000s: Osama Bin Laden, MATTHEW BARNEY, the White

二〇〇〇年代：（奧薩瑪·賓·拉登，馬修·巴爾尼，白線條樂團，《黑道家族》，復古牛仔褲，祖傳番茄，推特）
17-PT ADOBE GARAMOND PREMIERE PRO MEDIUM SUBHEAD，羅伯特·斯林巴赫設計，二〇〇五年。

Stripes, *The Sopranos*, mom jeans, heirloom tomatoes, Twitter.

在「視覺尺寸」（optical sizes）的字體家族裡，輸出尺寸不同的字型會有不同的樣式風格。平面設計師會依據脈絡挑選適合的樣式。設計用於標題或展示的視覺尺寸字型樣式通常較為細緻、抒情；而用於內文與圖說文字的字型樣式筆觸會較濃重。

# No Job 太小

48-PT BODONI　　8-PT BODONI

凹設計

有些字體放大時很好看，
縮小後卻顯得太虛弱。

視覺尺寸

## HEADLINES are slim, *high-strung* prima donnas.

（「標題」是纖瘦、激動的女高音。）25-PT ADOBE GARAMOND PREMIERE PRO DISPLAY

## SUBHEADS are *frisky* supporting characters.

（「副標題」是活潑的配角。）25-PT ADOBE GARAMOND PREMIERE PRO SUBHEAD

## TEXT is the *everyman* of the printed stage.

（「內文」是印刷舞台上的尋常人。）25-PT ADOBE GARAMOND PREMIERE PRO REGULAR

## CAPTIONS get *heavy* to play small roles.

（「圖說文字」是濃重醒目的小角色。）25-PT ADOBE GARAMOND PREMIERE PRO CAPTION

9 PT

In the era of METAL TYPE, type designers created a different *punch* for each size of type, adjusting its weight, spacing, and other features. Each size required a unique typeface design.

ADOBE GARAMOND PREMIERE PRO DISPLAY

在使用金屬活字的時代，字體設計師會為不同大小的活字製作不同的「鋼字沖」，以調整印刷字體的字重、間距、與其他條件。每一種尺寸都需要有自己的字體設計。

When the type design process became automated in the NINETEENTH CENTURY, many typefounders economized by simply *enlarging or reducing* a base design to generate different sizes.

ADOBE GARAMOND PREMIERE PRO REGULAR

十九世紀字體設計的流程進入機械化之後，許多鑄字師為了省時省力，在製作不同尺寸的字型時只會根據基本字體直接放大或縮小尺寸。

This MECHANIZED APPROACH to type sizes became the norm for photo and digital type production. When a text-sized letterform is enlarged to poster-sized proportions, its thin features become too heavy (and vice versa).

ADOBE GARAMOND PREMIERE PRO CAPTION

以機械化的方式調整字型尺寸成為相片與數位字體製作的準則。當符合內文尺寸的字型被放大至海報尺寸的比例時，原本細瘦的筆劃會變得太濃重（反之亦然）。

7 PT

A DISPLAY or *headline* style looks spindly and weak when set at small sizes. Display styles are intended for use at 24 pts. and larger.

展示或標題樣式的字型若以小尺寸呈現，看起來會顯得單薄又虛弱。展示樣式的字型尺寸通常會以24 pts以上。

Basic TEXT styles are designed for sizes ranging from 9 to 14 pts. Their features are strong and *meaty* but not too assertive.

基本的內文樣式尺寸大小通常介於9–14pts之間。它們看起來強壯飽滿，但不會太搶眼。

CAPTION styles are built with the heaviest stroke weight. They are *designed* for sizes ranging from 6 to 8 pts.

「圖說文字」樣式的筆觸最為濃重。它們的尺寸介於6–8 pts之間。

80 PT

## SCALE
## 比例

「比例」指的是設計元素與版面上其他物件以及作品本身實際尺寸互相比較的結果。比例是相對的。12-pt的字型在32吋螢幕上看起來很小，但印在書頁上就顯得虛胖超重了。設計師們藉由操控字型的比例以製作出層級與對比的效果。比例改變有助於創造視覺上的對比、運動、深度，以及表現不同程度的重要性。比例是與身體直接相關的。人們在判斷物件大小時，會直覺地與自己的身體和所處環境互相比較。

## THE WORLD IS FLAT
（世界是平的）

**囧設計**
字型大小缺乏變化讓這個設計看起來充滿不確定感又彆扭。

## THE WORLD IS FLAT

對比的比例
字型大小上的強烈對比讓這個設計表現出活力、決斷、與深度感。

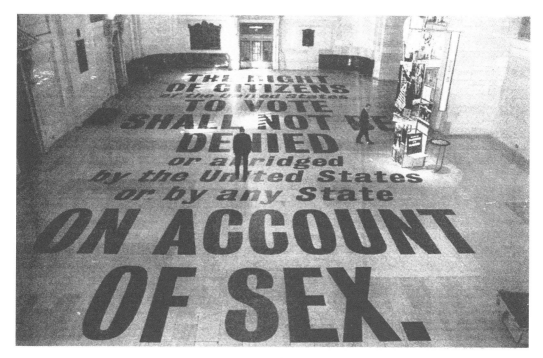

《美國憲法第十九修正案》（THE XIX AMENDMENT），一九九五年紐約中央車站裡的字體編排展示。設計者：史蒂芬·道爾（Stephen Doyle）。贊助單位：紐約州婦女部（the New York State Division of Women）、大都會運輸署（the Metropolitan Transportation Authority）、露華濃（Revlon）、美林證券（Merrill Lynch）。大比例的內文文字為這項公開展覽帶來衝擊性的效果。

# BLOW-UP: (WARREN NIEDICH) PHOTOGRAPHY, CINEMA AND THE BRAIN

《爆炸：攝影、電影、與大腦》（BLOW-UP: PHOTOGRAPHY, CINEMA, AND THE BRAIN），書本封面，二〇〇三年。設計者：保羅・卡羅斯（Paul Carlos）與爾舒拉・巴爾貝（Urshula Barbour）／ Pure + Applied。作者：瓦倫・尼迪克（Warren Niedich）。將字母的邊緣裁切掉增加了比例感。重疊的色彩讓人聯想到印刷或相片沖印的細節。

比例

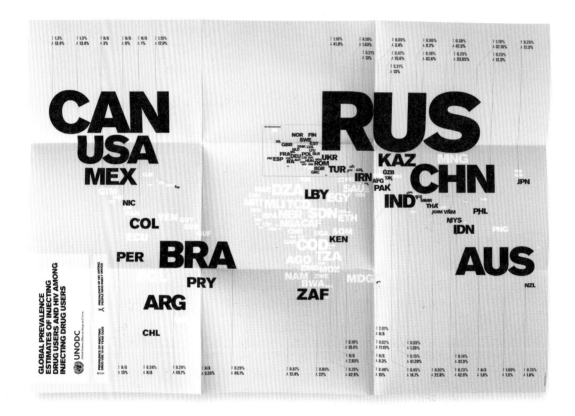

聯合國毒品與犯罪問題辦公室（United Nations' Office On Drug and
Crime，UNODC），地圖，二〇〇九年。設計者：哈利・皮爾斯
（Harry Pearce）與傑森・程（Jason Ching）／Pentagram。聯合國毒
品與犯罪問題辦公室在一系列的海報中利用字型比例顯示了全球各地「
藥物成癮治療計畫」（drug treatment programs）、愛滋病發病率，以
及其他資料的比較結果。設計師以國家名稱縮寫（GBR,USA, RUS...）
繪製了簡單版的世界地圖。這些海報特別以俄羅斯警察當局為訴求對
象，因為該國在藥物成癮治療方面極度缺乏追蹤記錄。請注意俄羅斯的
愛滋病高發病率與「藥物成癮康復計畫」低可用度之間的對比。

《左輪手槍：電影雜誌》
（Revolver：Zeitschrift FÜR
FILM），雜誌，一九九八年至二
〇〇三年。設計者：葛爾文·舒密
特（Gerwin Schmidt）。這是一
本由電影導演創作給電影導演們看
的雜誌。大字型與小頁面之間的對
比製造出戲劇化與意外的效果。

# TYPE CLASSIFICATION
## 字體分類

SABON

# Aa

BASKERVILLE

# Aa

BODONI

# Aa

**HUMANIST OR OLD STYLE**
人文主義或舊風格體
十五與十六世紀的羅馬正體字仿自古希臘羅馬的書法筆跡。Sabon字體是一九六六年揚‧奇喬爾德（Jan Tschichold）根據十六世紀的Claude Garamond字體所設計。

**TRANSITIONAL**
過渡時期體
相較於人文主義字母，這些字體的襯線更銳利，軸線也更垂直。約翰‧巴斯克維爾的字體於十八世紀推出之時，其銳利的樣式與粗細明顯的對比震驚了當時的社會。

**MODERN**
現代體
詹巴提斯塔‧波多尼於十八世紀末、十九世紀初設計的這套字體極為抽象。請注意它纖細銳利的襯線、垂直軸線、以及粗細筆觸之間的強烈對比。

基本的字體分類系統發展自十九世紀，當時的印刷商希望能對他們創作的字體在藝術史上的傳承加以追本溯源。「人文主義（Humanist）字體」與書法和手部的運動緊密相關；「過渡時期（Transitional）字體」和「現代（modern）字體」則較抽象而不有機。這三個主要類別大致對應了藝術與文學史上的文藝復興、巴洛克、與啟蒙時期。接著，字體編排設計的歷史學家與評論家開始提出更細緻的分類法，試圖掌握住各種字體的多樣性。二十世紀與二十一世紀的設計師們仍然持續根據過去傳統字體的特色創造出新的字體。

CLARENDON

# Aa

**EGYPTIAN OR SLAB SERIF**
埃及體或粗襯線體
十九世紀時，有許多使用於廣告上的粗筆畫裝飾字體問世。埃及字體有著濃重、厚片般的襯線。

GILL SANS

# Aa

HELVETICA

# Aa

FUTURA

# Aa

**HUMANIST SANS SERIF**
人文主義無襯線體
無襯線字體在二十世紀蔚為流行。艾瑞克‧吉爾（Eric Gill）於一九二八年設計的Gill Sans帶有人文主義體的特徵。請注意字母「a」小巧輕快的尾端，與線條有如手寫書法般的粗細變化。

**TRANSITIONAL SANS SERIF**
過渡時期無襯線體
麥克斯‧米丁格（Max Miedinger）於一九五七年設計的Helvetica是全世界最普遍使用的字體之一。它類似於過渡時期無襯線體，帶有勻稱筆直的特色。這些字型也被稱為「無特色無襯線體」（anonymous sans serif）。

**GEOMETRIC SANS SERIF**
幾何無襯線體
有些無襯線字體是根據幾何樣式設計出來的。在保羅‧倫納於一九二七年設計的Futura字體中，「O」是完美的圓形，而「A」和「M」的頂端則是三角形的尖角。

## 經典字體

**Sabon**
14 PT

This is not a book about fonts. It is a book about how to use them. Typefaces are essential resources for the graphic designer, just as glass, stone, steel, and other materials are employed by the architect.
SABON 9/12

Selecting type with wit and wisdom requires knowledge of how and why letterforms evolved.
7/9

**Baskerville**
14 PT

This is not a book about fonts. It is a book about how to use them. Typefaces are essential resources for the graphic designer, just as glass, stone, steel, and other materials are employed by the architect.
BASKERVILLE 9/12

Selecting type with wit and wisdom requires knowledge of how and why letterforms evolved.
7/9

**Bodoni**
14 PT

This is not a book about fonts. It is a book about how to use them. Typefaces are essential resources for the graphic designer, just as glass, stone, steel, and other materials are employed by the architect.
BODONI BOOK 9.5/12

Selecting type with wit and wisdom requires knowledge of how and why letterforms evolved.
7.5/9

**Clarendon**
14 PT

This is not a book about fonts. It is a book about how to use them. Typefaces are essential resources for the graphic designer, just as glass, stone, steel, and other materials are employed by the architect.
CLARENDON LIGHT 8/12

Selecting type with wit and wisdom requires knowledge of how and why letterforms evolved.
6/9

**Gill Sans**
14 PT

This is not a book about fonts. It is a book about how to use them. Typefaces are essential resources for the graphic designer, just as glass, stone, steel, and other materials are employed by the architect.
GILL SANS REGULAR 9/12

Selecting type with wit and wisdom requires knowledge of how and why letterforms evolved.
7/9

**Helvetica**
14 PT

This is not a book about fonts. It is a book about how to use them. Typefaces are essential resources for the graphic designer, just as glass, stone, steel, and other materials are employed by the architect.
HELVETICA REGULAR 8/12

Selecting type with wit and wisdom requires knowledge of how and why letterforms evolved.
6/9

**Futura**
14 PT

This is not a book about fonts. It is a book about how to use them. Typefaces are essential resources for the graphic designer, just as glass, stone, steel, and other materials are employed by the architect.
FUTURA BOOK 8.5/12

Selecting type with wit and wisdom requires knowledge of how and why letterforms evolved.
6.5/9

（這不是一本關於字型的書，而是一本關於如何使用它們的書。字體是平面設計師不可或缺的重要資源，就像玻璃、石材、鋼鐵、和其它素材為建築師所用一樣。）

（擁有字體演進過程與原因的相關知識，才能具備挑選合適字體的慧眼。）

# TYPE FAMILIES
## 字體家族

十六世紀時，印刷商開始將羅馬正體字與斜體字配
對組成家族。到了二十世紀初期，這個概念才成為
制式的作法。

字體家族解析 <span style="float:right">ADOBE GARAMOND PRO，羅伯特・斯林巴赫設計，一九八八年</span>

## The roman form is the core or spine from which a family of typefaces derives.

ADOBE GARAMOND PRO REGULAR

（正體字是字體家族開枝散葉時的核心或主幹。）
正體樣式也被稱為一般或普通樣式，是標準、直立版的字體。通常被
認為是字體家族的族長。

## *Italic letters, which are based on cursive writing, have forms distinct from roman.*

ADOBE GARAMOND PRO ITALIC

（斜體字是根據草寫筆跡發展而來，樣式與正體字有明顯區別。）
斜體樣式用於強調重點。尤其在襯線字體上，斜體樣式的形狀與筆觸通
常與正體樣式明顯不同。請注意字母「a」在正體與斜體上的差異。

## SMALL CAPS HAVE A HEIGHT THAT IS SIMILAR TO the lowercase x-height.

ADOBE GARAMOND PRO REGULAR（所有小型大寫字）

（小型大寫字的高度與小寫字母的「X」高度相近。）
小型大寫字的設計是為了取代因為過於突兀而無法與同行文字整合的全
尺寸大寫字。小型大寫字會較小寫字母的「X」高度略高一點。

## **Bold (and semibold) typefaces are used for emphasis within a hierarchy.**

ADOBE GARAMOND PRO BOLD AND SEMIBOLD

（粗體〔和半粗體〕用於在層級中強調重點。）
二十世紀為了因應語氣加強的需求，在傳統字型裡加入了粗體樣式。無
襯線字體家族通常在字重（細、粗、黑等等）上有較多的變化。

## ***Bold (and semibold) typefaces each need to include an italic version, too.***

ADOBE GARAMOND PRO BOLD AND SEMIBOLD ITALIC

（粗體〔和半粗體〕也都需要有斜體版。）
這兩款字體的設計師試著讓粗體版看起來與正體字相近，沒有讓整體樣
式太過沉重。即便是小尺寸，字母的尾端仍然要保持清晰、開口明確。
許多設計師傾向於不使用傳統字體，例如Garamond的粗體與半粗體
版，因為它們的字重與這些傳統字體家族顯得格格不入。

---

## *Italics* are not *slanted* letters.

真正的
斜體字

**囧設計**
偽斜體字
這種被機械式地傾斜的字
母樣式寬鬆又笨拙，看起
來生硬而不自然。

## Some italics aren't slanted at all. In the type family *Quadraat*, the italic form is upright.

QUADRAAT，弗瑞德・斯梅耶爾斯設計，一九九二年。

有些斜體字根本完全不傾斜。在Quadraat字體家族裡，斜體樣式是筆直站立的。

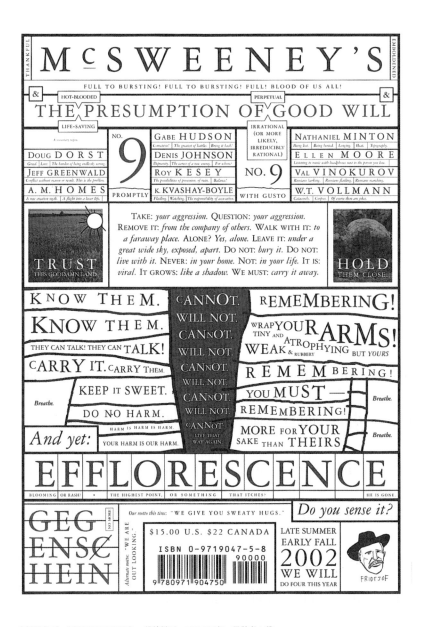

《麥斯威尼》（MCSWEENEY'S），雜誌封面，二〇〇二年。設計者：戴
夫‧艾格斯（Dave Eggers）。這本雜誌封面上使用了Garamond 3家族裡
各種不同尺寸的字型。雖然這個字體既古典又保守，但充滿妄想、帶有些
許瘋狂的排版方式卻呈現出極度現代的面貌。

## SUPERFAMILIES
## 超大字體家族

傳統羅馬正體字通常有個小型家族——有正體字、斜體字、小型大寫字，或者再加上粗體和半粗體（各自另有斜體版），共同組成一個親密的小團體。無襯線體家族往往有較多字重與尺寸大小上的變化，例如細、淺、黑、壓縮、窄等等。超大字體家族裡則包括了數十種字重與／或寬度不同的相關字型，通常都會有無襯線與有襯線版本。至於小型大寫字與非齊線數字（過去只在襯線字型中出現），也被一併納入Thesis、Scala Pro等其它現代超大字體家族當中。

超大字體家族解析

nnn  ppp

Scala
*Scala Italic*
SCALA CAPS
**Scala Bold**

Scala Sans Light
Scala Sans
Scala Sans Condensed
**Scala Sans Cond Bold**
**Scala Sans Bold**
**Scala Sans Black**
SCALA JEWEL CRYSTAL
SCALA JEWEL DIAMOND
SCALA JEWEL PEARL
SCALA JEWEL SAPHYR

SCALA PRO，馬丁·馬約設計，其中包括有Scala（1991）和Scala Sans（1993）。有襯線與無襯線的樣式兩者有共同字脊。Scala Pro（OpenType樣式）於二〇〇五年問世。

UNIVERS是瑞士字體設計師阿德里安·弗魯提格（Adrian Frutiger）於一九五七年設計。他為Univers設計了二十一種版本，包括五種字重和五種寬度。雖然有些字體家族會隨著時間不斷擴充，但Univers從一開始便被視為是一套完整的系統。

TRILOGY是傑瑞米·唐卡德（Jeremy Tankard）於二〇〇九年所設計的超大字體家族。他的設計靈感來自於三種十九世紀的字體風格：無襯線體、埃及體、與粗胖體（fat face）。粗胖體風格擁有極細的襯線與極粗的垂直線，讓這個家族的字體呈現出奇特的扭曲感。

超大字體家族解析

This is not a book about fonts. It is a book about how to use them. Typefaces
THE SERIF MEDIUM ROMAN 有襯線中體正體字　　　　　　　（這不是一本關於字型的書，而是一本關於如何使用字型的書。字體）

*are essential resources for the graphic designer, just as glass, stone, steel, and*
THE SERIF MEDIUM ITALIC 有襯線中體斜體字　　　　　　　（是為平面設計師所運用的 一種基本素材，就像玻璃、石塊、鋼鐵、與）

OTHER MATERIALS ARE EMPLOYED BY THE ARCHITECT. SOME DESIGNERS CREATE
THE SERIF MEDIUM SMALL CAPS 有襯線中體小型大寫字　　　　　（其他素材之於建築師 一樣。平面設計師有時候會自行創作）

**their own custom fonts. But most**
THE SERIF BLACK ROMAN 有襯線黑體正體字

**graphic designers will tap the vast**
THE SERIF EXTRA BOLD ROMAN 有襯線特粗正體字

**store of already existing typefaces,**
THE SERIF BOLD ROMAN 有襯線粗體正體字

**choosing and combining each with**
THE SERIF SEMI BOLD ROMAN 有襯線半粗正體字

（字體與手繪美術字，然而黑體正體字更普遍的情形是，他們會往廣大的現行字體庫裡搜尋，為特定的觀眾或情境）

regard to the audience or situation.
THE SERIF MEDIUM ROMAN 有襯線中體正體字

Selecting type with wit and wisdom
THE SERIF SEMI LIGHT 有襯線半細體字

requires knowledge of how and why
THE SERIF LIGHT ROMAN 有襯線細體正體字

letterforms have evolved. The history
THE SERIF EXTRA LIGHT ROMAN 有襯線特細體正體字

（挑選並組合出適用的字體。要勝任這份工作、展現個人巧思，必須具備字體如何演變、與為什麼如此演變的相關知識。）

of typography reflects a continual tension between the hand and machine, the
THE SANS MEDIUM ROMAN 無襯線中體正體字　　　　　　　　　（字體編排設計的歷史反映了 手與機械、）

*organic and geometric, the human body and the abstract system. These tensions*
THE SANS MEDIUM ITALIC 無襯線中體斜體字　　　　　　　（有機與幾何、人體與抽象系統之間持續的緊張關係。這些緊張關係）

MARKED THE BIRTH OF PRINTED LETTERS FIVE CENTURIES AGO, AND THEY CONTINUE TO
THE SANS MEDIUM SMALL CAPS 無襯線中體小型大寫字　　　　　（標誌了五百多年前印刷字母的誕生，時至今日也仍然）

**energize typography today. Writing**
THE SANS BLACK ROMAN 無襯線黑體正體字

**in the West was revolutionized early**
THE SANS EXTRA BOLD ROMAN 無襯線特粗正體字

**in the Renaissance, when Johannes**
THE SANS BOLD ROMAN 無襯線粗體正體字

**Gutenberg introduced moveable type**
THE SANS SEMI BOLD ROMAN 無襯線半粗正體字

（刺激著字體編排設計的發展。西方的書寫在文藝復興早期有重大革新，當時約翰尼斯‧古騰堡在德國發明了活字印刷。）

in Germany. Whereas documents and
THE SANS MEDIUM ROMAN 無襯線中體正體字

books had previously been written by
THE SANS SEMI LIGHT ROMAN 無襯線半細體正體字

hand, printing with type mobilized all
THE SANS LIGHT ROMAN 無襯線細體正體字

of the techniques of mass production.
THE SANS EXTRA LIGHT ROMAN 無襯線特細體正體字

（過去的書籍與文獻印賴手寫方式製作，活字印刷的出現讓大量生產的技術活絡起來。）

Thesis字體，盧卡斯‧德‧古魯特（Lucas de Groot）設計，一九九四年。

# CAPITALS AND SMALL CAPITALS
## 大寫字與小型大寫字

一個由大寫字母組成的單字放在整段內文裡，看起來會顯得大而笨重；而一長串大寫字母組成的句子更是讓人看了抓狂。小型大寫字是為了配合小寫字母的X高度而設計的。許多設計師對真正的小型大寫字近似於正方形的比例深感著迷。除了內文之外，他們也會在副標題、文章署名、請帖等等地方使用小型大寫字。設計師們通常傾向於完全使用小型大寫字而不會混搭小型大寫字與大寫字，以避免上伸部干擾行間的清爽感。在InDesign與其他應用程式當中，使用者只要按下一個鍵就可以製作出「偽小型大寫字」；但這些細瘦的字體看起來卻不合時宜。

+ CAPITAL
　investment
－ CAPITAL
　punishment
　CAPITAL
　crime

**囧設計**
在這個小寫與大寫字母組成的文字區塊裡，行距看起來不太平均，因為大寫字母高度較高且沒有下伸部。

CAPITAL
investment
CAPITAL
punishment
CAPITAL
crime

調整過的行距（leading）藉由移動小型大寫字的基線可以選擇性地微調行距，讓行與行之間的空間看起來較為均衡。

PSEUDO SMALL CAPS are shrunken versions of FULL-SIZE CAPS.

（偽小型大寫字是全尺寸大寫字的縮水版。）

**囧設計**
偽小型大寫字
Helvetica從來沒有包括小型大寫字在其中。
這些自己冒出來的字母看起來貧乏瘦弱；
它們是違反自然的醜八怪。

TRUE SMALL CAPS integrate PEACEFULLY with lowercase letters.

（真正的小型大寫字能與小寫字母自在無礙地整合在一起。）

小型大寫字，SCALA PRO
請使用真正屬於字體家族一份子的小型大寫字。在使用OpenType字型時（名稱會加上Pro字樣），請利用「字元」（Character）面板裡的OpenType選單選用小型大寫字。較舊的版本會將小型大寫字以個別檔案的形式列在「文字」（Type）下的「字體」（Font）選單內。

《紐約雜誌》（New York Magazine），設計者：克里斯·狄克森（Chris Dickson），二〇〇九年。這段文字裡混搭了Miller字體家族的襯線字（包括小型大寫字）與Verlag字體家族的無襯線字。

# Tasty Vagabonds
*The two camps of the burgeoning food-truck phenomenon: stable and nomadic.*
BY AILEEN GALLAGHER

**TRUCKS THAT ROVE**

**CUPCAKE STOP**
The inevitable cupcakes-only truck rolled out in May. *twitter. com/cupcakestop.*

**TREATS TRUCK**
Cookies, crispy treats,

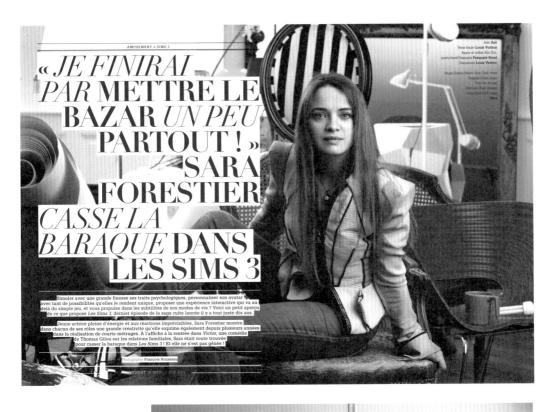

« *JE FINIRAI PAR* METTRE LE BAZAR *UN PEU* PARTOUT ! » SARA FORESTIER *CASSE LA BARAQUE* DANS LES SIMS 3

Jean Ape
Veste blazer **Louis Vuitton**
Bague et collier **Bon Ton**,
quartz fumé/diamants **Pasquale Bruni**
Chaussures **Louis Vuitton**

Bége Entrée Pastis Side Chair verte
Dossier Chair rouge
Tom Vac rouge
Fauteuil Chair Graisse
Vitra Chair DSX rouge
Vitra

Simuler avec une grande finesse ses traits psychologiques, personnaliser son avatar avec tant de possibilités qu'elles le rendent unique, proposer une expérience interactive qui va au-delà du simple jeu, et vous propulse dans les subtilités de nos modes de vie ? Voici un petit aperçu de ce que propose *Les Sims 3*, dernier épisode de la saga culte lancée il y a tout juste dix ans.

Jeune actrice pleine d'énergie et aux réactions imprévisibles, Sara Forestier montre dans chacun de ses rôles une grande créativité qu'elle exprime également depuis plusieurs années dans la réalisation de courts-métrages. À l'affiche à la rentrée dans *Victor*, une comédie de Thomas Gilou sur les relations familiales, Sara était toute trouvée pour casser la baraque dans *Les Sims 3* ! Et elle ne s'est pas gênée !

Photographie **François Rousseau**

AMUSEMENT NUMERO 5 JUIN 2009

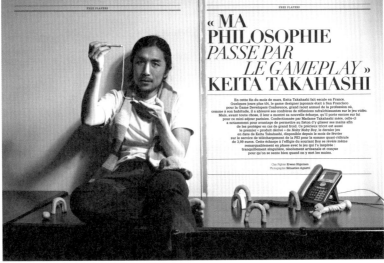

« MA PHILOSOPHIE *PASSE PAR LE GAMEPLAY* » KEITA TAKAHASHI

En cette fin du mois de mars, Keita Takahashi fait escale en France. Quelques jours plus tôt, le game designer japonais était à San Francisco pour la Game Developers Conference, grand raout annuel de la profession où, comme à son habitude, il a abreuvé des confrères de réflexions rafraîchissantes sur le jeu vidéo. Mais, avant toute chose, il leur a montré une nouvelle écharpe, qu'il porte encore sur lui pour ce mini-séjour parisien. Confectionnée par Madame Takahashi mère, celle-ci a notamment pour avantage de permettre au fiston d'y glisser ses mains afin de les protéger en cas de grand froid. Ce précieux tricot est aussi le premier « produit dérivé » de *Noby Noby Boy*, disponible depuis le mois de février en date de Keita Takahashi, disponible depuis le mois de février sur le service de téléchargement de la PS3 pour la somme quasi-ridicule de 3,99 euros. Cette écharpe à l'effigie du souriant Boy se révèle même remarquablement en phase avec le jeu qui l'a inspirée : tranquillement singulière, résolument artisanale et conçue pour qu'on se sente bien quand on y met les mains.

Chat Fighter **Erwan Higuinen**
Photographie **Sébastien Agnetti**

《消遣雜誌》（Amusement Magazine），設計者：愛麗絲‧里卻爾（Alice Litscher），二〇〇九年。這本法國文化雜誌將Didot大寫正體與斜體緊密排列在一起，做出令人印象深刻的混搭效果。內文使用的是Glypha字體。

組合不同的字體就像是在做一道沙拉。一開始,不同顏色、口味、材質的素材都先各取少量。不求協調,讓它們盡量表現對比;避免含糊,找出具有特色的差異。讓每一份材料扮演各自的角色:甜蜜的番茄、鮮脆的小黃瓜、偶爾加上刺激味蕾的鯷魚。在同一行文字上混搭字體時,設計師通常會調整字級,好讓整體 X 高度一致。若混搭字體不同行,設計師往往會在比例、風格、或字重上做變化,以創造出對比。請試著將大而細的字型與小而粗黑的字型混搭在一起,製造出風味與材質對比鮮明的交融效果。

**囧設計** 誰該為此負責?
為了與版面相合,第二行使用了略微擠壓原始字型所產生的變體(或許他們以為這麼做沒有人會發現)。然而最下面一行卻出現了字重不同的文字。

---

### 單一家族字體混搭

## Creamy and **Extra Crunchy** | *Differences within a **single family***

(濃稠與超酥脆 / 單一家族裡的個別差異)UNIVERS 47 LIGHT CONDENSED AND UNIVERS 67 BOLD CONDENSED

## Sweet Child of **MINE** | *Differences within a* **SUPERFAMILY**

(我的甜蜜寶貝 / 超大字體家族裡的個別差異)QUADRAAT REGULAR AND ITALIC; QUADRAAT SANS BOLD

## Noodles with **Potato Sauce** | *Bland and blander*

(麵配薯泥醬 / 清淡與更清淡)HELVETICA NEUE 56 MEDIUM AND HELVETICA NEUE 75 BOLD

**囧設計**
這些字體來自同一個家族,但他們的字重太接近,混搭的效果不好。

---

### 不同家族字體混搭

## Jack Sprat and his **voluptuous wife** | *Two-way* **contrast**

(傑克・斯普瑞特和他貪吃的老婆 / 雙重對比)THESIS SERIF EXTRA LIGHT AND VAG ROUNDED BOLD

## Sweet, SOUR, and **hot** | THREE-*way* ***contrast***

(甜,酸,辣 / 三重對比)BODONI ROMAN, THESIS SERIF EXTRA LIGHT SMALL CAPS, AND FUTURA BOLD

## **Mr. Potatohead and Mrs. Pearbutt** | *Too close for comfort*

(蛋頭先生與梨臀太太 / 近得讓人不舒服)ADOBE GARAMOND PRO BOLD AND ADOBE JENSON PRO BOLD

**囧設計**
這兩種字體風格太接近,彼此沒辦法產生對比。

各色字體小菜組成一道令人賞心悅目的拼盤。

GLYPHA細體，阿德里安‧弗魯提格設計，一九七九年。大尺寸的字體和細緻的筆畫線條取得平衡。

埃及粗窄體，根據一八二〇年的字體所設計的行式活字印刷（LINOTYPE）字型。自從米爾頓‧葛雷瑟（MILTON GLASER）於一九七〇年代設計發行了《紐約雜誌》之後，這個奇特、粗胖的字型便間或使用在這本刊物上。此處這個字型設定的字級較小但特別加黑，在頁面上有狠咬一口的效果。

MILLER小型大寫字，馬修‧卡爾特、強納森‧胡福勒、和托比亞斯‧弗萊勒、瓊斯共同設計，一九九七年至二〇〇〇年。這套字體有鬆脆的襯線，筆畫粗細間有強烈對比，被認為是一種蘇格蘭羅馬正體（SCOTCH ROMAN TYPEFACE）。

# The Word

EDITED BY EMMA PEARSE

## EVENTS

**BENOIT DENIZET-LEWIS**
*The Powerhouse Arena, 37 Main St., nr. Water St., Dumbo (718-666-3049)*
The writer from *The New York Times Magazine* reads from *American Voyeur: Dispatches From the Far Reaches of Modern Life*, a collection of his analytical reportage on everything from pro-life summer camps to the clothing company Abercrombie & Fitch; 1/13 at 7.

**SOUTHERN WRITERS READING SERIES**
*Happy Ending Lounge, 302 Broome St., nr. Forsyth St. (212-334-9676)*
An open mike for writers from below the Mason-Dixon line, where they'll read and discuss (and drink) all things southern; 1/13 at 8.

**SUZE ORMAN**
*Barnes & Noble, 33 E. 17th St., nr. Broadway (212-253-0810)*
The high priestess of financial invincibility presents her latest, *Women and Money: Owning the Power to Control Your Destiny*; 1/14 at 7.

**MARY JO BANG**
*McNally Jackson, 52 Prince St., nr. Mulberry St. (212-274-1160 )*
Two poets in one room: Susan Wheeler hosts a discussion with the spectacularly named National Book Critics Circle Award winner, whose latest collection is titled *The Bride of E*; 1/14 at 7.

**JOYCE CAROL OATES AND ELAINE SHOWALTER**
*92nd St. Y, 1395 Lexington Ave. (212-415-5500)*
What two better authorities to discuss women and writing on the occasion of the publication of Showalter's *A Jury of Her Peers*, a history of American women writers from 1650 to 2000; 1/17 at 11 a.m.

**PATTI SMITH**
*Barnes & Noble, 33 E. 17th St., nr. Broadway (212-253-0810)*
The poet queen of punk reads from her book *Just Kids: From Brooklyn to the Chelsea Hotel, a Life of Art and Friendship*, about the fabulous, rocky friendship with Robert Mapplethorpe; 1/19 at 7. *Smith will also appear with the playwright Sam Shepard on January 21 at 8 p.m. at 92nd St. Y, 1395 Lexington Ave. (212-415-5500).*

**COUNTESS LUANN DE LESSEPS**
*Borders, 10 Columbus Circle, nr. Eighth Ave. (212-823-9775)*
The Real Housewife of New York, who says that "class is a state of mind," appears in the glamorous flesh to share her intimate knowledge of sophisticated living; 1/21 at 7.

**IN THE FLESH**
*Happy Ending Lounge, 302 Broome St., nr. Forsyth St. (212-334-9676)*
Former sex columnist, editor of *Best Sex Writing 2010*, and blogge Rachel Kramer Bussel hosts her monthly series of erotic re this time with the theme of sex and food (and rumo cupcakes all around); 1/21 at 8.

**NICK FLYNN**
*BookCourt, 163 Court St., nr. Pacific*
The cult hit memoirist (an Taylor) reads from his lates hitting work about child obsession with torture, of the Iraqi men depic 1/22 at 7.

**OZZY OSBOU**
*Borders, 10 C*
The film
c

VERLAG，強納森‧胡福勒設計，一九九六年。原本強納森‧胡福勒是受阿勃特‧米勒委託為古根漢美術館（GUGGENHEIM MUSEUM）設計一套專用字體，但後來VERLAG成為廣泛使用於各種用途的通用字體。它親切的幾何樣式來自於法蘭克‧洛依德‧萊特（FRANK LLOYD WRIGHT）為古根漢美術館立面所做的題字。

〈消息〉（THE WORD）：《紐約雜誌》，設計者：克里斯‧狄克森，二〇一〇年。從早期的廣告字型「埃及粗窄體」到現代功能性強大的「無襯線Verlag」，這個內容豐富的頁面混搭了四種歷史上各個時期的字體家族。這些相異的素材以不同大小比例混搭在頁面上，為版面創造出張力與對比。

# NUMERALS
## 數字符號

「齊線數字（Lining numerals）」的字寬是一致的，好讓數字在表單中能夠整齊排列。為因應現代商業的需求，齊線數字在二十世紀初期問世。齊線數字的高度與大寫字母相同，因此它們在內文段落中有時候會顯得過於笨重。

「非齊線數字（Non-lining numerals）」，也稱為「內文數字（text numerals）」或「舊體數字（old style numerals）」，和小寫字母一樣具有上伸部與下伸部。非齊線數字在一九九○年代因其獨特的外形與復古的字體姿態而重返潮流。舊體數字如同一般字體講求比例均衡；每一個數字都有自己的字寬。

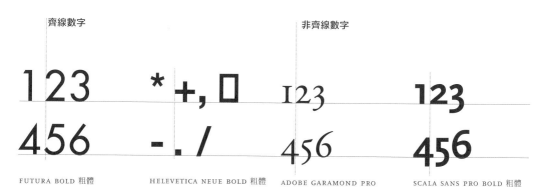

齊線數字

非齊線數字

FUTURA BOLD 粗體　　　HELEVETICA NEUE BOLD 粗體　　ADOBE GARAMOND PRO　　SCALA SANS PRO BOLD 粗體

使用齊線數字的內文段落

（一本《戰爭與和平》〔War and Peace〕多少錢？現代圖書館經典版〔Modern Library Classc〕平裝本的定價是$15.00，在亞馬遜書店〔Amazon〕折了32%之後的價格則是$10.50元。但若考慮人們花在閱讀這本大部頭文藝小說上的時間成本呢？假使你一分鐘可以閱讀400字——這是平均值的兩倍——讀完《戰爭與和平》要花上1,476分鐘（24.6小時）。若每天投入四小時閱讀這本書，你可以在六天多一點之後將它讀完。假使你每小時的工資是$7.25（美國基本工資），閱讀《戰爭與和平》的費用將會是$184.50（€130.4716，£11.9391, or ¥17676.299）

使用非齊線數字的內文段落

（一本《戰爭與和平》〔War and Peace〕多少錢？現代圖書館經典版〔Modern Library Classc〕平裝本的定價是$15.00，在亞馬遜書店〔Amazon〕折了32%之後的價格則是$10.50元。但若考慮人們花在閱讀這本大部頭文藝小說上的時間成本呢？假使你一分鐘可以閱讀400字——這是平均值的兩倍——讀完《戰爭與和平》要花上1,476分鐘（24.6小時）。若每天投入四小時閱讀這本書，你可以在六天多一點之後將它讀完。假使你每小時的工資是$7.25（美國基本工資），閱讀《戰爭與和平》的費用將會是$184.50（€130.4716，£11.9391, or ¥17676.299）

ADOBE GARAMOND PRO字體同時包括了齊線數字與非齊線數字，設計師可以根據工作內容的情況選擇適合的樣式。齊線數字看起來比較大，因為它們的高度與大寫字母相同。

非齊線數字在視覺上與內文相當協調。不同的數字樣式各有搭配的數學與貨幣符號樣式。較小的貨幣符號與非齊線數字較相襯。

| | | | | | | | | |
|---|---|---|---|---|---|---|---|---|
| 99.8 | 32.3 | **DOM** | DomCasual | ... | 26 | 7451 | 57.0 | - |
| 73.8 | 16.1 | **EGIZ** | Egiziano | ... | dd | 2789 | 61.6 | + |
| 32.7 | 18.5 | **EURO** | Eurostile | ... | 9 | 1449 | 99.5 | - |
| 69.6 | 59.4 | **FKTR** | FetteFraktur | ... | dd | 3944 | 87.0 | + |
| 66.8 | 2.8 | **FRNK** | FrnklinGthc | ... | dd | 11712 | 48.8 | + |
| 17 | 7 | **FRUT** | Frutiger55 | ... | | 1814 | 34.5 | - |
| 35.8 | 15 | **FUTU** | FuturaBook | ... | 18 | 11325 | 20.5 | + |
| 52.3 | 10.1 | **GDY** | GoudyOldStyl | ... | dd | 2685 | 46.5 | - |
| 95.3 | 26.8 | **GILL** | GillSans | ... | dd | 10748 | 72.3 | + |
| 96.2 | 35.4 | **GLRD** | Galliard | ... | 26 | 1566 | 1.1 | - |
| 72.7 | 9.6 | **GMND** | Garamond | ... | 27 | 2376 | 62.3 | - |
| 102.3 | 20.7 | **GROT** | Grotesque9 | ... | 47 | 6147 | 8.0 | - |
| 87.8 | 19.1 | **HLV** | Helvetica | ... | dd | 3009 | 63.3 | + |
| 79.3 | 35.6 | **HOBO** | Hobo | ... | dd | 5981 | 25.2 | - |
| 97.3 | 56.9 | **HTXT** | HoeflerText | .5e 1.3 dd | 4548 | 93.7 | + |
| 85.1 | 11.4 | **INTR** | Interstate | .32 2.1 dd | 10127 | 19.3 | + |
| 72.7 | 59.1 | **JNSN** | Janson | ... | 17 | 8065 | 63.2 | + |
| 84.8 | 68.7 | **KIS** | KisJanson | ... | dd | 4641 | 80.9 | - |
| 65 | 7.9 | **KSMK** | FFKosmik | ... | 20 | 510 | 26.3 | + |
| 35.9 | 8.9 | **LTHS** | LithosBlack | ... | dd | 1669 | 39.8 | + |
| 104.7 | 1.5 | **LtrG** | LetterGothic | ... | dd | 8091 | 20.6 | + |

| | | | | | | |
|---|---|---|---|---|---|---|
| **HLV** Helvetica | ... | dd | 3009 | 63.3 | +0.35 |
| **HOBO** Hobo | ... | dd | 5981 | 25.2 | +0.79 |
| **HTXT** HoeflerText | .5e 1.3 | dd | 4548 | 93.7 | +0.99 |
| **INTR** Interstate | .32 2.1 | dd | 10127 | 19.3 | +1.86 |
| **JNSN** Janson | ... | 17 | 8065 | 63.2 | +1.11 |
| **KIS** KisJanson | ... | dd | 4641 | 80.9 | -0.29 |
| **KSMK** FFKosmik | ... | 20 | 510 | 26.3 | +0.92 |

# 123

RETINA，由托比亞斯·弗萊勒·瓊斯於二〇〇〇年為《華爾街日報》（Wall Street Journal）財經版極端的字體編排需求所設計。這些數字可以成欄整齊排列。不同字重的Retina字體有其對應的字寬，因此在編排報紙版面時，即使不同字重的數字混合排列，欄位仍然能保持完美對齊。

月曆，一八九二年。
這份月曆迷人的數字符號沒有成欄對齊，因為它們的字寬並不一致。這些數字不適合用於呈現現代的財務資料。

# PUNCTUATION
## 標點符號

$$\{[\text{“‘},\text{-};\text{:’”}]\} \quad \{[\text{“‘},\text{•};\text{:’”}]\}$$

**最為普遍使用的標點符號**

## 5'2" eyes of blue
（五呎 二吋藍眼睛）
以「上標符號」（prime marks）或「影線符號」（hatch marks）
表示呎和吋

## It's a dog's life.
（這不是人過的生活。）
以「撇號」（apostrophes）表示縮讀字或所有格

## He said, "That's what she said."
（他說，「她就是這麼說的。」）
以「引號」（quotation marks）表示對話

好的逗號設計可以在美妙的細節中展現字體的本質。Helvetica的逗號是一個厚實的正方形加上一撇活潑的弧形，而Bodoni的逗號則是一個豐滿、帶有細柄的球形。設計師與編輯除了要熟悉標點符號的文法規則外，同時也需要了解各種字體編排設計的常例。以直書的「上標符號」或「影線符號」（通常被稱為「笨蛋引號」〔dumb quotes〕）來取代「撇號」和「引號」（或一般所說的「捲曲引號」〔curly quotes〕、「字型設計師引號」〔typographer quotes〕、或「聰明引號」〔smart quotes〕）是普遍常見的錯誤。「雙引號」與「單引號」分別由四個不同的符號所代表，每個符號也都各有其鍵盤組合。要知道你的鍵盤組合是什麼！修正客戶手稿上似是而非的標點符號通常是設計師的責任。

## "The thoughtless overuse" of quotation marks is a disgrace upon literary style—and on typographic style as well.

（對於引號「草率地過度使用」在寫作上來說是很丟臉的一件事——在排版上來說也是。）

**囧設計**
引號在內文的邊緣刻出了一塊白色空間。

更多標點符號錯誤用法，請參見附錄。

## "Hanging punctuation" prevents quotations and other marks from taking a bite out of the crisp left edge of a text block.

（「懸掛標點符號」〔hanging punctuation〕可以避免引號與其它符號在內文段落左側酥脆的邊緣上咬下一口。）

**懸掛引號**
將引號往邊界推，讓段落邊緣看起來較為清爽。

書呆子警報：在InDesign裡製作懸掛標點符號時，要先在引號前插入一個空白鍵。接著按住option鍵，再以向左鍵將引號拉往邊界。你也可以利用「視覺邊界對齊方式」（Optical Margin Alignment）或「縮排到此處」（Indent to Here）等工具選單。

## 囧設計

紐約市區觀光

市區的街道險象環生。每年有好幾百萬美金砸在製作這些排版失誤的廣告招牌上。這些招牌有部分的確是沒有經過設計的廉價商品，但其中不乏為知名企業或機構所設計的廣告看板。它們實在沒有理由犯下這種明顯的疏失。

## 做對了

「撇號」（apostrophes）與「引號」（quotation marks）有時候被稱為「捲曲引號」（curly quotes）。你可以在這間素食餐廳裡好好享用它們。

## 搞錯了

「影線符號」（hatch marks）的正確用法是用於標示呎和吋。唉，這裡的披薩是鍵盤組合錯用下不幸的犧牲者。在InDesign或Illustrator裡需要使用影線符號時，請至「字符」（Glyphs）面板當中找尋。

## ORNAMENTS
## 裝飾圖案

並非所有排版上的元素都和語言有關。數百年來，裝飾圖案已經被設計為可以直接與內容文字整合了。在活版印刷的時代，印刷商會將裝飾元素逐一組合，在頁面上製造出一個較大的圖案或花樣。到了十九世紀，印刷商會先收集可以與各種文字搭配的圖案，提供給客戶挑選。時至今日，各式各樣的裝飾符號都有數位化的版本，可以像字體一樣利用鍵盤打出來、放大縮小、並且輸出。有些現代的裝飾圖樣是成套的模組系統，可以透過組合產生更大的花樣和結構，平面設計師只要利用現成的素材就能夠改編出新的創意。主題式的圖示與圖案也都有數位化的圖形可以使用。

《說出來》（SPEAKUP），蘇琵薩‧瓦塔娜桑撒妮（Supisa Wattanasansanee）／卡德桑‧迪馬克（Cadson Demak）設計，二〇〇八年。由T26字型公司發行。

印刷裝飾圖案，弗萊與斯蒂爾鑄字廠（Fry and Steele），倫敦，一七九四年。揚‧索雷納爾（Jan Tholenaar）、瑞瑠德‧索雷納爾（Reinoud Tholenaar）、薩斯琪亞‧歐頓霍夫－索雷納爾（Saskia Ottenhoff-Tholenaar）共同收藏。

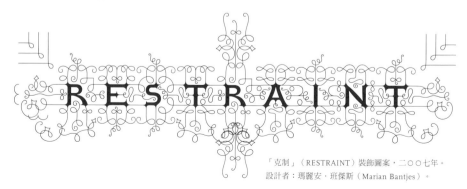

「克制」（RESTRAINT）裝飾圖案，二〇〇七年。
設計者：瑪麗安‧班傑斯（Marian Bantjes）。

《舞墨》雜誌（DANCE INK MAGAZINE）：阿勃特・米勒・一九九六年。設計師從祖札娜・里柯於一九九四年所設計的字型Whirligigs當中挑選了一個裝飾圖案並反覆使用它，為彩墨製造出有如罩紗飄逸的效果。Whirligigs是一套模組化的裝飾圖案，將圖案彼此組合可以創造出無數樣式上的變化。

WHIRLIGIGS，祖札娜・里柯設計，僑人字型公司發行，一九九四年。

GESCHAD. FANTAISIE KAPITALEN

UIT DE

LETTERGIETERIJ VAN JOH. ENSCHEDÉ EN ZONEN TE HAARLEM

Nº 5170. Op 11 Augustijn.

**HAARLEM**

Nº 5168. Op 11 Augustijn.

Nº 5031. Op 102 Punten.

GRAFT

Nº 5040. Op 10½ Augustijn.

Dl. V. Bl. 123.

FANTAISIE KAPITALEN，字體樣本，一八九七年。設計：恩斯赫德父子（Joh. Enchedé & Zonen）。揚．索雷納爾、瑞璐德、索雷納爾、薩斯琪亞．歐頓霍夫－索雷納爾共同收藏。

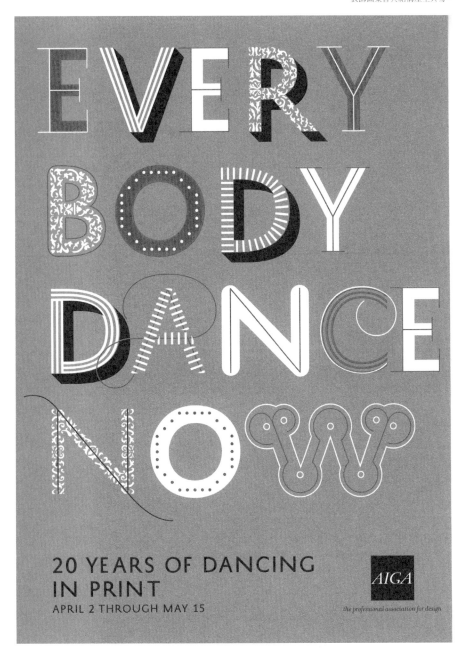

《大家來跳舞》（EVERYBODY DANCE NOW），明信片，二〇〇九
年。設計者：阿勃特・米勒・克莉絲汀・斯皮爾曼（Kristen Spilman）
、傑瑞米・霍夫曼（Jeremy Hoffman）／五角星（Pentagram）。彼
德・比拉克（Peter Bilak）的History字體設計於二〇〇八年，其中包括
有許多可以層疊成獨特組合的裝飾性與結構性元素。

# LETTERING
## 手繪美術字

透過以手繪方式創作美術字,平面設計師整合了圖
像與文字,讓設計與圖畫完美流暢地結為一體。手
繪美術字可能仿自既成的字體,也可能從藝術家自
己的畫作或字體樣式衍生而來。設計師往往會結合
各種不同的技巧,利用手繪方式或以電腦軟體創作
美術字。

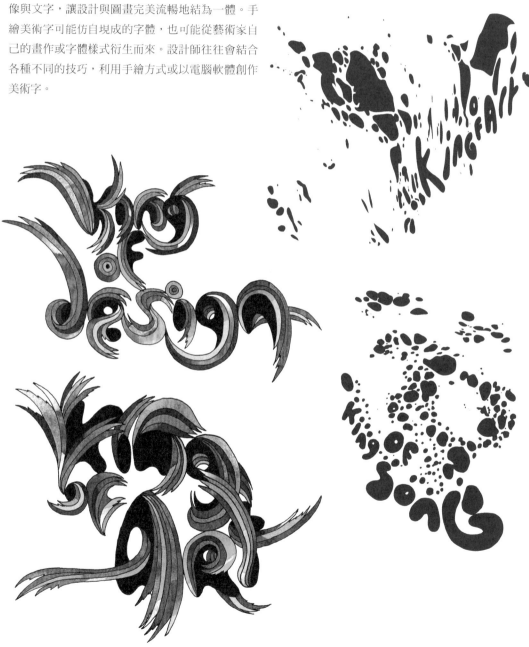

《TOKION》雜誌：〈王者〉（Kings），
設計者：狄安‧丘克（Deanne Cheuk），
二○○二年至二○○三年。這些雜誌標題結
合了手繪圖畫與數位創作的畫作。

「蝗蟲樂團」（The Locust）和「融化香蕉樂團」（Melt Banana），絹
版印刷海報，二〇〇二年。設計者：諾倫・史垂爾斯（Nolen Strals）。
就如同在這些音樂海報上所見，手繪美術字是平面設計裡一股活潑的力
量。手繪美術字是許多數位字體的基礎，但論及感染力，真正的手繪字
才是王道。

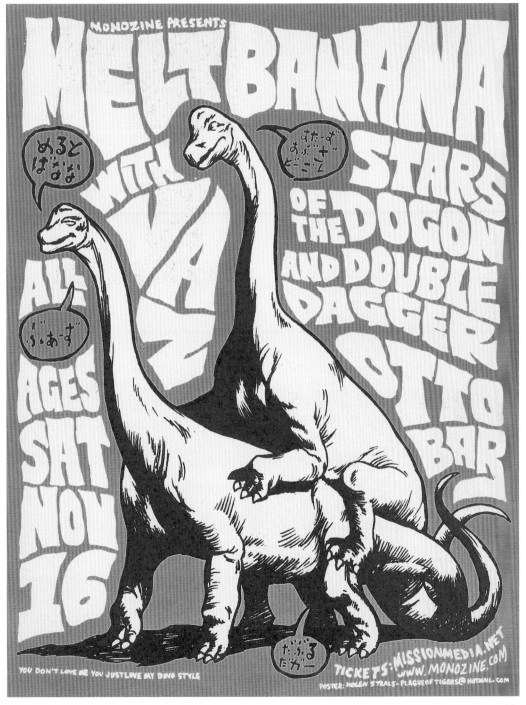

# LOGOTYPES AND BRANDING
## 標準字與品牌

「標準字」（logotype）是利用字體編排設計或手繪美術字，以讓人留下深刻印象的方式呈現出某個組織的全稱或簡稱。有些商標會包含抽象符號或圖畫，然而標準字是以文字和字體創造出獨特的視覺語言。可以利用現成的字體或客製化的手繪字設計出標準字。標準字是整體視覺品牌的一部分，設計師視之為一種存在於不同環境（並且隨之改變）的「語言」。完整的視覺識別系統會包括色彩、花樣、圖像、標誌看板要素、以及成套的字體。有時候標準字會成為一套字體的設計基礎。許多字體設計師會與平面設計師合作，共同為特定客戶打造一套獨一無二的字體。

「修伯」（HÜBER）企業識別系統，一九九八年。設計者：約翰・史坦考斯基（Jochen Stankowski）。這套工程公司的識別系統以「H」為概念出發，「H」圖像的比例會因應不同的環境脈絡而改變。

# STADSSCHOUWBURG UTRECHT

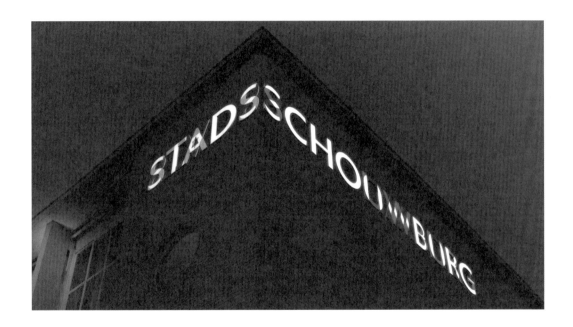

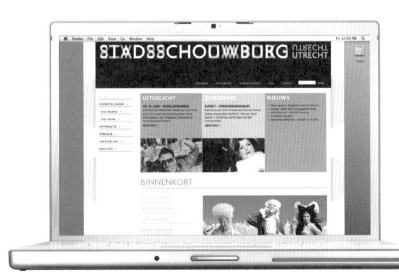

「烏特勒支城市劇院」
（UTRECHT CITI THEATER）識
別系統，二〇〇九年。設計者：埃
登史畢克曼（Edenspiekermann）
設計公司。這個充滿企圖心的視覺
識別系統使用了以Agenda字體為基
礎的客製化字體。在這套客製化字
體中字母被設計為分離的元素，可
以根據不同的應用需求——包括標
誌看板、海報、印刷品、和網路傳
播等——做出鏡像、層疊、翻轉、
動態等變化。

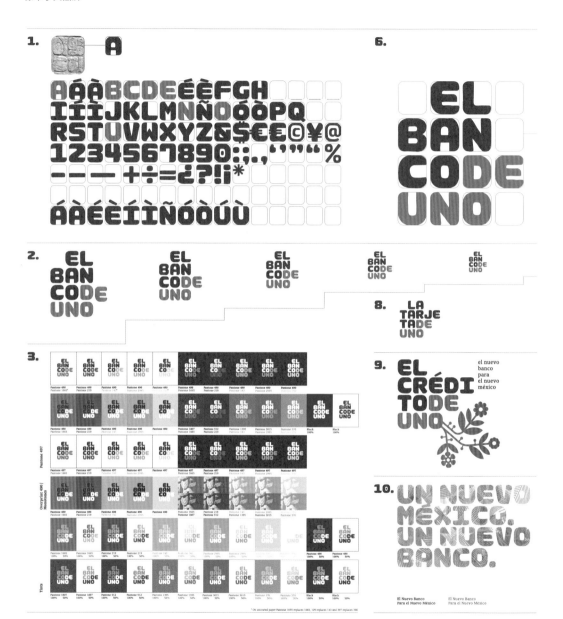

EL BANCO DE UNO品牌視覺設計，二〇〇七年。廣告代理商：賽芙倫
（Saffron）廣告。識別系統設計者：約書亞．狄斯特勒（Joshua Distler）
、麥可．亞賓克（Mike Abbink）、戈柏．史萊爾（Gabor Schreier）、維
吉妮亞．薩爾東（Virginia Sardón）。客製化字體設計：麥可．亞賓克、
保羅．凡．德．藍（Paul van der Laan）。這套精心製作的識別系統是為
一家墨西哥銀行所設計，其中樣式短而結實的客製化字體發想自馬雅人的
象形文字。

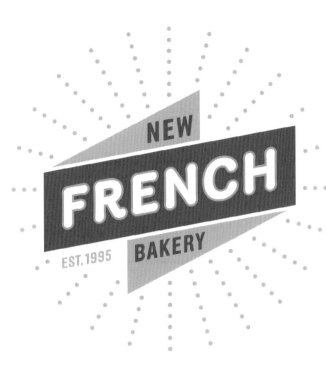

ABCDEFGHIJKLMNOPQRSTUVWXYZ
abcdefghijklmnopqrstuvwxyz
0123456789

ABCDEFGHIJKLMNOPQRSTUVWXYZ
abcdefghijklmnopqrstuvwxyz
0123456789

「新法式烘焙坊」（New French Bakery）品牌視覺設計，二〇〇九
年。設計：Duffy & Partners。標準字是平面設計語言當中的一部
分。Duffy & Partners在設計標準字時會廣泛納入許多元素，包括色
彩、花樣、以及字體。設計師們利用描繪輪廓、層疊、加框等技巧創
造出深度、細節，與些許親切的人味。這些元素組合在一起，共同呈
現出這個品牌的個性特色。

# TYPEFACES ON SCREEN
## 螢幕字體

在全球資訊網（World Wide Web）剛興起的頭幾年，設計師們被迫只能利用內建在終端使用者電腦裡、少得可憐的幾種字體進行設計，之後才逐漸發展出可以在網頁內容當中嵌入字型、或在使用者瀏覽網站時帶入字型的幾種技術。其中一種作法，是將特殊字型存放在第三方伺服器上，由使用者自行下載；這項服務的費用由設計者支付。另一種作法則是在CSS（Cascading Style Sheets，或稱「層疊樣式表」）當中使用@font-face規則，可以自伺服器上下載各種數位字型；只有經過授權的字體才能透過@font-face合法取得。

網路字型 1.0

# Verdana was designed by the legendary typographer *Matthew Carter* in 1996 for digital display. Verdana has a large x-height, simple curves, open forms, and loose spacing.

Verdana是由著名的字型設計師馬修·卡爾特（Mathew Carter）於一九九六年為數位化展示的需求所設計。Verdana有較大的X高度、簡潔的弧線、開放的樣式、與較寬鬆的字距。

# Georgia is a serif screen face built with sturdy strokes, simple curves, open counters, and generous spacing. Designed by Matthew Carter in 1996 for Microsoft, Georgia is widely used on the web.

Georgia是有襯線的螢幕字體，具備有結實的筆觸、簡潔的弧線、開放的字谷、與寬大的字距。Georgia由馬修·卡爾特於一九九六年為微軟（Microsoft）設計，是在網路上被廣泛使用的字體。

一九九六年由微軟發行的Verdana和Georgia是為網路環境特別設計的字體。在嵌入字型興起之前，它們是少數可以在網路上穩定使用的字體。

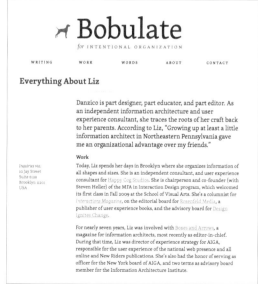

嵌入字型，螢幕擷取畫面，細部，二〇〇九年。字體：Greta和Fedra，由彼德．比拉克／Typotheque字型公司所設計。二〇〇九年，數位字型公司Typotheque啟用一項先進的服務，設計師只要支付一次性的授權費，就可以換得在任何網站上使用 Typotheque 字型的許可。Typotheque的Open Type字型支援全球各國語言，包括阿拉伯語與北印度語；字型都存放在Typotheque的伺服器上，使用者可以透過CSS裡的@font-face規則取得。

Bobulate，網站，二〇〇九年。傑森．聖塔．馬利亞（Jason Santa Maria）為莉茲．丹季柯（Liz Danzico）所設計。字體：Skolar，大衛．布雷吉納（David Brezina）設計。這個網站的設計使用了Typekit，這項第三方服務可以在使用者造訪網站時釋出字型。由於字型來源資訊隱晦，Typekit可以有效遏止剽竊行為。服務費用由設計者或網站擁有者支付。

「反鋸齒」（anti-aliasing）利用字型邊緣畫素或次畫素（sub-pixels）的亮度變化，在螢幕上製造出平滑的圓弧效果。Photoshop和其它套裝軟體可以讓設計師挑選「反鋸齒」效果的強弱程度。字級非常小的時候，反鋸齒程度強的字型看起來會顯得有點模糊。它同時也會增加圖像檔案裡使用的色彩數目。

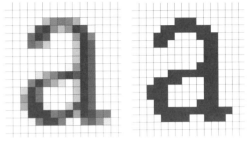

反鋸齒字母　　　　　　　　點陣字母

# smooth <sub>smooth</sub>

反鋸齒字型：平滑設定（模擬螢幕效果）

# none <sub>none</sub>

無反鋸齒功能：無設定（模擬螢幕效果）

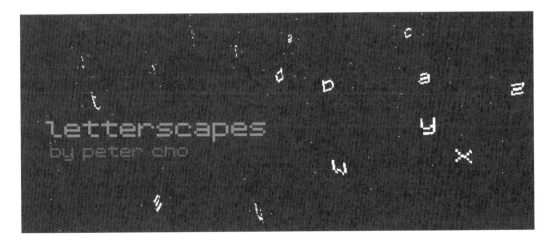

LETTERSCAPES網站，二〇〇二年。
設計者：彼德・趙（Peter Cho）。簡潔的點陣字母在3D空間當中躍動著。

# BITMAP TYPEFACES
## 點陣字體

點陣字體（Bitmap typefaces）是以螢幕或其它輸出裝置顯示畫面的構成要素「畫素」（pixels，picture elements）打造出來的。PostScript字母輪廓是向量式的外框，而真正的點陣字則是由數目固定、呈直線排列、或明或暗的小單元所構成。真正的點陣字會使用於收銀機、看板螢幕、和各種小型螢幕設備上。

現在大部分點陣字體並不是真正的點陣字。它們是先在網格上畫出輪廓，接著再以PostScript、TrueType、或OpenType字型輸出。如此一來，它們就可以任意搭配各種標準化的排版軟體使用。許多設計師都喜歡在作品當中運用這些外形帶有幾何感的像素化字體。

LoResNine
LoResTwelve
LoResFifteen
LoResTwentyEight

LoResNine
LoResTwelve
LoResFifteen
LoResTwentyEight

依原本的解析度設定字級
（9、12、15、和28 pts）

全部都設定為28 pts

LO-RES窄體，由僑人字型公司的祖札娜‧里柯所設計。lo-res字體家族於二○○一年發行，裡頭包含了成套根據里柯一九八五年創造的點陣字改作而來的外框字型（PostScript）。LO-RES窄體字有各種大小不同的字型，每一種字型的筆畫粗細都是一個像素大小。因此lo-res 28 pts窄體字的外形會遠比LO-RES 9 pts窄體字來得細瘦緊密，而LO-RES 9 pts窄體字在放大後也會變得較為粗胖。點陣字型是為了在低解析度的螢幕上顯示而設計的，應該以它原本的大小或整數倍數的大小來使用（將9像素的字型放大為18、27、36像素，以此類推）。

NIJHOF & LEE收據，二○○三年。這張來自阿姆斯特丹（Amsterdam）一間設計與字體編排設計專門書店的收銀機收據是以點陣字型列印。

Elementar，古斯塔佛・費雷拉（Gustavo Ferreira）於二〇〇九年設計，Typotheque 字型公司發行。Elementar是一個點陣字體家族，透過控制常見的參數，例如字高、字寬、水平與垂直要素的對比程度等，創造出數十種不同字重、樣式的字型。Elementar 適用於印刷品、螢幕、與各種介面。這套字體發想自阿德里安・弗魯提格的Univers字體家族。

Fontlab和其他應用程式讓設計者得以自行打造可與標準軟體—例如InDesign和Photoshop—無縫整合的功能性字型。

　　定義基本概念是設計字體的第一步。這些字體是有襯線還是無襯線的？是模組化的還是有機的？你要根據幾何概念來設計字體，還是要手繪？是要用於展示目的，還是要做為內文文字使用？要往傳統字體素材中找尋靈感，還是要從頭開始發想？

　　下一步則是畫草圖。有些設計師會在進行數位化之前先以鉛筆打稿，也有人會直接以字型設計軟體打造自己的字體。先從幾個核心字母開始畫起，

例如「O」、「U」、「H」、和「N」，把會在字型中反覆出現的圓弧、直線、和形狀先建立起來。雖然一套字體裡的每個字母都是獨一無二的，然而它們也有許多共同的屬性，例如X高度、線條粗細、對稱軸線、和樣式比例的共同語彙。

　　你可以透過增加相鄰字母間的空白區域來調整字距，也可利用同樣方式訂出特定字母之間的適讀間距。製作一套完整的字體是一項浩大工程。然而對嫻熟於繪製字體的人來說，這整個過程絕對是值回票價的。

CASTAWAYS，字體草稿與成品，二〇〇一年。藝術與字體指導：安迪·克魯茲（Andy Cruz）。字體設計：肯恩·巴爾伯（Ken Barber）／House Industries。House Industries是一間數位字型公司，它們的原創字體都深受流行文化與設計歷史的啟發。設計師肯恩·巴爾伯先以手繪方式製作鉛筆草圖，接著再將輪廓數位化。Castaways字體的靈感來自於拉斯維加斯（Las Vegas）的廣告招牌。這些字母的外形讓人聯想起傳統招牌畫家與美術字藝術家的手繪筆觸。

MERCURY粗體，校樣（page proof）與螢幕擷圖，二〇〇三年。設計：強納森·胡福勒／Hoefler & Frere-Jones字型公司。Mercury是為了在便宜紙張上進行快速、大量印刷的現代報業所設計的字體。這套厚實足以防彈的字體具有粗短的襯線與健壯的垂直筆畫。下方校樣上的批注對於一切細節——包括字寬、字重、大小、和襯線的樣式等——都有所評論，在設計的過程中會有許多這一類的校樣。在數位字體裡，每一個字母都會包括一系列由點所控制的圓弧與直線。在較大的字體家族裡，可以藉由在兩個極端之間——如淡與濃或窄與寬——修改參數值，以自動變化出不同的字重與字寬。接著設計者再就變化後的結果進行調整，確認字體的易讀性與視覺上的協調性。

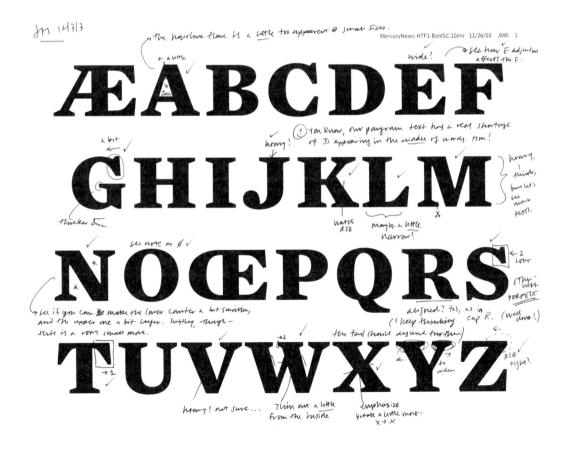

# EXERCISE: MODULAR LETTERFORMS
## 練習：模組化的字體

請利用方塊網格或點狀網格設計字母，並製作出一個點陣字體的原型。以網格和直線構成的元素取代傳統字體裡的圓弧與對角線。避免做出太多「階梯」細節；它們是冒牌的圓弧與對角線。這個練習是對一九一〇與一九二〇年代的回顧，當時前衛派設計師利用簡單的幾何元素設計了許多實驗字體。這項練習也著眼於從收銀機收據、LED看板、到螢幕字型顯示的數位科技結構，足見字體是一個由元素所構成的系統。

溫蒂‧妮絲（Wendy Neese）

布蘭登‧麥克林（Brendon McClean）

布魯斯‧威倫（Bruce Willen）

詹姆斯‧艾爾瓦瑞茲（James Alvarez）

馬里蘭藝術學院學生作品範例

喬伊‧帕茨（Joey Potts）

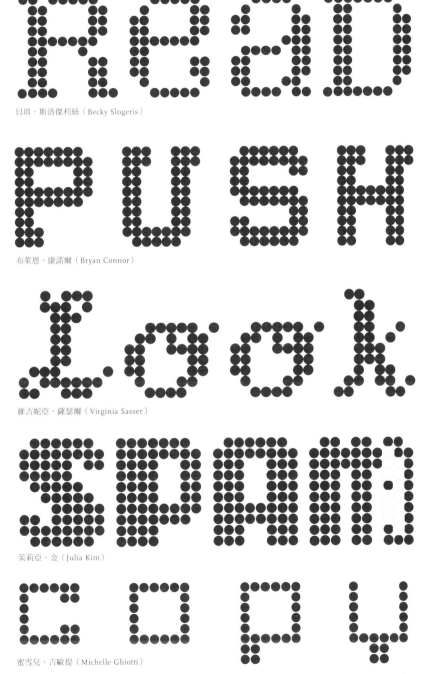

貝琪‧斯洛傑利絲（Becky Slogeris）

布萊恩‧康諾爾（Bryan Connor）

維吉妮亞‧薩瑟爾（Virginia Sasser）

茱莉亞‧金（Julia Kim）

蜜雪兒‧吉歐提（Michelle Ghiotti）

字型是從哪裡來的，為什麼會有這麼多不同的樣式呢？有些字型內建在你的電腦作業系統當中，有些則是與套裝軟體綁定在一起。在普遍流通的字型裡，有少數字型被公認具有最高品質，例如Adobe Garamond Pro和Hoefler Text；然而其它字型（包括Comic Sans、Apple Chancery、和Papyrus）卻惹得世界各地自視甚高的設計師們紛紛咒罵嫌棄。

如果你想要在這些常見的字型之外擴充你的字型庫，你就需要向數位字型公司付費購買字型。這些數位字型公司有些是如Adobe和FontShop般的大型企業，它們旗下有數千種不同的字體可供授權使用；另外也有專注發行少數幾種字體的獨立字型公司，例如荷蘭的Underware和英國的Jeremy Tankard Typography。此外你也可以學著創作自己的字型，或者在網路上找到可供免費使用的字型。

不同的字型樣式反映了與時俱進的科技創新與商業發展；普遍來說，較舊的字型樣式在現代的作業系統上仍然能夠使用。

PostScript/Type I是Adobe於一九八〇年代為桌上型電腦系統所設計的字型。Type I字型是利用PostScript程式語言所寫，為了在紙張或影片上產生高解析度圖像而創作。Type I字型有兩個檔案：螢幕字型與列印字型。你必須同時安裝兩個檔案才能完整使用這套字型。

TrueType是較晚近的字型樣式，由蘋果電腦與微軟分別為了在各自的作業系統上使用而開發。TrueType字型在安裝上較Type I來得簡易，因為它只有一個字型檔。

OpenType，這套由Adobe開發的字型樣式可以在各種不同的平台上使用。每一個檔案最多可支援儲存六萬五千個字母，如此一來，不同樣式風格和字體變化的字母就可以儲存在同一個字型檔案當中。在TrueType或Type I字型裡，小型大寫字、交錯連字（alternate ligatures）、和其它特殊字母會存放在另一個字型檔案裡（這個檔案有時候會被標籤為「專家」〔Expert〕檔）；然而在OpenType字型裡，它們也是主字型的一部分。這些擴充的字母組當中也會包括重音音標字母和其它為因應不同歐洲語言排版需求所設置的特殊文字。有擴充字母組的OpenType字型通常會加上「Pro」的標籤。OpenType字型也會在全部大寫的狀態下自動調整連字號（hyphens）、括號（brackets）、和圓括號（parentheses）的位置。

{[(HALF-BAKED?)]}

SCALA, PostScript/Type I字型樣式

{[(HALF-BAKED?)]}

SCALA pro, OpenType字型樣式

## 小型大寫字和舊體數字，你們藏在哪裡？

書呆子警報：你可以在你的設計軟體當中透過「文字」（Type）選單底下的OpenType選項或其它OpenType版面工具很快地找到小型大寫字和數字。小型大寫字不會像其它風格變體一樣出現在「字體」（Font）選單底下，因OpenType將它視為主字型的一部分。不論是哪種字型，你都可以在「文字與表格」[1]（Type & Tables）選單下的「字符」（Glyphs）選項裡看到所有特殊字母。你會從中發現許多意想不到的元素，包括花式字型（swashes）、連字、裝飾圖案、分數等等。在符號上點擊兩下就可以將它插入你的段落文字當中。

[1]「文字與表格」選項在「視窗」（Windows）的選單下。

£ § ¥ ¼ ½ ¾ É Ë Ì Å
Ã Â Á Ý ø å ë ð ñ ò þ
ÿ ą ą ě ę ǧ ǧ d dž z ž ž
ő Ġ Ġ į į ĭ ĭ † ✠ ☞ ☜

SCALA PRO，OpenType字型，馬丁·馬約設計，二〇〇五年。SCALA PRO有許多特殊文字，可供不同的歐洲語言排版時使用。你可以在InDesign的「字符」（Glyphs）選單下找到這些特殊文字。

# SAVE YOURSELF SOME EMBARRASSMENT AND LEARN TO USE THESE COMMONLY ABUSED TERMS CORRECTLY.

少出點糗，學習如何正確使用這些被濫用的語詞。

### 是字體（typeface）還是字型（font）？

「字體」是字的設計；而「字型」則是傳遞這個設計的機制。就金屬活字來說，製造字模的鋼字沖具體表現了字的設計；而字型，則是由鑄造的金屬活字所組成。在數位系統裡，字體指的是視覺設計的部分，而字型則是讓你可以安裝、取得、輸出這些設計的軟體。一套字體可能會有好幾種字型，但由於數位字體的設計與字型的製作兩者間的關係在今日更為密不可分，大多數人會交互使用這兩個名詞。然而字體迷在正確使用這兩個名詞的堅持上是不會妥協的。

### 是字元（character）還是字符（glyph）？

為了符合萬國碼（Unicode）的標準，字體設計師會將「字元」與「字符」加以區分。萬國碼是一套國際標準，用以標識國際認可的各種書寫系統。只有具備獨特功能的符號才會被認為是一個「字元」，並且在萬國碼中分配到一個「編碼位置」（code point）。一個字元，例如小寫「a」，可能會有好幾種不同的字符表現（a, $a$, A）。每一個字符都是特定字元的某種表現形式。

### 是大寫羅馬（Roman）還是小寫羅馬（roman）？

「羅馬帝國」（The Roman Empire）是一個專有名詞，此處自然使用大寫羅馬；但是提到「羅馬正體字」（roman letterforms）時，就像「義大利斜體字」（italic letterforms）一樣，我們會使用小寫羅馬。至於做為拉丁字母的名稱時，要使用大寫羅馬。

# FONT LICENSING
## 字型授權

誰是字體的使用者？字體的使用者終究是讀者們。但在這些字體找到方法出現在書本封面或玉米片包裝背面之前，它們還得先由另一個使用者經手：平面設計師。

數位字型可以輕易地複製、改作、和流通，但是當你購買字型的時候，你便同時接受了限制這套字型使用方式的「終端使用者授權協議」（End User License Agreement，EULA）。美國的智慧財產權法令將字型視為軟體的一部分（一組獨特的向量點）並加以保護，但它保護的範圍並沒有涉及字體的視覺設計。因此複製數位字型並分享給他人（你的朋友、客戶、或你的長輩親戚）是違反「終端使用者授權協議」的行為；而在FontLab裡開啟一個字型檔案、加入新的字形或修改其中部分字符、並且以新的檔名或原本註冊的檔名存檔，也同樣違法。除了經濟考量之外，字體設計師們也擔心──一旦使用者動手編輯他們的字型並散布給其他人，他們原本的作品便會隨之走樣了。

然而只要你沒有更動軟體本身，大部分的「終端使用者授權協議」允許使用者在製作標誌或標題時修改字型輪廓；而為印刷字體樣本製作新的數位版本也是合法的。舉例來說，你可以將Helvetica字體的全套字母列印出來、重新畫過這些字母、以字型設計軟體將它們數位化、再對外釋出你個人版本的Helvetica字型。就算沒有別的好處，這個費時費力的練習也會讓你了解一套設計精良的字體它的價值所在。一套用途廣泛的字體除了會包括有各種不同字重、樣式風格、與特殊字元外，還有一套深厚的設計基礎。字型要價不斐，因為它們都是精雕細琢的商品。

Most of the FREE FONTS found on the Internet have poor spacing and incomplete character sets. Many are *stolen property* distributed without CONSENT. The fonts displayed here, however, are freely given by their creators. A typeface comes to life and finds a voice as people begin to use it.

網路上大部分的免費字型不是字距設計不良就是字母不成套；有許多被剽竊的字型未經過授權便遭四處散布。然而這裡所舉的字型是由它們的創作者免費提供使用的。字體在人們開始使用它之後才被賦予了生命，並得以發聲。

FONTIN，約斯・拜佛嘉（Jos Buivenga）/ Ex Ljbris設計，二〇〇四年。

DESIGNERS have long sought to CONTROL the behavior of users, clients, manufacturers, retailers, and the press. How will a work be interpreted? Will it survive over time in its DESIRED STATE of completion? An architect succeeds when the occupants of his house behave ACCORDING TO PLAN. The rise of online tools has challenged designers' sense of CONTROL in every discipline: the user has become a designer.

設計師們長久以來便一直在找尋「控制」使用者、客戶、製造商、零售商、與媒體行為的方法。他們的作品會被如何詮釋？隨著時間發展，他們的創作是否能以完成時的理想狀態存續下去？一名建築師是否成功，端看房屋居住者的行為是否會依照他的建築設計進行。線上工具的興起已經在各種面向上對設計者的「控制」感形成挑戰：使用者已經成為設計者了。

AUDIMAT，傑克・尤辛（Jack Usine）/ SMeltery.net設計，二〇〇三年。

Some fonts are *distributed freely* in order to preserve UNFAMILIAR traditions. Disseminating a historic revival at no cost to users encourages a broader understanding of history. Reviving typefaces is a DEEP-ROOTED practice. Why should one creator *claim ownership* of another's work? Who controls the past?

有些字型之所以透過免費方式發行流通，是為了要保存大眾較為陌生的傳統。以不收分文的方式將復古風格的字體散布出來，可以讓大眾對過去歷史有更進一步的了解。復興古字體的作法由來已久。創作者何以能對別人的作品聲稱擁有所有權呢？誰又能夠控制過去？

Antykwa Poltawskiego，亞當・波塔斯基（Adam Półtawski）設計，一九二〇年代至三〇年代；雅努什・馬利安・諾瓦斯基（Janusz Marian Nowacki）數位化，一九九六年。

SOME FREE FONTS are produced for *underserved linguistic communities* for whom few typefaces are available. Still others are created by people who want to participate in the *open source movement*. The OFL (Open Font License) permits users to alter a typeface and contribute to its ongoing evolution.

有些免費字型是為了欠缺資源的語言社群所設計，這些社群通常只有少數字型可以使用。也有些免費字型是由想加入「開放資源運動」（open source movement）的人們所創作的。「開放字型授權條款」（Open Font License，OFL）允許使用者修改字體，以促進字體的演化發展。

GENTIUM開放字型授權條款，維克特・高特尼（Victor Gaultney）設計，二〇〇一年。

TO PARTICIPATE IN a viable, diverse *ecology of content* (journalism, design, art, typography, and more), *everyone has to pay.* BUT PERHAPS everyone shouldn't have to *pay for everything.* If some resources are willingly given away, the result is a RICHER WORLD.

要加入一個生生不息、多樣化的內容生態圈（新聞、設計、藝術、字體編排設計等等），每個人都必須有所付出，但或許不是樣樣都得付費不可。假使有些人樂意將資源分送出去，我們就可以擁有一個更富足的世界。

OFL SORTS MILL GOUDY，仿作自弗烈德里克・W. 高第（Frederic W. Goudy）於一九一六年設計的Goudy Old Style字體，貝瑞・舒瓦茲（Barry Schwartz）設計，二〇一〇年；可移動字體聯盟（League of Moveable Type）發行。

# EVERY OBJECT IN THE WORLD CAN PASS FROM A

LEAGUE GOTHIC，可移動字體聯盟設計，二〇〇九年；復舊自莫里斯·富勒·本頓的字體

# CLOSED, SILENT EXISTENCE TO AN ORAL STATE,

ALTERNATE GOTHIC NO.1.，美國鑄字師公司（American Type Founders Company，ATF）發行，一九〇三年。

# OPEN TO **APPROPRIATION** BY SOCIETY, FOR THERE

DOWNCOME，埃杜阿爾多·里希夫（Eduardo Recife）/ Misprinted Type設計，二〇〇二年。

# IS NO LAW, WHETHER NATURAL OR NOT, WHICH

# FORBIDS TALKING ABOUT THINGS. A TREE IS A

SHORTCUT，埃杜阿爾多·里希夫設計，二〇〇三年。

# TREE. YES, OF COURSE. BUT A TREE AS EXPRESSED BY

米妞·杜赫埃（Minou Drouet）是一名法國的兒童詩人與作曲家，在一九五〇年代經常受到知識份子們冷嘲熱諷。

# MINOU DROUET IS NO LONGER QUITE A TREE, IT IS A

DIRTY EGO，埃杜阿爾多·里希夫設計，二〇〇一年。

# TREE WHICH IS DECORATED, ADAPTED TO A CERTAIN

# TYPE OF CONSUMPTION, LADEN WITH LITERARY SELF-

MISPROJECT，埃杜阿爾多·里希夫設計，二〇〇一年。

# INDULGENCE, REVOLT, IMAGES, IN SHORT WITH A TYPE

# OF SOCIAL USAGE WHICH IS ADDED TO PURE MATTER.

段落文字：羅蘭·巴特（Roland Brathes），〈現代神話〉（Myth Today），一九五七年；
英譯者：安奈特·拉維爾斯（Annette Lavers）。

{**TEXT** 文本}

「網路空間與公民社會」
（CYBERSPACE AND CIVIL
SOCIETY），海報，一九九六年。
設計者：海耶斯·韓德森（Hayes
Henderson）。設計者沒有以虛無
的網格象徵網路空間，而是以文
字段落層疊出來的污漬塑造了一
個兇惡的人形黑影。

# TEXT 文本

字母集合為文字，文字組合成句子。在字體編排設計裡，「文本」(text) 被定義為一連串接續的文字，有別於長度較短的標題或圖說文字。主要的區塊通常被稱為「正文」(body)，是由內容當中最主要的部分所組成。也有人稱它為「連續文本」(running text)，它可以從這個頁面、欄位、圖框流動到另一個頁面、欄位、圖框。文本可以被視為物體——一個結實堅固的物件——或某種被倒入頁面或螢幕容器裡的液體。文本可以是固態或液態；可以是肉身，也可以是熱血。

作為「正文」，文本比環繞在其周圍的元素——從圖片、圖說文字文、頁碼，到大標題、按鈕、和選單——要來得更有整體性、更完整。設計師處理文本的方式通常是一以貫之的，他們會讓散布在文件空間裡的文本看起來像是個條理一致的個體。在數位媒體當中，較長的文本通常會被切分為數段，讀者可以透過搜尋引擎或超連結取得各段落文本。現代的設計師與文字工作者要為各種五花八門的脈絡背景生產文字內容，從印刷頁面到軟體環境、螢幕環境、和數位設備等，各有其限制與發展機會。

設計師們提供了進入與離開文字洪流的管道；他們將文本切割成塊，並附上可以穿越大量資訊的捷徑與替代路線。從簡單的縮排（表示以下進入新想法）到特別打亮的連結（宣告自此跳往另一個位置），字體編排設計幫助讀者在鋪天蓋地的內容中找到方向。使用者或許正埋首找尋一段特定的資料，或苦惱於如何快速消化大量內容好為手邊急用找出需要的元素。雖然許多書籍裡將字體編排設計的目的定義為提昇書寫文字的可讀性，但就現實面來說，設計最人性化的功能之一，是在於幫助讀者避開不必要的閱讀。

《日課詩篇》（PSALTER-
HOURS），英文手寫本，十三世
紀。Walters Ms. W.102,
fol. 33v.，巴爾的摩沃爾特斯藝
術博物館（Walters Art
Museum，Baltimore）館藏。一名
僧侶正沿著頁面邊緣往上爬，要
以下方邊緣空白處的正確行句取
代錯誤的段落文字。

## ERRORS AND OWNERSHIP
## 錯誤與所有權

字體編排設計讓「文本」的文學意圖——也就是作為一個完整、原創的作品，一個以基本形式表現概念的穩定個體——變得更加明確了。在印刷術發明之前，手寫文件裡滿是舛誤。複本是從其它複本抄寫來的，每個版本都有其錯誤與缺漏。於是抄寫員們發展出各種異想天開的方法將缺漏補正的句子插進手寫文件中，好挽救並修復這些費時費力、精雕細琢的物品。

取代手抄文件的活字印刷術是邁入大量生產的第一套系統。就和其它大量生產的形式一樣，每單位的製造成本（鉛字排版、確認其正確性、印刷）會隨著印數的增加而降低。就這項技術來說，人力與資本主要投入在工具維修與準備上，而不是個別產品的製作上。印刷系統讓編輯與作家可以在將手寫稿謄挪到活版盤上的階段進行內容校正。「校樣」（proofs）是在進入最後量產階段之前製作的測試複本。校對者的工作在於確保印刷文字能準確如實地呈現作者的手寫原稿。

然而縱使是通過印刷城堡大門的文本也並非恆久不變。每一個書籍版本都代表了文本留下的記錄，這個記錄會隨著每回作品內容被翻譯、引用、修訂、詮釋、或傳授而改變。由於寫作與出版的數位工具興起，手寫原稿差不多已經銷聲匿跡。電子紅筆筆跡取代了編輯難以辨認的鬼畫符。使用者可以下載網路上的段落文字，並加以重新編排、利用、組合。

印刷幫助作者奠定了文本所有權人的地位，著作權法也於十八世紀初誕生，為作者對其著作資產的權利提供保障。然而到了數位時代，兩派人馬的戰火卻迭起不休——其中一方認為對於資料與創意應該保有基本的自由使用權利，而另一方卻希望對於出版與編寫內容所做的投資必須加以保障（有時候他們對於保障的要求是很含糊的）。

古典的字體編排設計頁面強調作品的完整與收束，並建立起作為一件完成品的威信。二十世紀與二十一世紀的設計策略則有別於以往，它們向資訊洪流與歷史的侵蝕性展現「文本」的開放與包容，反映出作者權被競奪的本質。

馬歇爾‧麥克魯漢（Marshall McLuhan），《古騰堡星系》（The Gutenberg Galaxy, Toronto: University of Toronto Press, 1962）

關於智慧財產權的未來，請參閱羅倫斯‧萊席格（Lawrence Lessig）的著作，《誰綁架了文化創意？如何找回我們的「自由文化」》（Free Culture: How Big Media Uses Technology and the Law to Lock Down Culture and Control Creativity, New York: Penguin, 2004。繁體中文版由早安財經出版社於二○○八年出版。）

**字體編排設計會把語言從某種認知與探索的手段改變為隨身的日常用品。**
**——馬歇爾‧麥克魯漢（Marshall McLuhan），一九六二年。**

*On the Way to Lainguage*

"How indeed could I aim my argument at some singular destination, at one or another among you whose proper name I might for example know? And then, is knowing a proper name tantamount to knowing someone?" (MC, 2). Derrida demonstrates for his part that the most general structure of the mark participates in a speech destined in advance to addressees (*destinataires*) who are not easily determinable or who, as far as any possible calculation is concerned, in any case command a great reserve of indetermination. This involves a language operating as a system of marks: "Language, however, is only one among those systems of *marks* that claim this curious tendency as their property: they *simultaneously* incline towards increasing the random indetermination *as well as* the capacity for coding or, in other words, for control and self-regulation" (MC, 2). We begin to discern how the simultaneity of determining, coding, and even supercoding forms a deep cooperation with the inclination in language toward anticoding, or what Derrida sees as the inflated reserves of random indeterminateness. This double-edged coding, we must remember, regards, as it were, nonschizophrenic language, if such a thing there be. "Such competition between randomness and code disrupts the very systematicity of the system while it also, however, regulates the restless, unstable interplay of the system. Whatever its singularity in this respect, the linguistic system of these traces or marks would merely be, it seems to me, just a particular example of the law of destabilization" (MC, 2). It may be useful to note that Derrida understands language in terms primarily of traces and marks, where Lainguage concerns signs in the first place, and in particular the broken rapport of that which is signifying to what ostensibly lies hidden behind it, or the disconnection between signs and signs or signs and referents. Laing is led to assume the latency of a single, unique, localizable but timid presence—rather than trace or residual mark—from where it could be securely determined who speaks, and to whom. This all too brief excursion into "My Chances," which may unwittingly reproduce the effect and trauma of a chance encounter, means to engage a dialogue between the question of address raised by Laing and the ones raised in turn by Derrida. For it now appears that Laing places his bets on the sustained systematicity of the system which Derrida shows always already to fall under a law of destabilization.[89] Moreover, Derrida does not suggest lan-

guage to be s... seems to want *translation* of light of an a... been saying a... make contact stract or terr... touch. In fact that I throw, come across to and Laing had part, that, thre... whose destination the case with their muteness was guage were ar... release-controls structurally ma... ratus. The Other fully retrievable is there to be given, agement begins wit... or alive, traversing *fort* slashing into the as self or Other telephone to raise the telephone speak... sound waves: "'she' tem as though it was be hallucinated" (D... "Anything she want... one time. Reality di... or fear. Every wish and every dread tom way. Thus 203). He reads The case history weed garden. Is tanity of omni...

《電話簿：科技、精神分裂症、電話》（THE TELEPHONE BOOK: TECHNOLOGY, SCHIZOPHRENIA, ELECTRIC SPEECH），書籍，一九八九年。設計者：理查・艾克斯利（Richard Eckersley）。作者：阿維塔爾・羅奈爾（Avital Ronell）。版面構成：麥克・詹森（Michael Jensen）。出版者：內布拉斯加大學出版社（University of Nebraska Press）。攝影：丹・梅爾斯（Dan Meyers）。這本書將寫作視為材料科學的哲學論述，並透過字體編排設計突顯出文本在修辭學上產生的爭議。舉例來說，這個版面便被排版造成的「河流」——也就是頁面中由上而下相續的空白——分割得支離破碎。原本平均、一致的組織結構在傳統字體編排設計裡是神聖不可侵犯的，現在卻遭到這些河流褻瀆破壞。

## SPACING
## 字距

設計不光是在做記號，同時也在掌握間隔。字體編排設計師的藝術創作除了處理具象的字體之外，也要考量字體之間與周圍的負空間。以活版印刷來說，空間全都是由實體物件組成的，那是一大塊上面沒有任何浮凸圖像的金屬板或木板。插入文字或字母之間的鉛字條或薄銅片看似毫無個性可言，實則與周圍的文字一樣具體存在。薄鉛條（leading）是活字之間的水平分隔線；較寬的塊狀「空鉛」（furniture）則定義出頁面的邊界。

雖然我們知道字與字之間本來就會出現空白，但由於說話時聽不出間隔，口說語言因而被認為是一種連續的流動。然而對於將說話的聲音轉為複合文字的字母寫作來說，字距就變得十分重要了。在希臘字母被發明出來之後，讓文字得以依個別單位被辨識的字距概念也隨之問世。

你可以試著在沒有適當字距的情況下閱讀一整行文字感受一下字距的重要性。

隨著字體編排設計的演變發展，間隔與手勢被制式化成為人造的字距與標點符號。在手寫文件時代，標點符號的使用會因抄寫員而異；到了印刷時代，標點符號就成為印刷頁面上被標準化、受規範約束的部分配備。傳播學者瓦爾特·翁（Walter Ong）便告訴我們印刷如何將文字轉化為在空間中被精準定位的視覺物件：「將每個字母鑄造在個別金屬塊上的活版印刷，或稱為活字，在根本上標誌了心理層面的突破性發展……印刷將文字放置在空間中的方式遠比寫作來得冷酷無情。寫作將文字從聲音的世界搬移到視覺空間當中，但印刷將文字鎖定在空間裡的特定位置上。」字體編排設計讓文本成為一個物件——一個有其已知維度和固定位置的有形物件。

在一九六〇年代提出解構理論的法國學者賈克·德希達（Jacques Derrida）曾經寫道，雖然字母代表聲音，但少了無聲的符號與空間仍然起不了作用。字體編排設計運用可以被「看見」而非「聽見」的智性與技巧——例如字距與標點符號——駕馭字母悄然無聲的尺度。拉丁字母並沒有演變為一種記錄口語的單純符碼，而是超越了它與口說文字之間的連結，發展出自己的視覺資源，進而成為一種力量更為強大的科技。

瓦爾特·翁，《口語與書寫思維》（Orality and Literacy: The Technologizing of the Word, London and New York: Methuen, 1981）。也請參見賈克·德希達，《論文字學》（Of Grammatology，英譯者：佳亞特里·查克拉沃蒂·斯皮瓦克〔Gayatri Chakravorty Spivak〕, Baltimore: Johns Hopkins University Press, 1976）

**一個活生生的口說語言之所以能夠在寫作中產生字距，實則與它的死亡有關。——賈克·德希達，一九七六年。**

# LINEARITY
## 線性

法國評論家羅蘭·巴特在他的論文當中提到兩種對立的寫作模式：封閉、固定的「作品」相對於開放、不穩定的「文本」。從巴特的觀點看來，所謂作品是一種整齊、被井然包裝的物件，經過校稿，受到版權保護，並且透過印刷藝術而變得完美與完整。相對地，文本無法受到控制，它在四散各處的標準情節與概念交織而成的網絡上運作著。巴特描繪文本為「完全由引證、參考資料、回響、文化語言（哪種語言不是？）、過去與現在所交織而成，這一切都穿梭在一個巨大的立體聲環境中⋯⋯『文本』的象徵就是『網路』（network）。」就巴特於一九六〇與七〇年代的文章來看，他期望網際網路可以成為一個分散而連接的網絡。

　　雖然巴特談的是文學，但他的概念正和語言的視覺表現形式「字體編排設計」相呼應。一直以來，個別的傳統文本頁面，都是由書本的導航功能——從標誌讀者位置的頁碼和標題，到諸如索引、附錄、摘要、註釋、和目錄等工具——所支持著。這些工具之所以能夠出現，是因為經過字體編排設計的書籍是由一連串固定的頁面所構成的，而正文被放置在有成套配件的柵格上。

　　這些工具全都對線性造成了攻擊，它們提供了進入與逃離單向流動的論述的方法。話語的流動是單向的，而寫作卻同時佔據了空間與時間。開發空間的維度、並且將讀者從線性的束縛中解放出來，是字體編排設計最緊要的任務之一。

　　雖然數位媒體被普遍認為具有非線性傳播的可能性，然而從沿著電視螢幕底部大步邁進的「CNN新聞速報」到都會裡隨處可見、不斷循環播放的跑馬燈LED看板，線性仍然在電子領域裡大行其道。電影片尾字幕結合了字體編排設計與電影，好讓觀眾在觀看按規定必須揭露的影片所有權與著作權資訊時，能夠自無可避免的冗長乏味中轉移他們的注意力。初階的電子閱讀器，例如亞馬遜（Amazon）的Kindle（2007），提供的是高度連續性、極為線性的閱讀經驗；在某些電子書上，往回翻頁或往前跳頁要比在紙本書上來得麻煩多了。

羅蘭·巴特，〈從作品到文本〉（From Work to Text），《圖像／音樂／文本》（Image/Music/Text），史蒂芬·希斯（Stephen Heath）英譯，（New York：Hill and Wang，一九七七年），第一百五十五至一百六十四頁。

文本⋯⋯是一個多維度的空間，各式各樣的書寫——但沒有任何原創——在其中相互交融、撞擊。——羅蘭·巴特，一九七一年。

關於文書處理的線性概念，請參考南西‧柯普蘭（Nancy Kaplan）論文〈布雷克與我們的問題：關於圖像與文字的一些反思〉（Blake's Problem and Ours: Some Reflections on the Image and the Word），《讀者的／作者的文本，3.2》（Readerly/Writerly Text, 3.2，春夏號，一九九六年），第一百二十五頁。關於PowerPoint，請參考愛德華‧R‧塔夫特，〈PowerPoint的認知風格〉（The Cognitive Style of PowerPoint, Cheshire, Conn.: Graphics Press, 2003）。

線性概念支配了許多商用軟體應用程式。舉例而言，文書處理程式便將文件視為一種線性流動。（相對地，頁面版型設計程式如Quark XPres和Adobe InDesign讓使用者以空間概念進行工作，他們可以將文本分割為欄或頁，並且在上面設置錨點或地標。）PowerPoint和其它簡報軟體的功能則是透過引導觀眾了解演說所表達的線性內容，做為口語的輔助工具。然而一般來說，PowerPoint並沒有緩和演說的單向流動，反而使之更為強化。原本只要一張紙就能展示一張地圖或口頭簡報的摘要，PowerPoint的簡報卻在一個又一個的螢幕播放中不斷拖延時間。

不過也並非所有數位媒體都捨棄空間配置而對線性流動情有獨鍾。資料庫（database）是當代明確而清楚的資訊架構之一，它便是非線性形式。資料庫提供讀者與作者同步的選項清單，它是一個元素可以被配置為無數種序列的系統。資料庫的版面建立在大量的資訊上，這些資訊會被加以組裝以回應使用者的反饋。網路讓作者、編輯與設計師必須以更具創意的工作方式處理新型態的微內容（microcontent，網頁標題、關鍵字、替代文字標籤〔alt tags〕），好讓資料可以被搜尋、編入索引、標籤，或者做記號，以方便查找。

關於資料庫的美學，請參考雷夫‧曼諾維奇的著作《新媒體的語言》（The Language of New Media, Cambridge: MIT Press, 2002）。

資料庫是隱身在電子遊戲、雜誌、和目錄背後的架構，這些項目創造出的是資訊空間，而不是線性的結果。實體商店與圖書館則是可見於人為環境中的實體物件的資料庫。媒體評論家雷夫‧曼諾維奇（Lev Manovich）曾經形容語言本身就是一種資料庫和檔案館，人們利用其中的元素組合出線性的口語表達方式。許多設計案強調空間甚於序列、強調完整系統甚於片段語句、強調同步架構甚於線性敘事。現代設計經常會結合建築、字體編排設計、電影、指標、品牌、與其他表達形式。透過強化設計案的空間特性，設計師可以增進對於複雜文件與環境的了解。

空間概念的運用愈見巧妙，同時也在字體編排設計的歷史上留下了印記。在數位時代，字母透過觸鍵與滑鼠而出現，不再需要從裝滿人造零件的沉甸甸抽屜裡一個個揀取；空間變得流動而不再僵固，字體編排設計也從穩定的物件主體演化為一個靈活的屬性系統。

**資料庫與記述天生便是宿敵。它們在同一個人類文化的領域裡互相競逐，兩者都聲稱唯有自己才擁有為世界創造意義的權利。——雷夫‧曼諾維奇，二〇〇二年。**

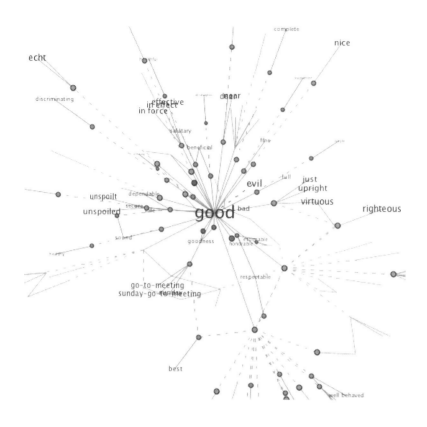

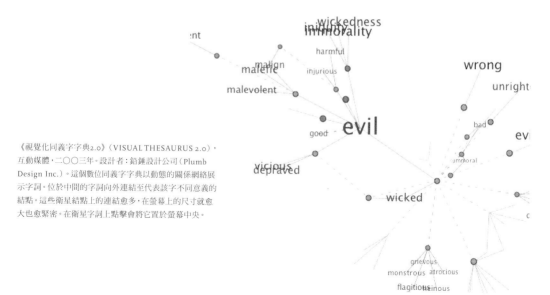

《視覺化同義字字典2.0》（VISUAL THESAURUS 2.0），
互動媒體，二〇〇三年。設計者：鉛錘設計公司（Plumb
Design Inc.）。這個數位同義字字典以動態的關係網絡展
示字詞。位於中間的字詞向外連結至代表該字不同意義的
結點。這些衛星結點上的連結愈多，在螢幕上的尺寸就愈
大也愈緊密。在衛星字詞上點擊會將它置於螢幕中央。

《圖像／音樂／文本》，羅蘭‧巴特的著作《圖像／音樂／文本》一書中的用語索引與文本統計資料。出版者：Amazon.com，二○一○年。Amazon提供書籍文本的自動化分析資料，好讓讀者對內容有些概念。用語索引的功能會將書中最常使用的一百個字依第一個字母的順序排列出來，並且根據它們的出現頻率決定字體大小。

## Concordance (learn more)

These are the 100 most frequently used words in this book.

according action again always analysis another art author between body cannot case certain characters code comes connotation different discourse does elements even example fact first form functions given historical however idea image itself know language least level linguistic longer may meaning message moment music must name narrative nature new nothing now object once order own part perhaps person photograph place point possible precisely reader reading relation say see seen sense sentence sequence set signified signifier signs simply since social society speech still story structural structure subject system term text though thus time two units voice whole without word work writing

## Text Stats

These statistics are computed from the text of this book. (learn more)

**Readability** (learn more) | | **Compared with other books** | |
|---|---|---|---|
| Fog Index: | 22.1 | 98% are easier | 2% are harder |
| Flesch Index: | 24.3 | 93% are easier | 7% are harder |
| Flesch-Kincaid Index: | 18.8 | 98% are easier | 2% are harder |

**Complexity** (learn more) | | | |
|---|---|---|---|
| Complex Words: | 19% | 70% have fewer | 30% have more |
| Syllables per Word: | 1.7 | 67% have fewer | 33% have more |
| Words per Sentence: | 36.1 | 99% have fewer | 1% have more |

**Number of** | | | |
|---|---|---|---|
| Characters: | 396,905 | 48% have fewer | 52% have more |
| Words: | 64,614 | 49% have fewer | 51% have more |
| Sentences: | 1,791 | 25% have fewer | 75% have more |

雖然繼承了作者的角色，但抄寫員的內心不再有熱情、脾氣、感受、印象，只有這部浩瀚的字典讓他得以從中源源不絕地產生寫作。

——羅蘭‧巴特，一九六八年。

# KATHERINE mcCoy
# MICHAEL mcCoy

ART *science*

Nothing pulls you into the territory between art and science quite so quickly as design. It is the borderline where contradictions and tensions exist between the quantifiable and the poetic. It is the field between desire and necessity. Designers thrive in those conditions, moving between land and water. A typical critique at Cranbrook can easily move in a matter of minutes between

MATHEMATIC *poetic*

a discussion of the object as a validation of being to the precise mechanical proposal for actuating the object. The discussion moves from Heidegger to the "strange material of the week" or from Lyotard to printing technologies without missing a beat. The free flow of ideas, and the leaps from the technical to the mythical, stem from the attempt to maintain a studio plat- form that supports each student's search to

DESIRE *necessity*

find his or her own voice as a designer. The studio is a hothouse that enables students

**the**

and faculty to encounter their own visions of the world and act on them — a

**new**

process that is at times chaotic, conflicting, and occasionally inspiring.

Watching the process of students absorbing new ideas and in- fluences, and the incredible range of in- terpretations of those ideas into design, is

MYTHOLOGY *technology*

an annual experience that is always amaz- ing. In recent years, for example, the de-

**discourse**

partment has had the experience of watching wood craftsmen metamorphose into high technologists, and graphic designers into software humanists. Yet it all seems consistent. They are bringing a very per- sonal vision to an area that desperately needs it. The messiness of human experi-

PURIST *pluralist*

ence is warming up the cold precision of technology to make it livable, and lived in.

Unlike the Bauhaus, Cranbrook never embraced a singular teaching method or philosophy, other than Saarinen's exhortation to each student to find his or her own way, in the company of other artists and designers who were en- gaged in the same search. The energy at Cranbrook seems to come from the fact of

INDIVIDUAL *communal*

the mutual search, although not the mutual conclusion. If design is about life, why shouldn't it have all the complexity, vari- ety, contradiction, and sublimity of life?

Much of the work done at Cranbrook has been dedicated to changing the status quo. It is polemical, calculated to ruffle designers' feathers. And

DANGEROUS *rigorous*

Fer
198
Ke
Cra
A b
cial
tog
colla
grap

# BIRTH OF THE USER
## 使用者的誕生

巴特的理論模型認為文本是一個開放的參考資源網絡、而非封閉完美的作品，並且主張在創造意義上讀者的重要性遠大於作者。讀者「演繹」文本就如同音樂家演奏樂器一般。作者無法對文本的意義加以控制：「文本本身已有所表現（就像門、或機器的『運作』）而讀者會再次演繹，他們演繹文本的方式就像是在玩一種遊戲，也希望能藉由再次練習重製演繹的經驗。」就如同樂譜詮釋音樂，閱讀正是書寫文字的演出。

　　一九八〇年代至一九九〇年代初期，平面設計師開始採納「讀者文本」（readerly text）的概念，他們利用層疊式的文本與連鎖網格探索巴特「作者已死」（death of the author）的理論。以往的古典模型視字體編排設計為乘載內容的水晶酒杯，然而這個跳脫傳統的觀點取而代之，認為內容本身會隨著每一次的演出行為而改變。字體編排設計變成一種詮釋方法。

　　設計師凱瑟琳・麥考伊（Katherine McCoy）打破「看」（seeing）與「讀」（reading）兩者間傳統的二分法，將字體編排設計重新定義為一種「論述」（discourse）。圖片可以被閱讀（分析、破譯、拆解），而文字可以被觀看（被視為圖像、形式、花樣）。她的理論重視模糊性與複雜性，除了驅策讀者自己產生意義之外，也試圖透過形成著作者身份的過程提昇設計者的地位。

　　另外一個在一九九〇年代末期出現的模型則不利於設計者的權力主張，這個模型並非來自文學批評界，而是來自人機互動（HCI）研究與介面及可用性設計的領域。我們這個時代的優勢主體既非讀者也不是作者，而是使用者，一個懷抱著大量需求、等待修復的個體──有認知、有肉體、有情緒。使用者就像病人或孩童一樣，他需要受到保護、呵護，但也同時需要被仔細檢視、控制，並加以研究與測試。

　　比起文本的意義來說，文本如何被運用變得更為重要。有人在這裡點擊以解決那裡的問題；有些人買了這個也買了那個。互動式的環境不僅讓使用者有某種程度的控制權與自導權，但同時它也能更悄然無息地收集關於觀眾的各種資訊。巴特視文本為被人演繹或玩耍的遊戲，這個比喻在使用者回應系統發出的信號時也仍然適用。我們或許演繹了文本，但它也在演繹我們。

《葛蘭布魯克的設計：新論述》（CRANBROOK DESIGN：THE NEW DISCOURSE），書籍，一九九〇年。設計者：凱瑟琳・麥考伊（Katherine McCoy）、P. 史考特・馬凱拉、和瑪麗・盧・克蘿（Mary Lou Kroh）。出版者：Rizzoli。攝影者：丹・梅爾斯（Dan Meyers）。在凱瑟琳與麥克・麥考伊的指導下，葛蘭布魯克藝術學院（Cranbrook Academy of Art）於一九七〇年代至一九九〇年代早期成為實驗性設計的領導中心。凱瑟琳・麥考伊發展出「字體編排設計即論述」（typography as discourse）的模型，在這個模型理論中，設計者與讀者皆能主動積極地詮釋文本。

**依據人們的能力與性格上的弱點設計人機介面，你不但能幫助使用者把工作完成，還能讓他們成為更快樂、更有生產力的人。──傑夫・拉斯金（Jef Raskin），二〇〇〇年。**

平面設計師可以利用使用者互動的理論重新檢視我們關於視覺傳播的一些基本假設。舉例來說，為什麼網路上的讀者會比印刷品的讀者更缺乏耐心呢？一般普遍的看法是數位顯示原本就比紙墨來得難以閱讀。然而根據一九八〇年代晚期的人機互動研究，一樣是清晰黑字搭配白色背景，在螢幕上與在印刷頁面上的閱讀效率是不相上下的。

數位讀者的不耐起因於文化，而不是顯示科技的基本特質。網站使用者的期望與印刷品使用者不同。他們期望能感受到「生產力」，而不是沉思冥想；他們期望自己進入搜尋模式，而不是加工處理模式。使用者們也預期自己會因為接收到錯誤的線索而被挫折、困擾、與拖延。螢幕族群的文化習慣正在促使印刷上的設計改變，同時也證實了延伸性的閱讀仍然會在印刷品上持續發生。

還有另一個普遍的假設，認為與文本相較，圖示是更為通用的傳播模式。圖示是連結使用者與電腦的「圖形化使用者介面」（GUIs, graphical user interfaces）的核心。然而文本往往比圖片提供了更具體、易懂的線索。圖示不見得能簡化將內容譯為多種語言的過程，因為解釋圖示本身也需要這些語言。數位化桌面上無窮無盡的圖示經常有著不必要的細節與深度，它們強化功能品牌識別的功能已經大過於支援可用性了。二十世紀的現代設計者擁戴圖像為一種「通用」語言，然而到了數碼時代，文本已然較圖像成為更普遍的分母——它可以被搜尋、被翻譯，也能因應各種非主流或未來媒體而改變樣式與風格。

或許二十世紀的藝術與設計最奮力推動的便是從實體上將樣式與內容整合在一起，以達達主義與未來主義的詩人為例，他們便利用字體編排設計創造出內容與頁面上特定的字體樣式及固定版型無法分離的文本。比方說，樣式表（style sheet）便強迫設計師必須從全面性與系統性的角度思考，不能只專注於特定表面的固定結構上。這種思考方式讓內容得以因應不同的裝置與使用者而被重新編排修改，也在電子儲存媒體開始有其衰敗過時的週期時，為資料的後路預先作好準備。

關於螢幕可讀性，請參見約翰·D. 顧爾德（John D. Gould）等人合著，〈在電腦顯示器上閱讀的速度可以和紙上閱讀一樣快〉（Reading from CRT Displays Can Be as Fast as Reading from Paper），《人因》（Human Factors），第二十九卷第五期（1987），第四百九十七頁至五百一十七頁。

關於躁動的使用者，請參見賈考伯·尼爾森（Jakob Nielsen），《設計網路可用性》（Designing Web Usability, Indianapolis: New Riders, 2000）。

關於介面圖像的失靈，請參見傑夫·拉斯金（Jef Raskin），《人性化介面：設計互動式系統的新方向》（The Humane Interface: New Directions for Designing Interactive Systems, Reading, Mass. : Addison-Wesley, 2000）。

**網路使用者不喜歡閱讀……他們想要不斷地移動、點擊。**
**——賈考伯·尼爾森，二〇〇〇年。**

在二十世紀，現代藝術家與評論主張每一種媒體都是獨特的。舉例而言，他們將電影定義為一種有別於劇場的建構式語言，而繪畫則是因其過程而被描述為一種具形的媒體。然而在今天，媒體不見得就是訊息。設計已經成為一種「跨媒體」的事業，作者與生產者在各式各樣的產品上創造出有角色、地點、情境與互動的世界。一個遊戲可能會因應電視螢幕、桌上型電腦、遊樂器、手機而有不同版本，更別提還有T恤、便當盒、塑膠玩具等週邊商品了。

另一個現代主義的迷思——「留白」的美麗與思索——在使用者的時代也面臨修正。現代的設計者發現，頁面上的開放空間與印刷區域同樣都是具體存在的。然而，留白不見得是對心智友好的一種作法。視覺密度（visual density）的狂熱擁護者愛德華·塔夫特（Edward Tufte）便主張應該要在單一頁面或螢幕上讓傳達的資料量最大化。比起多頁有大量留白的頁面，資訊有條不紊的單一頁面有時候更能幫助讀者與內容產生連結、比較，同時快速查找資訊。字體編排設計就像都會生活一樣，緊密的排列讓人們和想法有更多彼此深入交流的機會。

在我們這個資訊爆炸、流言漫天的時代，一個人一次仍然只能消化一個訊息。這個殘忍的事實正是魔法背後的祕密：當觀眾的注意力被分散時，巧妙的技法出現了。各種資訊競相爭取使用者的關注，而透過選擇他們想看的內容，使用者有機會形成資訊經濟。設計師可以幫助他們做出令他們滿意的選擇。

字體編排設計是字母的介面。使用者理論傾向於採用規範式而非創新式的解決方案，將設計侷限在背景之中。讀者往往無視於字體編排設計的介面，兀自就著習以為常的閱讀慣例沿著字句一路移行。然而，有些時候應該要允許介面失靈。強化字體編排設計，它可以讓頁面、螢幕、場所、或產品的結構與識別更加醒目。

發源於文藝復興時期的字體編排設計讓文本變成一個固定、平穩的形式。就如同字母的主體，文本的主體也逐漸轉變為更開放、更靈活的工業日用品。

關於跨媒體設計思考，請參見布蘭達·羅瑞爾（Brenda Laurel），《追求理想境界的企業家》（Utopian Entrepreneur, Cambridge: MIT Press, 2001）。

傑夫·拉斯金談到了人類注意力的匱乏以及留白空間的迷思。《人性化介面：設計互動式系統的新方向》，第七十四頁。

**假使人們不擅於從長長的清單中搜尋微小的事物，那麼《華爾街日報》早在好幾年前就會宣告破產了。——傑夫·拉斯金，二〇〇〇年。**

電子媒體的評論家已經注意到網路傳播的興起並沒有對字體編排設計造成令人害怕的崩壞（或甚至是印刷品的死亡），反倒是對字母帝國的迅速發展推了一把。如同彼德‧拉南費爾德（Peter Lunenfeld）所提到的，電腦重振了寫作的力量，使之再度流行：「字母與數字的文本已經從它自己的灰燼中站起，一隻數位火鳳凰從螢幕上逃逸，牠穿過網路，在虛擬空間的領土中翱翔。」對文本來說，電腦顯示要比電影或電視螢幕來得更友善，因為它提供了實體上的親近（physical proximity）、使用者控制、以及適合人體的比例尺寸。

　　印刷書籍不再是手寫文字的主要守護者。品牌塑造（branding）是文學素養一個強而有力的變體，它圍繞著符號、圖像、與字體編排設計的標準，在建築物、包裝、唱片封套、網站、商店櫥窗、以及無數各種表面與空間上留下記號。隨著網際網路的擴張，展示文本的新（與舊）慣例很快便成形了，它們改編自印刷品與建築裡的象徵：視窗（window）、邊框（frame）、橫幅（banner）、選單（menu）。在這樣的多媒體潮流裡，設計師所面對的是各種不同形式的文本，除了不斷延伸的內文主體之外，他們還要讓標題、平台、圖說文字、註解、醒目引言、企業標誌、導覽列、替代文字標籤，以及其它發布、支援、或甚至遮掩文本主體的補充性語言得以具體呈現。

　　在網路世界裡，容易分神的讀者們格外珍惜他們的時間，他們重視功能大於形式，也因而寫作的崩解最為極端。這種坐立不安並非電腦螢幕的基本特質所導致，而是由於網際網路是一個進行搜尋、查找、掃描、探勘的空間，在這裡發展出了新的行為模式。曾經在二十世紀顛覆了作者權利王座的讀者現在陷入了痛苦衰敗的處境，被我們這個時代的強勢角色——也就是使用者——所取代；他們微少的關注是我們最夢寐以求的珍品。可別輕易浪費了。

關於電子寫作，請參見彼德‧路南費爾德，《對齊格線：數位藝術、媒體、與文化的使用者指南》（Snap to Grid: A User's Guide to Digital Arts, Media, and Cultures, Cambridge: MIT Press, 2001）；傑‧大衛‧波爾特（Jay David Bolter），《寫作空間：電腦、超文本、與印刷品的補救》（Writing Space: Computers, Hypertext, and the Remediation of Print, Mahwah, NJ: Lawrence Erlbaum Associates, 2001），以及史都華‧摩斯洛普（Stuart Moulthrop），〈你說你想要來場革命？超文本與媒體的法則〉，《新媒體讀者》（The New Media Reader），諾亞‧渥爾普利普－弗路恩（Noah Wardrip-Fruin）與尼克‧孟佛特（Nick Monfort）合編（Cambridge: MIT Press, 2003）第六百九十一頁至七百零三頁。

**超文本意謂著文學之死已然終結。——史都華‧摩斯洛普，一九九一年。**

DESIGNOBSERVER.COM，網站，二〇一〇年。設計：潔西卡・荷芬（Jessica Helfand）、威廉・杜蘭托（William Drenttel）、麥可・貝汝（Michael Bierut）、貝琪・瓦爾多（Betsy Vardell）。這個論述設計的超級大站首頁上有大量的內容，它將印刷質感的字體編排設計呈現在螢幕上。

# KERNING
## 字距微調

「字距微調」指的是兩個字母之間空間的調整。拉丁字母是隨著時間逐一演變出來的；它們被設計的時候，從來沒有人想過要考量到手動或自動調整間距的問題。因此有些字母在組合的時候，如果沒有一併考量間距問題，看起來就會有些奇怪。舉例來說，外形的角度向上或形成開放空間的字母（W, Y, V, T）周圍就會產生縫隙。在金屬活字當中，上方或下方突出的字母會延伸超出支撐它的鉛字條，好讓鄰近兩個字母可以更緊密相合。在數位字型當中，成對字母的間距則是透過字型設計師所創作的字距調整表（kerning table）進行控制，它會明確定出有問題的字母組合應該採用何種間距。

在進行頁面排版時，設計師可以選擇要使用「公制字字距微調」（metric kerning）或「視覺特殊字距微調」（optical kerning），或者以手動方式在任何想要修改的地方調整字距。一套設計精良的字體只需要些許、或完全不需要做字距微調的微調，特別是當它以文本內容的大小出現時。

「公制字字距微調」使用的是字體當中內建的字距調整表。當你在你的頁面排版程式上選擇了公制字字距，你便等於採用了這個字體的設計師特別鍾愛的字距。公制字字距微調看起來通常都相當好看，特別是當字體小的時候。便宜新奇的字型往往很少或根本沒有內建的字距調整表，需要採用視覺特殊字距微調的作法。

「視覺特殊字距微調」是由頁面排版程式自動執行。有別於利用字型內的字距調整列出成對字母字距的方式，「視覺特殊字距微調」會衡量所有字母的外形，並在任何需要調整的地方加以調整。有些平面設計師會在標題使用視覺特殊字距微調，並且在文本當中使用「公制字字距微調」。為了讓流程更有效率、前後作法一致，你可以在「字元樣式」裡先行設定字距微調的方式。

# Takes Two

SCALA PRO，未作字距微調
字距顯得不均衡，T/a, T/w、w/o之間有縫隙。

# Takes Two

SCALA PRO，有作公制字字距微調
T/a和T/w的間距較為平均。

# Takes Two

SCALA PRO，有作視覺特殊字距微調
T/a, T/w、w/o的間距似乎較為平均。

# *Warm Type*

SCALA PRO ITALIC，未作字距微調
T/a和T/y的字距顯得不均衡。

# *Warm Type*

SCALA PRO ITALIC，有作公制字字距微調
W/a和T/y的字距較為平均。

# *Warm Type*

SCALA PRO ITALIC，有作視覺特殊字距微調
其字元間距可以與公制字字距微調媲美。

# LOVE LETTERS

SCALA PRO ALL CAPITALS，未調整為字距微調
T/ T的間距過緊。

# LOVE LETTERS

SCALA PRO ALL CAPITALS，有作公制字字距微調
改善了T/ T之間的字距。

# LOVE LETTERS

SCALA PRO ALL CAPITALS，有作視覺特殊字距微調
改善了T/ T和O/V之間的字距。

標題的字距微調。「公制字字距微調」與「視覺特殊字距微調」之間細微的差異，在較大的字體下變得更為明顯。大部分的問題發生在大寫字與小寫字之間。H／a、T／a、和T／o之間的字距在「視覺特殊字距微調」下有所改善。這裡所使用的InDesign「視覺特殊字距微調」功能會讓較大的文字字距變得更為緊密，並且讓較小的文字字距更為寬鬆。在選擇字距微調的調整方式前請先看看兩種不同的效果。

## Ha
公制字字距微調

## Ha
視覺特殊字距微調

**公制字字距微調與視覺特殊字距微調的比較**

## Books And Harlots Have Their Quarrels In Public.
（書和妓女都會在大庭廣眾之下爭吵。）

# Books And Harlots Can Be Taken To Bed.
（書和妓女都可以帶上床。）

Books and harlots—
footnotes in one are
as banknotes in the
stockings of the other.

（書和妓女──書中的註腳就如同妓女絲襪裡的鈔票一樣。）

──瓦爾特・班雅明（WALTER BENJAMIN），一九二五年。

書和妓女都會在大庭廣眾之下爭吵。

## Books And Harlots Have Their Quarrels In Public.
（書和妓女都會在大庭廣眾之下爭吵。）

# Books And Harlots Can Be Taken To Bed.
（書和妓女可以帶上床。）

Books and harlots—
footnotes in one are
as banknotes in the
stockings of the other.

（書和妓女──書中的註腳就如同妓女絲襪裡的鈔票一樣。）

──瓦爾特・班雅明（WALTER BENJAMIN），一九二五年。

QUADRAAT SANS，使用視覺特殊字距微調

書呆子警報：除了使用「視覺特殊字距微調」功能外，上方的文本已經將字元間距縮減至百分之八十。以較大的字體來說，一般的字元間距往往看起來過寬。你可以在InDesign裡「段落樣式選項」（Paragraph）下的「齊行」（Justification）選單裡調整字元間距。

# TRACKING
## 字距調整

針對整個區塊的文字調整字元間距稱為字距調整（tracking或letterspacing）。利用調寬一個字、一行字、或一整區文本的字距，設計師可以創造出更通透、開放的畫面。在整段文本當中，字距通常只會做微量的調整，以製造出隨性的閱讀者不易發現的細微效果。偶爾單一字詞會因為有被突顯的需要而調整字距，尤其是當整行文字中使用了大寫字或小型大寫字的時候。字距緊縮雖然極少被使用於內文，但這項功能可以將短行的內文往上拉抬，以騰出空間。黑色背景上的白色字體在經過字距調整之後會變得較容易閱讀。

SCALY-BREASTED PARTRIDGE
*Arborophila chloropus*
12 in (30 cm)
Southeast Asia

CRIMSON-HEADED PARTRIDGE
*Haematortyx sanguiniceps*
10 in (25 cm)
Borneo

《世界鳥類圖鑑》（BIRDS OF THE WORLD），書籍，二〇〇七年。作者：雷斯·貝雷茨基（Les Beletsky）。出版社：約翰霍普金斯大學（The Johns Hopkins University）。藝術總監：查爾斯·尼克斯（Charles Nix）。設計師：查爾斯·尼克斯、惠特妮·格蘭特（Whitney Grant）、梅·簡派森（May Jampathom）。這本書的字體設定為Adobe Caslon和Caslon 540，在圖說文字的標題上使用了調整過字距的小型大寫字。

### 調整內文字距

**標準字距**

Letters do love one another. However, due to their anatomical differences, some letters have a hard time achieving intimacy. Consider the letter *V*, for example, whose seductive valley makes her limbs stretch out above her base. In contrast, *L* solidly holds his ground yet harbors a certain emptiness above the waist. Capital letters, being square and conservative, prefer to keep a little distance from their neighbors.

**加寬字距（+20）**

Letters do love one another. However, due to their anatomical differences, some letters have a hard time achieving intimacy. Consider the letter *V*, for example, whose seductive valley makes her limbs stretch out above her base. In contrast, *L* solidly holds his ground yet harbors a certain emptiness above the waist. Capital letters, being square and conservative, prefer to keep a little distance from their neighbors.

**緊縮字距（−20）**

Letters do love one another. However, due to their anatomical differences, some letters have a hard time achieving intimacy. Consider the letter *V*, for example, whose seductive valley makes her limbs stretch out above her base. In contrast, *L* solidly holds his ground yet harbors a certain emptiness above the waist. Capital letters, being square and conservative, prefer to keep a little distance from their neighbors.

（字母是彼此相愛的。然而由於結構上的差異，有些字母沒辦法與其它字母親近。就拿字母V來說，性感的深V讓她的兩條枝幹從底部向外伸展出去。相較之下，L不但腳踏實地，而且在腰部以上還保留了相當大的空曠空間。大寫字母較為方正穩重，他們喜歡與鄰居們保持一點距離。）

**囧設計**
字距過緊的文本
字母間的字距緊到讓人覺得不舒服。

（書和妓女──兩者都有靠她們吃飯卻又不斷騷擾她們的男人。就書來說，這個男人就是書評·瓦爾特·班雅明·一九二五年。）

Books and harlots—both have their type of man, who both lives off and harasses them. In the case of books, critics. WALTER BENJAMIN, 1925

REVERSED TYPE, 沒有調整字距

Books and harlots—both have their type of man, who both lives off and harasses them. In the case of books, critics. WALTER BENJAMIN, 1925

REVERSED TYPE, 字距加寬25點

設計師們最常在標題與企業標誌上使用字距調整功能（這裡也經常需要進行字距微調）。當字體變得愈大，字母間的空間也會隨之擴張，有些設計師會在大規模的文字區塊上利用字距調整功能縮減字距。大寫字或小型大寫字通常會使用較寬鬆或開放的字距，字母稍微分開站立，讓它們看起來更為高貴莊嚴。

### 調整標題與企業標誌的字距

## LOVE LETTERS
大寫字：標準字距

## LOVE LETTERS
大寫字：加寬字距（+75）

## LOVE LETTERS, LOVE LETTERS
小型大寫字：標準字距 vs. 加寬字距（+75）

## love letters, *love letters*
小寫字：標準字距

## love letters, *love letters*
小寫字：加寬字距（+75）

**囧設計：調整小寫字母的字距**
小寫字母──尤其是斜體字──的字距若過於寬鬆，看起來會顯得很笨拙，因為這些字是設計要與其它字緊密成行的。

EROS，企業標誌，一九六二年。設計：賀伯·魯巴林（Herb Lubalin）。在一九六〇年代與一九七〇年代，先進的商業平面設計以極為緊密的字距為其特色。在這裡，字母彼此親密地互相支撐著，正與主體（eros意為「愛神」）所代表的意義相呼應。

CRUET & WHISK與THYMES，企業標誌，二〇〇六年。設計：Duffy & Partners。大寫字寬鬆的字距讓這些企業標誌呈現出友善、復古的氣息，同時也讓設計顯得輕盈明快。

你可以利用字距、字的大小、和字母在頁面
上擺放的位置來表達一個字的意義或一個
概念。設計師們在創作企業標誌、海報、或
社論標題時經常會朝這個方向思考。這裡的
作品透過字母的字距調整與配置具體表現
出一些動作，例如中斷（disruption）、擴張
（expansion）、遷移（migration）等。圓形的
O讓Futura字體在這項作業當中的運用充滿
樂趣。

馬里蘭藝術學院學生作品範例

sition          transiti

（過渡）約翰・庫多斯（Johnschen Kudos）

disruption          c o mpression

（壓縮）約翰・庫多斯

（中斷）約翰・庫多斯

ion

t

a

e x p**expansion** i o n

ig

.m
migra tion

（擴張）馬可斯·寇薩爾（Marcos Kolthar）

（遷移）傑森·霍格（Jason Hogg）

**elimina ion**

**repetition**

（重複）海瑟·威廉斯（Heather Williams）

（淘汰）海瑟·威廉斯（Heather Williams）

# LINE SPACING
## 行距

一行字的底線與另一行字底線之間的距離稱為「行距」（line spacing），也被稱為leading；leading的說法來自於分隔上下兩行金屬活字時所使用的鉛條（lead）。在大部分的排版與影像處理軟體中，行距被預設為字體大小的百分之一百二十，因此10點大小的字體會搭配12pts的行距。設計師們利用行距的調整創造出別具特色的字體編排配置。縮減標準行距會讓版面看起來更緊密，但會有字母的上伸部與下伸部彼此碰撞的風險。放寬行距則會創造出一個較為清爽、開放的文字區塊。隨著行距增加，各行文字變得愈來愈像獨立的圖像元素，而不再屬於完整的視覺形狀與結構的一部分了。

（青菜蘿蔔，各有所好）

*different*

## folks

*different*

## strokes

---

**囧設計**

自動調整行距在這裡產生了不平均的結果。

*different*

## folks

*different*

## strokes

---

利用「基線位移」工具（baseline shift）調整行距，可以幫助你創造一個均衡的版面。

# Aa
↑

書呆子警報：「基線位移」是手動調整一個或多個字母水平位置的方式。「基線位移」經常於混搭不同大小或樣式的字體時使用。在標準軟體應用程式的「字型」工具列裡可以找到基線位移工具。

### 行距的各種變化

The distance from the baseline of one line of type to another is called *line spacing*. It is also called *leading*, in reference to the strips of lead used to separate lines of metal type. The default setting in most layout and imaging software is 120 percent of the type size. Thus 10-pt type is set with 12 pts of line spacing. Designers play with line spacing in order to create distinctive layouts. Reducing the standard distance creates a denser typographic color—while risking collisions between ascenders and descenders.

The distance from the baseline of one line of type to another is called *line spacing*. It is also called *leading*, in reference to the strips of lead used to separate lines of metal type. The default setting in most layout and imaging software is 120 percent of the type size. Thus 10-pt type is set with 12 pts of line spacing. Designers play with line spacing in order to create distinctive layouts. Reducing the standard distance creates a denser typographic color—while risking collisions between ascenders and descenders.

The distance from the baseline of one line of type to another is called *line spacing*. It is also called *leading*, in reference to the strips of lead used to separate lines of metal type. The default setting in most layout and imaging software is 120 percent of the type size. Thus 10-pt type is set with 12 pts of line spacing. Designers play with line spacing in order to create distinctive layouts. Reducing the standard distance creates a denser typographic color—while risking collisions between ascenders and descenders.

The distance from the baseline of one line of type to another is called *line spacing*. It is also called *leading*, in reference to the strips of lead used to separate lines of metal type. The default setting in most layout and imaging software is 120 percent of the type size. Thus 10-pt type is set with 12 pts of line spacing. Designers play with line spacing in order to create distinctive layouts. Reducing the standard distance creates a denser typographic color—while risking collisions between ascenders and descenders.

6/6 SCALA PRO
（6 pt字體搭配6 pts 行距，或稱為「密排」﹝set solid﹞）

6/7.2 SCALA PRO
（6 pt字體搭配7.2 pts行距）

6/8 SCALA PRO
（6 pt字體搭配8 pts行距）

6/12 SCALA PRO
（6 pt字體搭配12 pts行距）

Ancient maps of the world

An

when the world was flat

Avid

inform us, concerning the void

Dream

where America was waiting

Of

to be discovered,

Trans-

Here Be Dragons. James Baldwin

for-

O to be a dragon. Marianne Moore

mation Adrienne Kennedy, People Who Led to My Plays

MARGO JEFFERSON

舞墨：對於轉化的狂熱夢想
（DANCE INK：AN AVID DREAM
OF TRANSFORMATION），雜誌
內頁，一九九二年。設計：阿勃特‧
米勒。出版者：佩琪‧塔爾（Patsy
Tarr）。極大化的行距讓兩股文本
交織在一起。

設計師會嘗試極端的行距，以創造出獨特的字體編排設計結構。開闊的行距讓設計師可以任意把玩行與行之間的空間，而緊密的行距則會產生有趣──但有時令人不太自在──的碰撞。

interminável do embarque, decido respirar um pouco e procurar o sr. Creso com mais calma, outra hora.

**PISO OCIDENTAL – EMBARQUE**

A área de embarque é chamada de "aquário": um longo corredor com paredes e portas de vidro que separam o pré-embarque das plataformas. O ônibus estaciona nas baias, lá fora, e um funcionário abre as tais portas de vidro, chamando os passageiros. Só então eles passam à região do embarque. Protegem-se, assim, os demais usuários da fumaça emitida pelos veículos, em parte absorvida por um enorme tubo exaustor pintado de amarelo.

Em pé, na plataforma 1, enxerga-se o corredor inteiro, até o fim. Em primeiro plano, um relógio de ponteiros e uma larga escada em caracol que leva ao piso superior. No vão embaixo da escada, algumas lanchonetes e lojas de miudezas encaixam-se com perfeição. De ambos os lados, indicados ao longo do corredor, sucedem-se os números das plataformas 1 a 50, pintados de branco dentro de quadrados verdes, sobrepondo-se ligeiramente uns aos outros como em uma agenda telefônica.

Há poucas crianças vagando pela área. Em compensação, são muitos os seguranças, funcionários de limpeza e vendedores de bebidas caminhando com seus carrinhos. A maioria dos passageiros é composta de adultos que esperam em pé, pois não há lugar para sentar (apenas quatro cadeiras de plástico laranja diante de cada plataforma). Consegue-se escutar remotamente o som dos alto-falantes que tocam "Ovelha negra" em versão acústica e diversas músicas instrumentais, para dar a impressão de que o terminal é calmo. "Mas só pra dar a impressão, mesmo", brinca um dos fiscais da Socicam.

Antes da primeira plataforma par, ergue-se uma sala VIP, como a dos aeroportos. É um espaço envidraçado voltado exclusivamente para o bem-estar dos passageiros das empresas Cometa, 1001 e Catarinense, em viagens a Santa Catarina, Paraná, Rio de Janeiro e Minas Gerais. A abertura das portas é automática e o usuário é recebido por duas moças de saia azul, salto alto e lencinho amarelo, que conferem os bilhetes e aconselham os passageiros a se sentir em casa. Nas paredes, pôsteres de capitais: Curitiba, Florianópolis, São Paulo e Belo Horizonte. No teto, a pintura de um céu azul-escuro com estrelas e o cometa Halley, símbolo da Viação Cometa. Há longas fileiras que somam ao todo 160 cadeiras estofadas em dois tons: marrom-terra e azul-marinho, sob o piso limpíssimo e brilhante. Há duas TVs sintonizadas no canal Globo News, duas máquinas de café e chocolate, uma máquina de refrigerante, quatro aparelhos de ar-condicionado e um galão de água gelada ou natural, "vestido" com um pano branco onde

027

《客運站黃皮書》（O LIVRO AMERELO Do TERMINAL），書頁，二〇〇八年。設計者：伊蓮‧拉莫斯（Elaine Ramos）、瑪莉亞‧卡羅萊娜‧森派歐（Maria Carolina Sampaio）。作者：凡妮莎‧芭芭拉（Vanessa Barbara）。出版者：Cosac Naify。在這個例子中，頁面上的內文行距設定得很寬鬆，並且印刷在極薄的紙張上。文字區塊的垂直位置各頁不同，讓文字得以從另一面的兩行文字間透出來。

《夢幻城市：鮑洛‧索雷里的生態建築》（VISONARY CITIES：THE ARCOLOGY OF PAOLO SOLERI），書籍‧一九七〇年。設計者：鮑洛‧索雷里。這本經典的後現代設計作品利用極度緊縮的行距創造出頁面上戲劇化的稠密感。這本書成書於數位排版的年代以前，它所利用的是照相排版與乾式轉印字的技術。

# ALIGNMENT
## 對齊

選擇讓段落文字左右齊行、置中對齊、或靠左靠右對齊是基本的字體編排設計動作。每一種對齊方式都有其獨特的樣式特性、文化聯想、與美學表現上的風險。

置中對齊的文字區塊是對稱的，
就如同古典建築的立面一樣。
置中對齊的樣式經常出現於邀請函、標題頁、證書、與墓碑上。
文字置中的欄位邊緣往往非常參差不齊。
置中對齊的行句需要斷行以突顯關鍵字詞
（例如新娘的名字或婚禮日期），
或讓一個新的想法換行重新開始。
這種斷行被稱為「有意義的斷行」
（breaking for sense）。

左右齊行的文字區塊有平整的左右邊緣。自從活字印刷的發明得以製作出一頁又一頁邊緣筆直的文字欄位以來，左右齊行便一直是排版的標準規範。在金屬活字排版的時代，印刷商必須以手工方式將各行對齊，他們會利用小型金屬隔片調整字與字、或字母與字母之間的間距，好讓所有行句的長度相同。同樣一件事，在數位排版的時代可以透過自動化的方式完成。左右齊行的格式可以有效利用空間，同時也讓頁面的外觀看起來清爽整齊。然而考量字體大小，若行句的長度過短，難看的隙縫便可能會出現。使用連字號可以將過長的文字斷開，並且讓內文的行句保持緊湊排列。設計師通常會利用「緊縮字距」將多餘的文字排進同一行內，或以「加寬字距」的方式讓過於寬鬆的行句看起來較為均衡。

### 置中對齊
長短不一的行句排列在中心軸線上

置中對齊的文本既正式又古典。設計師使用這種格式時會替內文作「有意義的斷行」，並創作出優雅、有機的版面。置中往往是放置版面元素最簡單、最直覺的作法。但若使用不當，置中的文本看起來就會顯得沉重又悲慘，像塊墓碑一樣。

### 左右齊行
左側與右側的邊緣都是平整的

左右齊行的文本讓頁面看起來清爽整齊。對於空間的有效利用讓它成為報紙與書籍的樣式規範。然而由於文本的行句會被強迫平均分散，難看的隙縫可能會隨之出現。考量字體的大小，若行句長度夠長的話，就可以避免這種問題發生。字體愈小，每一行內就可以排進更多的字。

（這個沉悶的樣式斷行處理很隨便，沒有考量段落文字的韻律感。）

（當設計師把行句的長度設定得太短、或作者選用了過長的字，就可能會出現難看的隙縫。）

**囧設計**

THIS DREARY SHAPE HAS RANDOM LINE BREAKS THAT DON'T RESPOND TO THE RHYTHM OF THE WRITTEN TEXT.

樣式拙劣的文字區塊在大部分的使用情況下，置中文字應該被斷開成為長短不一的行句。

**囧設計**

Ugly gaps appear when the designer has made the line length too short, or the author has selected words that are too long.

到處都是洞
這個欄位太窄，以至於裡頭有許多隙縫。

在靠左對齊／右側參差（flush left / ragged right）的
文本當中，左側邊緣是剛硬的、右側邊緣是柔和的。
文字的間距不會變動，所以段落文字的行句裡不會出
現大的孔洞。

這種樣式顧及了語言的流暢性，不屈就於方方正正的
規矩，因而在二十世紀以前主要使用於詩歌的排版上。
儘管有其優點，但靠左對齊的樣式實則充滿了危險。首
先，設計師必須小心翼翼地控制右側參差不齊的邊緣
外形。好的參差樣式看起來令人覺得賞心悅目，沒有過
長或過短的行句，連字號的使用也極有節制。

看起來太平均（或太不平均）的參差，或當它已經開始
形成某種常見的形狀，例如楔形、月形、或跳水板形，
都會被認為是「糟糕」的樣式。

靠右對齊／左側參差（flush right / ragged left）是變化
自大家熟悉的靠左對齊樣式。靠右對齊的文本閱讀不易
是字體編排設計界普遍的常識，
因為它強迫讀者的雙眼在換行時必須重新搜尋行句的起
始位置。

這件事或許是真的，也或許只是人云亦云。話雖如此，靠
右對齊的樣式極少使用於較長的文本當中。

然而靠右對齊的文本若使用於較小的文字區塊，可以讓
註解、花絮、引言、或其它評論主要文章或圖片的文字變
成吸睛的邊欄。對齊或參差的邊緣可以在大量的資訊之
間吸引讀者的注意力（或讓人產生反感）。

## 靠左對齊／右側參差
左側邊緣剛硬、右側邊緣柔和

靠左對齊的文本顧及語言的有機流動，避開了左右行齊
樣式備受困擾的間距不均問題。糟糕的參差樣式可能會
毀了靠左對齊欄位自在的有機外形。設計師必須在避免
使用過多連字號的前提下，非常謹慎地創造出看似隨
性、自然的邊緣。

(糟糕的參差樣式會在邊緣形成奇怪的形狀，看起來一點也不自然。)

---

A bad rag will fall
into weird shapes
along the right
edge, instead
of looking
random.

囧設計
糟糕的參差樣式
難看的楔形毀了參差的邊
緣。

## 靠右對齊／左側參差
右側邊緣剛硬、左側邊緣柔和

讓文本靠右對齊是一種受到歡迎的跳脫常例的作法。將靠
右對齊的樣式使用在圖說文字、邊欄、和其它次要文字上，
可以暗示各個元素彼此之間的連帶關係。由於靠右對齊的
文本較為少見，可能讓謹慎的讀者感到困擾。糟糕的參
差樣式也同樣會對靠右對齊的文本形成威脅，就同它們
折磨靠左對齊的文本一般。標點符號也可能會弱化文本右
側剛硬的邊緣。

(過多的標點符號〔在行句的末端〕會攻擊、威脅、且通常會弱化靠
右對齊的邊緣。)

---

Lots of punctuation
(at the ends of lines)
will attack, threaten,
and generally
weaken the flush
right edge.

囧設計
標點符號吃掉邊緣
過多的標點符號弱化了右側
邊緣。

四種對齊的樣式（置中對齊、左右齊行、靠左對齊、靠右對齊）形成了版面構成的基本原則。對讀者來說，每一種在傳統上各有其直覺的使用方式。

置中對齊

左右齊行

for Coppet. But when the eighty days had passed and the bugaboo was safely on board the *Bellerophon*, she came back to the scenes she loved so well and to what for her was the only heaven: Paris. ¶ She has been called a philosopher and a literary light. But she was only socio-literary. Her written philosophy does not represent the things she felt were true—simply those things she thought it would be nice to say. She cultivated literature, only that she might shine. Love, wealth, health, husband, children—all were sacrificed that she might lead society and win applause. No one ever feared solitude more: she must have those about her who would minister to her vanity and upon whom she could shower her wit. As a type her life is valuable, and in these pages that traverse the entire circle of feminine virtues and foibles she surely must have a place. ¶ In her last illness she was attended daily by those faithful subjects who had all along recognized her sovereignty—in Society she was Queen. She surely now had won her heart's desire, for to that bed from which she was no more to rise, courtiers came and kneeling kissed her hand, and women by the score whom she had befriended paid her the tribute of their tears ❧ She died in Paris at the age of fifty-one.
217

《維吉爾作品集》（THE WORKS OF VIRGL），為賈科伯·湯森（Jacob Tonson）印製，一六九八年。傳統上，標題頁會設定為置中對齊的格式。這個雙色的標題頁是以兩道印刷程序印製的（請注意兩色文字沒有完全對齊）。大型字體主要是設計用於標題頁或讚美詩歌集的印刷上。

《阿爾伯特·哈伯德作品全集》（THE COMPLETE WRITINGS OF ELBERT HUBBARD），第二冊，Roycroft Shop印製，一九〇八年。這個新文藝復興風格的書頁仿效印刷興起初期百年的樣式。整個文字區塊不但完美地左右齊行，其中並且在段落結尾與斷行處使用了段落符號，以保持頁面的完整性。

靠左對齊

靠右對齊

## L'ENNEMI

Ma jeunesse ne fut qu'un ténébreux orage,
Traversé çà et là par de brillants soleils;
Le tonnerre et la pluie ont fait un tel ravage,
Qu'il reste en mon jardin bien peu de fruits vermeils.

Voilà que j'ai touché l'automne des idées,
Et qu'il faut employer la pelle et les râteaux
Pour rassembler à neuf les terres inondées,
Où l'eau creuse des trous grands comme des tombeaux.

Et qui sait si les fleurs nouvelles que je rêve
Trouveront dans ce sol lavé comme une grève
Le mystique aliment qui ferait leur vigueur?

— O douleur! ô douleur! Le Temps mange la vie,
Et l'obscur Ennemi qui nous ronge le cœur
Du sang que nous perdons croît et se fortifie!

17

132             Technique

things that could not have been done at all had he stuck to his original idea.

*No shields*      Trade-markery is a country cousin of heraldry; it can claim that kin, but native good taste will keep it from trying to ape its noble relative. I mean that trade-marks in the form of shields are a joke—as comical as those mid-Victorian trade devices surrounded by the Garter. Things like that, in first instances (they are now meaningless survivals), were efforts on the part of Trade to sit in the same pew with Race. Under the modern dispensation, with kings at a discount, the feudal touch may be dispensed with. One makes this comment about shields as trade-marks because a cosmic law operates to convince every expectant proprietor of a new trade-mark that he wants his device in the shape of a shield.

*Flexible*      A good trade-mark is the thing that lives inside a boundary line—not the boundary line itself. It should be possible for the device to step outside its circle, or triangle, or what not, and still be the same—an unmistakable emblem. In other words, marks that depend for their individuality upon triangular frames, circles, squares, etc., are weak brethren; they are of a low order of trade-mark vitality.

*Typographic* *flavor*      For the greater number of advertising uses a trade-mark design needs to be given a typographic flavor. It will stand in close relation to type in the usual advertisement and its stance will be more comfortable if it is brought into sympathy with type. This means that the proprietor will have to relax the rigor of his rule and allow his design (originally rendered in soft lithographic grays and stipples) to be redrawn in positive line, with considerable paper showing. It is not necessary to ape the style of a woodcut in this effort after typographic flavor; but it is necessary to echo, to a certain extent, the crisp black lines and

《夏爾·波特萊爾／惡之華》（CHARLES BAUDELAIRE / LES FLEURS DU MAL），比爾·藍星（Bill Lansing）印製，一九四五年。傳統上詩歌的格式會被設定為靠左對齊，因為在這種文學體裁裡斷行是不可或缺的元素。詩歌通常不會設定為置中對齊，除非是寫在卡片上。

《廣告版面》（LAYOUT IN ADVERTISING），由W. A. 德威金斯（W. A. Dwiggins）設計、撰寫，一九二八年。在這本經典的廣告設計實務指南當中，德威金斯將小標或關於主題的提示放置在邊欄。在這張左手頁（偶數頁）的頁面上，這些提示文字被設定為靠右對齊，以靠近它們所對應的內容。

有時候設計師會在使用對齊的原型樣式時特別強調它們的視覺特性。將不同的對齊樣式結合使用可以創造出具有動感與出人意表的版面。

"Grandma! Grandma! Look at me! I did it!"
Oval yelled from the water, her youth taut
as a syllogism.

"I saw you darling!" Mother waved. Then she sat
back and smiled, nature on her side after all.

"Well sure," Square began—
He heard the suck of Circle's chest cavity, speech
lobes echoing the startle of her brain's emotive
region to vibrate vocal chords so that the up-rush
of breath through her body would come out as,

"What?!"

She pushed her sunglasses up onto her head
to reveal that her eyes had widened to the size
of an animal's before it pounces. And in response,
an electro-chemical jolt contracted his muscles
to quickly voice "But it's more complicated than
that" (accelerando) as he tried to recover.

Tried and failed, he saw, realizing that Mother
would take his words as confirmation of Circle's
phobia of conceiving. Circle's eyes remained
trained on him."Sometimes more kids just
aren't in the cards," he tried.

"What he means," Circle said, emotion beginning to
raise veins, "is that we've decided to limit our family."

"Limit your?—"

"It's not like when you and dad were raising
a family. Kids cost a lot. The public schools are
worthless so you can't even think about sending
them there. And anyway, who's going to watch a
baby while I'm at work? Square doesn't have time.
He can't even figure out the ending to his dumb…"
Dumb?

"…story, watching Oval after school like he does
and I don't have time to be around them.
Not like you were with us."
a common story

"Well, things have certainly changed," Mother
sighed in that exhausted victim tone she adopted
whenever she was about to play her "tired blood"
card. "In my day, children just came or they
didn't. We were just the organ they did it through."
of a common man

"Geez, that's what you want me to go back to?"
Circle laughed, her smile an incipient "fear
grin" primates often exhibited just before
tension broke into fight or flight. "A crap
shoot?" This last was meant for him. He decided
to let pass the crack about his "dumb" story.
Homo being common to all men

"I only meant—"
and women (obviously)

"Mother, I can't not know what I know!" Her
exasperated tone left a pregnant silence at the table.
"Excuse me," she said, "I need a refill on my ice."
She stood up and there was the shock of her body:
a flat athletic torso, muscular shoulders and arms
in a cheetah-print swimsuit (a legacy of African,
i.e. savage sexuality) that made him want her.
"Anybody else want anything?"

45

靠左對齊與靠右對齊:《VAS:平原上的歌劇》(vas: an opera in flatland),書頁,二〇〇二年。設計者:史蒂芬·法瑞爾(Stephen Farrell),作者:史提夫·托馬蘇拉(Steve Tomasula)。在這本排版獨具特色的小說當中,文本與圖片分別沿著幾條細長的標準線靠左與靠右對齊。懸掛標點符號與粗體字母突顯了筆直對齊的邊緣。

靠左對齊與靠右對齊:《異規》（INFORMAL），書籍，二〇〇二年。設計者《傑努濟・史密斯（Januzzi Smith），作者：塞西爾・巴爾蒙德（Cecil Balmond），攝影：丹・梅爾斯。這本書是以突破傳統的手法進行結構工程與建築的一項宣言。這裡的內文欄位讓靠右齊行與靠左齊行的格式並列，在內文裡創造出一道細微但持續連接的縫隙，並且讓外側邊緣參差不齊。

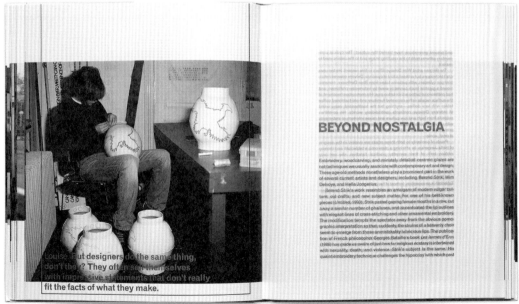

左右齊行:《赫拉・容格里絲》（HELLA JONGERIUS），書籍，二〇〇三年。設計者：COMA，攝影：丹・梅爾斯。透明的紙張突顯了文字區塊左右齊行的特色。書中的圖片都是從同一個水平位置向下垂放，讀者可以從書本邊緣看見這些圖片所創造出來的一條貫穿線。

請利用對齊的樣式（靠左對齊、靠右對齊、左右齊行、
置中對齊）生動地詮釋一段文本。這段文本取自瓦
爾特‧翁的著作《口語與書寫思維：文字的技術化》
（The Technologizing of the Word），其中說明了相較
於手寫時代較為有機的頁面，活字印刷的發明如何把
新的空間秩序強加於書寫文字上。這些作品對於潛藏
於所有字體編排設計作品之下的衝突──包括剛硬
與柔和、工業與自然、計畫與隨機──都作出了回應。

PRINT SITUATES WORDS IN SPACE
MORE RELENTLESSLY THAN WRITING
EVER DID. writing moves words from the sound world
BUT PRINT LOCKS WORDS INTO to a world of visual space,
POSITION IN THIS SPACE. CONTROL
OF POSITION IS EVERYTHING IN
PRINT. PRINTED TEXTS LOOK
MACHINE-MADE, AS THEY ARE.
in handwriting, control of space tends to be ornamental,
TYPOGRAPHIC CONTROL TYPICALLY
IMPRESSES MOST BY ITS TIDINESS ornate, as in calligraphy.
AND INVISIBILITY: THE LINES
PERFECTLY REGULAR, ALL JUSTIFIED
ON THE RIGHT SIDE, EVERYTHING
COMING OUT EVEN VISUALLY, AND
WITHOUT THE AID OF GUIDELINES OR
RULED BORDERS THAT OFTEN
OCCUR IN MANUSCRIPTS. THIS IS AN
INSISTENT WORLD OF COLD, NON-
HUMAN, FACTS.

**馬里蘭藝術學院學生作品範例**

（印刷將文字放置在空間中的方式遠比寫作來得冷酷無情。寫作將文字從聲音的世界搬移
到視覺空間當中，但印刷將文字鎖定在空間裡的特定位置上。印刷裡最重要的就是對於位
置的控制。印刷文字看起來像是機器製造的，而它們的確是。在手寫文稿裡，空間的控制
往往是具有裝飾性的、華麗的，就像書法一樣。字體編排控制最讓人印象深刻的通常就是
它的整齊劃一與控制於無形之間：每一行絕對端端正正，右側完全對齊，所有一切看起來
都很均衡，也不需要手抄本中經常出現的引導線或邊線加以協助。這是一個堅定的世界，
冷酷、無人性、只有事實。）

字距不一的文字打破了嚴整對齊的欄位。
張璐（Lu Zhang）

PRINT

situates words in space more relentlessly

than writing ever did.  Control of position

is everything in print. Printed texts look

machine-made, as they are. Typographic

control typically impresses most by its

WRITING   tidiness and invisibility: the lines perfectly

moves words from the sound world   regular, all justified on the right side,

to a world of visual space,   everything coming out even visually, and

but print locks words   without the aid of guidelines or ruled

into position in this space.   borders that often occur in manuscripts.

In handwriting, control of space   This is an insistent world of cold,

tends to be ornamental, ornate,   non-human, facts,

as in calligraphy.

靠左對齊與靠右對齊的文本以中軸形成鉸鏈狀。
約翰‧庫多斯（Johnschen Kudos）

Print situates words
in space more
relentlessly than
writing ever did.
*Writing moves words from the sound world to a world of visual space,*
but print locks
words into position
in this space.
Control of position
is everything in
print. Printed texts
look machine-made,
as they are.
*In handwriting, control of space tends to be ornamental, ornate.*
Typographic control
typically impresses
most by its tidiness
and invisibility: the
lines perfectly regular,
all justified on the
right side, everything   This is an insistent
coming out even   world of cold,
visually, and without   non-human, facts.
the aid of guidelines
or ruled borders that
often occur in
manuscripts.

窄而參差的欄位間以置中對齊的長句作為橋樑。
班傑明‧魯茲（Benjamin Lutz）

relentlessly than writing ever did. Writing moves words from the sound world to a world of visual space, but print locks words into position in this space. Control of position is everything in print. Printed texts look machine-made, as they are. In handwriting, control of space tends to be ornamental, ornate, as in calligraphy. Typographic control typically impresses most by its tidiness and invisibility: the lines perfectly regular, all justified on the right side, everything coming out even visually, and without the aid of guidelines or ruled borders that often occur in manuscripts. This is an insistent world of cold, non-human, facts.

Print situates words in space more

Print situates words in space more relentlessly than writing ever did. Writing moves words from the sound world to a world of visual space, but print locks words into position in this space.

Control of position is everything in print.

Printed texts look machine-made, as they are. In handwriting, control of space tends to be ornamental, ornate, as in calligraphy. Typographic control typically impresses most by its tidiness and invisibility: the lines perfectly regular, all justified on the right side, everything coming out even visually, and without the aid of guidelines or ruled borders that often occur in manuscripts. THIS IS AN INSISTENT WORLD OF COLD, NON-HUMAN, FACTS.

段落的開頭被移到了最後。
丹尼爾・阿爾貝羅（Daniel Arbello）

單行滑出了整齊的區塊之外。
卡琵拉・翠絲（Kapila Chase）

Print situates words in space more relentlessly than writing ever did.

*Writing moves words from the sound world to a world of*

V I S U A L   S P A C E

but print locks words into position in this space. Control of position is everything in print. Printed texts look machine-made, as they are.

*In handwriting, control of space tends to be ornamental, ornate, as in calligraphy.*

Typographic control typically impresses most by its tidiness and invisibility: the lines perfectly regular, all justified on the right side, everything coming out even visually, and without the aid of guidelines or ruled borders that often occur in manuscripts.

This is an insistent world of cold, non-human, facts.

Print situates words in space more relentlessly than writing ever did. Writing moves words from the

sound world to a world of visual space, but print locks words into position in this space.

Control of position is everything in print. Printed texts look

machine-made, as they are. In handwriting, control of space tends to be

ornamental, ornate, as in calligraphy. Typographic control typically impresses most

by its tidiness and invisibility: the lines perfectly regular, all justified on the right side,

everything coming out even visually, and without the aid of guidelines or ruled borders that often occur

in manuscripts. This is an insistent world of cold, non-human, facts.

元素從對齊的欄位中逃離。
艾弗拉特・雷瓦許（Efrat Levush）

文本被排列為邊緣參差的正方形網格。
金・班德（Kim Bender）

## VERTICAL TEXT
## 垂直文本

羅馬字的設計是要讓每個字相鄰並排，而不是上下交疊。小寫字母相疊看起來尤其奇怪，因為它們的上伸部與下伸部讓垂直的字距變得不平均，而字母不同的字寬也讓堆疊起來的組合看似搖搖欲墜。（字母「I」一直是個問題。）大寫字母堆疊起來比小寫字母穩固。將欄位設定為置中對齊可以讓字寬的差異看起來比較均衡。許多亞洲的書寫系統，包括中文，原本就是以直式書寫；它們的方塊文字有利於直式書寫。以垂直樣式表現拉丁文字最簡單的方式，就是將水平方向的文字轉為垂直方向。這樣便可以在創造出垂直軸線的同時，仍然保持字母之間原本的相互關係。

書背。堆疊的字母有時候會出現在書背上，但垂直底線的排版方式較為普遍。在美國，以由上往下閱讀為主流。

**囧設計**
堆疊的小寫字母

堆疊的小型大寫字

由上而下　　　由下而上　　　雙向

垂直底線。關於文字方向應該由上往下還是由下往上並無硬性規定，但普遍來說，尤其在美國，書背上的文字通常為由上而下。（你也可以同時以往上往下兩種方式排列文字。）

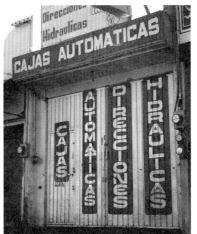

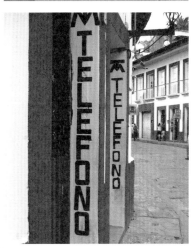

墨西哥街頭的招牌文字
照片由安卓雅·馬爾克斯（Andrea Marks）拍攝。堆疊字母經常會出現在街頭利用狹窄的垂直空間所作的商業廣告中。這些招牌上的字母皆為手繪。寬形的字母與方形化的「O」比保留原本圓形樣式的窄形字母更適合堆疊在一起。在某些情況下，字母們會以特殊的方式對齊並藉此製造出垂直的關係，就像右方這個畫在門框內一處狹窄平面上的「Optica」招牌。

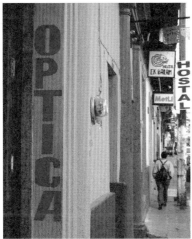

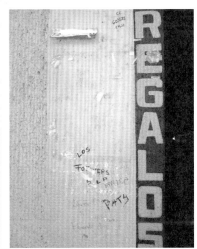

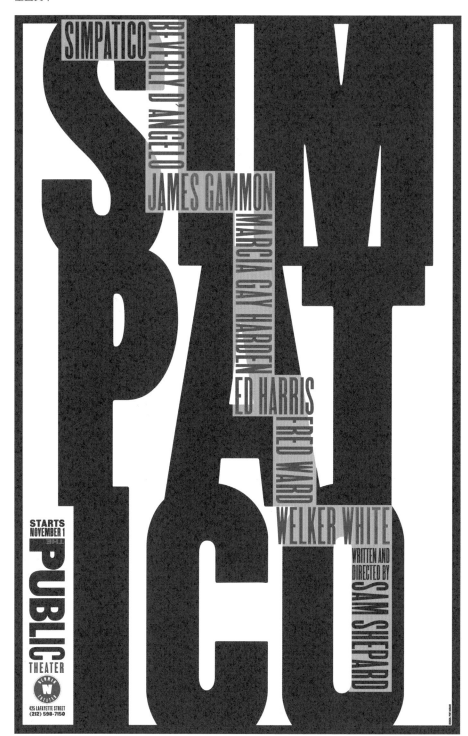

SIMPATICO

BEVERLY D'ANGELO

JAMES GAMMON

MARCIA GAY HARDEN

ED HARRIS

FRED WARD

WELKER WHITE

STARTS
NOVEMBER 1
THE
PUBLIC
THEATER
N
425 LAFAYETTE STREET
(212) 598-7150

WRITTEN AND
DIRECTED BY
SAM SHEPARD

《暗夜驚狂》（SIMPATICO），為公共劇院（the Public Theater）所設計的海報，一九九四年。設計者：寶拉‧雪兒／五角星。垂直底線上的文字製造出貫穿海報的動態感。公共劇場的標誌也採用了垂直底線，讓它可以毫無困難地被擺放在街頭旗幟上。

《跨越平行線》（PARALLELEN IM SCHNITTPUNKT），海報，一九九七年。出版者：Art-Club Karlsruhe。文字與地景的軸線相交，創造出簡潔、有力、直白的海報。鏡像文字分別為德文與法文。

# ENLARGED CAPITALS
## 放大大寫字

在一段文本的起頭，讀者們需要有個進入文本的邀請。放大大寫字（enlarged capitals，或稱為versals）普遍被用於標示書本章節或雜誌文章的入口。許多中世紀的手稿都因為精雕細琢的裝飾字而熠熠生輝。這項傳統直到印刷術興起仍然持續不墜。剛開始，起首字母是以手繪方式畫在印刷好的頁面上，這為大量生產的書籍增添了手寫本的色彩，而手寫本可要比印刷品來得珍貴許多。起首字母很快就成為字體編排設計的一部分。印刷師可以將它們和主要內文一起擺在木刻印刷板內或另外鑄造鉛字，或者以其它的流程——例如雕版——將它們加進來。在今天，放大大寫字通常會被視為屬於出版物字體編排設計系統的一部分。

《關於紀念地的觀察》（A VIEW OF THE MONUMENTS）書頁，十八世紀。這一頁以兩道程序製作完成：活版印刷與插圖版畫。

《紐約時報》（NEW YORK TIMES）書評，報紙頁面，二〇〇九年。藝術總監：尼可拉斯・布萊克曼（Nicholas Blechman），插圖繪製：艾琳・路佩登。在這個版面中，下沉大寫字是一張獨立的插圖。

**I**N THIS PARAGRAPH 在這個段落裡，放大大寫字與緊跟在後的文本設定在同一條底線上。這種簡單的作法在印刷品與螢幕上都很容易應用。將內文的前幾個字設定為小型大寫字可以讓起首字母與內文之間過渡得更順利。

**A**N ENLARGED LETTER 切入文字區塊的放大大寫字被稱為「首字放大下沉」（dropped capital，dropped cap）。這裡的範例是以 InDesign 裡的「首字放大」（Drop Caps）功能製作出來的。這套軟體會在一個或多個文字周圍製造出一個空間，並且讓這個空間依需求的行數下沉。設計師可以調整這個大寫字的大小與字距，好讓它與周圍的文本搭配。在網頁上，可以利用CSS做出首字放大下沉。圍繞在大寫字周圍的長方形空間看起來可能會有點彆扭，就如同在這裡看到的，字母「A」會產生有斜度的輪廓。

**W**AS IT THE BEST OF TIMES[2] 這是最好的時代、最壞的時代，抑或是新羅馬體的時代（Times New Roman）？這裡的首字放大下沉（有襯線粗體）被視為一個單獨的物件擺放。這個大寫字背後有一個看不見的文字方塊被設定為「文繞圖」（text wrap），好讓文字可以順著「W」右側外伸的筆畫排列。同樣地，「W」左側的筆畫向外伸出邊界外，讓這個字母看似穩穩地固定在這個文字區塊上。這種手動調整的作法沒有辦法被系統化應用。

**GRAB YOUR READER BY THE CAHUNAS AND NEVER EVER LET GO** 死命抓住你的讀者，絕對不要放手。設計師們有時候會為了其它目的而改編首字放大下沉的作法。這裡的字母可能會被一張插圖或頭像所取代，也或許會單純做一些排版上的變化，例如從原來的文字區塊裡切出一個空間，並且插入標題或副標題。這些手段可以讓大家原本習以為常的頁面結構流動起來，以產生更多元、或有時候令人意想不到的用途。

2 原文「the best of times」與「the worst of times」語出狄更斯（Charles Dickens）名著《雙城記》（A Tale of Two Cities）開卷語：「那是最美好的時代，也是最糟糕的時代。」（It was the best of times. It was the worst of times.）

# MARKING PARAGRAPHS
## 標示段落

段落不是本來就存在的。句子是口說語言裡自然生成的文法單位，而段落卻是為了將大量內容分切成可口的份量所設計出來的文學慣例。

縮排（indent）自十七世紀起便被廣泛使用。在段落之間增加間距（段落間距）則是另一種標準作法。在網頁裡，一個段落是一個「語意單位（semantic unit）」（在html當中以 <p> 作為段落標籤），顯示在螢幕上時通常後方會插入一個空白字元。

典型的縮排指的是內縮一個em空格（em space）、或加空鉛（quad），這個em空格大約等於所使用字體的大寫字母寬度。也因此內縮寬度會與字型的大小成比例；假使你改變了字型的字級大小或欄寬，縮排的寬度也會隨之做適當的調整。另外一種作法是，你可以利用跳格鍵（tab key）做出任何深度的縮排。設計師可能會利用這種作法，好讓縮排可以與一道垂直的網格線或其它頁面元素對齊。請不要將完整內文的第一行縮排。縮排是為了示意需要暫停或作出間隔；當一段文本才剛起頭的時候不需要喊暫停。

儘管縮排與段落間距的作法隨處可見，但設計師們還是發展出各種不同的替代方案，好讓他們以獨特的方式呈現內容。

**書呆子警報：** 利用排版軟體裡的「段落後間距」（Space After Paragraph）功能，就可以在段落之間插入所需寬度的間距。跳行的作法往往會讓間距過寬，徒然浪費空間。請養成習慣只在最後的段落末端執行「換段」（輸入鍵，Enter鍵）；若你不想增加多餘的間距，請執行「換行」（Shift + Enter）。

桌子上覆蓋著桌巾，而桌巾本身又被一塊塑膠桌布保護著。一層又一層的窗簾掛在窗戶上。我們有地毯、沙發套、杯墊、護牆板、燈罩。每個小玩意兒都擺放在一塊飾布上，每朵花都種在自己的花盆裡，而每個花盆也都有自己的一個淺碟。

所有一切都被保護著、包圍著。即便是在花園裡，植物叢被鐵絲網所環繞，小徑的輪廓也被磚塊、馬賽克、或石板刻劃著。

這或許可以被分析為是一種焦慮性的隔離行為，一種執念的象徵：這是屋主和小資產階級們不但擁有，而且要一而再、再而三強調他們擁有什麼的執念。在這裡—— 在其它地方也是 —— 這些反覆出現的象徵，它們的涵義與浮濫使用的狀況，早已不言而喻。

——尚‧布希亞（*Jean Baudrillard*），一九六九年。

縮排與換行

桌子上覆蓋著桌巾，而桌巾本身又被一塊塑膠桌布保護著。一層又一層的窗簾掛在窗戶上。我們有地毯、沙發套、杯墊、護牆板、燈罩。每個小玩意兒都擺放在一塊飾布上，每朵花都種在自己的花盆裡，而每個花盆也都有自己的一個淺碟。

所有一切都被保護著、包圍著。即便是在花園裡，植物叢被鐵絲網所環繞，小徑的輪廓也被磚塊、馬賽克、或石板刻劃著。

這或許可以被分析為是一種焦慮性的隔離行為，一種執念的象徵：這是屋主和小資產階級們不但擁有，而且要一而再、再而三強調他們擁有什麼的執念。在這裡—— 在其它地方也是 —— 這些反覆出現的象徵，它們的涵義與浮濫使用的狀況，早已不言而喻。）

——尚‧布希亞（*Jean Baudrillard*），一九六九年。

換行與二分之一行距（段落間距）

桌子上覆蓋著桌巾，而桌巾本身又被一塊塑膠桌布保護著。一層又一層的窗簾掛在窗戶上。我們有地毯、沙發套、杯墊、護牆板、燈罩。每個小玩意兒都擺放在一塊飾布上，每朵花都種在自己的花盆裡，而每個花盆也都有自己的一個淺碟。

所有一切都被保護著、包圍著。即便是在花園裡，植物叢被鐵絲網所環繞，小徑的輪廓也被磚塊、馬賽克、或石板刻劃著。

這或許可以被分析為是一種焦慮性的隔離行為，一種執念的象徵：這是屋主和小資產階級們不但擁有，而且要一而再、再而三強調他們擁有什麼的執念。在這裡——在其它地方也是——這些反覆出現的象徵、它們的涵義與浮濫使用的狀況，早已不言而喻。）

——尚·布希亞（*Jean Baudrillard*），一九六九年。

桌子上覆蓋著桌巾，而桌巾本身又被一塊塑膠桌布保護著。一層又一層的窗簾掛在窗戶上。我們有地毯、沙發套、杯墊、護牆板、燈罩。每個小玩意兒都擺放在一塊飾布上，每朵花都種在自己的花盆裡，而每個花盆也都有自己的一個淺碟。所有一切都被保護著、包圍著。即便是在花園裡，植物叢被鐵絲網所環繞，小徑的輪廓也被磚塊、馬賽克、或石板刻劃著。這或許可以被分析為是一種焦慮性的隔離行為，一種執念的象徵：這是屋主和小資產階級們不但擁有，而且要一而再、再而三強調他們擁有什麼的執念。在這裡——在其它地方也是——這些反覆出現的象徵、它們的涵義與浮濫使用的狀況，早已不言而喻。）

——尚·布希亞（*Jean Baudrillard*），一九六九年。

凸排（OUTDENT，HANGING INDENTATION）與換行

行間加寬字距，不換行

■桌子上覆蓋著桌巾，而桌巾本身又被一塊塑膠桌布保護著。一層又一層的窗簾掛在窗戶上。我們有地毯、沙發套、杯墊、護牆板、燈罩。每個小玩意兒都擺放在一塊飾布上，每朵花都種在自己的花盆裡，而每個花盆也都有自己的一個淺碟。■所有一切都被保護著、包圍著。即便是在花園裡，植物叢被鐵絲網所環繞，小徑的輪廓也被磚塊、馬賽克、或石板刻劃著。■這或許可以被分析為是一種焦慮性的隔離行為，一種執念的象徵：這是屋主和小資產階級們不但擁有，而且要一而再、再而三強調他們擁有什麼的執念。在這裡——在其它地方也是——這些反覆出現的象徵、它們的涵義與浮濫使用的狀況，早已不言而喻。）

——尚·布希亞（*Jean Baudrillard*），一九六九年。

桌子上覆蓋著桌巾，而桌巾本身又被一塊塑膠桌布保護著。一層又一層的窗簾掛在窗戶上。我們有地毯、沙發套、杯墊、護牆板、燈罩。每個小玩意兒都擺放在一塊飾布上，每朵花都種在自己的花盆裡，而每個花盆也都有自己的一個淺碟。

所有一切都被保護著、包圍著。即便是在花園裡，植物叢被鐵絲網所環繞，小徑的輪廓也被磚塊、馬賽克、或石板刻劃著。

這或許可以被分析為是一種焦慮性的隔離行為，一種執念的象徵：這是屋主和小資產階級們不但擁有，而且要一而再、再而三強調他們擁有什麼的執念。在這裡——在其它地方也是——這些反覆出現的象徵、它們的涵義與浮濫使用的狀況，早已不言而喻。）

——尚·布希亞（*Jean Baudrillard*），一九六九年。

使用符號，沒有縮排或換行

田設計：排版上作了太多提示。同時使用段落間距與縮排不但浪費空間，也讓文字區塊的形狀看起來軟弱而含糊。

*Dominus Salomoni secundo apparens, iubet sua seruare praecepta, addita comminatiore nisi seruata fuerint: Salomon plures aedificat ciuitates, gentes sibi facit tributarias, & classe in Ophir missa plurimum auri recipit.*

## CAP. IX.

ACTVM est autem cùm perfecisset Salomon ædificium domus Domini , & ædificium regis , & omne quod optauerat & volueratfacere, ² apparuit ei Dominus secundò ‖ sicut apparuerat ei in Gabaon. ³ Dixítque Dominus ad eum, Exaudiui orationem tuam & deprecationem tuam, quam deprecatus es coram me:sanctificaui domũ hanc quam ædificasti , vt ponerem nomen meum ibi in sempiternum , & erunt oculi mei & cor meum ibi cunctis diebus. ⁴ Tu quoque si ambulaueris coram me, sicut ambulauit * pater tuus , in simplicitate cordis & in æquitate:& feceris omnia quæ præcepi tibi , & legitima mea & iudicia mea seruaueris, ‖ ponam thronum regni tui super Israel in sempiternum, ‖sicut locutus sum Dauid patri tuo, dicens , Non auferetur vir de genere tuo de solio Israel. ⁶ Si autem auersione auersi fueritis vos & filij vestri, non sequentes me , nec custodientes mandata mea , & ceremonias meas quas proposui vobis, sed abieritis & colueritis deos alienos , & adoraueritis eos: ⁷ auferam Israel de superficie terræ quam dedi eis, & templum quod sanctificaui nomini meo proiiciam à cõspectu meo, eritque Israel in prouerbium , & in fabulam cunctis populis. ⁸ Et domus hæc erit in exemplum : omnis qui transierit per eam, stupebit & sibilabit, & dicet, ‖Quare fecit Dominus sic terræ huic & domui huic? ⁹ Et respondebunt, Quia dereliquerunt Dominum Deum suum, qui eduxit patres eorum de terra-Ægypti , & secuti sunt deos alienos , & adorauerunt eos,& coluerunt eos: idcirco induxit Dominus super eos omne malum hoc. ¹⁰ ‖ Expletis autem annis viginti postquàm ædificauerat Salomon duas domos , id est , domum Domini & domum regis. ¹¹ (Hiram rege Tyri præbente Salomoni ligna cedrina & abiegna , & aurum iuxta omne quod opus habuerat:)tunc dedit * Salomon Hiram viginti oppida in terra-Galilææ. ¹² Et egressus est Hiram de Tyro, vt videret oppida quæ dederat ei Salomon, & non placuerunt ei , ¹³ & ait , Hæcine sunt ciuitates quas dedisti mihi , frater ? Et appellauit eas Terram-chabul , vsque in diem hanc. ¹⁴ Misit quoque Hiram

A

*2.Par.7. c. 11.*
*Sup.3.4.5.*

*Dauid 2.*

*2.Re.7.b.12 c.16.*
*1.Pa.22. b. 10.*

B

*De.29.d. 24.*
*Iere.22.b.5.*

*2.Par.8.a.1*

*rex L.*

C

《聖經》，頁面細部，大約為西元一五〇〇年。在這個漂亮的版面配置上、緊密、無間斷的內文欄位與週遭騷動的細節──包括首字放大下沉、邊界上的註解、和三角形的章節摘要──形成對比。

---

不同的內容自然會產生不同的段落標記方式。在早期的印刷書籍中，段落是以符號，例如「‖」，來作為標示，而不另外增加間距或換行。到了十七世紀，將段落的第一行縮排並且在段落最末端換行成了制式標準。商用印刷品傾向於在完整的版面上採用破碎的區塊，這樣可以讓讀者一點、一點地瀏覽文本。現代的文學樣式，例如訪談錄，則鼓勵設計師建構出創新的字體編排設計系統。

ALL BUILT-IN FIXTURES are furnished with nickel hardware and 1½-inch casing, to be used as a casing or as a ground for the finished casing.

Stock carried in pine (unfinished).

All ironing boards carried in stock are 12 inches wide—any width made to order.

"PEERLESS" equipment is very simple to install, will require no special arrangements of your plans and will make your house or apartment a real home, a good investment and add a distinction you could not acquire otherwise.

Hoosier Cabinets furnished in oak or flat white finish. Also with aluminum or porceliron table slides.

廣告傳單，一九一一年。這個複雜的設計以過多的提示懇求讀者閱讀：縮排、換行、段落間距、與裝飾圖案。

dominate its board?

I'd be interested to know what Maxwell Anderson and David Ross think about the possibility of changing the membership of museum boards so that they more fully represent the communities they claim to serve. Can we imagine a Whitney Museum board that is not a rich man's club?

**Irving Sandler**

There are diverse museum audiences. A significant constituency consists of artists. They need what they see to make art. In talking to artists, at least of my generation, everyone has told me of the importance of the Museum of Modern Art's permanent collection in the development of their art. I would hope that museums could serve all of their diverse audiences, but the health of art and its future depends on how they meet the needs of artists.

**Maurice Berger**

Dan, you wrote: "Because of this feeling of being excluded, I believe that one of the most important commitments any museum professional can make is to try to reach out and connect to the public through continuous lectures, gallery tours, workshops, and the difficult but necessary writing of readable wall and brochure texts."

This is a very important point, yet I suspect that you may be the exception rather than the rule. All too often, I have found (as a consultant to a number of museums) resistance on the part of many curators to examining and improving their pedagogical skills. Indeed, education departments are often marginal to or left out of the curatorial process. On Thursday, I will open a two-day session on museum education, public address, and pedagogy.

Irving, you wrote: "A significant constituency consists of artists. They need what they see to make art. . . . I would hope that museums could serve all of their diverse audiences, but the health of art and its future depends on how they meet the needs of artists."

A very important observation—the museum as a space of education, inspiration, and motivation for other artists.

**Maxwell L. Anderson**

Alan asked about the possibility of opening up major museum boards. It took quite some time to persuade the Whitney Museum board that it would be logical to have a seat for an artist. I was lucky enough to have three artists on the board of Toronto's Art Gallery of Ontario, a much larger museum spanning from the Renaissance to the present with a budget comparable to the Whitney's.

125

The concern expressed by the Whitney's board was that having an artist could create conflicts of interest. I noted that it might well be a conflict of interest to have trustees who actively collected in the general areas that the museum does, but that I trust members to recuse themselves when discussions warrant it.

Eventually, I was given the green light by the Nominating Committee to invite Chuck Close, who graciously accepted over a bottle of Glenlivet in his studio, and proved to be a superb trustee. Chuck has helped keep the conversation alive and focused on the museum's mission. His term was up this June.

My nominee to succeed him would have provided a return engagement to mine a museum, in this case the Whitney, but that was not to be. Chuck's term has been extended, and he will be terrific as long as he cares to stay on. My preference was to alternate, at the end of each three-year term, between a more senior artist and a midcareer artist.

As far as other positions on boards, the prevailing desire of most nominating committees is to have trustees with the means necessary to fuel a campaign and support the annual fiscal burden of the operating budget. One can understand the impulse. On the other hand, across the nation there is still an unfilled need for greater ethnic diversity and better representation of various segments of an artistic spectrum—in the Whitney's case, for example, for more collectors of contemporary art.

For the makeup of a board to change, there has to be an overarching will to do it. That is not the impulse around the United States today. When times are tight, whatever will there might be is put to the side in a quest to find people with proven capacity to give.

**Mary Kelly**

Over the years, I have noticed how the same work, shown in different contexts, draws vastly different audiences, in terms of numbers and responses, and perhaps this is why I placed emphasis on the issue of reception in my earlier remarks. Of course, in making a work, there is a subjective investment that presupposes an audience, or put another way, the desire of the other. I think artists are always speaking, consciously or unconsciously, to very specific people—friends, lovers, patrons, collectors, and sometimes to certain communities—professional, political, social, generational, or geographic, but this is never the same audience constructed by the exhibition. Considered as a "statement," you could say an exhibition is formulated by a curator/author who is given the

---

《明日的博物館：一段虛擬的對話》（MUSEUMS OF TOMORROW: A VIRTUAL DISCUSSION），書頁，二〇〇四年。法蘭克・納努－庫瓦庫（Franc Nunoo-Quarcoo）與凱倫・霍華德（Karen Howard）設計。在這段有多位作者的文本當中，版面上以凸排（取代縮排）標示了段落的分隔。

《設計超越設計》（DESIGN BEYOND DESIGN），書頁，二〇〇四年。揚・凡・托爾恩（Jan van Toorn）。在持續進行的對話中，以跨出邊界的行句與文字區塊標示了發言者的改變。

---

**discussion**

hasn't been any talking about artistic practice and political practice. So how can artists and graphic designers intervene? At the same time, it is not for the others that one intervenes, it is with the others and for oneself. That is very important; we should not be paternalistic missionaries. I think that politics itself is an art, politics is the art of managing conflicts, the art of relations of force, and therefore necessarily involves the people who possess the power of expression. For let me remind you that expression and the orderly transfer of ideas play a very, very important role in conflicts.

**Member of the audience**

I would like to ask Jörg Petruschat how he sees the relation between social conflict and artistic practice, especially in relation to design.

**Jörg Petruschat**

I can hear... but today it's the seventh of November and... at school I had to learn russian. I'll try it.

I came here for three reasons. I see that revolution in technology served to cement the social status quo. Many designers hope to change the world when they go to technologies and I think that is a big illusion. And my duty is not to say to you what you have to do in future, but my duty is to think about what I see in the present. And I think it's an illusion to run behind the technology changes in the hope of changing the social status quo. In my opinion we should not make the mistake of thinking that we are the greatest because we are the latest. We have to look into the history and the problems of history because the situation, as I showed, from the fifteenth down to the nineteenth century has many similarities with the situation today. That's the first.

The second is that technology is a political structure, it transmits a kind of power, of economic power, and this is a new form that we cannot touch in our everyday life. This technology functions behind a façade. So the political is also structural in this case.

When designers think there are possibilities to change the world in contact with these technological systems they think like Walter Gropius, that the computer's only an instrument. I think that is false. The computer is not only an instrument but a big structure with many standards, and standards affect everyday life. That's the third reason.

**Member of the audience**

I enjoyed Susan's talk very much. But I have some doubts. Are you really saying: I want to go back to the original meaning of the word aesthetics, to go back to perception, and I want to see how perception is displaced in our culture?

**Susan Buck-Morss**

I do think that there is this opacity of representation, in other words, the way art is not just communication, the way that there's something

90

---

**friday 7 november**

else going on there. Either it's the medium itself, or it's something else that is extremely important. That's the most political we can do better to concentrate on that, than to think about exactly what message is getting across in the sense of a representational message, a direct message. But when you speak about aesthetics and an aesthetics problematic, I think it's what the avant-garde can only hope to do now. I think the avant-garde legitimated its leadership in the past by thinking it knew where history was going. I think this notion of history in progress is very dangerous. You can't be elitist if you know where we're going and you know what's holding us. I really agree with Benjamin that one has to stay radical but give up absolutely the notion of progress or automatic progress.

What does that leave for an avant-garde? That is my question and I was trying to argue as the past of political art, but not all of political art. And in this avant-garde possibility I was thinking about interruption in a temporal sense, or displacement. Maybe it is a very important political intervention to even use their own bodies as this kind of space where not very pleasant things happen. You think that it's still possible, and for me rather fruitful, to think of a tradition of avant-garde art and how that could be reformulated, not in the way that would say what political art should be about, but something that gives some description and direction.

**Lorraine Wild**

My question... do you think that in the context of what you're talking about, that it keeps being useful to talk about art, even at all as the definition of what is actually avant-garde or necessary at the moment? I was thinking about that when you opened up with the installation by Ramírez in Tijuana's public plaza, that in fact is a building that demonstrates a code. Why could actually not call that art at all, you could call that an informational exhibition, but that somehow this nomenclature that we attach to the activity immediately sets it out into a different round, makes it more difficult to talk about; and that encrusted with the whole idea of cultural hierarchy that in fact works against the very thing.

**Susan Buck-Morss**

Well, I mean it's interesting, what you say. What the difference is between the word design and the word art. Art is the code word in late western bourgeois society for disinterested interest, for non-instrumental practice. And so I am trying to occupy that or to use it. In fact you're talking about public space of communication; you're not actually talking about anything that obeys the conventional definitions of art. Somehow, we get stuck with this almost retrogressive notion of art, but then actually that very same definition has been used to prevent or tends to create a wall when it comes to this sort of activi-

91

# CAPTIONS
## 圖說文字

圖說文字的配置與樣式會對讀者的閱讀體驗造成影響，就如同視覺經濟與版面衝擊一樣。有些讀者天生就容易被圖片與說明文字所吸引，其他人則喜歡閱讀主要的書寫內文，以插圖做為文本的輔助。從讀者的觀點來看，圖說文字與圖片保持親密對他們來說的確有其便利性。然而將圖說文字與圖片相鄰擺放，對空間利用來說卻不見得是有效率的作法。設計師應該以編輯的角度處理這個問題。假使圖說文字對於了解這個視覺內容來說是必要的，那麼應該讓它們儘量貼近圖片。若它們的功能不過只是做為記錄而已，相鄰的安排就更容易被犧牲掉了。

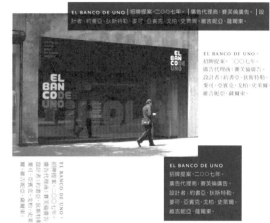

EL BANCO DE UNO，招牌提案，二〇〇七年。廣告代理商：賽芙倫廣告。設計者：約書亞·狄斯特勒、麥可·亞賓克、戈柏·史萊爾、維吉妮亞·薩爾東。

EL BANCO DE UNO，招牌提案，二〇〇七年。廣告代理商：賽芙倫廣告。設計者：約書亞·狄斯特勒、麥可·亞賓克、戈柏·史萊爾、維吉妮亞·薩爾東。

《I報》（I Newspaper），二〇〇九年。設計者：尼克·穆洛佐斯基（Nick Morzowski）。在這份葡萄牙的報紙上，圖說文字以其排版樣式敘述了一個故事。

網站上的圖說文字。網路內容管理系統會將圖片與圖說文字整合在資料庫裡。設計師們利用尺標、外框、層疊、和色塊將圖片與說明在視覺上串連起來,讓它們成為緊密結合的單位。這裡展示了在網頁上呈現圖說文字的四種不同方式。

互動式網頁圖說文字文字,Guardian.co.uk,二〇〇九年。設計總監:馬克‧波爾特(Mark Porter)。在《衛報》(the Guardian)的網站上,當使用者將游標移到這個圖片上時,輔助的圖說文字會顯現出來。

# HIERARCHY
## 層級

在字體編排設計裡，「層級」藉由強調部分元素、並且將其它元素降級表現了內容的組織結構。視覺化的層級可以幫助讀者快速瀏覽整段內文，了解自己該從哪裡進出文本，以及如何從內容提供的資訊中擷取、挑選所需。在層級架構中，每一層都應該會有一個以上的線索作為示意，示意的方式在全文裡必須保持一致。這些線索有些以空間配置方式示意（縮排、調整行距、調整位置），有些以圖像方式示意（大小、樣式、色彩）。可能的作法千變萬化。

在作家所接受的訓練裡，如「未來的計劃」或「過去的歷史」這一類帶有贅詞的說法是需要避免的。但在字體編排設計裡，有些冗贅的作法是可以被接受、甚至是建議採用的。舉例來說，傳統上段落會以換行「與」縮排同時加以標示，這種重複的提示經過驗證有其實效，因為這兩個線索可以相輔相成。如果想要讓示意的作法看起來優雅簡練，試著不要在每個層級或間隔使用超過三個以上的線索。

在內文中強調一個字或詞，通常只需要一種信號。斜體字是標準的強調樣式，但實際上還有許多替代作法，包括粗體、small caps（小型大寫字）、或更改顏色。像Scala這種全系列的字體家族裡，有許多不同字重與樣式變化的字型可以搭配使用。你也可以利用不同的字型製造出強調的效果。假使你想要混搭不同的字型家族，例如Scala和Futura，請記得調整字級大小好讓字體的「X」高度保持一致。

### 粗體，
### 斜體，
### 加底線
### 全部大寫！

囧設計

太多信號了。只需要一種變化就可以
製造出強調的效果。

### 層級的表現

| I | 天使的層級 | 天使的層級 | 天使的層級 | | 天使的層級 |
|---|---|---|---|---|---|
| | A. 天使（Angel） | 天使（Angel） | 天使（Angel） | 天使 | 天使（Angel） |
| | B. 大天使（Archangel） | 大天使（Archangel） | 大天使（Archangel） | 的層級 | 大天使（Archangel） |
| | C. 智天使（Cherubim） | 智天使（Cherubim） | 智天使（Cherubim） | | 智天使（Cherubim） |
| | D. 熾天使（Seraphim） | 熾天使（Seraphim） | 熾天使（Seraphim） | | 熾天使（Seraphim） |
| II | 神職人員的層級 | 神職人員的層級 | 神職人員的層級 | | 神職人員的層級 |
| | A. 教宗（Pope） | 教宗（Pope） | 教宗（Pope） | 神職人員 | 教宗（Pope） |
| | B. 樞機主教（Cardinal） | 樞機主教（Cardinal） | 樞機主教（Cardinal） | 的層級 | 樞機主教（Cardinal） |
| | C. 總主教（Archbishop） | 總主教（Archbishop） | 總主教（Archbishop） | | 總主教（Archbishop） |
| | D. 主教（Bishop） | 主教（Bishop） | 主教（Bishop） | | 主教（Bishop） |
| III | 文本的層級 | 文本的層級 | 文本的層級 | | 文本的層級 |
| | A. 作品（Work） | 作品（Work） | 作品（Work） | 文本 | 作品（Work） |
| | B. 章（Chapter） | 章（Chapter） | 章（Chapter） | 的層級 | 章（Chapter） |
| | C. 節（Section） | 節（Section） | 節（Section） | | 節（Section） |
| | D. 子節（Subsection） | 子節（Subsection） | 子節（Subsection） | | 子節（Subsection） |
| 符號、縮排、換行 | | 只有縮排與換行 | 改變字型、縮排、換行 | | 對齊、改變字型、換行 |

主要標題 ——— 常見的字體編排設計疾病

主要文本 ——— 長期接觸字體編排設計的人口當中出現了各種不同的機能障礙問題。以下列出較常被觀察到的疾病。

　　　　　字體狂熱症（TYPOPHILIA）
　　　　　對於字體的外形有極度的愛慕與執迷，往往沒有其它任何感興趣的事物。字體狂熱者通常會孤苦無依地死去。

　　　　　字體恐懼症（TYPOPHOBIA）
　　　　　毫無理性地厭惡字體，對於圖像、裝飾字、和——有某些致命病例——項目符號（bullets）與短劍符號（daggers）情有獨鍾。字體恐懼症患者的恐懼往往可以藉由穩定施給Helvetica與Times Roman字體獲得緩解（但非治癒）。

子節 ———

　　　　　字體焦慮症（TYPOCHONDRIA）
　　　　　對於錯用字體隨時有莫名的焦慮。這種狀況經常伴隨OKD（optical kerning disorder，視覺特殊字距微調失調）發生，患者會反覆不斷地調整字元間距。

　　　　　字體失溫症（TYPOTHERMIA）
　　　　　不願意對單一字體——或甚至對醫生所建議的五、六種字體——許下一輩子的承諾。字體失溫症患者經常會為「熱門」的新字型所誘惑，在沒有取得適當的授權下便迫不及待開始試用。

常見的字體編排設計疾病

表現文件層級的
方式有百百種。

長期接觸字體編排設計的人口當中出現了各種不同的機能障礙問題。以下列出較常被觀察到的疾病。

字體狂熱症　對於字體的外形有極度的愛慕與執迷，往往沒有其它任何感興趣
（TYPOPHILIA）　的事物。字體狂熱者通常會孤苦無依地死去。

字體恐懼症　毫無理性地厭惡字體，對於圖像、裝飾字、和——有某些致命病
（TYPOPHOBIA）　例——項目符號（bullets）與短劍符號（daggers）情有獨鍾。字體
　　　　　　　恐懼症患者的恐懼往往可以藉由穩定施給Helvetica與Times
　　　　　　　Roman字體獲得緩解（但非治癒）。

字體焦慮症　對於錯用字體隨時有莫名的焦慮。這種狀況經常伴隨OKD
（TYPOCHONDRIA）　（optical kerning disorder，視覺特殊字距微調失調）發生，患者
　　　　　　　會反覆不斷地調整字元間距。

字體失溫症　不願意對單一字體——或甚至對醫生所建議的五、六種字體——許
（TYPOTHERMIA）　下一輩子的承諾。字體失溫症患者經常會為「熱門」的新字型所誘
　　　　　　　惑，在沒有取得適當的授權下便迫不及待開始試用。

## 傳達用的層級

複雜的內容需要建立深度分層的層級。在雜誌和網站上，通常會有多位使用者接觸並處理字體編排的樣式，包括有作者、編輯、設計師、和網站策劃。假使層級的組織條理分明，使用者在應用時比較能保持前後一致性。設計師會製作「樣式指南」（style guides）向系統使用者說明層級的原則，並示範要如何應用層級系統。

《國際團結》（SOLIDARIETÀ INTERNAZIONALE），雜誌重新設計，二〇〇九年。設計者：黃金分割設計公司（Sezione Aurea）。出版品通常會委請設計公司製作可供內部設計師與編輯使用的新樣式。這套重新設計的樣式使用了羅伯特‧斯林巴赫設計的Myriad與Utopia字體。這份鉅細靡遺的樣式指南扮演了將新樣式傳達給雜誌社同仁的角色。

## 結構性的層級

設計師與編輯要從結構的角度、而非樣式的角度來組織內容，在數位化的文件當中尤其如此。利用排版軟體製作樣式表時，應該以「標題」、「副標題」、和「圖說文字」等名詞取代「粗體」、「細小」、或「蘋果綠Arial。」作為元素的標籤。在CSS當中，例如em（emphasis，強調）、strong、和「p」（paragraph，段落）是結構性的，而「i」（italic，斜體）、「b」（bold，粗體）、和br（break，間隔）都是視覺性的。當主要內容被轉譯至不同的媒體上，樣式仍然應該參考文件的章節而不是特定的視覺屬性。

結構性層級讓網站可以被搜尋引擎與使用者取得。HTML5使用了以下分區要素：＜section＞、＜article＞、＜aside＞、和＜nav＞。一個區塊可以是另一個區塊的母區塊。當區塊被標記在另一個區塊內部時，便表示該子區塊隸屬於母區塊之下。一般會希望設計師能在區塊中使用大標（headings，＜h1＞、＜h2＞、＜h3＞，以此類推），以反映出文件的架構。

更多關於網頁設計標準規格，請參考傑佛瑞‧澤爾曼（Jeffrey Zelman）與伊森‧馬爾寇特（Ethan Marcotte）的著作，《跨平台網頁設計——使用Web標準技術》（Designing with Web Standards），第三版（Berkeley, CA: New Riders, 2009）。繁體中文版由旗標出版社於二〇〇四年出版。

THE CITY，網站，二〇一〇年。設計：葛拉罕‧史丁森（Graham Stinson）THE CITY是一個協助教會與非營利組織參與社區活動的社交網站。網站會自動偵測讀者是否正利用桌上型電腦或手機瀏覽，並且重新導向至對應的版面以產生客製化的畫面。每一種版面都參照不同的CSS檔案；但每個頁面主要的HTML仍然是一樣的。

## 層級與可及性（ACCESSIBILITY）

網路的發明是為了讓資訊可以被通用存取，不論人們的行為能力或是否能夠使用專門的應體或軟體。許多使用者沒有顯示特定檔案所需的瀏覽器或外掛軟體（plug-ins），而視力受損的使用者沒有辦法閱讀過小的字體或非語言的內容。製作結構性的層級讓設計師能夠安排出各種版面的作法，以因應各種不同觀眾在軟體、硬體、和實際操作上的需求。

有時候，好的字體編排設計是用來聽、而不是看的。視覺受損的使用者會使用自動報讀軟體（screen readers），這種軟體會將網站線性化為一段連續的文本，好讓機器將內容朗讀出來。網站線性化得以順利成功的技巧包括有：避免在版面上使用表格；一貫地使用替代文字標籤（alt tags）、圖說文字、與圖片描述；將頁面的錨點放置在反覆出現的導覽元素前方，好讓使用者可以直接回到主要內容。有各式各樣的軟體可以讓設計師測試他們網站頁面的線性化程度。

CLAPHAMINSTITUTE.ORG，網站，二〇〇三年。
設計者：卡倫·戴（Colin Day）/ Exclamation Communications。出版者：克拉普漢機構（The Clapham Institute）。這個網站的設計是希望看得見與看不見的讀者都能夠使用。下方是這個網頁的線性化版本。視力受損的讀者可以聆聽內文，其中包括了每一張圖片的替代文字標籤。「跳至內容」（skip to content）的錨點讓使用者可以避免聆聽到一成串的導覽元素。

LIGHTHOUSE.ORG，網站，二〇一〇年。設計者：丹·莫爾（Dan Mall）與凱文·薛倫（Kevin Sharon）／ Happy Cog。前端程式設計：珍恩·盧卡斯（Jenn Lukas）。資訊架構：凱文·霍夫曼（Kevin Hoffman）。可及性研究與測試：安琪拉·柯爾特（Angela Colter）與珍妮佛·薩頓（Jennifer Sutton）。這個網站的視覺版面（左圖）為視力正常的使用者做了優化，但原始碼（下圖）則為視覺障礙者進行優化，使用者可以利用自動報讀軟體將文本線性化。舉例來說，在視覺呈現中，導覽清單直接出現在識別標誌的下方。然而在原始碼裡，機構名稱後方緊跟著標語，避免頁面一開頭就被導覽元素給塞滿了。這一類視覺呈現與原始碼上的差異會盡量降低，因為並非所有自動報讀軟體的使用者都是視障，有些透過原始碼導覽的障礙人士仍然能看得見視覺化的版面。假使視覺化的版面與原始碼之間的差異過大，使用者會覺得非常困惑。視覺化版面與原始碼之間的關係也會為搜尋引擎進行優化。

```html
<body class="home">
<div id="content-wrap">

<div id="header">

    <p class="language"><a href="#">En Espa&ntilde;ol?</a></p>

    <p class="move"><a href="#content">Skip to main content</a></p>

    <h1>
            <img src="/i/logo.gif" alt="" class="hide" />
            <a href="/" title="home">Lighthouse International</a>
    </h1>

    <div class="home-intro">

            <p class="mission"><strong>Dedicated to fighting vision loss through prevention, treatmen

            <div class="home-feature">
                    <img src="/i/content/dorrie-smith.png" alt="Dorrie Smith, blog author and Lighthe

            <h2><a href="/services-assistance/help-with-computers-technology/dorries-sight/i

            <p>Dorrie Smith has found a way to read the Times every morning despite significa
            </div>

            <div id="home-empty-repeat"></div>
    </div>

    <form action="/results/" method="post" id="search">
            <fieldset>
                    <legend><label for="searchtext" class="move-js">Search Lighthouse.org</label></l

                    <p>
                            <input type="text" id="searchtext" name="searchtext" class="filled" valu
                            <input type="image" src="/i/widgets/search.gif" alt="Search" />
                    </p>
            </fieldset>
    </form>

    <div id="secondary">
            <ul>
                    <li class="first"><a href="/services-assistance/">Services & Assistance</a>
                    <li><a href="/low-vision-and-blindness/">About Low Vision & Blindness</a></l
                    <li><a href="/vision-health/">Vision Health</a></li>
                    <li><a href="/research/">Research</a></li>
                    <li><a href="/news-events/">News & Events</a></li>
                    <li><a href="/donate-volunteer/">Donate & Volunteer</a></li>
                    <li class="form-wrap">
                            <form action="/listings/" method="post" id="find-help">
                                    <p>
                                            <label for="searcharea">Find Help In Your Area</label>
                                            <input type="text" id="searcharea" name="searcharea" val
                                            <input type="image" src="/i/widgets/find-help.gif" alt="
                                    </p>
                            </form>
```

...ung des Kaisers

abgebildet:

„Ich habe es nicht gewollt."

Bei Soissons wurden die feindlichen Reih'n
Von den tapfern Deutschen geschlagen,
Da stellt nach der Schlacht Kaiser Wilhelm sich ein,
Um den Helden ein Dankwort zu sagen.

Und wo der geliebte Herrscher erscheint,
Erheben sich grüßend die Hände.
Aus tausend kräftigen Stimmen vereint
Gab's ein Jubelgeschrei ohne Ende.

Nachdem schritt der Kaiser, der sichtlich bewegt,
Auf das Feld, wo vor wenigen Stunden
Die Helden zur ewigen Ruh man gelegt,
Die den Tod auf dem Schlachtfeld gefunden.

Am Grab eines Jünglings stand der Kaiser gebannt—
Kaum „Siebzehn" — im Grab bei den Alten,
Der Herrscher von Wehmut jetzt übermannt
Konnt' der Tränen sich nicht mehr enthalten.

Er betete Worte fremddeutsch — treu wie Gold,
Vor denen ein Weltall sich beuge:
„Gott Vater im Himmel — ich hab's nicht gewollt.
Du weißt es — Du bist mein Zeuge."

Paul Hambrock
Oberstjäger a.D.

Mit Genehmigung des Generalkommandos.

Karl Kraus zählt Wilhelm II. zu „den Schwerverbrechern auf dem Thron" mit der „Beteuerung, daß sie es nicht gewollt haben, woran sie, da sie es taten, doch schuldig sind" [F 595,2].

1920; F 531,52f.

→ gemeinsames **Vorgehen**

→ etwas zum **Vortrag** bringen

→ in die **Falle** gehen

→ ich habe alles reiflich **erwogen**

→ im **Lauf** des Abends

→ ein **Laut** auf den Lippen

→ zum **Schluß**

→ zu **Mantua** in Banden Der treue Hofer war

→ **Gesellschaft** mit beschränkter Haftung / G. m. b. H.

→ **vorlieb** nehmen

seit der Thronbesteigung !) — —

— — So erlebte ich, daß er einen doc[
Major, den Adjutanten des Kronprinzen,
Ohr zog, ihm einen tüchtigen Sch
gab und sagte: — —

— — empfing er in Tempelhof im
minister und den Chef des Militärkabinettes
alten Esel glaubt, daß ihr alles besser

*) Deutsche Verlagsanstalt, Stuttgart,

Und daß das »gemeinsame Vorgehen« für
war, »sobald Kraus die Satire auf Kaiser Wilh
werde«, beweist eine Vertrautheit der In
Programm, die ich selbst am Nachmittag noc
ihnen in die Falle gegangen! Aber wenn ein
Innsbruck auf Demonstrationen ausgehen, b
Abends eine Ahnung von dem Vorhandense
will ich dem Wilhelm glauben, daß er es nicht
Josef, daß er alles reiflich erwogen hat. Die
einer vagen Kenntnis meiner Gesinnung, abe
die ihre auszuleben, in den Saal geführten
Abends ein Dutzend weit besserer Anlässe —
zwei Diebsgenerale — hatten vorübergehen
der Laut auf den Lippen erstarb, und erst zu
über die eigene Unregsamkeit ihnen Bewu
ihre Anwesenheit legitimierten, indem si

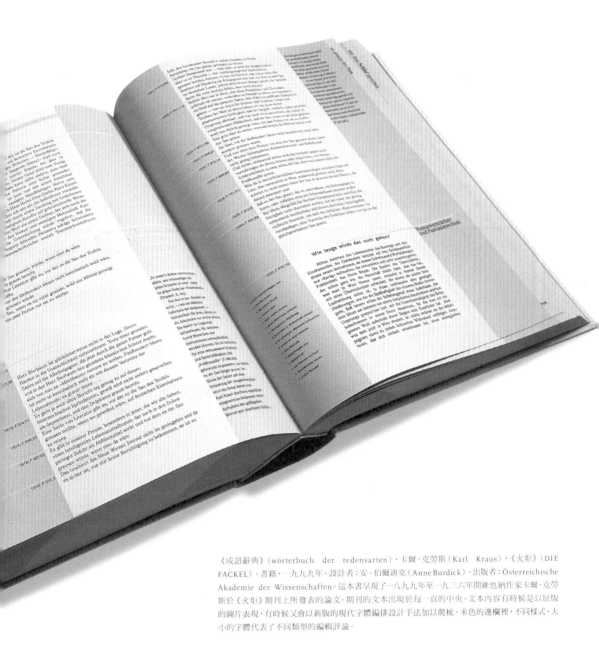

《成語辭典》（wörterbuch der redensarten），卡爾·克勞斯（Karl Kraus），《火炬》（DIE FACKEL）。書籍，一九九九年。設計者：安·伯爾迪克（Anne Burdick）。出版者：Österreichische Akademie der Wissenschaften。這本書呈現了一八九九年至一九三六年間維也納作家卡爾·克勞斯於《火炬》期刊上所發表的論文。期刊的文本出現於每一頁的中央。文本內容有時候是以原版的圖片表現，有時候又會以新版的現代字體編排設計手法加以爬梳。米色的邊欄裡，不同樣式、大小的字體代表了不同類型的編輯評論。

《雷達》雜誌（RADAR），二〇〇八年。設計者：路克·
海曼（Luke Hayman）／五角星·凱特·艾勒澤桂（Kate
Elazegui）／雷達。迎合大眾市場的雜誌封面通常會由一
張大尺寸照片、大標題、大型識別標誌、以及一堆當期雜
誌內刊載文章的預告所組成。《雷達》雜誌的封面將專
題報導放在最顯著的位置，再搭配以許多小標題吸引讀
者。相較之下，這本雜誌的目錄頁便呈現出較為輕鬆的
概觀風貌。在這裡，字體編排設計的層級特別突顯了文
章標題，並以頁碼做為容易找尋的定位點。

《信徒》雜誌（THE BELIEVER），封面封底，二〇〇九年。設計：戴夫·埃格斯（Dave Eggers）。插圖繪製：查爾斯·伯恩斯（Charles Burns）。這本文學雜誌的封面繁複卻容易閱讀，它在內文上以大小、字重不同的粗襯線體宣傳刊載在雜誌裡的內容。線畫插圖與文字流暢地整合在一起。封底有完整的內容目錄，為讀者提供了方便使用的介面。《信徒》雜誌的設計受到十九世紀年曆樣式的影響，以飾邊與框線吸引讀者對內容的關注，並且創作出令人印象深刻的視覺特色。

麥可‧貝汝、凱瑞‧鮑威爾（Kerrie Powell）、
桑妮‧古格力爾莫（Sunnie Guglielmo）

麥可‧貝汝、賈斯汀‧威爾斯（Justin Weyers）

麥可‧貝汝

《雷達》雜誌（RADAR），二〇〇八年。設計者：路克‧海曼（Luke
Hayman）／五角星、凱特‧艾勒澤桂（Kate Elazegui）／雷達。迎合大眾
市場的雜誌封面通常會由一張大尺寸照片、大標題、大型識別標誌、以
及 一堆當期雜誌內刊載文章的預告所組成。《雷達》雜誌的封面將專題
報導放在最顯著的位置，再搭配以許多小標題吸引讀者。相較之下，這
本雜誌的目錄頁便呈現出較為輕鬆的概觀風貌。在這裡，字體編排設計
的層級特別突顯了文章標題，並以頁碼做為容易找尋的定位點。

麥可‧貝汝‧傑納維夫‧帕紐斯卡（Genevieve Panuska）

麥可‧貝汝‧賈桂琳‧金（Jacqueline Kim）

麥可‧貝汝‧安德魯‧梅普斯（Andrew Mapes）

麥可‧貝汝‧蜜雪兒‧梁（Michelle Leong）、
薩沙‧費南多（Sasha Fernando）

挑選一段有重複性結構的文本，例如目錄、新聞聚合器（news aggregator）、或行事曆。分析該文本的內容結構（主標題、副標題、時間、地點、主要內文……等等），並創作能夠在視覺上表現出這個結構的層級。讓讀者能輕易地找到他們想要的資訊。以犯罪報告為例，有些讀者可能會掃瞄犯案地點的資訊，看看是否有他們鄰近地區的資料，但有些人可能會被特定案件駭人聽聞的細節所吸引。利用字級大小、字重、行距、樣式、和欄位結構來區分不同層級。製作一份樣式表（印刷品以排版軟體製作、網站則以CSS製作），以便於快速地發展出各種不同的變化版。

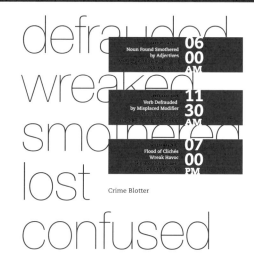

Crime Blotter

Callie Neylan, Betsy Martin

# Crime Blotter 犯罪記錄

**06 00 AM**

**EAST VILLAGE**
**Noun Found Smothered by Adjectives** *Message lost in dense cloud of confused signals.*

東村
上午六點
被詐騙（defrauded）
名詞被發現遭形容詞勒斃。
訊息在令人困惑的信號濃煙中失蹤。

凱麗・尼蘭（Callie Neylan）、貝琪・馬汀（Betsy Martin）

**11 30 AM**

**UPPER EAST SIDE**
**Verb Defrauded by Misplaced Modifier** *Missing the point revenge is sought by victim.*

上東區
上午十一點三十分
被報復（wreaked）
動詞遭不得體的修飾詞詐騙。
受害者沒有搞清楚狀況，正尋求報復。

**07 00 PM**

**WILLIAMSBURG**
**Flood of Clichés Wreaks Havoc** *Hipster kicks bucket after biting bullet and butterfly.*

威廉斯堡
晚間七點
窒息（smothered）
陳腔濫調的洪水肆虐為害。
文青咬下子彈與蝴蝶後身亡[3]。

[3]「Bite the Bullet」在英語當中有「硬著頭皮去做某事」的意思。

# Crime Blotter 犯罪記錄

6:00AM | EAST VILLAGE
**Noun Found Smothered by Adjectives**
Message lost in dense cloud of confused signals.

11:30AM | UPPER EAST SIDE
**Verb Defrauded by Misplaced Modifier**
Missing the point, revenge is sought by victim.

7:00PM | WILLIAMSBURG
**Flood of Clichés Wreaks Havoc**
Hipster kicks bucket after biting bullet.

Katie Burk, Paulo Lopez

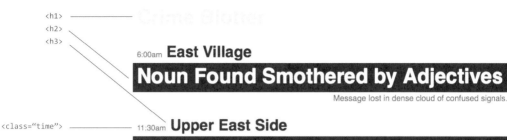

`<h1>`
`<h2>`
`<h3>`

6:00am **East Village**

# Noun Found Smothered by Adjectives

Message lost in dense cloud of confused signals.

`<class="time">`

11:30am **Upper East Side**

# Verb Defrauded by Misplaced Modifier

Missing the point, revenge is sought by victim.

7:00pm **Williamsburg**

# Flood of Clichés Wreaks Havoc

Hipster kicks bucket after biting bullet.

`<p>`

這些字體編排設計上的變化是在
css中利用如上所示的結構性層級
而產生的。

在美國公共廣播電台（NATIONAL
PUBLIC RADIO）舉辦的工作坊中
由內部設計師所做的範例，二〇
一〇年。

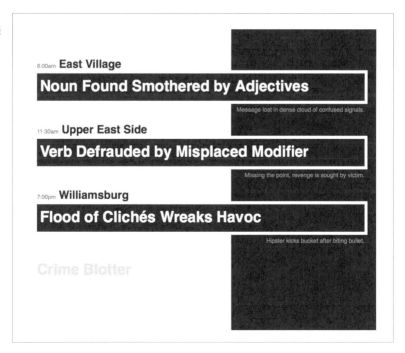

大衛・萊特（David Wright）、尼爾森・徐（Nelson Hsu）

在平面設計的真實世界裡，處理大量的文本是經常出現的挑戰。設計師們透過層級、對齊、與版面配置的原則，讓內容易於瀏覽，並創造愉快的閱讀體驗。你可以利用各式各樣的長清單——行事曆活動、字典裡的釋義、金句良言、分類廣告、或大學課程說明的某一頁——來嘗試這個練習。替清單上的元素加上編號，這些編號可以成為供你運用的圖像元素。設計一張能夠在視覺上以有趣的方法呈現內容的海報。利用樣式表快速、一致地對不同的樣式手法進行測試。

莎賓娜・柯根
（Sabrina Kogan）

馬里蘭藝術學院學生作品範例

貝琪·斯洛傑里斯（Becky Slogeris）

安迪·曼戈爾德
（Andy Mangold）

{GRID 網格}

Plauti fabulæ funt indicio. Ságuine canino contra toxica nihil præstantius putatur. Vomitiones quoqȝ hoc animal móstraffe uidetur. Et alios ufus ex eo mire laudatos referemus fuis locis. Nunc ad statutũ ordinem pergemus. Aduerfus serpentiũ ictus efficacia habentur fimum pecudis recens in uino decoctum illitumqȝ. Mures diffecti et impofiti quoqȝ natura non eft spernenda præcipue in afcenfu fyderum ut diximus: cum lumine lunæ fibrarum numero crefcente atqȝ decrefcente. Tradũt magi iocinere muris dato porcis in fico fequi dantem id animal. In homine quoqȝ fimiliter ualere. fed refolui cyatho olei poto. Muftelarũ duo genera. Alterũ fidueftre. Diftãt magni- tudine. Græci uocant ictides. Harũ fel cõtra afpidas dicitur efficax:cætero uenenũ. Hæc autẽ quæ in domibus noftris oberrat:et catulos fuos(ut auctor eft Cicero)quoti- die traïffert:mutatqȝ fedem ferpétes profequitur.Ex ea inueterata fale denarii põdus in cyathis tribus datur percuffus:aut uentriculus coriandro fartus inueteratufqȝ et in uino potus.Et catulus muftelæ etiã efficacius. Quædam pudenda dictu tãta aucto- rum affeueratione commendantur:ut prætente fas non fit. Siquidem illa concordia rerum aut repugnantia medicinæ gignuntur. Veluti uncarum animalis fetidiffimi et dictu quoqȝ fafhdiédi natura contra ferpentium morfus et præcipue afpidum ualere dicitur. Item contra uenena omnia. Argumento qȝ dicitur gallinas quo die id ederit nõ iterfici ab afpide. Carnes quoqȝ earũ percuffis pluurimũ prodeffe. Eis iis quæ tradunt humaniffimum illinire morfibus cum fanguine teftudinis. Item fuffitu eorũ abigere fanguifugas adhærentes:hauftafqȝ ab animalibus reftinguere in potu datos. Quãqȝ et oculos quidam iis inungunt trinis cum fale et lacte mulierum. Aurefqȝ cum melle et rofaceo ammixtis. Eos qui agreftes fintiet in malua nafcantur crematos cinere p- mixto rofaceo infundunt auribus.Cætera quæ de iis tradunt:uomicæ et quartanatũ remedia:aliorũqȝ morborũ quãqȝ ouo aut cæra aut faba inclufos cenfeant deuorãdos falfa nec referenda arbitror. Lethargi tamen medicinæ cum argumento adhibenti quoniam uincatur afpidum fomnifica uis feptenos fcyatho aquæ dantes puerilibus annis quaternos. Et ftranguriæ fiftulæqȝ impofitæe:adeo nihil illa rerum omnium parens fine ingennuis caufis genuit. Quin et adalligatos feuo brachio binos lana fubrepta paftoribus refiftere nocturnis febribus prodierunt:diurnis in rofeo panno. Rurfus iis aduerfatur fcolopendra fuffitu qȝ necat. Afpides percuffos torpore & fom- no necant:omnium ferpentium minime fanabiles. Sed et uenenum earum fi fáguis attingit:aut recens uulnus ftatim iterimit. Inueteratũ ulcus tardius. De cætero potũ quantalibet copia:non nocet. Non enim eft tabifica uis itaqȝ uccifa morfu earum animalia cibis innoxia funt. Contarer in proferendo ex iis remedia:nifi M. Varronẽ fcirem. lxxxii.uitæ anno prodidiffe afpidũ ictus efficaciffime curari haufta a pcuffis ipforum urina. Bafilifci:quem etiam ferpentes ipfi fugiunt alios olfactu necantem: qui hominem uel fi afpiciat tantum dicitur interimere:fanguinem magi miris laudi- bus celebrant coeuntem picis modo et colore dilutum cinnaþri clarorem fieri. Tri- buunt ei et fucceffus petitionum a poteftatibus:& a diis etiam precum:morborum remedia beneficiorum munere. Quidã id Saturni fanguinem appellant. Draco nõ habet uenena. Caput eius limini ianuarum fubditum propitiatu orationæ diis fortu- natam domum facere promittitur. Oculis eius iueteratis et cum melle trinis functos non paueícere ad nocturnas imagines etiam pauidos cordis. Pingue in pelle dorcadũ neruis ceruinis adalligatum in lacerto conferre iudiciorum uictoriam. Primũ fpõdy- lum adiectis poteftatum mulcere. Dentes eius illigatos pellibus caprearum ceruinis neruis:mites præftare dominos:poteftatefqȝ exorabiles. Sed fuper omnia eft cõpofi- tio:qua inuictos faciunt magorum mendacia. Cauda draconis et capite uilis leonis e fronte et medulla eiufdem equi uictoris fpuma canis unguibus adalligatis ceruino corio:neruifqȝ cerui alternatis et dorcadis. Quæ arguiffe non minus refert:qȝ contra ferpentes remedia demonftraffer:quoniam hæc morborum beneficia funt. Draconũ

《自然史》(HISTORIA
NATURALIS),書籍,一四七二
年。印刷者:尼可拉斯·詹森,巴
爾的摩沃爾特斯藝術博物館,威
尼斯收藏。這本書以優雅、完整
的文字區塊為其特色,並使用了
最早期的羅馬正體字。這一頁當
中沒有任何換行或縮排的樣式
出現。

# GRID 網格

網格將空間或時間切分成整齊的單位。網格可能是簡單或複雜的，特有或通用的，也可能是被嚴格定義或寬鬆詮釋的。它們在頁面、螢幕、或人為打造的環境空間中，建立出一套配置內容的系統。為了應對來自內容（文本、圖像、資料）的內部壓力與外在的邊界或邊框（頁面、螢幕、視窗），有效的網格不會是一套死板僵固的準則，而是一個靈活有彈性的結構、一副可以與大量資訊肌肉合作、運動自如的骨架。

網格屬於字體編排設計的技術架構，從具體的印刷模組化、到圖像應用程式中使用的尺規、參考線（guides）、與整合系統都包括在內。雖然軟體會讓人產生圓滑弧線與連續色調的錯覺，但每一個數位圖像或記號終究都是從一個由整齊劃界的區塊群所組成的網格建構出來的。隨處可見的圖形化使用者介面（GUI，graphical user interface）語言創造了一個讓視窗彼此之間可以隨意交疊覆蓋的網格空間。

除了在設計製作背景當中所佔的位置之外，網格也成為一套明確清楚的理論工具。一九一〇年代與一九二〇年代的前衛派設計師特別突顯了活版印刷的機械式網格，將它們帶到充滿爭議的頁面上來。在二次世界大戰後的瑞士，平面設計師以字體編排設計中的網格為核心打造了一套全方位的設計方法論，希望能藉此建構出全新、理性的社會秩序。

網格在字體編排設計的發展史上經歷了數百年的演變。對平面設計師來說，網格是一套經過精雕細琢的智慧型裝置，融合於意識形態與雄心抱負之中。它們就像是難以逃躲的篩網，以某種解析度的網眼篩過幾乎所有的寫作與複製系統。

[本頁主要為一四九七年《拉丁聖經》之黑體字拉丁文排版，兩欄式網格中呈現古拉丁文內文，因年代與字體原因難以逐字辨識。]

《拉丁聖經》（LATIN BIBLE），
書頁，一四九七年。印刷者：安登·
柯伯爾爵（Anton Koberger）。兩
欄式的網格吞噬了另一組欄位。每
一頁都是被狹窄的溝道與開放空
間切割的緻密團塊，而開放空間上
原本應該要有以手寫方式添加上
去的華麗大寫字母。每一頁的版面
配置皆有所不同。

# GRID AS FRAME
## 邊框網格

就如同大部分的書寫系統，字母的書寫也會被組織為成欄成行的文字。雖然手寫時會以線條將文字連結起來，但金屬活字的運用卻有一套更嚴謹的條理。每一個字母都佔據了一個區塊，字母們再聚集在整齊排列的長方形當中。存放在柵格盒子裡的字母們成了元素資料庫，書本當中的每一頁都是由這套既有樣式所形成的矩陣組合出來的。

在二十世紀之前，網格發揮了文字區塊邊框的功能。古典書頁的邊界會就著齊平、堅實的文字區塊創造出一個單純的界線。時至今日，即便過去完美的長方形現在已經被縮排與換行打破，邊欄上也散佈著頁碼與逐頁標題（running heads，標示書本或章節標題的文字），由單獨的文字區塊主導頁面仍然是書本樣式的主流。

除了成為經典範式的單欄頁面之外，在印刷興起後的幾百年間出現了各種不同的版面配置方式，包括了從《古騰堡聖經》的兩欄式網格，到衍生自中世紀手抄本傳統、聖經文字旁圍繞著學者評注的優雅版面。多語言（polyglot）的書籍會同時呈現不同語言的文本，需要在版面上劃出複雜的區塊。

這種樣式一方面捍衛了「頁面即框架」的主權，另一方面也讓多個文本可以同時並存。哲學家賈克·德希達曾經形容西方藝術的畫框是一種看起來獨立於畫作之外的樣式，但卻又是讓藝術有別於日常之物的必需品。畫框或台座提昇了藝術品，讓它跳脫了俗物的範疇。作品的地位與能見度是有賴於框架而建立的。

大致說來，字體編排設計是一種框架的藝術，它的設計會讓它的形式隨著順從於內容之下而逐漸消融。設計師們將他們大部分的精力投注在邊界（margin）、邊緣（edge）、和空白空間這些介於存在與不存在、可見與不可見之間的元素。隨著印刷術的進步，邊欄成為書本的使用者介面，提供頁碼、逐頁標題、評注、註釋、與裝飾圖案展示的空間。

**框架……消失了，它埋藏自己、隱沒自己，就在展現出最強大的能量時，它消融了。框架絕對不是背景……但它也不像邊欄有著厚實的形體。或者至少它是一個自願消失的形體。——賈克·德希達，一九八七年。**

כפר בראשית א     GENESIS. Tranſlat.B.Hierony. Creatio.

*(Hebrew text, Genesis chapter 1)*

ראשית ברא אלהים את השמים ואת
הארץ ׃ והארץ היתה תהו ובהו וחשך
על פני תהום ורוח אלהים מרחפת על
פני המים ׃ ויאמר אלהים יהי אור
ויהי אור ׃ וירא אלהים את האור כי טוב ויבדל
אלהים בין האור ובין החשך ׃ ויקרא אלהים לאור
יום ולחשך קרא לילה ויהי ערב ויהי בקר יום אחד ׃
ויאמר אלהים יהי רקיע בתוך המים ויהי מבדיל
בין מים למים ׃ ויעש אלהים את הרקיע ויבדל בין
המים אשר מתחת לרקיע ובין המים אשר מעל לרקיע
ויהי כן ׃ ויקרא אלהים לרקיע שמים ויהי ערב
ויהי בקר יום שני ׃
ויאמר אלהים יקוו המים
מתחת השמים אל מקום אחד ותראה היבשה ויהי
כן ׃ ויקרא אלהים ליבשה ארץ ולמקוה המים קרא
ימים וירא אלהים כי טוב ׃ ויאמר אלהים תדשא
הארץ דשא עשב מזריע זרע עץ פרי עשה פרי למינו
אשר זרעו בו על הארץ ויהי כן ׃ ותוצא הארץ דשא
עשב מזריע זרע למינהו ועץ עשה פרי אשר זרעו בו
למינהו וירא אלהים כי טוב ׃ ויהי ערב ויהי בקר
יום שלישי ׃ ויאמר אלהים יהי מארת ברקיע
השמים להבדיל בין היום ובין הלילה והיו לאתת
ולמועדים ולימים ושנים ׃ והיו למאורת ברקיע
השמים להאיר על הארץ ויהי כן ׃ ויעש אלהים
את שני המארת הגדלים המאור הגדל לממשלת
היום ואת המאור הקטן לממשלת הלילה ואת
הכוכבים ׃ ויתן אתם אלהים ברקיע השמים להאיר
על הארץ ׃ ולמשל ביום ובלילה ולהבדיל בין האור
ובין החשך וירא אלהים כי טוב ׃ ויהי ערב ויהי
בקר יום רביעי ׃ ויאמר אלהים ישרצו המים שרץ
נפש חיה ועוף יעופף על הארץ על פני רקיע השמים ׃

## GENESIS. Tranſlat.B.Hierony. Creatio.

### CAPVT PRIMVM.

IN principio creauit Deus cœlum & terrá. Terra autem erat inanis & vacua: & tenebræ erant super faciê abysſi: & spiritus Dei ferebatur super aquas. Dixitq́, Deus, Fiat lux. Et facta lux. Et vidit Deus lucem quòd esset bona: & diuiſit lucem à tenebris. Appellauitq́, lucem diem; & tenebras nocté. Factumq́, est vespere & mane dies vnus. Dixit quoque Deus, Fiat firmamentû in medio aquarum: & diuidat aquas ab aquis. Et fecit Deus firmamentum, diuiſitq́; aquas quæ erant sub firmamento, ab his quæ erant super firmamentû. Et factum est ita. Vocauitq́; Deus firmamentû, cælum: & factum est vespere, & mane dies secundus.

Dixit verò Deus, Congregentur aquæ quæ sub cœlo sunt, in locum vnum:& appareat arida. Et factum est ita. Et vocauit Deus aridã, terram:congregationeſq́; aquarum appellauit maria. Et vidit Deus quòd esset bonum. Et ait, Germinet terra herbá virentem & facientem semen; & lignum pomiferû faciens fructû iuxta genus suum, cuius semen in semetipso sit super terram. Et factû est ita. Et protulit terra herbam virenté, & facienté semen iuxta genus suû; lignumq́; faciens fructû, & habens vnumquodq́; sementem secundû speciem suam. Et vidit Deus quòd esset bonum. Et factum est vespere & mane dies tertius. Dixit autê Deus, Fiant luminaria in firmamento cæli; & diuidant diem ac nocté; & sint in signa & têpora & dies & annos: Vt luceát in firmaméto cæli, & illuminent terrá. Et factum est ita. Fecitq́; Deus duo luminaria magna: luminare maius, vt præesset diei: & luminare minus, vt præeset nocti: & stellas. Et posuit eas Deus in firmaméto cæli, vt lucerét super terrá: Et præessent diei ac nocti; & diuiderent lucem ac tenebras. Et vidit Deus quòd esset bonû. Et factum est vespere, & mane dies quartus. Dixit etiam Deus, Producant aquæ reptile animæ viuentis, & volatile super terram sub firmamento cæli.

תרגום אונקלוס

*(Targum Onkelos, Aramaic text)*

בראשית ברא יי ית שמיא וית ארעא ׃ וארעא הות צדיא וריקניא וחשוכא על אפי תהומא ורוחא מן קדם יי מנשבא על אפי מיא ׃ ואמר יי יהא נהורא והוה נהורא ׃ וחזא יי ית נהורא ארי טב ואפרש יי בין נהורא ובין חשוכא ׃ וקרא יי לנהורא יממא ולחשוכא קרא ליליא והוה רמש והוה צפר יומא חד ׃ ואמר יי יהא רקיעא במציעות מיא ויהא מפריש בין מיא למיא ׃ ועבד יי ית רקיעא ואפריש בין מיא דמלרע לרקיעא ובין מיא דמעל לרקיעא והוה כן ׃ וקרא יי לרקיעא שמיא והוה רמש והוה צפר יום תנין ׃

בקדמין

**CAPVT PRIMVM.**

IN principio fecit Deus cælum & terrã. At terra erat inuisibilis et incõposita, et tenebræ super abyssum: & spiritus Dei ferebatur super aquam. Et dixit Deus, Fiat lux, & facta est lux. Et vidit Deus lucé, quòd bona: & diuisit Deus inter lucem, & inter tenebras. Et vocauit Deus lucé diem: & tenebras vocauit nocté: & factũ est vespere, & factũ est mane, dies vnus. Et dixit Deus, Fiat firmamentũ in medio aquæ: & si diuidat inter aquã, & aquã. Et fecit Deus firmamentũ, diuisitq́ Deus inter aquã quæ erat sub firmamento: & inter aquã quæ super firmamentũ. Et vocauit Deus firmamentũ cæli: & vidit Deus, quòd bonũ. Et factũ est vespere, & factũ est mane, dies secũdus. Et dixit Deus, Cõgregetur aqua quæ sub cælo, in cõgregationé vnã, & appareat arida. Et factũ est ita: & cõgregata est aqua quæ sub cælo, in cõgregationé suã: & apparuit arida. Et vocauit Deus aridã, terrã: et cõgregationes aquarũ vocauit maria. Et vidit Deus quòd bonũ. Et dixit Deus, Germinet terra herbã fœni seminãté semé secundũ genus et secundũ similitudiné: & lignũ pomif. faciens fructũ, cuius semen ipsius in ipso, secundũ genus super terrã. Et factũ est ita. Et protulit terra herbã fœni seminãté semen secundũ genus & secundũ similitudiné: & lignũ pomif.ferũ faciens fructũ, cuius semé eius in ipso, secundũ genus super terrã. Et vidit Deus quòd bonũ. Et factũ est vespere, & factũ est mane, dies tertius. Et dixit Deus, Fiant luminaria in firmamento cæli, vt luceant super terrã, ad diuidendum inter diê, & inter nocté: & sint in signa, & in tempora, & in dies, & in annos. Et sint in illuminatione in firmamento cæli, vt luceant super terram. Et factũ est ita. Et fecit Deus duo luminaria magna: luminare maiꝰ in principiũ diei: & luminare minus in principat. noctis: et stellas. Et posuit eas Deus in firmamento cæli: vt lucerẽt super terrã, Et præessent diei, & nocti, & diuiderẽt inter lucé & tenebras. Et vidit Deus quòd bonũ. Et factũ est vespere, & factũ est mane, dies quartus. Et dixit Deus, Producant aquæ reptilia animarũ viuentiũ, & volatilia volatilia super terrã, secundũ firmamentũ cæli. Et factũ est ita.

---

**CHALDAICÆ PARAPHRASIS TRANSLATIO.**
**CAPVT PRIMVM.**

IN principio creauit Deus cælum & terram. Terra autem erat deserta & vacua; & tenebræ super faciem abyssi: & spiritus Dei insufflabat super faciem aquarum. Et dixit Deus, Sit lux: & fuit lux. Et vidit Deus lucem quòd esset bona. Et diuisit Deus inter lucem & tenebras. Appellauitq́ Deus lucem diem, & tenebras vocauit noctem. Et fuit vespere & fuit mane dies vnus. Et dixit Deus, Sit firmamentum in medio aquarum: & diuidat inter aquas & aquas. Et fecit Deus firmamentum: & diuisit inter aquas quæ erant sub firmamento: & inter aquas quæ erant super firmamentum: & fuit ita. Et vocauit Deus firmamentum cælum: & fuit vespere & fuit mane, dies secundus. Et dixit Deus, Congregentur aquæ quæ sub cælo sunt, in locum vnum: & appareat arida. Et fuit ita. Et vocauit Deus aridam terram: & locum congregationis aquarum appellauit maria. Et vidit Deus quòd esset bonum. Et dixit Deus, Germinet terra germinationem herbæ, cuius filius sementis seminatur secundùm genus suum; & arborem facientem fructum, cuius filius sementis in ipso secundùm genus suum. Et vidit Deus quòd esset bonum. Et fuit vespere & fuit mane, dies tertius. Et dixit Deus, Sint luminaria in firmamento cæli ad illuminãdum super terram: & fuit ita. Et fecit Deus duo luminaria magna: luminare maius vt dominaretur in die: & minus, vt dominaretur in nocte: & stellas. Et posuit eas Deus in firmamento cæli ad illuminandum super terram: Et vt dominarentur in die & in nocte: & vt diuiderent inter lucem & tenebras: & vidit Deus quòd esset bonum. Et fuit vespere & fuit mane, dies quartus. Et dixit Deus, Serpant aquæ reptile animæ viuentis: & auem quæ volat super terram super faciem aëris firmamenti cælorum.

A 2

《多種語言聖經》（BIBLIA POLYGLOTTA），書頁，一五六八年。印刷者：克里斯多佛·普雷頓（Christopher Platin），安特衛普（Antwerp）。普雷頓的《多種語言聖經》內頁被劃分為五種不同語言的區塊（希伯來語〔Hebrew〕、希臘語、阿拉姆語〔Aramaic〕、敘利亞語〔Syriac〕、和拉丁語〔Latin〕）。每一區的比例都依其手寫體獨特的印刷質感而有所不同。這一頁是被切分為好幾部分的緻密長方形。這些部分——雖然具有高度個別性——彼此組合為一體。由威廉·達納·歐爾卡特（William Dana Orcutt）複製，《完美書籍的探求》（In Quest of the Perfect Book, New York: Little, Brown and Co., 1926）。

### CHAPITRE SECOND.

*I. La colonne de Pompée. II. On ne convient pas sur ses mesures. III. Colonne d'Alexandre Severe.*

I. LA fameuse colonne de Pompée est auprès d'Alexandrie : on ne sait pour quelle raison elle porte le nom de Pompée ; je croirois volontiers que c'est par quelque erreur populaire. Plusieurs voiageurs en ont parlé, tous conviennent qu'elle est d'une grandeur énorme. Deux des plus modernes en ont donné le dessein & les mesures ; mais ils different considerablement entre eux sur la hauteur du piedestal, de la colonne & du chapiteau : cependant tous deux disent qu'ils l'ont mesurée.

,, Pour ce qui est de la colonne, dit l'un, ( c'est Corneille Brun p. 241. ) ,, elle est sur un piedestal quarré, haut de sept ou huit pieds & large de qua-,, torze à chacune de ses faces. Ce piedestal est posé sur une base quarrée, ,, haute d'environ un demi pied, & large de vingt, faite de plusieurs pierres ,, maçonnées ensemble. Le corps de la colonne même n'est que d'une seule ,, pierre, que quelques-uns croient être de granit ; d'autres disent que c'est ,, une espece de pâte ou de ciment, qui avec le tems a pris la forme de pierre. ,, Pour moi je croi que c'est une vraie pierre de taille, du moins autant que ,, j'ai pu le reconnoitre par l'épreuve que j'en ai faite. Et si cela est vrai, com-,, me personne presque n'en doute, il y a sujet de s'étonner comment on a ,, pu dresser une pierre de cette grandeur : car après l'avoir mesurée, j'ai trou-,, vé qu'elle a quatre-vingt-dix pieds de haut, & que sa grosseur est telle, que ,, six hommes peuvent à peine l'embrasser ; ce qui revient, selon la mesure ,, que j'en ai prise, à trente-huit pieds. Au haut il y a un beau chapiteau pro-,, portionné à la grosseur de la colonne, mais fait d'une piece separée.

L'autre, qui est M. Paul Lucas, en parle en cette maniere : ,, Un de mes ,, premiers soins fut d'aller examiner la colonne de Pompée, qui est près d'A-,, lexandrie du côté du couchant, & je croi qu'il seroit difficile de rien ajou-

---

#### CAPUT SECUNDUM.

*I. Columna Pompeii. II. De ejus mensuris non convenit inter eos qui istac loca adierunt. III. Columna Alexandri Severi.*

I. CEleberrima illa Pompeii columna prope Alexandriam erigitur. Cur Pompeii columna vocetur, ignoratur. Libenter crederem hujusmodi denominationem ex populari errore manavisse. Ex peregrinantibus omnes enormis magnitudinis esse narrant. Duo recentiores & figuram & mensuras dederunt, at inter illos non convenit de stylobarae, columnae & capitelli magnitudine. Attamen ambo dicunt se mensuras excepisse.

,, Quantum ad columnam, inquit Cornelius ,, Brunius p. 241. ea imposita est quadrata styloba-,, te cujus altitudo est septem octove pedum, la-,, tera vero singula in faciebus sunt quatuordecim ,, pedum. Stylobates autem ille quadrata basi im-

,, ponitur, altitudine dimidii pedis, ex lapidibus ,, plurimis structa basis est, longitudinis circum-,, quaque viginti pedes habens. Columna ex uno ,, lapide est, plurimi putant ex marmore granito ,, esse, alii vero quasi caementum & compactam ,, materiam esse, quae procedente tempore, formam ,, lapidis sumpserit. Puto ego esse lapidem quantum ,, saltem experiri licuit. Quod si ira sit, id quod ,, nemo hodie in dubium vocat ; plane mirum ,, quo pacto tantum lapidem erigere potuerint. ,, Nam cum mensuram duxissem, nonaginta pedes ,, altitudinis habere comperi, tantaeque ejus est spis-,, situdo, ut sex viri simul vix illam amplecti pos-,, sint, id quod ad mensuram a me sumtam redu-,, citur, circuitus enim ejus est triginta & octo ,, pedum. In culmine capitellum est ex uno lapide ,, secundum columnae proportionem.

Alius, nempe Paulus Lucas, columnam sic des-,, cribit. ,, Ubi primum potui columnam Pompeii ,, adii, quae prope Alexandriam est versus oc-,, cidentem. Difficile autem esset ejus mensuras

---

《古籍補遺》(Supplement au livre de l'antiquité),書頁,巴黎,一七二四年。這本雙語書籍的兩欄式網格提供法文文字一個單欄的大區塊,而下方的兩小欄則是拉丁文區塊。引號在引言的左側邊緣發揮了邊框的功能。

《倫敦新聞畫報》(THE ILLUSTRATED LONDON NEWS),右圖,報紙頁面,一八六一年。早期的報紙廣告是由印刷者所設計,而不是由客戶或廣告代理商提供。這些排得密密麻麻的廣告佔據了四欄網格,並以橫隔線使之排列整齊。

《皇室聖經》(THE IMPERIAL FAMILY BIBLE),下一頁,書籍,一八五四年。這本書的結構十分罕見,註釋出現在頁面中央而非底部或邊緣。邊欄從外側移到內側了。

mount Perazim,[1] he shall be wroth as *in* 'the valley of Gibeon, that he may do his work, 'his strange work; and bring to pass his act, his strange act.

22 Now therefore 'be ye not mockers, 'lest your bands be made strong: for I have heard from the Lord God of hosts, "a consumption, even determined upon the whole earth.

23 ¶ Give 'ye ear, and hear my voice; hearken, and hear my speech.

24 Doth the ploughman plough all day to sow? doth he open and "break the clods of his ground?

25 When he hath made plain the face thereof, doth he not cast abroad the fitches,[2] and scatter the cummin, and cast in[3] the principal wheat, and the appointed barley, and the rye,[4] in their place?[5]

26 For[6] 'his God doth instruct him to discretion, *and* doth teach him.

27 For the fitches are not 'thrashed[7] with a thrashing-instrument, neither is a cart-wheel turned about upon the cummin; but 'the fitches are beaten out with a staff, and the cummin with a rod.

28 'Bread-corn is bruised;[8] because he will not ever be thrashing it, nor break *it with* 'the wheel of his cart, nor bruise *it with* his horsemen.

29 This also 'cometh forth from the Lord of hosts, *which* is wonderful in counsel, *and* excellent in working.

## CHAPTER XXIX.

*God's heavy judgments upon Jerusalem, 1–6. The unsatiableness of her enemies, 7, 8. The senselessness, 9–12, and deep hypocrisy of the Jews, 13–17. A promise of sanctification to the godly, 18–24.*

WOE[9] to Ariel, to Ariel, the[10] city *where* David dwelt! 'add ye year to year; let them kill[11] sacrifices.

2 Yet 'I will distress Ariel, and there shall be heaviness and sorrow: and' it shall be unto me as Ariel.[12]

3 And I will *d*camp against thee round about, and will lay siege against thee with a mount, and I will raise forts against thee.

4 And 'thou shalt be brought down, *and* shalt speak out of the ground, and thy speech shall be low out of the dust, and thy voice shall be, as

of one that hath a familiar spirit, o' of the ground, and thy speech sha' whisper[1] out of the dust.[2]

5 Moreover, 'the multitude of th' strangers shall be like small dust, an' the multitude of the terrible ones *sha* be *g*as chaff that passeth away; yea it shall be *h*at an instant suddenly.

6 Thou shalt be 'visited of the Lord of hosts with thunder, and wit' earthquake, and great noise, wit' storm and tempest, and the flame o' devouring fire.

7 And 'the multitude of all th' nations that fight against Ariel, ever all that fight against her and he' munition, and 'that distress her, shal' be "as a dream of a night-vision.

8 It shall even be[3] "as when an hungry *man* dreameth, and, behold, h' eateth; but he awaketh, and his sou' is empty: or as when a thirsty *man* dreameth, and, behold, he drinketh; but he awaketh, and, °behold, *he i* faint, and his soul hath appetite: so shall the multitude of all the nations be that fight against mount Zion.

9 ¶ Stay yourselves, *p*and wonder; cry[4] ye out, and cry: *q*they are drunken,[5] but not with wine; they stagger, but not with strong drink.

10 For 'the Lord hath poured out upon you the spirit of deep sleep, *s*hath closed your eyes: the prophets and your rulers,[6] 'the seers, hath he covered.

11 And the vision of all[7] is become unto you as the words of a *u*book "that is sealed, which *men* deliver to one that is learned, saying, Read this, I pray thee: and he saith, 'I cannot; for it *is* sealed.

12 And the book[9] is delivered to him that is not learned, saying, Read this, I pray thee: and he saith, "I am not learned.

13 ¶ Wherefore the Lord[10] said, 'Forasmuch as this people draw near *me* with their mouth, and with their lips do honour me, but have removed their heart far from me, and *y*their fear[11] toward me is taught by the precept of men:

14 Therefore, behold, 'I will proceed[9] to do a marvellous work among

this people, *even* a marvellous work and a wonder; "for the wisdom of their wise *men* shall perish, and the understanding of their prudent *men* shall be hid.

15 Woe unto them that *seek deep to hide their counsel from the LORD, and* their works are in the dark, and they say, "Who seeth us? and who knoweth us?

16 Surely your turning of things upside down shall be esteemed *as the potter's clay: for shall the work say of him that made it, He made me not? or shall the thing framed say of him that framed it, He had no understanding?

17 *Is* it not yet a very little while and *Lebanon* shall be turned into a fruitful field, and the fruitful field shall be esteemed as a forest?

18 And in that day shall the deaf hear the words of the book, and the eyes of the blind shall see out of obscurity, and out of darkness.

19 The *meek also shall increase* their joy in the LORD, and the poor among men shall rejoice in the Holy One of Israel.

20 For the terrible one is brought to nought, and the scorner is consumed, and all that watch for iniquity are cut off:

21 That make a man an offender for a word, and lay a snare for him that reproveth in the gate, and turn aside the just for a thing of nought.

22 Therefore thus saith the LORD, who redeemed Abraham, concerning the house of Jacob, Jacob shall not now be ashamed, neither shall his face now wax pale.

23 But when he seeth his children, the work of mine hands, in the midst of him, they shall sanctify my name, and sanctify the Holy One of Jacob, and shall fear the God of Israel.

24 They also that erred in spirit shall come to understanding, and they that murmured shall learn doctrine.

### CHAPTER XXX.

*The prophet threateneth the people for their confidence in Egypt, 1—7, and contempt of God's word, 8—17. God's mercies toward his church, 18—26. God's wrath, and the people's joy in the destruction of Assyria, 27—33.*

WOE to the rebellious children, saith the LORD, that take coun-

sel, but not of me; and that cover with a covering, but not of my Spirit, that they may add sin to sin:

2 That walk to go down into Egypt, and have not asked at my mouth; to strengthen themselves in the strength of Pharaoh, and to trust in the shadow of Egypt!

3 Therefore shall the strength of Pharaoh be your shame, and the trust in the shadow of Egypt *your* confusion.

4 For his princes were at Zoan, and his ambassadors came to Hanes.

5 They were all ashamed of a people *that* could not profit them, nor be an help nor profit, but a shame, and also a reproach.

6 The burden of the beasts of the south: into the land of trouble and anguish, from whence *come* the young and old lion, the viper and fiery flying serpent, they will carry their riches upon the shoulders of young asses, and their treasures upon the bunches of camels, to a people *that* shall not profit *them.*

7 For the Egyptians shall help in vain, and to no purpose: therefore have I cried concerning this, Their strength *is* to sit still.

8 ¶ Now go, write it before them in a table, and note it in a book, that it may be for the time to come for ever and ever;

9 That this *is* a rebellious people, lying children, children *that* will not hear the law of the LORD:

10 Which say to the seers, See not; and to the prophets, Prophesy not unto us right things, speak unto us smooth things, prophesy deceits:

11 Get you out of the way, turn aside out of the path, 'cause the Holy One of Israel to cease from before us.

12 Wherefore thus saith the Holy One of Israel, Because ye despise this word, and trust in oppression and perverseness, and stay thereon:

13 Therefore this iniquity shall be to you as a breach ready to fall, swelling out in a high wall, whose breaking cometh suddenly at an instant.

14 And he shall break it as the

CH AIRrrrrrr R R

ÊÊÊÊÊÊÊÊ êêêêêêêêêêêêêêêêêêêêêêêêêêêêêêêêêêê
+ Je t'aime + - × 29 caresses + la lune et les uisseaux
chantent sous les arbres.... paradis de mes bras Viens
chance + - × + - 3000 par mois +
vanité eeeeeeeeeeeeee bague rubis 8000 +
6000 frs. chaussures
Demain chez moi
Suis sérieuse Trois
baisers futuristes

TYPOGRAPHIE EL LISSITZKY

P
MERZ -MAtinéen

DER BLINDE ZUSCHAUER. SCHEINWERFER. 4 PERSONEN

KURT SCHWITTERS
RAOUL HAUSMANN

LESEN SIE ZEITSCHRIFT MERZ LESEN SIE ZEITSCHRIFT

REVOLUTION In N
OGRA2M
TÄNZE VORTRAG
ZAHLENLYRIK — LEISE-ROLLEN — BELLENDER HUND

ANNA BLUME
DENATURIERTE POESIE MIT GESANG

TYPSI-STEP
WANG-WANG-BLUES
RAYNBOWS

TATA TATA Tui
tiLLaLaLa tiLLaLaLa
tiLLaLaLa tiLLaLaLa
tui tui tui tui tui tui tui

E E
E. E.
Tui

Neu!

DIE GESETZE DER LAUTE
ALS SEELENMARGARINE
DADAISTISCHE SEEFAHRT
MANIFEST vom fliegenden MAIKÄFER
MANIFEST vom BRUMKREISEL
DIE GESCHICHTE DES JOSEF GNOI
Phonetische Dichtungen

KOLUMBUS
D.R.P.

DRUCKEREI. J. LEUPI & CHAPMAN.

DADA IST DER SITTLICHE ERNST UNSERER ZEIT.
Niemand soll ohne dadaistischen Trost das alte Jahr beschließen
Unerwartete Einlagen.

F HET
MATERIAAL VOOR
VLOEREN - PUIEN
SCHOORSTEENMANTELS
FORTOLIE

《未來主義者的自由之語》（LES MOTS EN LIBERTÉ FUTURISTES: LETTRE D'UNE JOLIE FEMME À UN MONSIEUR PASSEISTE），詩，一九一二年。作者：F. T. 馬利內提（F. T. Marinetti）。在這首未來主義的詩歌裡，馬利內提對詩歌的傳統體例與活版印刷機械式網格帶來的限制大加抨擊。然而網格造成的直線壓力在這件組合作品當中仍然顯而易見。

《梅爾茲——下午場》（MERZ-MATINÉEN），海報，一九二三年。設計者：艾爾·李希茨基（El Lissitzky）。他是一名俄國的建構主義者、藝術家、與設計師，於一九二〇年代至歐洲各國遊歷。他在遊歐期間與各國的前衛派藝術家合作，其中包括了達達主義者柯爾特·史維特斯（Kurt Schwitters）。這張為達達主義派的活動所設計的海報結構嚴謹，由活版印刷的直線網格所構成與活化。

FORTOLIET，明信片，一九二五年。設計者：皮特·茲瓦特（Piet Zwart）。艾蓮·拉斯提格·柯恩（Elaine Lustig Cohen）收藏。荷蘭平面設計師皮特·茲瓦特受到風格派與建構主義的影響，他在為地板材料公司Fortoliet設計視覺識別標誌時突破了排版規則，打造出留名於歷史的字體。

## DIVIDING SPACE
## 劃分空間

十九世紀，報章雜誌多欄位、多媒體的頁面讓新型態的網格有了舞台，也使書籍崇高的地位以及使其與世隔絕的邊界受到挑戰。現代藝術家與設計師質疑框架的保護功能，他們將網格解放為一種有彈性、重要的、有系統的工具。前衛派藝術家與詩人對藝術和日常生活間的界線發動攻擊，創造出融合了都市經驗的新物件與新作法。

　　對於印刷傳統樣式展開抨擊的領導人物是F. T. 馬利內提（F. T. Marinetti），他在一九〇九年發起了未來主義（Futurist）運動。馬利內提設計的詩歌結合了不同風格與大小的字體，並且讓文字的行句橫跨好幾排。馬利內提精心操作印刷技術製造出反抗——但未能跳脫——活版印刷限制的作品；他在試著顛覆網格的同時也將它突顯出來了。達達主義藝術家與設計師也利用活版印刷、拼貼、蒙太奇（montage）、與各種照相製版的手法進行了類似的字體編排實驗。

　　建構主義（Constructivism）起源於一九一〇年代的蘇聯，它以未來主義與達達主義的字體編排設計為基礎，對字體編排設計的傳統展開較為理性的攻擊。艾爾·李希茨基（El Lissitzky）以印刷廠的元素突顯活版印刷技術，利用印刷機的尺規讓字模活躍於印刷品之上。建構主義以尺規劃分空間，讓空間的對稱呈現新的平衡面貌。這個頁面不再是讓內容一目瞭然的固定式、層級分明的視窗，而是一個可以被勘測、連結、超越邊界的開闊空間，。

　　對於荷蘭藝術家與設計師來說，網格是通往無限的門戶。皮特·蒙德里安（Piet Mondrian）的作品以垂直與水平線條構成抽象的畫面，暗示網格已經擴大到超越了畫布的限制。提奧·凡·杜斯伯格（Theo van Doesburg）、皮特·茲瓦特、和其它荷蘭風格派的成員們都運用了這種概念來進行設計與字體編排。他們以網格的網眼過篩，將字母的弧線與角度轉變為直角的系統。和建構主義者一樣，他們利用垂直與水平的線條架構出畫面。

**字體編排設計主要是一種劃分有限畫面的行為。**
**——威利·鮑邁斯特（Willi Baumeister），一九二三年。**

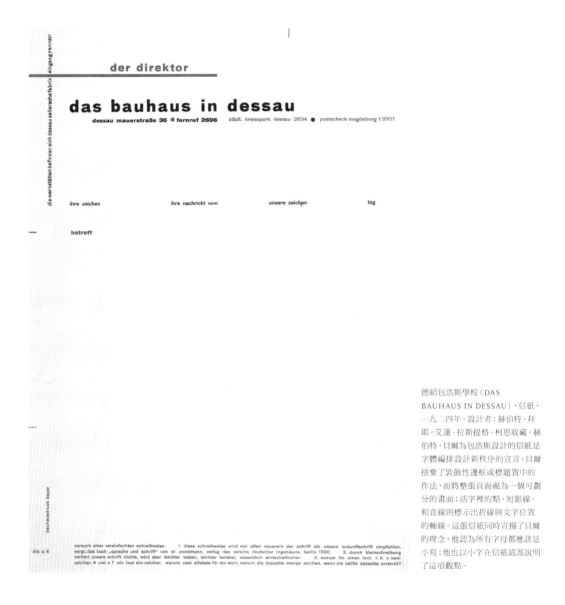

德紹包浩斯學校（DAS
BAUHAUS IN DESSAU），信紙，
一九二四年。設計者：赫伯特·拜
耶。艾蓮·拉斯提格·柯恩收藏。赫
伯特·貝爾為包浩斯設計的信紙是
字體編排設計新秩序的宣言。貝爾
捨棄了裝飾性邊框或標題置中的
作法，而將整張頁面視為一個可劃
分的畫面；活字裡的點、短影線、
和直線則標示出折線與文字位置
的軸線。這張信紙同時宣揚了貝爾
的理念，他認為所有字母都應該是
小寫；他也以小字在信紙底部說明
了這項觀點。

**新的字體編排設計質疑的對象不僅僅是傳統的「框架」，還包括了對稱性
的整套原理。——保羅·倫納，一九三一年。**

揚·奇喬爾德一九二八年於德國出版的著作《新字體編排設計》(The New Typography)採納了未來主義、建構主義、和風格派的理念,並且將它們作為商務印刷業者與設計師的實用建議。使用標準尺寸紙張、並且依功能分區的信紙,是奇喬爾德將現代主義應用於實務上的重要表現。儘管未來主義與達達主義對於傳統慣例多所抨擊,但奇喬爾德卻將設計視為一種維持條理與秩序的工具手段並大加鼓吹;同時他也開始將網格理論化,根據標準的度量單位建立起模組化的網格系統。

在向四面八方擴張空間的情況下,現代網格不知不覺中跨過了傳統的頁面框架。同樣地,現代建築也以不連續的平台、模組化的元素、與帶狀窗戶取代了立面置中的傳統建築樣式。保護性的框架變成了一個連續不斷的區塊。

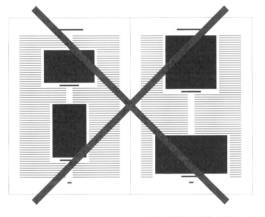

《新字體編排設計》,圖解,一九二八年(重繪)。設計師與作者:揚·奇喬爾德。

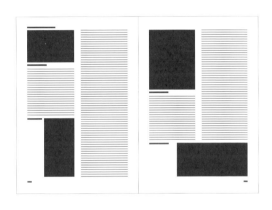

奇喬爾德以圖解方式呈現雜誌的好設計與壞設計,他提倡將圖片與內容交錯配置,避免強迫文字圍繞在置中於頁面的圖片外。奇喬爾德在說明這項實驗時寫道,假使這些代表照片的半色調(又稱為「區塊」)是固定尺寸而非任意大小,他重新設計後的頁面會更具視覺效果。

**我故意將寬度不同且大小隨意的區塊擺放在這裡,因為這就是必須經常面對的挑戰(雖然在區塊大小標準化之後,未來這種情形會較少發生)。——揚·奇喬爾德,一九二八年。**

ZAHN-NOPPER，商店識別標誌，
一九六一年至一九六三年。設計
者：安登・斯丹高斯基（Anton
Stankowski）。這個識別系統展現
了程序化的設計方法，其中利用了
有限的幾個元素打造出多樣，但在
基因上彼此關連的解決方案。這個
系統的主要核心是彈性的建構法
則，而不是一個固定的識別標誌。

# GRID AS PROGRAM
## 程序網格

瑞士設計理論的經典著作包括有約瑟夫・慕勒－布洛赫曼的《平面設計中的網格系統》（Grid Systems in Graphic Design, Switzerland: Ram Publications, 1996；首次出版於一九六一年）和《平面藝術家和他的設計問題》（The Graphic Artist and His Design Problems, Switzerland: Arthur Niggli Ltd., 1961）以及卡爾・蓋斯納，《設計程序》（Designing Programmes, Switzerland: Arthur Niggli Ltd., 1964）。也可以參考埃米爾・胡德的著作，《字體編排設計》（Typography, New York: Hastings House, 1981；首次出版於一九六七年）。

二次世界大戰之後，瑞士的平面設計師們將《新字體編排設計》的概念發展為全面性的設計方法論。當時「網格」（grid，於德文為raster）一詞被普遍使用在頁面配置上。麥克斯・比爾（Max Bill）、卡爾・蓋斯納（Karl Gerstner）、約瑟夫・慕勒－布洛赫曼（Josef Müller-Brockmann）、埃米爾・胡德（Emil Ruder）等人都是新理性主義的實踐者與理論家，他們對於催生一個正直、民主的社會不遺餘力。他們在藝術上抗拒表現自我與純然直覺的陳腔濫調，而嚮往胡德所謂的「冷靜迷人之美」的境界。

蓋斯納的著作《設計程序》（Designing Programmes，一九六四年）是一份系統導向設計的宣言。蓋斯納將設計「程序」定義為一套建構視覺解決方案的法則。蓋斯納將他的方法論與電腦程式的新領域連結，展示了一些由電腦產生的花樣做為範例，他以數學運算方式描繪出視覺元素，再根據簡單的規則將它們組合起來。

這批瑞士的理性主義者將前輩如貝爾、奇喬爾德、雷納、與其他前衛派設計師的想法發揚光大，他們捨棄數百年來「頁面即框架」的模型，支持連續性的建築空間。傳統書籍會在受到保護的邊欄裡放置圖片說明文字、評論、與頁碼，理性主義的網格則會將頁面切分為好幾個欄位，每個欄位所佔的比重相當，暗示了無定限的向外發展進程。圖片被裁切成特殊比例的形狀，以符合網格的模組。為了建構出更精緻的網格，瑞士設計師們利用重複結構的邊界產生出各種不同的變化與驚喜。在單一出版品中，這種網格可以透過許多方式啟動，最後也總是會回歸到根本的結構上。

這種很快被人稱為「瑞士設計」的方法在全世界都有擁護者（與反對者）；許多美國設計師認為瑞士理性主義與以大眾文化為主流、快速求新求變的社會脫節而加以揚棄。然而今日的設計師們必須面對大規模資訊專案，程序化的思考方式又開始重新流行。對於為了因應動態的內容主體而設計的彈性「程序」，其需求較以往有過之而無不及。

字體編排設計的網格是排字、表格、圖片……等等的比例調節器。其難題在於：要在極度順從規則與極度自由之間找到平衡點。或者是：要求取出可變度最大化的常數。——卡爾・蓋斯納，一九六一年。

14. Eingangshalle

15. Treppe

## 2 Mehrfamilienhäuser im Doldertal Zürich

**Räumliche Organisation**

Situation: Die beiden Mehrfamilienhäuser liegen im Villenviertel, auf halber Höhe des westwärts abfallenden „Zürichberg" [4]. Längs dem Grundstück verläuft auf der Nordwestseite eine öffentliche Parkanlage mit einem dichten Baumbestand. Die Zufahrtsstrasse genannt „Doldertal" hat ein Gefälle von 10% und ist nicht durchgehend. Die Schrägstellung der Blöcke zur Baulinie ergibt eine verbesserte Südlage für die Wohnräume, eine Abdrehung der Schlafräume von der Strasse und eine lockere Gesamtanlage, ohne gegenüberliegende Schmalseiten. [5] (Siehe auch baugesetzliche Sonderheiten.) Raumprogramm: Es ist versucht worden, die Vorzüge des Einfamilienhauses soweit als möglich auf die Etagenwohnung zu übertragen (freies, schallsicheres Wohnen, Einbeziehung der Landschaft, grosse Wohnterrassen, weitgehende innere Ausstattung). Im Untergeschoss: Gedeckter Vorplatz mit zwei Garagen, Eingangshalle mit Treppenaufgang, Abstellräume, Vorratskeller, Waschküche und Trockenraum, die beiden letzten nur im untern Haus. Unter der Eingangshalle mit besonderm Eingang [9] [7] liegen Heizung und Kohlenraum. Im Parterre: eine Vierzimmerwohnung mit Mädchenzimmer und ein Einzimmer-Appartment mit direktem Eingang vom Garten. Im Obergeschoss: eine 5/6-Zimmerwohnung mit Mädchenzimmer. Zu dieser

2 Mehrfamilienhäuser im Doldertal Zürich     52

Wohnung gehört noch ein auf Höhe Dachgeschoss liegendes Sonnenbad [12] [16], durch eine Eisentreppe von der Terrasse erreichbar. In beiden Wohnungen liegen Treppe und Küche ausserhalb der eigentlichen Wohnfläche (Schallisolation); dennoch hat die Küche eine betriebstechnisch zentrale Lage (Verbindung mit der Terrasse, je eine Durchreiche nach Essplatz und Treppenhaus). Im Dachgeschoss ein grosses und ein kleines Atelier, Abstellräume im Treppenbau.

**Technische Durchbildung**
(vgl. Technische Details)

Konstruktionsprinzip: Eisenskelett, Eisenbeton-Zwischendecken, Fassadenausmauerung mit gebrannten Hohlsteinen, hintermauert mit Gipsdielen. Die Fassaden sind konstruktiv von den Zwischendecken getrennt. Das zurückgesetzte Dachgeschoss besteht aus Holz mit einer äussern Eternitverkleidung. Zur Fertigstellung des Äussern sind ausschliesslich Materialien mit unterhaltsloser Oberfläche verwendet worden: Edelputz (weisser Zement, Natursteinpartikeln, ohne Farbbeigabe); Eternit für Rolladenkasten, Brüstungen, Sonnen-Storen-Vordach und Dachgeschossaufbau; lackiertes Holz für Rolladen und Garagentore; Kupfer für sämtliche Spenglerarbeiten; feuerverzinktes Eisen für Fensterbleche, Geländer. Gestrichen sind lediglich die Fenster und gewisse Metallteile aus architektonischen Gründen. Fensterflächen: Horizontal-Schiebefenster in Föhrenholz in den Woh-

nungen. Grösse des Normalfensters 310 × 120 cm, zusammengeb mit dem Rolladenkasten; fester Teil einwärts klappbar zum Reinig Die Südfenster des Wohnraumes sind mit der Brüstung zusammen gebaut (vgl. [21], [22], [23]). Die Küchenfenster sind doppelt, übrigen Fenster am Bau sind einfach verglast. Die Ateliers hab durchgehende 45 cm hohe Oberlichter unter der Decke zum Lüftung klappen, sowie gewisse fest verglaste Fenster mit normaler Brüstu Verglasung: Wohnungsfenster Spiegelglas 6/7 mm, Atelier-Ob lichter Rohglas, Treppenhausfenster Drahtglas. Sonnenschutz: die Wohnzimmerfenster vor die Fassade gehängte Sonnensto [21] [44], für die Schlafzimmer Roll-Jalousien. Heizung: Jedes Ha hat seine eigene Warmwasserheizung für Kleinkaliberkoks, gleichzeitig für die Warmwasserbereitung benützt wird. Pro Ha ein Warmwasserboiler mit 1000 Liter Inhalt. Wohnungsausstattung: Die beiden Häuser sind für anspruchsvo Mieter, jedoch ohne Luxus ausgestattet. Die Zimmer sind de entsprechend geräumig dimensioniert (Wohnraum 35,00 m³, Terras 20,00 m³). Die Skelettkonstruktion erlaubt jederzeit eine den WO schen der Mieter entsprechende Variabilität des Grundrisses. Wohnraum befindet sich ein offener Kamin und ein breites Fenste brett für Blumen. Eingebaute Schränke im Korridor, in den Zimme kleiner Abstellraum. Fussböden: In den Wohnungen Holzmosa (Esche im Wohnraum, Eiche in den übrigen Räumen und im Korrido

16. Teilansicht von Südwest mit Eingang und Garagen

In den Küchen sind Steinzeugplatten, versuchsweise Linoleum; in den Bädern Terrazzo, schwarz, mit weissen Marmorkörnern. Die Treppentritte und Podeste bestehen ebenfalls aus Terrazzo (Tritte fertige Platten, Podeste im Bau gegossen und geschliffen). Die Stirnseiten der Tritte und die Sockel sind mit weissen, hartglasierten Platten belegt [14]. Die Böden der Ateliers sind mit hellgrauem Linoleum belegt. Wandbehandlung: Gipsverputz in sämtlichen Räumen, Kalkabrieb in Küchen, Bädern und Aborten. Die Wände der Zimmer sind mit Ausnahme derjenigen in den Wohnräumen und Gängen (tapeziert mit Grundpapier und Leimfarbanstrich, oder Ölfarbanstrich auf Stoffbespannung). In den Ateliers Verkleidung der Wände in Holzkonstruktion mit Sperrplatten (gewachste finnische Birke).
Im Treppenhaus: Aussenwand stoffbespannt, mit Ölfarbe gestrichen, mittlere Brüstungswand gespachtelt und Hochglanz mit Ripolin gestrichen; der Handlauf in Eisen, im Feuer weiss emailliert. Fenstersimsen: Diese bestehen in allen Räumen der Wohnungen aus perforierten, 3 cm starken Schieferplatten. Ausstattung der Bäder und Küchen: Grösse des Bades in den Wohnungen 6 m² mit Badwanne, Bidet und zwei Lavabos, W.C. Der Spiegel über dem Lavabos ist gegen die festverglaste Fensterfläche gehängt (Licht auf das Gesicht). Die Küchen sind vollständig ausgestattet, je eine Durchreiche ins Treppenhaus und in den Wohn-Essraum, zweiteiliger Aufwaschtisch in Chrom-

nickel-Stahlblech, Kühlschrank, Arbeitsflächen in Ahornholz. Elektrische Beleuchtung: Diese ist in allen Wohn- und Schlafräumen, Gängen, Küchen, Ateliers eine indirekte.

**Ökonomische Angaben**
Die beiden Häuser sind Privatbesitz von Herrn Dr. S. Giedion, Zentralsekretär der Internationalen Kongresse für Neues Bauen. Die Baukosten inkl. Architektenhonorar betragen: 43,5 Maurerstunden pro m³ umbauten Raumes bei total 1985 m³ pro Haus, offene Halle im Parterre zur Hälfte gerechnet. Die durchschnittlichen Baukosten für normale Wohnbauten in Zürich, ohne besonderen Ausbau, betragen 38 bis 40 Maurerstunden pro m³ umbauten Raumes. (1 Mstd. = Fr. 1.72 1935/36)

**Ästhetischer Aufbau**
Die Schrägstellung der Blöcke ergibt einerseits eine lockere Gesamtanlage und erhöht andererseits deren plastische Selbständigkeit. Der zweigeschossige Charakter der Häuser (Baubestimmung der betreffenden Zone) wird durch das Loslösen des Baukörpers vom Terrain und durch das Zurücksetzen des Dachgeschosses gewahrt. Dieser Eindruck wird verstärkt durch die vom Hauptbau abweichende Konstruktion des Dachgeschosses (Holz und Eternit). In der Südfassade ist durch Weglassen der gemauerten Brüstungen ein äusseres Zusam-

menfassen von Wohnraum und Wohnterrasse erreicht. In der räumlichen Gliederung treten vielfach schräg verlaufende Wände auf, wodurch eine gewisse Auflockerung der Rechtwinkligkeit erreicht wird. Die Eingangshalle ganz in Glas hat eine freie Form und lässt den Durchblick in den rückwärtsliegenden Park frei.
Der Garten reicht über die weitergeführten Gartenplatten (Granit) bis zum Treppenaufgang. In den Wohnräumen und Ateliers reichen die Fenster bis zur Decke, in den Schlafräumen ist ein Sturz von 40 cm. In der Dimensionierung von Bauteilen und Ausstattungsdetails ist eine der betreffenden Material entsprechende Sparsamkeit sowie eine organische und gepflegte Formgebung beobachtet worden.
Materialbehandlung und Farbgebung: Aussen wirken die Baustoffe in ihrer natürlichen Struktur und Farbe: Edelputz (weisser Zement mit roten, schwarzen und glimmernden Steinsplittern), Eternit, lackiertes Holz, Eisenteile feuerverzinkt, mit Aluminiumfarbe gestrichen. Farbe an folgenden Stellen: Fensterrahmen dunkelgrau, Geländerrohre, Abdeckbleche weissgrau und hellgrau gestrichen. Im Innern: Die Wände im Treppenhaus, in den Gängen und Nebenräumen sind weissgrau, ebenso das gesamte Holzwerk, Radiatoren, Leitungen. Die Wände der Wohn- und Schlafräume sind hell getönt (beige, rosa, hellblau, grau). Besondere farbige Akzente kommen weder aussen noch innen vor; es ist damit der wechselnden Bewohnung des Miethauses Rechnung getragen worden.

53
**2 Mehrfamilienhäuser im Doldertal Zürich**

《新建築》（DIE NEUE ARCHITEKTUR·The NEW ARCHITECTURE），書籍·一九四〇年。設計者：麥克斯·比爾。作者：麥克斯·羅斯（Max Roth）。攝影者：丹·梅爾斯。

這本書由麥克斯·比爾於一九四〇年設計，被公認為第一本使用系統化模組網格的出版品。書中每一張圖片都被調整為符合欄位結構的大小——就如同揚·奇喬爾德於一九二八年所預測——並填入一個、兩個、或三個區塊當中。為了向版面樣式的創舉致敬，作者稱比爾為「本書字體編排結構的創造者」。

Der New-York-Times-Prospekt zeigt die Lösung einer komplexen Aufgabe; zeigt, wie eine Idee, ein Text und die typographische Darstellung über mehrere Phasen hinweg integriert werden. Darüber hinaus kann sich die Aufgabe stellen, Prospekte wie diesen wiederum mit andern Werbemitteln und Drucksachen zu integrieren. Denn heute brauchen Firmen mehr und mehr nicht bloss hier einen Prospekt, da ein Plakat, dort Inserate usw. Heute braucht eine Firma etwas anderes: Eine Physiognomie, ein optisches Gesicht.

Die Beispiele dieser Seiten geben die Physiognom der boîte à musique, eines Grammophongeschäfts in Basel, wieder. Die boîte à musique hat ein Signe und einen firmeneigenen Stil – und doch wieder nicht wenn man unter dem einen ein starres, nachträglich überall dazugesetztes Zeichen und unter dem ande ein bloss ästhetisches Prinzip versteht. Vielmehr: Die einmal definitiv festgelegten, aber jeweils den verschiedenen Funktionen und Proportionen angepassten Elemente selber bilden das Signum und de Stil in einem.

Abbildung 13 zeigt die Struktur. Fixiert sind die Elemente Schrift und Rahmen; ferner die Verbindung von beiden und das Prinzip der Variabilität: der Rah men kann, ausgehend von der Ecke unten rechts, nach oben sowie nach links beliebig um ganze Einheiten vergrössert werden. Einen in sich proportion hervorragenden Fall gibt es nicht. Es gibt nur wortgleiche Varianten; und hervorragend ist die Variant dann, wenn sie der jeweiligen Aufgabe am besten a gemessen ist.

Abbildung 14 zeigt die Neujahrskarte mit gleichzeit verschieden proportionierten Varianten; 15 den Brie bogen, wo das Signum dem (gegebenen) Din A4 Format angepasst ist; 16 und 17 Inserate, wieder en sprechend dem zur Verfügung stehenden Insertion raum bemessen; 18 ein Geschenkbon.

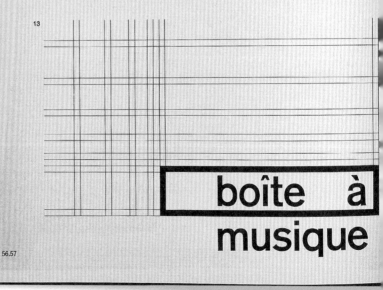

13

56.57

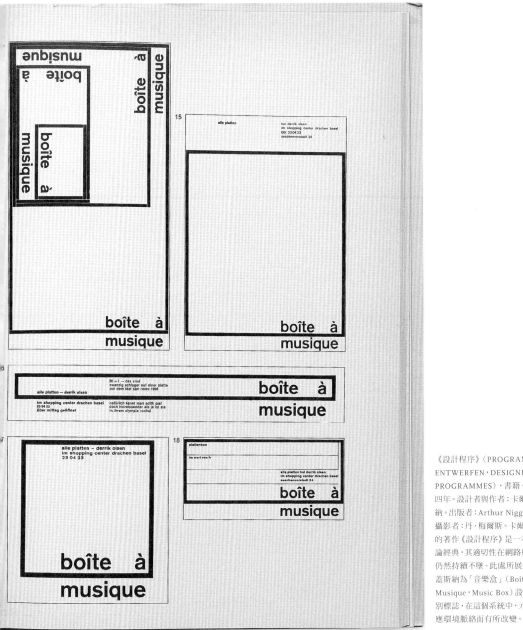

《設計程序》（PROGRAMME
ENTWERFEN・DESIGNING
PROGRAMMES），書籍，一九六
四年。設計者與作者：卡爾・蓋斯
納。出版者：Arthur Niggli Ltd.，
攝影者：丹・梅爾斯。卡爾・蓋斯納
的著作《設計程序》是一本設計理
論經典，其適切性在網路媒體時代
仍然持續不墜。此處所展示的是
蓋斯納為「音樂盒」（Boîte à
Musique，Music Box）設計的識
別標誌，在這個系統中，元素會因
應環境脈絡而有所改變。

# GRID AS TABLE
## 表格網格

表格（tables）與曲線圖（graphs）是字體編排設計網格的一種變化型。表格當中包括了垂直欄與水平列，資料放置在每一個儲存格（cell）裡。曲線圖則是由x軸與y軸構成的網格上標示出一條線，圖上的每一個維度都代表了一個變數。根據資訊設計界重量級評論家與理論家愛德華・塔夫特的說法，表格與曲線圖讓數字彼此之間的關係得以被眼睛所理解並快速進行比較。在表格與曲線圖中，網格是一種認知工具。

　　表格是網頁設計的核心面向。一九九五年，表格功能被整合至HTML編碼當中，網頁作者因而能夠呈現表格資料。平面設計師們迫不及待要替網頁寬鬆疲軟的內文主體定型，他們很快便為HTML表格發展出各種未經授權的使用方法，將這項呈現資料的工具分毫未差地轉變為字體編排設計的網格。設計師們利用這項表格功能控制圖片與圖說文字的擺放位置，並據以建立邊界、間溝、和多欄式螢幕畫面。透過表格，他們也可以在一份文件中結合多種不同的對齊樣式——例如靠左對齊與靠右對齊，並且建立優雅的編號清單與項目符號清單。

攀登吉力馬札羅山（CLIMBING KILIMANJARO），下圖，互動資訊圖表，二〇〇七年。平面設計總監：史帝夫・杜尼斯（Steve Duenes）/NYTimes.com。圖片由《紐約時報》（New York Times）提供。這個互動式3D旅行記錄追蹤了湯姆・畢索（Tom Bissell）椎心蝕骨的吉力馬札羅山（Mount Kilimanjaro）登頂過程。節節昇高的曲線標示出畢索移動的距離與高度變化之間的關係。這張圖表將他的攀登路徑與沿途所拍攝的照片、以及畢索持續上升的心跳與急速下降的血氧濃度等記錄報導整合在一起。

關於資訊設計的美學與倫理，請參考愛德華‧塔夫特的著作《資訊視覺化》（Envisioning Information, Cheshire, Conn.: Graphics Press, 一九九〇年）。

關於設計無障礙網站，請參考傑佛瑞‧澤爾曼與伊森‧馬爾寇特的著作，《跨平台網頁設計——使用Web標準技術》（Designing with Web Standards），第三版（Berkeley, CA: New Riders, 2009）；派屈克‧林區（Patrick Lynch）與莎拉‧霍爾頓（Sarah Horton）合著的《網頁樣式指南：網站製作的基本原則》（Web Style Guide: Basic Design Principles for Creating Web Sites, New Haven: Yale University Press, 2001）。也可參考網站：www.webstyleguide.com。

透過創造跨欄與跨列的儲存格，設計師建立的版面結構與資料圖表排列有序的區塊不會有太多關連。主表格一般被做為導航、內容、與網站識別的區域，而每一區裡都會包含一個較小的表格——或多個表格。網格會在網格裡增生。

網頁設計標準的提倡者反對這種變通的方法，認為這是虛假、不道德的設計手段。視覺化導向、不合邏輯的版面表格對視力受損的使用者來說會造成問題，因為他們所使用的各種設備會一個儲存格接著一個儲存格、一列接著一列地將數位頁面轉譯成聲音。「自動報讀器」會將數位文本「線性化」為一連串的口說文字。無障礙專家鼓勵網頁設計師盡可能「以線性的方式思考」，並確保他們的表格在以連續不斷的方式閱讀下也能夠被理解。無障礙網站也會考量老舊軟體或純文字瀏覽器使用者的需求。線性化思考除了幫助視力受損的觀眾之外，行動裝置的使用者也因為閱讀版面窄小而同樣能夠受惠。

MICA.EDU，網站，二〇〇四年。設計者：Carton Donofrio Partners。出版者：馬里蘭藝術學院。HTML表格的邊界被柔和地顯現出來，並成為這個整齊分格的網頁頁面要素之一。在這裡，表格要素不是被當成隱密的網格使用，而是一個可以將內容組織在欄與列當中的結構。

HTML，這個讓網際網路成為全球化大眾傳播工具的增值系統，是活版印刷的虛擬版本。活版印刷讓書籍的生產機械化，並且為全世界的印刷文化開路。就如同活版印刷一樣，HTML也是一個渴求文本的媒介，只要耐著性子慢慢處理，就能讓它展示圖像。

　　HTML與其它語言並存於網頁上，就像活版印刷也有與其搭配的其它技術一樣。用以製作圖像的平版印刷術（lithography）發明於十八世紀，而除了圖片之外，這項技術很快就將文字的印刷一併納入，如同活版印刷在它的機械網格中為木刻、雕版、和半色調照片區塊騰出空間一樣。到了二十世紀，平版印刷取代活版印刷成為全世界印刷方法的主流；搭配數位或照相排版使用，不論是文字或圖片，平版印刷都可以自在流暢地呈現。

　　平版印刷不像活版印刷那樣不斷被網格掌控著。Flash也是，這個動畫軟體在二十世紀、二十一世紀之交成為最普遍的網頁設計工具。Flash原本是為了向量式動畫的製作而設計的。雖然Flash最初的目的是為了解決圖畫問題，但設計師們很快就利用它來建構整個網站的介面。Flash網站在一九九〇年末期成為新網頁美學典範，它們通常以文字和圖片如畫般結合為其特色，所呈現出的風格多了電影性、少了印刷感。不久之後，Flash網站便被範本驅動網站（template-driven sites）所取代，這些網站是由動態的內容管理系統所建構起來的。在這些網站上，元素是透過CSS（層疊樣式表）安排放置；由於有結構性的外觀，所以即便隨著時間發展，仍然可以預知設計出來的結果。

徒手編排HTML網頁就像是進行金屬活字排版一樣，是一件緩慢而精細的工程。空白的表格儲存格被用於定義出開放空間的區域，但HTML會讓這些空間崩壞，因為假使儲存格內的值是完全空白的，網格會向內擠壓。這些空間通常會以透明的圖片填滿，就如同使用於金屬活字上的空白間隔素材。

砧板（THE CHOPPING BLOCK），網站（細部），二〇〇四年。設計者：湯瑪斯·洛摩爾（Thomas Romer）、傑森·希耶爾（Jason Hillyer）、查爾斯·米契萊（Charles Michelet）、羅伯特·里德（Robert Reed）、馬修·里奇蒙（Mathew Richmond）／砧板。這個網站重現了二十世紀初期的水果箱標籤設計，當時的水果箱標籤是以平版印刷方式結合文字與圖片。這個網頁是動態的，網頁元素會隨著時間載入。

JOSHUADAVIS.COM，網站，二〇〇九年。設計者：約書亞‧戴維斯
（Joshua Davis）。在這個範本驅動的網站上，所有元素都被自動配
置到一個制式的網格裡。

# RETURN TO UNIVERSALS
## 回歸通用性

威廉·吉布森（William Gibson）在他一九八四年的小說《神經喚術士》（Neuromancer）當中，將網路空間想像為一個浩瀚虛空的網格。吉布森故事中的數據牛仔（data cowboy）離開他的血肉之軀，神遊到了一個「無邊無際的透明立體棋盤裡。」在吉布森的小說中，這個棋盤網格是投射在心靈裡的，不受到任何螢幕或視窗的約束。

　　無邊無際的網格——對抗邊界、受心靈而非身體所控制——兼具了理性與崇高的形式，是現代主義理論當中強而有力的工具。在二十世紀早期，前衛派設計師突顯網格為的是要讓印刷的機械性更加戲劇化。二次世界大戰之後，瑞士設計師根據網格打造了全面性的設計方法論，將它與思想意圖融合；網格成為他們通往普及性語言的鑰匙。到了一九七〇年代與一九八〇年代，後現代轉向歷史的、在地的、與流行的源頭，許多設計師開始反對理性主義的網格，認為這是瑞士一絲不苟的社會底下所產生的奇特加工品。

　　網際網路的興起再次引起大家對於普及性設計思考的興趣。網頁發明於一九九〇年代早期（在瑞士），為的是要讓科學家與研究人員能彼此分享以不同軟體應用程式製作的文件。它的發明者提姆·伯納－李（Tim Berners-Lee）從沒料想到網頁會成為一種設計導向的媒體，並且將全世界不計其數、具有各種不同行為能力與動機的人們串連起來。

　　通用設計系統不能再被視為是小型地方設計社群無關痛癢的發想了。第二次現代主義已經浮上檯面；近百年前對於通用形式烏托邦式的追尋標誌了設計論述與學科的誕生，如今這種追尋又再次復甦。由於受限於地區性的喜好與個人的執迷，獨特的視覺表現方式往往顯得晦澀難懂、稀奇怪異，為了與之相抗衡，資訊會再次試圖擺脫實際形體，而此時共通性、透明性、與開放性的觀念也會隨之復活。

關於網頁的發明，請參考提姆·伯納－李的著作《一千零一網》（Weaving the Web, New York: HarperCollins，一九九九年。繁體中文版由台灣商務於一九九九年出版）。關於當代對於通用設計思考的論述，請參考威廉·立德威（William Lidwell）、克莉汀娜·荷登（Kritina Holden）、和吉兒·巴特勒（Jill Butler）合著的《設計的法則》（Universal Principles of Design, Gloucester, Mass.: Rockport Publishers，二〇〇三年。繁體中文版由原點出版社於二〇一一年出版）。另外也可參考威廉·吉布森的作品《神經喚術士》（Neuromancer, New York: Ace Books，一九八四年。繁體中文版由開元書印於二〇一二年出版）。

**創作出客觀有用的設計基本上是一件社會文化工作。**
**——約瑟夫·慕勒－布洛赫曼，一九六一年。**

WWW.SANDBERG.NL。網站,二
○○三年。設計者:魯娜・毛爾
(Luna Maurer)。出版者:Sandberg
Institute。這個網格是一個導航裝
置,它的畫面會隨著使用者的游標
在上面滑動而扭曲變形。垂直軸代
表學校的部門,水平軸代表各種學程
資訊。當使用者的游標滑過網格上
方,格室會發亮且看起來像是從螢幕
畫面上浮起,同時也表示這個交叉點
上有資訊內容可供點閱。

# GOLDEN SECTION
## 黃金分割

a

b

黃金分割出現在自然界、以及藝術
與設計之中，它有許多令人驚訝的
特性。舉例來說，當你將一個正方
形從一個黃金長方形中移走，剩
下來的部分會成為另一個黃金長
方形，無限重複這個過程便可以
創造出一個螺旋形。

少了關於黃金分割的討論，沒有一本關於字體編排設計的書會是完整的。黃金分割是在西方藝術與建築裡已有兩千年運用歷史的一個比例（意指兩個數字之間的關係）。黃金分割的公式是a : b = b : (a + b)。

這個意思是兩個相關要素當中較小數（例如長方形的較短邊）與較大數的關係，等於較大數與兩數和的關係。換句話說，邊長「a」對邊長「b」等於邊長「b」對兩邊長之和。以數字來表達的話，黃金分割的比例會是1 : 1.618。

有些平面設計師對於黃金分割非常著迷，會利用它創作出各種不同的網格與頁面樣式——甚至於有整本都在討論這個主題的專書。也有設計師認為，就作為衍生出尺寸與比例的基礎而言，黃金分割已經不如其它方法——比方說從標準工業紙張尺寸著手、或將畫面切成對半或一個個正方形、或者單純挑選整數頁樣式並在其中做合理的分割——來得有效。

A grid can be simple or complex, specific or generic, tightly defined or loosely interpreted. Typographic grids are all about control. They establish a system for arranging content within the space of page, screen, or built environment. Designed in response to the internal pressures of content (text, image, data) and the outer edge or frame (page, screen, window), an effective grid is not a rigid formula but a flexible and resilient structure, a skeleton that moves in concert with the muscular mass of content. Grids belong to the technological framework of typography, from the concrete modularity of letterpress to the ubiquitous rulers, guides, and coordinate systems of graphics applications. Although software generates illusions of smooth curves and continuous tones, every digital image or mark is constructed—ultimately—from a grid of neatly bounded blocks. The ubiquitous language of the gui (graphical user interface) creates a gridded space in which windows overlay windows. In addition to their place in the background of design production, grids have become explicit theoretical tools. Avant-garde designers in the 1910s and 1920s exposed the mechanical grid of letterpress, bringing it to the polemical surface of the page. In Switzerland after World War II, graphic designers built a total design methodology around the typographic grid, hoping to build from it a new and rational social order. The grid has evolved across centuries of typographic evolution. For graphic designers, grids are carefully honed intellectual devices, infused with ideology and ambition, and they are the inescapable mesh that filters, at some level of resolution, nearly every system of writing and reproduction.  A grid can be simple or complex, specific or generic, tightly defined or loosely interpreted. Typographic grids are all about control. They establish a system for arranging content within the space of page, screen, or built environment. Designed in response to the internal pressures of content (text, image, data) and the outer edge or frame (page, screen, window), an effective grid is not a rigid formula but a flexible and resilient structure, a skeleton that moves in concert with the muscular mass of content. Grids belong to the technological framework of typography, from the concrete modularity of letterpress to the ubiquitous rulers, guides, and coordinate systems of graphics applications. Although software generates illusions of smooth curves and continuous tones, every digital image or mark is constructed—ultimately—from a grid of neatly bounded blocks. The ubiquitous language of the gui (graphical user interface) creates a gridded space in which windows overlay

8.5× 11吋（美規）頁面上的
黃金長方形文字方塊

A grid can be simple or complex, specific or generic, tightly defined or loosely interpreted. Typographic grids are all about control. They establish a system for arranging content within the space of page, screen, or built environment. Designed in response to the internal pressures of content (text, image, data) and the outer edge or frame (page, screen, window), an effective grid is not a rigid formula but a flexible and resilient structure, a skeleton that moves in concert with the muscular mass of content. Grids belong to the technological framework of typography, from the concrete modularity of letterpress to the ubiquitous rulers, guides, and coordinate systems of graphics applications. Although software generates illusions of smooth curves and continuous tones, every digital image or mark is constructed—ultimately—from a grid of neatly bounded blocks. The ubiquitous language of the gui (graphical user interface) creates a gridded space in which windows overlay windows. In addition to their place in the background of design production, grids have become explicit theoretical tools. Avant-garde designers in the 1910s and 1920s exposed the mechanical grid of letterpress, bringing it to the polemical surface of the page. In Switzerland after World War II, graphic designers built a total design methodology around the typographic grid, hoping to build from it a new and rational social order. The grid has evolved across centuries of typographic evolution. For graphic designers, grids are carefully honed intellectual devices, infused with ideology and ambition, and they are the inescapable mesh that filters, at some level of resolution, nearly every system of writing and reproduction.  A grid can be simple or complex, specific or generic, tightly defined or loosely interpreted. Typographic grids are all about control. They establish a system for arranging content within the space of page, screen, or built environment. Designed in response to the internal pressures of content (text, image, data) and the outer edge or frame (page, screen, window), an effective grid is not a rigid formula but a flexible and resilient structure, a skeleton that moves in concert with the muscular mass of content. Grids belong to the technological framework of typography, from the concrete modularity of letterpress to the ubiquitous rulers, guides, and coordinate systems of graphics applications. Although software generates illusions of smooth curves and continuous tones, every digital image or mark is constructed—ultimately—from a grid of neatly bounded blocks. The ubiquitous language of the gui (graphical user interface) creates a gridded space in which windows overlay windows. In addition to their

A4（歐規，210×297mm）頁面上的
黃金長方形文字方塊

商用印刷機通常傾向於使用尺寸被裁切得整整齊齊的紙張，而不喜歡有零碎的部分。然而任何切淨尺寸的紙張上都可以畫出黃金長方形來。

關於設計與黃金分割的詳細論述，請參考金柏莉·伊蓮姆（Kimberly Elam），《設計的幾何學》（Geometry of Design, New York: Princeton Architectural Press, 2001）。若想特別了解黃金分割在字體編排設計上的運用，請參考約翰·肯恩（John Kane）的著作《字體入門》（A Type Primer, London: Laurence King, 2002）。

以黃金分割為基礎製作網站似乎有些可笑，然而這裡就有一個設計實例。這張線框圖畫出了一個500 × 809畫素的網頁，接下來這個「黃金螢幕」便被正方形與黃金長方形所切割。

# SINGLE-COLUMN GRID
## 單欄網格

A grid can be simple or complex, specific or generic, tightly defined or loosely interpreted. Typographic grids are all about control. They establish a system for arranging content within the space of page, screen, or built environment. Designed in response to the internal pressures of content (text, image, data) and the outer edge or frame (page, screen, window), an effective grid is not a rigid formula but a flexible and resilient structure, a skeleton that moves in concert with the muscular mass of content. Grids belong to the technological framework of typography, from the concrete modularity of letterpress to the ubiquitous rulers, guides, and coordinate systems of graphics applications. Although software generates illusions of smooth curves and continuous tones, every digital image or mark is constructed—ultimately—from a grid of neatly bounded blocks. The ubiquitous language of the gui (graphical user interface) creates a gridded space in which windows overlay windows. In addition to their place in the background of design production, grids have become explicit theoretical tools. Avant-garde designers in the 1910s and 1920s exposed the mechanical grid of letterpress, bringing it to the polemical surface of the page. In Switzerland after World War II, graphic designers built a total design methodology around the typographic grid, hoping to build from it a new and rational social order. The grid has evolved across centuries of typographic evolution. For graphic designers, grids are carefully honed intellectual devices, infused with ideology and ambition, and they are the inescapable mesh that filters, at some level of resolution, nearly every system of writing and reproduction. A grid can be simple or complex, specific or generic, tightly defined or loosely interpreted. Typographic grids are all about control. They establish a system for arranging content within the space of page, screen, or built environment. Designed in response to the internal pressures of content (text, image, data) and the outer edge or frame (page, screen, window), an effective grid is not a rigid formula but a flexible and resilient structure, a skeleton that moves in concert with the muscular mass of content. Grids belong to the technological framework of typography, from the concrete modularity of letterpress to the ubiquitous rulers, guides, and coordinate systems of graphics applications. Although software generates illusions of smooth curves and continuous tones, every digital image or mark is constructed—ultimately—from a grid of neatly bounded blocks. The ubiquitous language of the gui (graphical user interface) creates a gridded space in which windows overlay windows. In addition to their place in the background of design production, grids have become explicit theoretical tools. Avant-garde designers in the 1910s and 1920s exposed the mechanical grid of letterpress, bringing it to the polemical surface of the page. In Switzerland after World War II, graphic designers built a total design methodology around the typographic grid, hoping to build from it a new and rational social order. The grid has evolved across centuries of typographic evolution. For graphic designers, grids are carefully honed intellectual devices, infused with ideology and ambition, and they are the inescapable mesh that filters, at some level of resolution, nearly every system of writing and reproduction. A grid can be simple or complex, specific or generic, tightly defined or loosely interpreted. Typographic grids are all about control. They establish a system for arranging content within the space of page, screen, or built environment. Designed in response to the internal pressures of content (text, image, data) and the outer edge or frame (page, screen, window), an effective grid is not a rigid formula but a flexible and resilient structure, a skeleton that moves in concert with the muscular mass of content. Grids belong to the technological framework of typography, from the

A grid can be simple or complex, specific or generic, tightly defined or loosely interpreted. Typographic grids are all about control. They establish a system for arranging content within the space of page, screen, or built environment. Designed in response to the internal pressures of content (text, image, data) and the outer edge or frame (page, screen, window), an effective grid is not a rigid formula but a flexible and resilient structure, a skeleton that moves in concert with the muscular mass of content. Grids belong to the technological framework of typography, from the concrete modularity of letterpress to the ubiquitous rulers, guides, and coordinate systems of graphics applications. Although software generates illusions of smooth curves and continuous tones, every digital image or mark is constructed—ultimately—from a grid of neatly bounded blocks. The ubiquitous language of the gui (graphical user interface) creates a gridded space in which windows overlay windows. In addition to their place in the background of design production, grids have become explicit theoretical tools. Avant-garde designers in the 1910s and 1920s exposed the mechanical grid of letterpress, bringing it to the polemical surface of the page. In Switzerland after World War II, graphic designers built a total design methodology around the typographic grid, hoping to build from it a new and rational social order. The grid has evolved across centuries of typographic evolution. For graphic designers, grids are carefully honed intellectual devices, infused with ideology and ambition, and they are the inescapable mesh that filters, at some level of resolution, nearly every system of writing and reproduction. A grid can be simple or complex, specific or generic, tightly defined or loosely interpreted. Typographic grids are all about control. They establish a system for arranging content within the space of page, screen, or built environment. Designed in response to the internal pressures of content (text, image, data) and the outer edge or frame (page, screen, window), an effective grid is not a rigid formula but a flexible and resilient structure, a skeleton that moves in concert with the muscular mass of content. Grids belong to the technological framework of typography, from the concrete modularity of letterpress to the ubiquitous rulers, guides, and coordinate systems of graphics applications. Although software generates illusions of smooth curves and continuous tones, every digital image or mark is constructed—ultimately—from a grid of neatly bounded blocks. The ubiquitous language of the gui (graphical user interface) creates a gridded space in which windows overlay windows. In addition to their place in the background of design production, grids have become explicit theoretical tools. Avant-garde designers in the 1910s and 1920s exposed the mechanical grid of letterpress, bringing it to

這個標準的8.5 x 11吋頁面的四周邊界寬度一致。這是一種很經濟但有些無趣的設計。

這個頁面比標準美國信紙（letter）尺寸短了一吋。文字方塊是一個正方形，四周邊界寬度則大小不一。

每一回你在頁面排版軟體上開啟一個新文件檔時，你便等同於創造了一個網格。這個最簡單的網格是由一個被邊界包圍的單欄文字方塊所構成的。

　　排版軟體會在一開始便詢問你想要的頁面尺寸與邊界寬度，鼓勵你由外而內設計你的頁面。（把邊界去掉後剩下的空間就是文字方塊的欄位。）

當然也有其它方法，你可以由內而外設計你的頁面，先將你的邊界寬度設定為零，接著在空白頁面上放置參考線（guidelines）與文字方塊。利用這個作法，你可以不斷實驗你想要的邊界與欄寬，而不會在開啟新文件時便必須有所妥協。你可以在得到滿意的結果後，於主要頁面加上參考線。

GRID SYSTEMS        PAGE ONE

A grid can be simple or complex, specific or generic, tightly defined or loosely interpreted. Typographic grids are all about control. They establish a system for arranging content within the space of page, screen, or built environment. Designed in response to the internal pressures of content (text, image, data) and the outer edge or frame (page, screen, window), an effective grid is not a rigid formula but a flexible and resilient structure, a skeleton that moves in concert with the muscular mass of content. Grids belong to the technological framework of typography, from the concrete modularity of letterpress to the ubiquitous rulers, guides, and coordinate systems of graphics applications. Although software generates illusions of smooth curves and continuous tones, every digital image or mark is constructed—ultimately—from a grid of neatly bounded blocks. The ubiquitous language of the gui (graphical user interface) creates a gridded space in which windows overlay windows. In addition to their place in the background of design production, grids have become explicit theoretical tools. Avant-garde designers in the 1910s and 1920s exposed the mechanical grid of letterpress, bringing it to the polemical surface of the page. In Switzerland after World War II, graphic designers built a total design methodology around the typographic grid, hoping to build from it a new and rational social order. The grid has evolved across centuries of typographic evolution. For graphic designers, grids are carefully honed intellectual devices, infused with ideology and ambition, and they are the inescapable mesh that filters, at some level of resolution, nearly every system of writing and reproduction. A grid can be simple or complex, specific or generic, tightly defined or loosely interpreted. Typographic grids are all about control. They establish a system for arranging content within the space of page, screen, or built environment. Designed in response to the internal pressures of content (text, image, data) and the outer edge or frame (page, screen, window), an effective grid is not a rigid formula but a flexible and resilient structure, a skeleton that moves in concert with the muscular mass of content. Grids belong to the technological framework of typography, from the concrete modularity of letterpress to the ubiquitous rulers, guides, and coordinate systems of graphics applications. Although software generates illusions of smooth curves and continuous tones, every digital image or mark is constructed—ultimately—from a grid of neatly bounded blocks. The ubiquitous language of the gui (graphical user interface) creates a gridded space in which windows overlay windows. In addition to their place in the background of design production, grids have become explicit theoretical tools. Avant-garde designers in the 1910s and 1920s exposed the mechanical grid of letterpress, bringing it to

grid systems        page one

A grid can be simple or complex, specific or generic, tightly defined or loosely interpreted. Typographic grids are all about control. They establish a system for arranging content within the space of page, screen, or built environment. Designed in response to the internal pressures of content (text, image, data) and the outer edge or frame (page, screen, window), an effective grid is not a rigid formula but a flexible and resilient structure, a skeleton that moves in concert with the muscular mass of content. Grids belong to the technological framework of typography, from the concrete modularity of letterpress to the ubiquitous rulers, guides, and coordinate systems of graphics applications. Although software generates illusions of smooth curves and continuous tones, every digital image or mark is constructed—ultimately—from a grid of neatly bounded blocks. The ubiquitous language of the gui (graphical user interface) creates a gridded space in which windows overlay windows. In addition to their place in the background of design production, grids have become explicit theoretical tools. Avant-garde designers in the 1910s and 1920s exposed the mechanical grid of letterpress, bringing it to the polemical surface of the page. In Switzerland after World War II, graphic designers built a total design methodology around the typographic grid, hoping to build from it a new and rational social order. The grid has evolved across centuries of typographic evolution. For graphic designers, grids are carefully honed intellectual devices, infused with ideology and ambition, and they are the inescapable mesh that filters, at some level of resolution, nearly every system of writing and reproduction. A grid can be simple or complex, specific or generic, tightly defined or loosely interpreted. Typographic grids are all about control. They establish a system for arranging content within the space of page, screen, or built environment. Designed in response to the internal pressures of content (text, image, data) and the outer edge or frame (page, screen, window), an effective grid is not a rigid formula but a flexible and resilient structure, a skeleton that moves in concert with the muscular mass of content. Grids belong to the technological framework of typography, from the concrete modularity of letterpress to the ubiquitous rulers, guides, and coordinate systems of graphics applications. Although software generates illusions of smooth curves and continuous tones, every digital image or mark is constructed—ultimately—from a grid of neatly bounded blocks. The ubiquitous language of the gui (graphical user interface) creates a gridded space in which windows overlay windows. In addition to their place in the background of design production, grids have become explicit theoretical tools. Avant-garde designers in the 1910s and 1920s exposed the mechanical grid of letterpress, bringing it to

這個對稱的雙頁書頁內邊界較外邊界為寬，在書背的位置留了較開闊的空間。

書與雜誌應該要設計為跨頁（對開頁）樣式。設計的主要單位是雙頁跨頁，而不是單頁；左右邊界因此成了內外邊界。排版軟體會預設左右兩頁內邊界的寬度相同，並產生出一個對稱、鏡像的跨頁版面。然而你也可以隨心所欲設定自己想要的邊界寬度，製作不對稱的跨頁版面。

在這個不對稱的版面上，左邊界不論是在頁面的內側還是外側，總是比右邊界來得寬。

# MULTICOLUMN GRID
## 多欄網格

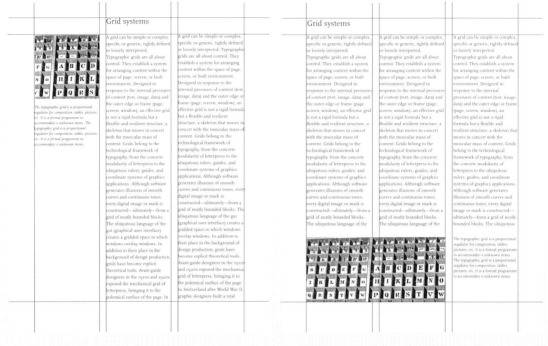

使用基本欄網格的方法有很多種。在這個例子當中，一欄保留給圖片與圖說文字，其它欄則留給內文。

在這個變化型當中，圖片與文本使用了同一個欄位空間。

單欄網格適用於簡單的文件，多欄網格則為層級較複雜或整合文字與圖片的出版品提供了更靈活變化的樣式。你創造的欄位愈多，你的網格就變得愈靈活。你可以利用網格為不同的內容創造出各自的區塊，讓出版品的層級表現得更清楚。一段文字或一張圖片可以只使用一個欄位，也可以跨欄位；不見得所有空間都必須被填滿。

不同寬度的元素在網格結構裡交錯配置。

Grid systems

刷

The typographic grid is a proportional regulator for composition, tables, pictures, etc. It is a formal programme to accommodate x unknown items.

一條水平帶將文字方塊與圖片區塊分隔開來。這條線
為這個頁面提供了一個內部結構，所有元素都向這條
線靠攏。

## 掛線（HANG LINE）

除了以網格欄位創造出垂直區塊外，你也可以利
將頁面作水平分割。舉例來說，橫跨頁面上方的區
塊可以保留給圖片與圖說文字使用，而內文主體
可以從共同的邊界線上「懸掛」而下。在建築上，
像這樣的水平參考點被稱為「基準」（datum）。

文字欄位從一個基準懸掛而下，跨過底部形成不整齊的邊緣。

Ifang Leisalpa
(Schloss),
2090 Meter

und verdichtet, wie dies im Betonbau üblich ist. Da der Beton
bei diesem Vorgang die Vor- und Rücksprünge der Rückseite
der Steinplattenwand umfliesst, entstand eine vorzügliche
Verzahnung und Verbindung der beiden Materialien Kunststein
(Beton) und Naturstein.

Allerdings konnten die Wände nicht in ihrer ganzen Höhe
auf einmal hintergossen werden. Das musste in Höhenetappen
von 50 cm erfolgen. Erst wenn der Beton einer Lage eine bestim-
te Festigkeit erreicht und sich mit dem Mauerwerk verbunden
hatte, konnte die nächste Lage von 50 cm darüber betoniert
werden. Eine höhere Schüttmasse von flüssigem Beton hätte
die freistehenden Steinplattenwände seitlich weggedrückt.

Insgesamt wurden für die Wände der Therme 450 m³ oder
1300 Tonnen Valser Quarzitplatten zu 3100 m² Wandfläche in
20 Schichten pro m² verarbeitet. Die Länge aller verwendeten
Plattenstreifen zusammen ergibt ein Total von 62.000 Lauf-
metern, was der Strecke von Vals nach Haldenstein entspricht.

Peter Zumthor

| **Valser Quarzit** | **Boden** | **Fugen und Mörtelmasse** | **Grotten** | |
|---|---|---|---|---|
| Druckfestigkeit: etwa 217 N/mm² | Breiten der Bahnen: 8–110 cm | EMACO R 304 BARRA 80 Firma | Trinkstein: polierte Quader |
| Rohdichte: 2.698 kg/m³ | Längen: bis 3,20 m, je Platte zum Teil | MBT | Eckverbin- dungen, Schwel- | aufeinander- geschichte Grösse |
| Wasseraufnahme- koeffizient: | über 3 m² in einer Stärke von 2 cm | len, Sturzplatten, Treppenunter- | etwa 0,5–1 m³ |
| Masse –% 0,25 | Oberflächen: | sichte und Tritte, | Quellgrotte: gebrochener |
| Gefräste Stein- platten: Stärken | poliert, gefräst, gestockt, ge- | Sitze als einzel- ne Werkstücke | Stein im Innern Schwitzstein: |
| 6, 3, 4, 7 und 3,1cm | schliffen in allen | gefertigt | minimale | eingefärbter und |
| Toleranz: 1 mm | Möglichkeiten | Toleranzen (weit | polierter Beton |
| Breiten: 12–30 cm | und einer Fugen- | unter SIA-Norm) | Steininsel: |
| Längen: bis 3,20 m | breite von 1 mm | beim Schneiden | grossformatige |
| über 60.000 lfm | | und Vermauern | gespaltene Platten |
| Fugenbreite: | | der Steine, wie zum | bis zu 3 m² je |
| etwa 2 mm | | Beispiel auf 6 m | Platte |
| | | Höhe weniger als | |
| | | 5 mm Toleranz | |

《石頭與水‧冬天‧二○○三/○
四》（STEIN UND WASSER,
WINTER 2003/04）‧小手冊‧二
○○三年。設計者：克雷門斯‧薛
德勒（Clemens Schedler）/辦公
室具體設計（Büro für konkrete
Gestaltung）。出版者：Hotel
Therme‧瑞士。這份介紹瑞士一
處溫泉的出版品當中使用了五欄
式網格。主要內文填滿了四欄區
塊，較小的文字則使用單欄欄位。

General Non-Fiction

Art

Photography

Collector's Editions

Film

Architecture

220 × 156 mm
8⅝ × 6⅛ inches
240 pp
c.80 b&w illus.

**Paperback**
0 7148 3164 6

£ 14.95  UK
$ 24.95  US
€ 24.95  EUR
$ 39.95  CAN
$ 49.95  AUS

# Béla Bartók

*Kenneth Chalmers*

- Sets Béla Bartók (1881–1945) and his work in the context of his homeland Hungary and his native city Budapest, where he lived for most of his adult life
- Covers the full range of his work from his early explorations of the folklore of Hungary to his Third Piano Concerto composed on his deathbed in the United States
- Brings out the singular nature of his genius and the originality of his contribution to music

**Kenneth Chalmers** is an author, translator and composer who has written on Bartók, Berg, Stravinsky, Verdi and Weill, and collaborated on Decca's 20-volume Mozart Almanac

562

66 mm
nches
240 pp
v illus.

erback
3203 0

05   UK
05   US
05   EUR
05   CAN
05   AUS

Design

Fashion &
Contemporary
Culture

Decorative Arts

**Music &
Performing Arts**
20th Century
Composers

Video

Index

# The Beatles

*Allan Kozinn*

- Follows the extraordinary development of the four self-taught musicians from Liverpool from their beginnings until the break-up in 1970
- Examines why the innovative music of the Beatles – created, at least initially, as ephemera – has remained so durable
- Considers not only the commercially released disks but also studio outtakes, demos, unreleased recordings and broadcast performances
- Sets the group's evolution against the backdrop of the popular culture explosion of the 1960s

**Allan Kozinn** has written musical criticism for the *New York Times* since 1977 and won ASCAP awards for his work, including the book *Mischa Elman and the Romantic Style*

'A well-rounded, readable account. Makes a convincing case for putting the Beatles on the shelf between Bartók and Boulez.' *(The Sunday Times)*

《費頓：秋，二〇〇三年》
（PHAIDON: FALL 2003），目
錄，二〇〇三年。設計者：漢斯・戴
特・萊克特（Hans Dieter
Reichert）。出版者：費頓出版社。
攝影者：丹・梅爾斯。這本出版書
商的目錄以理性優雅兼具的架構
展示了數百本書籍，每一本書都以
一個實體物件加上文件資料註釋
的方式呈現。邊界是這本目錄的導
航介面，其中有水平分隔線，也有
垂直分隔線。

多欄網格

Play serves learning though experimentation withou
risk. Learning occurs through quick, imprecise actions, conducted
within understood rules of a game, and free from threat or consum
mation. Play does not use up so much as build.

military-industrial world of computing, one important way to do so is to play.

Play takes many forms. For example, it can be individual or social. According to one classic taxonomy, individual play includes pursuit of sensations, exercise of motor apparatus and experimentation with higher mental powers. This mental play includes exercise of attention, emotion and will. Attention play includes tests of memory, imagination, focus and reason. On the other hand, social play includes fighting and rivalry, loving and courtship, imitation and status seeking. Imitative play includes movements, drama, behavioural constructions and emulation of inner states. [2]

Crafts and craft learning embrace quite a range of these playful forms. Arguably, no productive process combines so many so well. Sensation, skilled motion, attention, involvement, will — all must be balanced, and this is the basis for craft as recreation. Craft learning is a form of imitative social learning. Movements are physical skills taught directly, whether by demonstration or coaching. Drama is a lesser component here, although it may be understood in the willful suspension of disbelief that allows participation in an abstract medium. Constructions are the artifacts. They are the plastic play, the visual examples, the operational learning. Finally the inner state is the patience, reflectivity and intent that distinguish the master.

Play serves learning though experimentation without risk. Play often lacks any immediately obvious aim other than the pursuit of stimulation, but functions almost instinctively to serve the process of development. Learning occurs through quick, imprecise actions, conducted within understood rules of a game, and free from threat or consummation. Play does not use up so much as build. One thing it

builds is common sense. Play's endlessly variable series of awkward, exaggerated motions seeks ou the approximate arena for later development of tr competence.

There is much to be said for play in a mediu If a medium is defined by its affordances and constraints, then learning consists of exploring these properties. Experimentation is especially useful for becoming familiar with constraints: we learn from mistakes. We must accept that beginning work in a new medium will be full of setbacks. There will als be fortuitous discoveries, however particularly of affordances. Design is not only invention, but also sensitivity to a medium. Craft cannot be merely in service of technique, or of inappropriately conceive ends. The craftsman must begin to feel something about the artifacts, and only certain moves will fee right.

Of course when it comes to computation, we all must learn. In a sense, we're all children— the medium is *that* new. And of course, the most fluen experts here are often quite young. As all of us lear about this promising new domain, a chain of devel ments should be clear: play shapes learning; learni shapes the mind; mental structures shape software and software data structures afford work and play.

**Structure and Improvisation**

The master at play improvises. Consider the jazz pianist. In *Ways of the Hand — The Organization of Improvised Conduct* (1978), the musician David Sudnow gives us a rare description of otherwise ta knowledge in action. Improvising on a piece takes much more talent than simply playing from a notation or learning by rote, Sudnow explains. Moreove improvising begins with a sense of structure, from which it builds a cognitive map. For example, the 'way in' to an arpeggio is mentally mapped. The structure of the keyboard presents a physical map a chord, which may be modified in countless ways physical moves. One could play the adjacent keys, example, or one could translate by any arbitrary int val. One could transpose or invert. One could chang the order in which the notes were played, or the

2 Karl Groos, *The Play of Man*. New York: Appleton and Co., 1901

Then

**Discovery in Digital Craft**
keyboards, digital and musical

Malcolm McCullough

135

4/8

the same pitches as the first, the doubled back and went fast again, but over different pitches... There were innumerable variations possible; looking at 'structure' in this way and corresponding to various continuity practices, ways of the hand were cultivated that were suited to the performance of such manoeuvres... Transposition of such a figure to a new segment and correct repetition with respect to pitch, without slowing it down or slowing down parts of it, involved coping with the topography of the terrain by the hand as a negotiative organ with various potentials and limitations. [3]

empo, or the attack and decay. Of course one could substitute dominant, major and minor chords.

Sudnow argues that because these variations are sequences of physical positions, they are learned as active skills no longer necessary to be understood at a mental level. Each becomes a handful. That the hand gets a hold of a variation on a chord is indicated by observed tendencies to start into particular sequences with certain fingers on certain keys. The manoeuvre is known by the hand, and the mind only maps the way in. The ability to modify the run note by note — which would require conscious attention — only comes later. Even without attentive intellectual guidance, however, the natural tendency of the hand is not to repeat itself, even in a series of figural repetitions. Thus once a sufficient repertoire of runs is learned, this tendency inherently ensures a richness to the sound. The hand searches its territory for sequences, which process replaces a faithfulness to the score, and that makes jazz. For example:

The new run could be in various other ways only 'essentially related' to the preceding run. Say the first started slow and went up fast, then doubled back and went fast again, while the second started slowly and came back down through

Although jazz is the obvious case, it is hardly alone. Improvisation plays a role in many contemporary practices, and in many traditional crafts. Few of these worlds employ such a singular instrument as the piano; few are able to turn so much over to the hands, but all involve playful response to a structure. For example, of industrial design, Herbert Read insisted that "Art implies values more various than those determined by practical necessity." [4] As a modernist and industrialist, he felt admiration for fundamental structural laws, such as the golden section also admired by his contemporary Le Corbusier. He was convinced, however, that metrical irregularities based on a governing structure, rather than slavish adherence to the laws in their precision, was the basis for pleasurable expression. He cited Ruskin's line that "All beautiful lines are drawn under mathematical laws organically transgressed." [5] He held that this was the case even in the useful (industrial) arts.

Consider the case of processing a digital photograph. The makeup of the raster image file, the various tone scale and filtration operators, provides a very clear structure in which to work but demands no particular order of operation. The complex microstructure of the sampled pixels provides a sub-

The natural tendency of the hand is not to repeat itself, even in a series of figural repetitions. Thus once a sufficient repertoire of runs is learned, this tendency inherently ensures a richness to the sound. The hand searches its territory for sequences, which process replaces a faithfulness to the score, and that makes jazz.

3 David Sudnow, *Ways of the Hand—The Organization of Improvised Conduct*, Cambridge, MA: Harvard University Press, 1978, p 7
4 Herbert Read, *Art and Industry—The Principles of Industrial Design* New York: Horizon Press, 1954 [1934]
5 *Ibid.*

《假如／那麼 玩：新媒體的設計意涵》（IF/THEN PLAY: DESIGN IMPLICATIONS OF NEW MEDIA），書籍，一九九九年。設計者：Mevis and Van Deursen。編輯者：詹恩‧亞伯拉姆斯（Jan Abrams）。出版者：荷蘭設計學院（Netherlands Design Institute）。攝影者：丹‧梅爾斯。在這本關於新媒體的書籍當中，兩欄式網格包含了主要的內文主體。橫跨兩欄的引言則以細直線為框，暗示它們有如電腦螢幕上重疊的「視窗」。上方的邊界類似於瀏覽器上的工具列，提供這本書一個介面。

wild wirkende, dem Lennéschen Ideal folgende, baumreiche Naturgarten weicht englischen Rasenflächen, die sich mit nur noch wenigen Baum- und Strauchgruppen und gepflegten Blumenbeeten abwechseln. Mit dieser Veränderung, so der dritte Direktor des Zoos, Heinrich Bodinus, soll es möglich werden, den belebenden und erwärmenden Strahlen der Sonne Zutritt zu verschaffen. Anders als zuvor finden sich in den Berliner Zeitungen nun immer häufiger positiv gefärbte Erlebnisberichte. Vorläufiger Höhepunkt und nicht zu unterschätzender rite de passage für die breite Anerkennung des Gartens war das DREI-KAISER-TREFFEN im Herbst 1872: Kaiser Wilhelm, Kaiser Alexander II. von Rußland und Kaiser Franz-Joseph von Österreich-Ungarn werden in einem zwanzig Wagen umfassenden Zug über das Zoogelände kutschiert. Obwohl der Zoo zu dieser Zeit noch außerhalb der Stadt gelegen ist, ist dessen neuartige Gestaltung schon ein Zeichen dafür, daß die preußische Hauptstadt um die Anbindung an die Kultur der großen europäischen Metropolen bemüht ist. Die Bevölkerungszahl Berlins steigt mit der industriellen Entwicklung jener Jahre erheblich, und dem Zoo kommt (neben dem Stadtpark) zunehmend ein Erholungswert zu, der durch eine Reihe von technischen Neuerungen gesteigert werden kann: eine Dampfmaschine sorgt für Wasserzirkulation und verwandelt die früher im Sommer überlriechenden Gewässer des Gartens in belebte Weiher. Hinzu kommt die Erleichterung von An- und Abreise. Ab 1875 verbindet eine Pferdebahnlinie Berlin mit dem Zoo. Im Jahre 1884 folgt die Installation elektrischer Beleuchtung, die eine Ausdehnung der Öffnungszeiten bis in die Abendstunden zuläßt. Kinderspielhallen und -plätze werden eingerichtet. Wo sonst könnten sie sicher vor dem Getümmel der Weltstadt in frischer Luft ihre Glieder üben und ihre Lungen weiten? heißt es im Programmheft des Jahres 1899. ‖ Der Zoo entwickelt sich deutlich zu einem integralen Bestandteil der städtischen Kultur. Anders als in den Stadtparks — etwa dem Humboldthain — stellt hier der Eintrittspreis sicher, daß die das Vergnügen schmälernden Obdachlosen und Bettler vor den Toren bleiben. Zoofreunde werben um die Gunst von Kolonialoffizieren, die helfen sollen, die Tierbestände zu erhöhen und die in der Folge tatsächlich zunehmend als Donatoren fungieren. Forschungsreisen und Expeditionen in viele Regionen der Erde — häufig unter maßgeblicher Regie der Zoodirektoren — führen zur Entdeckung bislang unbekannter Tierarten. Die intensive Kooperation von Zoo und Naturkundemuseum setzt sich fort, so daß der Bestand des Museums 1894 auf etwa 2 Mio. Tiere, darunter etwa 150 000 Wirbeltiere, angewachsen ist. ‖ Der Berliner Zoo wird in den letzten Jahrzehnten des 19. Jahrhunderts zu einem repräsentativen Treffpunkt und zu einem Raum, in dem sich preußische Mentalität wenn auch nicht aufhebt, so doch relativiert. Fremdartige Tierwelt und eine Architektur des Orient, des Fernen Osten und der Savannen, verbindet sich, in einiger Entfernung vom hektischen und geschäftigen Leben der Stadt, zu einem den Stadtbewohnern bis dahin unbekannten Ambiente. Hier entwickelt sich Natur zum Unterhaltungsgegenstand. Die von Zirkussen, Menagerien und Märkten bekannten sensationellen und theatralischen Aspekte gehen mit dem zoologischen Erkenntnisinteresse eine eigenartige Symbiose ein. Getragen wird diese Entwicklung nicht zuletzt von ökonomischen Zwängen: immer wieder

90

kämpft die Zoogesellschaft um ihre Existenz. ‖ Der Zoo wird zu einem der Plätze der Stadt, wo sich Vorahnungen einer noch in Entwicklung begriffenen Weltstadt am ehesten materialisieren; kein Wunder, daß immer deutlicher auch Künstler und Gelehrte sich von diesem Raum angezogen fühlen. Neben einer Musiktribüne hilft ein erweiterter Restaurationsbetrieb den Aufenthalt in den meist nur unzureichend belüfteten Gebäuden aufzulockern. Ein Zeitgenosse beschreibt diese Bereicherung: Durch das neue Restaurationslokal ist die Zahl der großen Festsäle um ein Meisterwerk der Baukunst vermehrt worden. Wenn hier eine vortreffliche Militärkapelle ein Concert ausführt, dann bildet, in Folge des erhöhten Eintrittspreises, die elegante Welt die Mehrzahl der Besucher. Draußen dehnt sich eine lange Reihe Equipagen bis in die Winkel des Thiergartens; drinnen sind alle Plätze im weiten Umkreise des muschelförmig gebauten Orchesters besetzt; beim Klange der Instrumente, beim Geplätscher der Fontänen sitzt man, sich erfrischend, rauchend, plaudernd und scherzend unter den schattigen Bäumen und blickt in das abwechselnde, stets rege Thierleben hinaus, wie es sich in den benachbarten Grotten, auf Aesten und Teichen kund giebt.³ ‖ Die Auswahl der Tiere und der Situationen, in denen sich ihre Präsentation bewegte, erfolgt sorgfältig und bedacht, die Kuratoren entscheiden sich für besonders exotisch wirkende, kuriose, lächerliche, niedliche Tiere.⁴ Dabei gilt es stets, die Konfrontation mit potentiell Abscheu oder starkes Befremden erregenden tierischem Verhalten zu verhindern. ‖ Die zunehmende Popularität der Zoos korreliert mit dem Verschwinden von Tieren aus dem Alltagsleben des städtischen Menschen. Das Tier ist entweder Haustier, also Mitbewohner der Wohnung, oder drastisch auf seine Rohstofffunktion reduziert und fristet in fabrikartigen Hallen abseits der Städte sein ökonomisch optimiertes Dasein. Mit den zoologischen Gärten beginnt ein Verdrängungsmechanismus, der sich später auch auf Naturparks und Reservate erstreckt: die Gefangenschaft erscheint angesichts der systematischen Zerstörung der Lebensräume als ein Schutz der Natur und dient dazu, das unterschwellig vorhandene schlechte Gewissen zu beruhigen.

3) R. Springer: Berlin: Die deutsche Kaiserstadt. Reprint. Berlin 1971.

4) Interessanterweise vollzieht sich in einigen nordamerikanischen Gärten heute eine dem entgegengesetzte Entwicklung: Sowohl in Washington u.a. als auch in Montreal werden gezielt -unspektakuläre- wirtschaftsrelevante, eher -häßliche- Tiere einbezogen, die immerhin 98 Prozent des gesamten tierlichen Lebens auf der Erde ausmachen. Diese Verlinderung ist Teil einer Versöhnung, um einen grundlegend veränderten tierethischen Diskurs, um Menschen und Tierwelt Rechnung zu tragen. Vgl. Alexander Wilson: The Culture of Nature: North American Landscape from Disney to the Exxon Valdez. Cambridge 1992. Seite 235 ff.

**architektur** Franz Hessel
erinnert sich
in seinen Beobachtungen berlinischen Le-
bens an die merkwürdigen Behausungen
der Tiere: Liebt das Zebra sein afrikani-
sches Gehöft, der Büffel sein Borkenpa-
lais?[1] Die Steine von Bärenzwinger, Vogel-
haus und Löwenheim deutet Hessel als
Baukastensteine, der Zoo wird in seiner In-
terpretation zur natürlichen Fortsetzung
einer Kinderstube und einem Ort, wo die
vorzeitlichen Tierkulte Gelegenheit haben,
wiederaufzuleben. F. Lichterfeld bezieht
sich in einem Artikel der ILLUSTRIRTEN ZEI-
TUNG von 1873 auf die anfänglich vorhandene
Verwunderung der Stadtbewohner ob der
neuen, ungewohnten Bauwerke: Was sollen
diese Thürme mit der flammenden Sonne
und den phantastischen Drachen- und Ele-
fantenbildern in einer christlichen Stadt
wie Berlin? Diese Frage wurde früher häu-
fig aufgeworfen, zumal von Landleuten,
welche ihr Weg nach der Stadt an dem
fremden Heidentempel vorüber-
führte. Jetzt weiß jedermann in und um Berlin, daß der
fremde Heidentempel das neue Elefantenhaus ist. [...]
Nicht diesen, sondern dem Publikum zulieb wurde der
Neubau so reich ausgestattet, denn selbst dem Ele-
fanten ist eine Portion Moorrüben oder ein Bund Heu
lieber als der ganze architektonische und musivische
Schmuck seines neuen Hauses, und nun gar erst dem
Rhinoceros! ‖ Die stilistische Gestaltung der Bauten
steht offensichtlich auch in Zusammenhang mit der
Einbindung der zoologischen Gärten in kolonialistische
Zusammenhänge. Die Repräsentation fremdkulturel-
ler Elemente erlaubt Rückschlüsse auf die Konturen
eines rudimentär entwickelten Kosmopolitismus. Das
Einbringen von Elementen aus anderen Kulturzusam-
menhängen markiert den Wandel vom systematischen
zum geographisch orientierten Zoo. Wichtigen Einfluß
auf die Idee, Tiere in einem baulich-stilistischen Rah-
men zu zeigen, der gewisse Zusammenhänge zur Eth-
nographie der Heimatlandschaften aufweist, hatte
der Zoologe Philipp Leopold Martin. In seinem 1878 in
Leipzig erschienenen Kompendium DIE PRAXIS DER NA-
TURGESCHICHTE — er maßte sich an, es als vollständiges
Lehrbuch über das Sammeln lebender und todter Na-
turkörper zu bezeichnen — rationalisiert Martin die-
ses Vorgehen als ethnographisch-architektonische
Belehrung: Was ist aber nun wohl natürlicher und zu-
gleich lehrreicher, als die Natur in unseren Gärten
nach Welttheilen, Zonen und lokalen Verhältnissen
aufzustellen? [...] Der Wisent verlangt Wald und der
Buffalo die Prairie; und wenn wir dieses thun und in die
Prairie noch einen Wigwam als Stall hinsetzen, so be-
lehren wir damit zugleich das Publikum, denn es erhält
Bilder, die es niemals vergißt.[1] Die fremdkulturelle Ar-
chitektur der Stilbauten — auch wichtiger Bestandteil
der großen Weltausstellungen in dieser Phase — wird
jeglicher zeitlicher Entwicklung enthoben. Zoodirektor
Ludwig Heck schreibt rückblickend im
Jahre 1929: Man denke nur, wenn wir

[7] Franz Hessel Spazieren in Berlin Berlin 1929 / Seite 149
[8] Heinz-Georg und Ursula Klös Der Berliner Zoo im Spiegel seiner Bauten
1841–1989. Eine baugeschichtliche und denkmalpflegerische Dokumenta-
tion über den Zoologischen Garten Berlin 1990 / Seite 57 Die anderen
Ausführungen über die Architektur stützen sich partiell auf diesen Band

《FORM + ZWECK 27》，期刊，
一九九六年。設計者：Cyan，柏林
（Berlin）。在這份實驗性的期刊
上，緻密的齊行文字欄位緊挨著邊
界。設計師以符號區分段落而沒有
做斷行，讓文字區塊的緊密度最大
化。逐頁標題、頁碼、與圖片是一
條條切入文字實心牆的狹窄渠道。
註腳也被設計為齊行區塊，並且轉
向與頁面紋理呈九十度。

多欄網格

《減法》（SUBTRACTION），網站，二〇〇八年。設計者：寇伊‧芬恩（Khoi Vinh）。儘管有無數的網站將頁面切分為三個或更多個欄位，但一個功能完備的網格應該能允許一些要素「打破網格」，在一個內容區塊裡橫跨過多個欄位。芬恩設計的網站上有大量的留白空間，它們強化基本網格架構的同時，也讓使用者的雙眼得以在龐雜的資訊中獲得休息。芬恩有時候會以網格做為背景圖片，以便一邊工作一邊確認內容是否排列整齊。

NPR.ORG，網站，二〇〇九年至一〇年。設計者：NPR團隊（戴倫·毛洛〔Darren Mauro〕、珍妮佛·夏普〔Jennifer Sharp〕、凱莉·妮藍〔Callie Neylan〕、大衛·萊特〔David Wright〕、布萊恩·英格斯〔Brian Ingles〕、K.李伯納〔K. Libner〕、史考特·史特勞德〔Scott Stroud〕）。網頁的設計流程一般會先從網格與框架著手，以描繪出典型的頁面。至於視覺上的細節，例如字體的選擇、層級、與導航元素的樣式等，則會於稍後才加入。這個網站有八種頁面版型，每一種都是為了不同的編輯情境而設計。

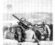
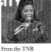

《新共和》（THE NEW REPUBLIC），線上雜誌，二〇〇九年。這個線上雜誌的首頁以三欄式網格提供讀者讀取大量評論文章內容的直接連結。觀點論壇的每一個單元都有自己的標誌，以反映出主品牌的文學調性。

# MODULAR GRID
## 模組網格

《設計程序》，網格示意圖，一九六三年（重繪）。設計者：卡爾·
蓋斯納。出版者：Arthur Niggli，蘇黎世（Zurich）。這個正方形
網格包括有六個垂直欄與六個水平模組，上方層疊了分別是一個、
兩個、三個、和四個單位的網格。在垂直方向上，這個網格是以 ro
pt 大小的尺度為基準，基線之間字型的間距也依此為據。

Grid systems

A grid can be simple or complex, specific or generic, tightly defined or loosely interpreted. Typographic grids are all about control. They establish a system for arranging content within the space of page, screen, or built environment. Designed in response to the internal pressures of content (text, image, data) and the outer edge or frame (page, screen, window), an effective grid is not a rigid formula but a flexible and resilient structure, a skeleton that moves in concert with the muscular mass of content. Grids belong to the technological framework of typography, from the concrete modularity of letterpress to the ubiquitous rulers, guides, and coordinate systems of graphics applications. Although software generates illusions of smooth curves and continuous tones, every digital image or mark is constructed—ultimately—from a grid of neatly bounded blocks. The ubiquitous language of the gui (graphical user interface) creates a gridded space in which windows overlay windows. In addition to their place in the background of design production, grids have become explicit theoretical tools. Avant-garde designers in the 1910s and 1920s exposed the grid of letterpress, bringing it to the polemical surface of the page. In Switzerland after World War II, graphic designers built a total design methodology around the typographic grid, hoping to build from it a new and rational social order. The grid has evolved across centuries of typographic evolution. For graphic designers, grids are carefully honed intellectual devices, infused with ideology and ambition, and they are the inescapable mesh that filters, at some level of resolution, nearly every system of writing and

The typographic grid is a proportional regulator for composition, tables, pictures, etc. It is a formal programme to accommodate x unknown items.The typographic grid is a proportional regulator for composition, tables, pictures, etc. It is a formal programme to accommodate x unknown items.

這個模組化網格由四欄與四列組成。一張圖片或一個文字方塊可能會佔據一個或多個模組單位。

Grid systems

A grid can be simple or complex, specific or generic, tightly defined or loosely interpreted. Typographic grids are all about control. They establish a system for arranging content within the space of page, screen, or built environment. Designed in response to the internal pressures of content (text, image, data) and the outer edge or frame (page, screen, window), an effective grid is not a rigid formula but a flexible and resilient structure, a skeleton that moves in concert with the muscular mass of content. Grids belong to the technological framework of typography, from the concrete modularity of letterpress to the ubiquitous rulers, guides, and coordinate systems of graphics applications. Although software generates illusions of smooth curves and continuous tones, every digital image or mark is constructed—ultimately—from a grid of neatly bounded blocks. The ubiquitous language of the gui (graphical user interface) creates a gridded space in which windows overlay windows. In addition to their place in the background of design production, grids have become explicit

The typographic grid is a proportional regulator for composition, tables, pictures, etc. It is a formal programme to accommodate x unknown items.The typographic grid is a proportional regulator for composition, tables, pictures, etc. It is a formal programme to accommodate x unknown items.

有無限可能的變化。

在模組網格當中,除了有由左到右排列的垂直區塊外,還有由上到下的水平區塊。這些模組單位控制了圖片與文字的配置與裁切方式。一九五〇年代與六〇年代,瑞士平面設計師包括了蓋斯納、胡德、慕勒-布洛赫曼等人發展出如同此處所展示的模組網格系統。

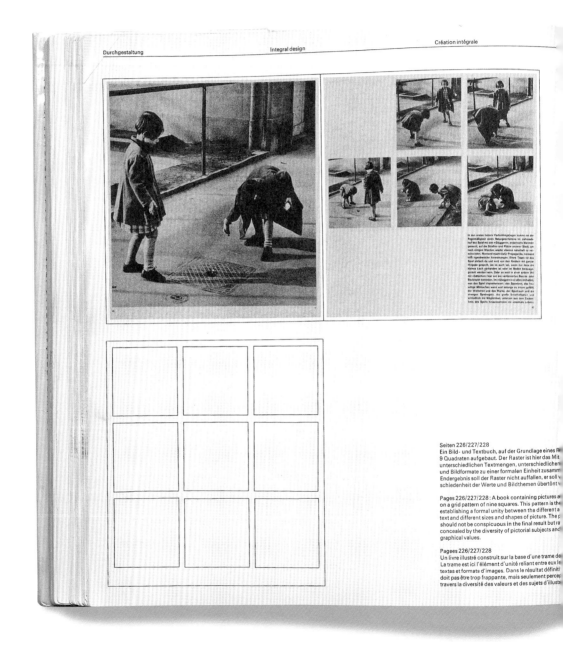

Seiten 226/227/228
Ein Bild- und Textbuch, auf der Grundlage eines R
9 Quadraten aufgebaut. Der Raster ist hier das Mit
unterschiedlichen Textmengen, unterschiedlichen
und Bildformate zu einer formalen Einheit zusamm
Endergebnis soll der Raster nicht auffallen, er soll v
schiedenheit der Werte und Bildthemen übertönt v

Pages 226/227/228 : A book containing pictures a
on a grid pattern of nine squares. This pattern is the
establishing a formal unity between the different a
text and different sizes and shapes of picture. The p
should not be conspicuous in the final result but ra
concealed by the diversity of pictorial subjects and
graphical values.

Pagees 226/227/228
Un livre illustré construit sur la base d'une trame de
La trame est ici l'élément d'unité reliant entre eux le
textes et formats d'images. Dans le résultat définiti
doit pas être trop frappante, mais seulement percep
travers la diversité des valeurs et des sujets d'illustre

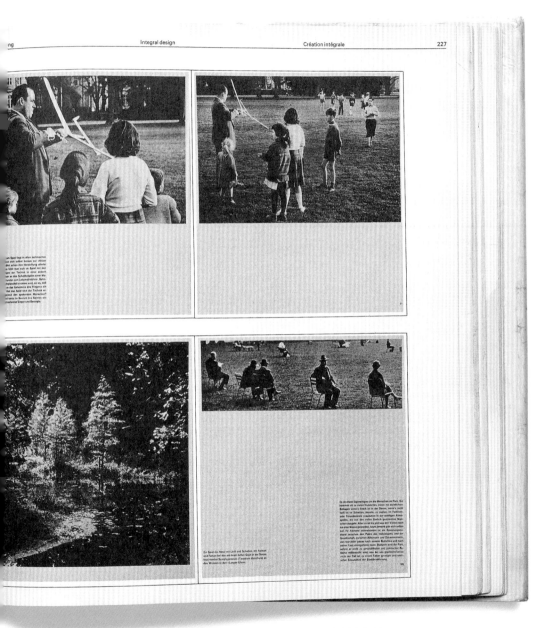

字體編排設計。書籍。一九六七年。設計者與作者：埃
米爾・胡德。出版者：Arthur Niggli。蘇黎世。攝影者：
丹・梅爾斯。在這本經典的設計書當中，埃米爾・胡德
展示了模組網格的使用方法。

模組網格是根據控制整份文件的基線網格（baseline grid）放置水平參考線而創造出來的。基線網格的作用在於將所有（或幾乎所有）版面要素安頓在一個共同的節奏上。你可以利用選擇字級與行距，例如10-pt 的Scala Pro與12 pts的行距（10/12），創造出一個基線網格。避免使用自動行距，這樣你就可以將行距設定為方便成倍數增加或被整除的整數。利用增加行距的方式在「文件喜好」（document preferences）裡設定基線網格。調整頁面上下邊界以吸收基線網格外多餘的空間。

　　根據基線網格的線條數來決定水平頁面單位的數量。算出整個文字欄位裡有幾條線，看看可以將這些線條平分至幾個水平頁面單位中。有四十二行文字的欄位可以被整齊平均地分入七個水平模組單位裡，每個單位當中有六行文字。假使你的線條數沒有辦法被完全平分，你可以調整上或下的頁面邊界，好吸收掉多出來的行數。

　　如果要設定標題、圖說文字、和其它要素的樣式，可以選擇和基線網格搭配的行距，例如標題設定為18/24、副標題為14/18、圖說文字則為8/12。網路設計師可以利用類似的方法（CSS當中的行高〔line height〕）創作出有整齊基線的樣式表。

　　盡可能將根據基線網格放置所有頁面要素，但不要勉強硬塞。有時候你無視於網格的存在，反而能創造出更好的版面。當你想要確認各項元素的擺放位置時，可以檢視基線網格；若它們造成干擾，可以將這項功能關閉。

基線網格。你可以在InDesign的「偏好設定」（Preferences）底下的「格點」（Grids）和「參考線」（Guides）視窗中設定基線網格。利用「版面」（Layout）當中的「建立參考線」（Create Guides）建立水平分隔。水平參考線要對應於頁面主要文字區塊的基線，數目要能夠將整個文字欄位的行數整除平分。

書呆子警報：在InDesign當中，你可以讓你的文字外框自動與基線網格對齊。請到「物件」（Objects）＞「文字框選項」（Text Frame Options）＞「基線選項」（Baselie Options）選擇行距。假使你的行距是12 pts，第一條基線就會從文字框的頂部下降12 pts。

更好的文字框。第一行文字從距離文字框12 pts的地方開始。在預設值中，第一行的位置會根據大寫字母高度而設定。

主標題
32/48 pt Scala Sans Pro Bold

副標題
18/24 Scala Sans Pro Italic

# baseline grids
## create a common rhythm

Captions and other details are styled to coordinate with the dominant baseline grid.

Modular grids are created by positioning horizontal guidelines in relation to a *baseline* grid that governs the whole document. Baseline grids serve to anchor all (or nearly all) elements to a common rhythm.

Create a baseline grid by choosing the typesize and leading of your text, such as 10-pt Scala Pro with 12 pts leading (10/12). Avoid auto leading so that you can work with whole numbers that multiply and divide cleanly. Use this line space increment to set the baseline grid in your document preferences. Adjust the top or bottom page margin to absorb any space left over by the baseline grid.

Determine the number of horizontal page units in relation to the numer of lines in the baseline grid. Count how many lines fit in a full column of text and then choose a number that divides easily into the line count to create horizontal page divisions. A column with forty-two lines of text divides neatly into seven horizontal modules with six lines each. If your line count is not neatly divisible, adjust the top and/or

bottom page margins to absorb leftover lines.

To style headlines, captions, and other elements, choose line spacing that works with the baseline grid, such as 18/24 for headlines, 14/18 for subheads, and 8/12 for captions. (Web designers can choose similar increments (line height) to create style sheets with coordinated baselines.)

Where possible, position all page elements in relation to the baseline grid. Don't force it, though. Sometimes a layout works better when you override the grid. View the baseline grid when you want to check the position of elements; turn it off when it's distracting.

InDesign, set the baseline grid in the Preferences>Grids and Guides window. Create horizontal divisions in Layout>Create Guides. Make the horizontal guides correspond to the baselines of the page's primary text by choosing a number of rows that divides evenly into the number of lines in a full column of text. Working in InDesign, you can make

圖說文字
9/12 Scala Sans Pro Italic

主要內文
10/12 Scala Pro.
這個尺寸制定了基線網格。

《設計如你所在乎》（DESIGN LIKE YOU GIVE A DAMN）
，書籍，二〇〇六年。設計者：保羅‧卡羅斯‧爾舒拉‧巴爾
貝‧卡薩莉娜‧賽佛爾特（Katharina S）／Pure + Applied。作者：人道主義建築
（Architecture for Humanity）、凱特‧斯特爾（Kate
Stohr），與卡麥隆‧辛克萊（Cameron Sinclair）。這本書在
設計上利用模組網格呈現了複雜的內容。有些頁面上主要內
文、圖說文字，與小圖片等排列緊密，有些頁面則以整頁出
血（full-bleed）的方式呈現照片，上方並層疊顯示了簡短的
文字敘述與重要的統計數字。

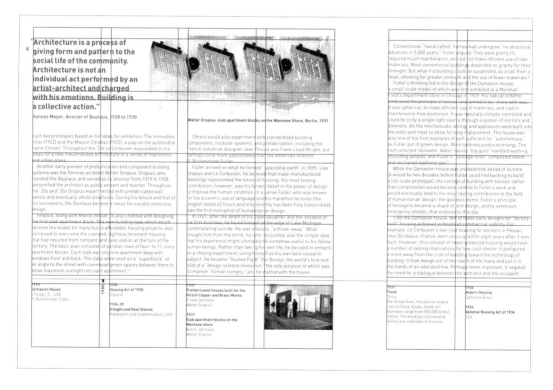

**women**

**WORK**
**2/3** of the world's working hours,

**PRODUCE**
**1/2** of the world's food, and yet

**EARN**
**10%** of the world's income and

**OWN LESS THAN**
**1%** of the world's property

Walter Kälin et al., eds., *The Face of Human Rights*, Baden: Lars Müller, 2004.

**2/3** of the **110 million** children not in school are girls
*"Women, Knowledge, and the Millennium Development Goals", Boston: Lars Müller, 2004.*

Women constitute **70%** of the estimated **1,300,000,000** people living in absolute poverty
*Walter Kälin et al., eds., The Face of Human Rights, Baden: Lars Müller, 2004.*

**BETWEEN 40-60%** of sexual assaults are committed against girls younger than 16.
*"Prevention and response to sexual and gender-based violence in refugee situations", UNHCR*

---

In war-torn countries and areas devastated by disaster, the presence of UNHCR tents is one of the first signs of aid.

## Lightweight Emergency Tent

**Location** Various
**Date** 2002–present
**Organization** Office of the United Nations High Commissioner for Refugees (UNHCR)
**End client** Refugees, internally displaced populations
**Design consultant** Shoonen Fenderesh
**Manufacturer** H. Sheikh Noor-ud-Din & Sons (Pvt.) Limited, Lahore, Pakistan
**Cost per unit** Approx. $190
**Area** 176 sq. ft./16.5 sq. m.
**Occupancy** 4–5 people
**Dimensions** 14 x 9.8 x 4 ft./5.5 x 3 x 2.1 m
**Weight** 81 lb./41.5 kg

Designers have tried to rethink this basic tent for decades. Everything from prefabricated structures to shipping containers to polyurethane yurts has been suggested or attempted. But as the agency politely points out, no guide to emergency materials, to date none of these systems has proven effective in refugee situations. Most fail simply because other emergency shelter arrangements will have been made before these systems even arrive. Some tent alternatives are perceived as "too permanent," making them difficult to site in host communities and creating less incentive for a refugee to return home. Others are difficult or costly to replicate.

But in recent years there has been a growing sense within the agency that the design of the standard family tent could and should be radically overhauled. In most emergencies the agency sends out plastic sheeting first. Depending on the size and complexity of the crisis, this sheeting may be the response of first and last resort. However, in cases where local materials are not available to build more permanent structures, where families cannot find shelter within the community or are displaced for longer periods of time, the UNHCR provides more durable alternatives — typically a ridge-style or center-pole double-fly tent made from canvas. Yet these canvas tents are not only heavy (and therefore costly to ship, but because canvas rots they deteriorate quickly and cannot be stockpiled for long periods. Wear and tear on the weakened material in the field significantly shortens the useful lifespan of the shelter.

In 2002 the UNHCR began testing a new design for this basic family tent it regularly dispatched to areas of crisis. The agency is

The UNHCR's new Lightweight Emergency Tent is in use in Meulaboh, West Sumatra, following the Indian Ocean tsunami of 2004.

---

## GripClips

**Location** Various
**Date** 1975–present
**Designer** Robert Gillis
**Manufacturer** Shelter Systems
**Cost** $9–59 (set of six)

It would be safe to say that few people know the ins and outs of tents better than Robert Gillis.

Not only did he design the first geodesic backpacking tent, based on Buckminster Fuller's ideas, for The North Face in the 1970s, but he also lived in a collection of tents (with his wife and three children) for more than 25 years — all of which he designed himself, including the tent that housed the family washing machine.

Although many of Gillis's tent innovations have stemmed from efforts to improve his own living conditions, from the beginning he saw the potential for translating his ideas to emergency shelter — in particular using the plastic sheeting that has become a standard

component of relief projects. However, working with plastic sheeting meant finding a way to "hold on to it," Gillis explains. "It was difficult to join the material without puncturing it. But puncturing it is a bad idea because it weakens it. The material deteriorates less if you don't tear it." The designer went through more than 10 different iterations before arriving at the GripClip, a small plastic fastener that clips onto any type of sheeting and has it to a frame.

Reducing the shelter to its most fundamental element, the connection between the sheeting and the support, enabled Gillis to design a number of tents, from a basic shelter frame to to more elaborate dome structures.

The clips also offered another advantage: They allowed for a range of shapes. Whereas most relief agencies distribute tunnel-shaped tents because the structure can be covered

with one large sheet of material, these tents are less stable in the wind than dome-shaped tents. Using GripClips, Gillis found he was able to layer sheeting in shingles to create a more stable structure that would also shed rain. "And I didn't have to sew it or heat-weld it or anything," he recalls. "Here was the perfect thing. It was totally wonderful."

More recently Gillis has focused on creating clips and fasteners to attach plastic sheeting to rods, frameworks, piping, or plywood, allowing families to turn damaged structures into transitional homes while they rebuild.

*opposite*
A GripClip, secured to a cross-piece of frame, shown from inside a shelter. The frame pieces are secured with plastic wrap.

*right*
GripClip's two plastic parts are designed to be twisted together with a piece of sheeting between them. The clip itself can be fastened to a frame structure with plastic ties, rope, or pipe clamps.

Robert Gillis inside a tent built with GripClips.

利用一個模組網格以你所能想到的各種方式配置一段文本。只要運用一種大小的字體、而且文字全部靠左對齊，你就會建構出完全以空間配置做為表現的字體編排層級。若你想要讓它變得更複雜一點，也可以加入一些變因，例如字重、字級大小、與齊行方式的變化。

Common typographic disorders

Various forms of dysfunction appear among populations exposed to typography for long periods of time. Listed here are a number of frequently observed afflictions.

typophilia
An excessive attachment to and fascination with the shape of letters, often to the exclusion of other interests and object choices. Typophiliacs usually die penniless and alone.

typophobia
The irrational dislike of letterforms, often marked by a preference for icons, dingbats, and—in fatal cases—bullets and daggers. The fears of the typophobe can often be quieted (but not cured) by steady doses of Helvetica and Times Roman.

typochondria
A persistent anxiety that one has selected the wrong typeface. This condition is often paired with okd (optical kerning disorder), the need to constantly adjust and readjust the spaces between letters.

Common typographic disorders

Various forms of dysfunction appear among populations exposed to typography for long periods of time. Listed here are a number of frequently observed afflictions.

typophilia

An excessive attachment to and fascination with the shape of letters, often to the exclusion of other interests and object choices. Typophiliacs usually die penniless and alone.

typophobia

The irrational dislike of letterforms, often marked by a preference for icons, dingbats, and—in fatal cases—bullets and daggers. The fears of the typophobe can often be quieted (but not cured) by steady doses of Helvetica and Times Roman.

typochondria

A persistent anxiety that one has selected the wrong typeface. This condition is often paired with OKD (optical kerning disorder), the need to constantly adjust and readjust the spaces between letters.

Common typographic disorders

Various forms of dysfunction appear among populations exposed to typography for long periods of time. Listed here are a number of frequently observed afflictions.

typophilia
An excessive attachment to and fascination with the shape of letters, often to the exclusion of other interests and object choices. Typophiliacs usually die penniless and alone.

typophobia
The irrational dislike of letterforms, often marked by a preference for icons, dingbats, and—in fatal cases—bullets and daggers. The fears of the typophobe can often be quieted (but not cured) by steady doses of Helvetica and Times Roman.

typochondria
A persistent anxiety that one has selected the wrong typeface. This condition is often paired with OKD (optical kerning disorder), the need to constantly adjust and readjust the spaces between letters.

Common typographic disorders

Various forms of dysfunction appear among populations exposed to typography for long periods of time. Listed here are a number of frequently observed afflictions.

typophilia

An excessive attachment to and fascination with the shape of letters, often to the exclusion of other interests and object choices. Typophiliacs usually die penniless and alone.

typophobia

The irrational dislike of letterforms, often marked by a preference for icons, dingbats, and—in fatal cases—bullets and daggers. The fears of the typophobe can often be quieted (but not cured) by steady doses of Helvetica and Times Roman.

typochondria

A persistent anxiety that one has selected the wrong typeface. This condition is often paired with OKD (optical kerning disorder), the need to constantly adjust and readjust the spaces between letters.

---

Common typographic disorders

| | typophilia | typophobia | typochondria |
|---|---|---|---|
| Various forms of dysfunction appear among populations exposed to typography for long periods of time. Listed here are a number of frequently observed afflictions. | An excessive attachment to and fascination with the shape of letters, often to the exclusion of other interests and object choices. Typophiliacs usually die penniless and alone. | The irrational dislike of letterforms, often marked by a preference for icons, dingbats, and—in fatal cases—bullets and daggers. The fears of the typophobe can often be quieted (but not cured) by steady doses of Helvetica and Times Roman. | A persistent anxiety that one has selected the wrong typeface. This condition is often paired with OKD (optical kerning disorder), the need to constantly adjust and readjust the spaces between letters. |

---

typophilia

Various forms of dysfunction appear among populations exposed to typography for long periods of time. Listed here are a number of frequently observed afflictions.

An excessive attachment to and fascination with the shape of letters, often to the exclusion of other interests and object choices. Typophiliacs usually die penniless and alone.

typophobia

The irrational dislike of letterforms, often marked by a preference for icons, dingbats, and—in fatal cases—bullets and daggers. The fears of the typophobe can often be quieted (but not cured) by steady doses of Helvetica and Times Roman.

typochondria

A persistent anxiety that one has selected the wrong typeface. This condition is often paired with okd (optical kerning disorder), the need to constantly adjust and readjust the spaces between letters.

Common typographic disorders

---

typophilia

Common typographic disorders

Various forms of dysfunction appear among populations exposed to typography for long periods of time. Listed here are a number of frequently observed affliflictions.

An excessive attachment to and fascination with the shape of letters, often to the exclusion of other interests and object choices. Typophiliacs usually die penniless and alone.

typophobia

The irrational dislike of letterforms, often marked by a preference for icons, dingbats, and—in fatal cases—bullets and daggers. The fears of the typophobe can often be quieted (but not cured) by steady doses of Helvetica and Times Roman.

typochondria

A persistent anxiety that one has selected the wrong typeface. This condition is often paired with okd (optical kerning disorder), the need to constantly adjust and readjust the spaces between letters.

# DATA TABLES
## 資料表格

圖表與曲線圖的設計是字體編排設計實務上一個內涵豐富的領域。在資料表格上，網格有其語義學的重要性。欄與列包含了不同類型的內容，好讓讀者能夠一目暸然並快速進行比較。設計師（與軟體預設值）經常會過度強調表格裡的線性網格，而不是讓字體編排設計主導頁面並管理好屬於它的領域。當文字欄位在視覺上彼此對齊的時候，它們也等於是在頁面或螢幕上創造出了隱形的網格格線。

| ACCOUNT | ACCOUNT NAME | TOTAL FOR ACCO |
|---------|--------------|----------------|
| 101001 | Instructional Supplies | $3,65 |
| 101002 | Office Supplies | $46 |
| 102004 | Equipment - Non-Capital | $1,28 |
| 105009 | Travel-Conference Fees | $56 |
| 110004 | Miscellaneous Entertainment | $8 |
| 114006 | Postage/Shipping-Local Courier | $21 |
| 151108 | Temp Staff-Contractual | $7 |
| 151181 | Honoraria-Critics/Vis Artist | $1,00 |
| | DEPARTMENTAL EXPENDITURES | $7,35 |

囧設計：資料獄

資料表中的界線與分隔應該要能讓資料之間的關係更清晰易懂，而不是將每一筆資料都禁閉在銅牆鐵壁般的儲存格內。

紐澤西捷運公司（NEW JERSEY TRANSIT），東北幹線時間表，原始版本與愛德華‧塔夫特改編版本。出處：愛德華‧塔夫特，《資訊視覺化》。原始設計（上圖）由沉重的水平分隔線與垂直分隔線構成。塔夫特稱之為「資料獄」（data prison）。他在改作的版本中利用將字體編排設計要素齊行排列的方式，讓它們自己呈現出這張表格的基本架構。

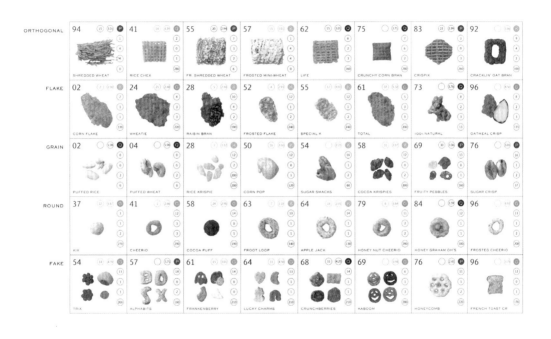

33

早餐週期表（PERIODIC BREAKFAST TABLE），雜誌內頁（細部），一九九八年。設計者：凱瑟琳・韋斯（Catherine Weese）。攝影者：約翰・赫爾朋恩（John Halpern）。出版者：Patsy Tarr, 2wice Magazine。這張圖表將早餐脆片依照形狀排列出來，並且註記了從纖維含量到每磅單位價格等多種特性。視覺化的資料展示方式讓讀者們可以就各項目快速進行比較。舉例來說，讀者或許會觀察到，含糖量較高的早餐脆片通常也伴隨有較鮮豔的顏色。

# EXERCISE: DATA TABLES
## 練習：資料表格

從一本老舊的科學書籍或其它資料來源挑選一張圖表出來，重新加以設計。右方這張圖片是十九世紀一場關於螞蟻的實驗的記錄表單。原本的設計強調垂直區塊而犧牲了水平區塊，儲存格中的文字與數字也混雜在一起。

下方經過重新設計的圖表去除掉許多分界線，在需要分界的地方以淺色調將水平列的資料統整在一起。新設計的圖表也以小圓點取代了數字，這個技巧讓眼睛可以在視覺上直接比較結果，而不需要個別閱讀數字資料。

**被麻醉的螞蟻**

| | LEFT ALONE | TAKEN TO NEST | THROWN IN WATER | BOTH NEST AND WATER | LEFT ALONE | TAKEN TO NEST | THROWN IN WATER | BOTH NEST AND WATER |
|---|---|---|---|---|---|---|---|---|
| PT 10 | •••• | | | | | | •••• | |
| 14 | | | •••• | | | | •• | •• |
| 15 | | | • | • | •• | | •• | |
| 29 | | | ••••• | | | | •••• | |
| CT 02 | | | ••••• | | | | ••• | • |
| 06 | | | ••••• | | | | •••• | |
| AL | 04 | | 20 | 01 | 02 | | 20 | 03 |

**酒醉的螞蟻**

| | LEFT ALONE | TAKEN TO NEST | THROWN IN WATER | BOTH NEST AND WATER | LEFT ALONE | TAKEN TO NEST | THROWN IN WATER | BOTH NEST AND WATER |
|---|---|---|---|---|---|---|---|---|
| OV 20 | | ••• | •• | | • | | ••••• | |
| 22 | •• | •• | | | | | •••••••• | |
| EC 01 | | ••••••• | •• | | | | •••••• | ••• |
| 05 | | •••••••••• ••••••• | ••••• | | | | •••••••• | •• |
| AN 15 | •••• | | | | • | | ••• | |
| 17 | | •••• | | | | •• | •••••• | • |
| AL | 06 | 32 | 09 | | 02 | 02 | 43 | 07 |

**118**   BEHAVIOUR TO INTOXICATED FRIENDS.

*Tabular View.—Experiments on Ants under
Chloroform and Intoxicated.*

| | CHLOROFORMED ANTS. | | | | | |
|---|---|---|---|---|---|---|
| | FRIENDS | | | STRANGERS | | |
| | To Nest | To Water | Unre-moved | To Nest | To Water | Unre-moved |
| Sept. 10 | ... | ... | 4 | ... | 4 | ... |
| 14 | ... | 4 | ... | 2 and brought out again | 2 | ... |
| 15 | 1 and brought out again | 1 | ... | ... | 2 | 2 |
| 29 | ... | 5 | ... | ... | 4 | ... |
| Oct. 2 | ... | 5 | ... | 1 and brought out again | 4 | ... |
| 6 | ... | 5 | ... | ... | 4 | ... |
| | 1 | 20 | 4 | 3 | 20 | 2 |
| | INTOXICATED ANTS. | | | | | |
| Nov. 20 | 3 | 2 | ... | ... | 5 | 1 |
| 22 | 2 | ... | 2 | ... | 8 | ... |

In these cases some of the Ants had partly recovered ; in the following they were quite insensible.

| | To Nest | To Water | Unre-moved | To Nest | To Water | Unre-moved |
|---|---|---|---|---|---|---|
| Dec. 1 | 7 none brought out again | 2 | ... | 3 all these brought out again | 6 | ... |
| 8 | 16 none brought out again | 5 | ... | 3 all these brought out again | 15 | ... |
| Jan. 15 | ... | ... | 4 | ... | 3 | 1 |
| 17 | 4 none brought out again | ... | ... | 3 one brought out again | 6 | ... |
| | **27** | 7 | 4 | 2 | 30 | 1 |

酒醉的朋友，取自約翰・陸伯克爵士（Sir John Lubbock）的著作《螞蟻、蜜蜂、黃蜂》（Ants, Bees, and Wasps, New Work: D. Appleton and Company, 1983）當中的資料表格。這項實驗的作者意在研究螞蟻對於遇到「朋友」（同一蟻群裡的成員）或「陌生人」時會如何反應。在第一個實驗中，「朋友」與「陌生人」都被施以三氯甲烷麻醉而陷入昏迷。在第二個實驗中，螞蟻只有酒醉。被麻醉的螞蟻——不論是「朋友」或是「陌生人」——通常都會被認為已經死亡而遭丟進蟻窩周圍的水溝中。對待酒醉螞蟻的方式則有所差別。許多醉醺醺的「朋友」被帶回蟻窩休養，至於酒醉的「陌生人」則通常會被丟進水溝裡。我們因而可以得到這樣的結論——螞蟻不該指望陌生人大發慈悲。

{ **APPENDIX** 附錄 }

# SPACES AND PUNCTUATION
## 空格與標點符號

作家或客戶提供的原稿往往會有錯用破折號或空格的情形發生。請參考可靠的書籍例如《芝加哥格式手冊》(The Chicago Manual of Style)以獲得如何使用標點符號的完整指南。以下的規則對於設計師來說尤其切身相關。

文字空格 (space bar) 是由空格鍵創造出來的。在兩個句子之間，或在逗號、冒號、分號之後，請使用一個空格就好。為原稿進行排版的首要步驟之一就是將所有雙空格去除掉。因此想要縮排、或讓文字換行時，不應該使用空格鍵，而是應該使用跳格鍵 (tabs)。HTML不會辨認雙空格。

en空格 (en spaces) 比文字空格略寬。en空格可以為同一行上的元素之間創造更明顯的間距；例如，將副標題與緊跟在後的文字內容區分開來，或者為排列於信紙信頭同一行內的元素做出分隔。

長破折號 (em dashes) 表現出文法上強烈的停頓語氣。一個長破折號為一個em寬——等於所使用字體點數的寬度。在原稿當中，破折號經常以兩個連字號 (--) 表示；這些連字號必須被替換掉。

短破折號 (en dashes) 主要用於連結數字 (1-10)。一個en的寬度是em的一半。原稿裡極少使用到短破折號，因此設計師們需要自行加上去。

連字號 (hyphens) 用於連結字詞、以及在行尾將文字斷開。排版軟體會自動斷字。當你需要保持邊緣參差或讓文字置中時，請關閉「自動連字」(auto hyphenation) 的功能；改用「選擇性連字號」(discretionary hyphens)，並且只於必要時使用。

選擇性連字號 (discretionary hyphens) 是以手動方式插入斷行，只有必要時才會出現於文件中。(假使這段文字在稍後的編輯中被重新整理過，選擇性連字號可能會消失。) 若排版者插入的是「實在」的連字號而不是「選擇性連字號」，連字號往往會隨意出現在行句的中間某處。

引號 (quotation marks) 和影線符號 (hatch marks) 不同，有向上的「左引號」(open) 與向下的「右引號」(close) 兩種形式。右單引號 (single close quote) 也被使用為「撇號」(apostrophe) ("It's Bob's font")。上標符號 (prime) 或影線符號應該只用於標示時和吋 (5'2'')。錯誤使用的影線符號會被視為「笨蛋引號」。雖然電腦作業系統與排版軟體通常有「自動修正引號」的功能，但電子郵件、文書處理、和/或客戶端提供的文件裡可能還是會出現許多笨蛋引號。自動修正引號的軟體往往會將撇號上下顛倒 ('tis變成'tis)，因此設計師們必須特別留意、並且記住必要的擊鍵組合。

刪節號 (ellipses) 包括了三個句點，中間沒有空格、沒有字元間距、沒有文字空格。刪節號代表了在一段引文中被省略的部分……或短暫的停頓。大多數字體中都有一個由緊密排列的點號構成的刪節號字體。

### MAC OS擊鍵組合

以下列出在文書處理、頁面排版、以及繪圖軟體當中經常使用的擊鍵組合。有些字型並未包含完整的特殊符號。

| 符號 | | 擊鍵組合 |
|---|---|---|
| — | 長破折號 | shift-option-hyphen |
| – | 短破折號 | option-hyphen |
| - | 標準連字號 | (hyphen key) |
| - | 選擇性連字號 | command-hyphen |
| **標點符號** | | |
| ' | 左單引號 | option-] |
| ' | 右單引號 | shift-option-] |
| " | 左引號 | option-[ |
| " | 右引號 | shift-option-[ |
| … | 刪節號 | option-; |
| **其它符號** | | |
| ( ) | en空格 | option-space bar |
| † | 短劍號 (dagger) | option-t |
| ‡ | 雙劍號 (double dagger) | shift-option-7 |
| © | 版權符號 (copyright symbol) | option-g |
| ® | 註冊商標符號 (registered symbol) | option-r |
| € | 歐元符號 | shift-option-2 |
| fi | fi連字 (fi ligature) | shift-option-5 |
| fl | fl連字 (fl ligature) | shift-option-6 |
| é | 閉口音 (accent aigu) | option-e + e |
| è | 開口音 (accent grave) | option-` + e |
| à | 開口音 | option-` + a |
| ù | 開口音 | option-` + u |
| ç | 軟音符 (cédille) | option-c |
| ü | 元音變音 (umlat) | option-u + u |
| ö | 元音變音 | option-u + o |

# These interruptions—especially the snide remarks--are killing my buzz.

（這些中斷符號——尤其是這幾個假貨--真是太掃我的興了。）

囧設計：兩個連字號取代了長破折號

破折號在句中代表了停頓。

在文書處理軟體的文件裡，破折號可以以兩個連字號表示；然而在排版的時候仍然必須使用長破折號。

破折號旁邊不要使用空格。

# El Lissitzky lived 1890–1941. Rodchenko lived longer (1891-1956).

（艾爾·李希茨基的生歿年份是1890–1941。羅欽可［Rodchenko］活得比較久［1891-1956］。）

囧設計：數字之間用了連字號

短破折號連結兩個數字，這表示「直到且包含」，而不是「之間」。

短破折號旁邊不要使用空格。

# It's okay to be second-best, but never, ever second–best.

（second-best［第二好］沒有關係，但是千萬不要second–best［把第二當最好］。）

囧設計：在該用連字號的時候用了短破折號

需要使用低調的連字號時不要使用短破折號。

# In the beginning was⋯the word⋯⋯Typography came later.

（開始的時候⋯是文字⋯⋯後來才有字體編排設計。）

這裡以刪節號代替個別獨立的句點符號。

刪節號裡的句點符號可以利用文字空格分開來，或者就如我們習慣的，也可以透過調整字元間距控制距離。

大部分字體都有自己的刪節號字體，通常這個字體的句點間距會比較緊密。

如果在句子最後使用刪節號，要再多加上一個句點（總共四個點）。

# She was 5'2" with eyes of blue. "I'm not dumb," she said. "I'm prime."

（她身高五呎六吋，有一雙藍眼睛。"I'm not dumb,"［我可不笨］她說。"I'm prime."［我優秀得很］）

囧設計：上標符號〔prime marks，又稱為笨蛋引號〕被用以取代引號

上標符號，或者影線符號，是用於標示吋和呎的。

將它們當做引號是字體編排設計中常見的禍害。

# "I'm not smart," he replied. "I'm a quotation mark."

（"I'm not smart,"［我不聰明］他回答。"I'm a quotation mark."［我就是個引號］）

引號與上標符號不同，它有分左引號與右引號。

右單引號也會被作為撇號使用。

錯誤使用的上標符號必須被找出來並且加以摧毀。

# Don't put two spaces between sentences.  They leave an ugly gap.

（不要在兩個句子之間插入兩個空格。  它們會留下難看的隙縫。）

囧設計：句子之間的兩個空格

雖然作家們堅持要在句子之間插入兩個空格（這個習慣通常是在高中時期養成的），

但排版時這些空格必須從原稿當中去除掉。

# EDITING
## 編輯

自從桌上出版（desktop publishing）在黑暗的一九八〇年代中期橫掃千軍之後，平面設計師已經取代了過去由特定行業獨佔的角色，例如排版與手工完稿。設計師們往往也被期望負起編輯的工作。每一件出版企劃應該都要有一位真正的編輯，這個人受過訓練、也有能力判斷書寫內容的正確性、精準性、與連貫性。在出版企劃裡，編輯不應該由作者或設計師擔任，因為編輯正是兩造之間的中立角色。假使企劃團隊裡沒有受過適當訓練的編輯，試著去找一位進來；假使沒辦法找到，那麼就要確定有人可以負起這個重要角色的責任，因為粗心大意的編輯將會導致代價慘痛且令人難堪的失誤。

出版品的文字編輯有三個基本的階段。「開發編輯」（developmental editing）著眼於內容方面較大的議題與作品架構；實際上，它還包括了在第一時間針對作品是否適合出版進行判斷。「文字編輯」（copy editing，也稱為行句編輯〔line editing〕，或原稿編輯〔manuscript editing〕）要從整件作品當中挑出贅詞、前後不連貫、文法錯誤、或其它瑕疵等問題並加以去除。文字編輯－必須仔細斟酌每一字、每一句——不應該對作品整體的意義或架構提出質疑、也不能調整作者的樣式風格，而是要加以精雕細琢、修正錯誤。「校對」（proofreading）必須就設計、排版後的頁面檢查其正確性、一致性、以及流暢性，是編輯的最後一個階段。每一個階段可能會反覆進行數個回合，端看企劃與團隊的性質而定。

### 錯誤分析

在文件經過寫作、編輯、設計、校對之後，印刷商會就設計師所提供的數位檔案製作印刷樣稿。許多客戶（或作者）直到印刷樣稿產生之後才發現其中的錯誤（或作出取捨）。這種馬行為有其代價，總得有人負起責任。

### 印刷商的失誤（PE'S，PRINTER'S ERRORS）

這是歸責於印刷商的錯誤，他們必須免費為設計師或客戶進行修正。印刷商的失誤指的是與設計師所提供、並且經印刷商確認同意的數位檔案和其它指示內容有明顯相異之處。印刷商的失誤在數位時代非常少見。

### 作者的變更（AA'S，AUTHOR'S ALTERATIONS）

這種錯誤不在少數。作者的變更是指對於已經核對過的內文或版面作出更改。假使更改來自於設計師，設計師必須為此負責；如果更改來自於客戶或作者，她或他也必須負責。為企劃案發展的每一個階段留下記錄有助於日後完責。設計師可以因為作者的變更而收取印刷費之外的費用，因為設計師必須更正檔案、印出新的紙本文件、（再次）送交客戶審核同意、（再次）與印刷商溝通等等。假使內容已經事先經過雙方同意，即便是在印刷樣稿產生之前，設計師也可以因為同意後的文件上所做的任何變更收取「作者變更費」。

### 編輯的變更（EA's，EDITOR'S ALTERATIONS）

編輯犯錯是編輯僱主的責任，這通常指的是客戶或者是作品的出版社。好的編輯會在第一時間就避免所有人出錯。

更多關於編輯流程的細節，請參考《芝加哥格式手冊》，第十五版（Chicago：University of Chicago Press，二〇〇三年）。

原稿編輯，也稱為文字編輯或行句編輯，需要專注於原稿上的每一個字，充份掌握文件必須遵循的樣式風格，並且有能力作出快速、合理、站得住腳的決定。—— 《芝加哥格式手冊》，二〇〇三年。

**只有編輯可以看透作家的心思。**

不論你的文采如何華美，編輯總是有辦法從拼字、文法、連貫性、贅詞、和句法結構上找出錯誤。

**作家不應該過度著重文本的格式。**

你現在花時間為你的文本張羅格式，之後編輯和／或設計師同樣還要再費一次工夫處理，把多餘的擊鍵動作拿掉。你只需要提供靠左對齊、單一字型、兩倍行高的文件。

**最好把高中時代學的一些東西忘掉。**

其中之一就是把i上頭的點換成愛心或者是笑臉。另外就是在兩個句子之間插入兩個空格。在排版上，句子之間只能有一個空格。

**空白鍵不是設計工具。**

不要以空白鍵製造縮排（只要使用跳格鍵就可以了），也不要以空格製造置中的效果或版面（除非你是E. E. 卡明斯[4]〔E. E. Cummings〕本人）。

**每一次變更都是造成新錯誤的威脅。**

每當檔案被「更正」，新的錯誤就會隨之出現。從版面邊緣參差不齊、過於整齊、頁面中斷，到拼字錯誤、缺漏字、拙劣或不完整的更正等等，都是可能出現的問題。

**不要等到校稿階段才仔細檢查排版的文字內容。**

等到印刷樣稿（藍線圖、樣張等等）產生之後才作更動的代價相當昂貴，同時也讓你原本已經慢了半拍的計畫時程更加延宕。

**知名遺言：「我們會趕上藍線圖的。」**

---

[4] E. E. 卡明斯（E. E. Cummings，1894-1962）是美國著名詩人，經常以實驗性的語法進行創作。

# EDITING HARD COPY
## 編輯紙本文件

Writers, editors, and designers use special symbols to mark changes such as ~~deleting~~, ~~posing~~trans, or ~~correcting~~ words or phrases. If you change your mind about a ~~deletion~~, place dots beneath it. Remove a comma by circling it. Add a period with a circled dot. If two words run together, insert a straight line and a space mark.

To combine two paragraphs, connect them with a line and note the comment "run-in" in the margin. (Circling notes prevents the typesetter from confusing comments with content.)

Insert two short lines to hyphenate a word such as secondrate. When removing a hyphen, close up the leftover space. To replace a hyphen with an em dash—a symbol that expresses a grammatical break—write a tiny m above the hyphen. If a manuscript indicates dashes with double hyphens--like this-- the typesetter or designer is expected to convert them without being told. Use an en dash, not a hyphen, to connect two numbers, such as 1914-1918.

In addition to correcting grammar, spelling, punctuation, and clarity of prose, editors indicate typographic styles such as italic (with an underscore) and boldface (with a wavy line). Underlining, which is rarely used in formal typography, is removed like this. Draw a line through a capital letter to change it to lowercase, underline a letter with three strokes to capitalize it. Use two underlines to indicate small capitals.

Double-space the manuscript and leave a generous margin to provide room for comments and corrections. Align the text flush left, ragged right, and disable automatic hyphenation.

---

*delete*
刪除

pose trans
對調

let it stand
保留（保持原樣）

#
*add space*
分開；增加空格

secondrate
加上連字號

left-over
拿掉連字號

*Dashing-no?*
長破折號

1914-1918
短破折號

*italic*
斜體字

**boldface**
粗體字

remove underline
拿掉底線

CASE
小寫

case
大寫

case
小型大寫字

---

作家、編輯、與設計師利用特殊符號標示文字的變更，例如刪除、對調、或文字語詞的更正（取代）。假使你對於刪除改變了心意，可以在刪除處下方加上小圓點。將想要刪除的逗號圈起來。以一個圓圈裡頭點上一點，表示要加一個句號。如果兩個字連在一起，從中間插入一道直線與一個間隔符號。

　　要將兩段文字結合在一起的話，拉一條線把它們連起來並且在邊界上加註「接排」（run-in）。（把加註的文字圈起來可以避免排版師把註解與內容搞混。）

　　插入兩條短線表示要為單字加上連字號，例如secondrate。如果要拿掉連字號，就將剩餘空間靠攏。要以長破折號——在文法上表示停頓的符號——取代連字號的話，就在連字號上方寫一個小小的m。假使原稿上以雙連字號表示破折號，像這樣「--」，那麼排版師或設計師應該主動轉換這些符號，而無需等待被告知。以短破折號而非連字號來連接數字，比方說1914-1918。除了更正文法、拼字、標點符號的錯誤，以及讓文句更通順之外，編輯也應該要標示出字體編排上所使用的樣式，例如斜體字（劃一條底線）和粗體字（劃波浪曲線）。底線極少被使用於正式的字體編排設計中，可以用這種方法表示要拿掉底線。在大寫字母上劃線表示要把它改成小寫字母。在字母下方劃上三條短線則表示要將它改為大寫。兩條底線的意思是在此處使用小型大寫字。

　　原稿請使用兩行間距並保留寬闊的邊界，以作為加註評論與更正內容的空間。讓文字保持靠左對齊、右邊參差，關閉「自動連字」（automatic hyphenation）的功能。

不要利用便利貼在原稿或樣稿上作記號。它們可能會掉落、擋住文字，也會讓文件不便於複印。

編輯電子檔案並且讓作者看到更改之處稱為「劃紅線」（redlining，也稱為「線上編輯」
〔editing online〕）。基本工作包括有去掉所有的雙空格，以及將影線符號（也就是「笨蛋引
號」）改為引號與撇號（也就是「聰明引號」）。編輯需要為作者指出做了哪些修改。

在文本結構與用語上所作的變更必須傳達給作者。需要有視覺化的方式顯示刪去和增
加了什麼素材。刪除的文字通常會被劃掉，而增加或替代的文字可能會以加上底線、反光區
塊、或變更文字色彩的方式表示。邊界上的線條代表此處有變更建議。〔對作者的疑問則會
在方括弧內提出。〕5

在標點符號上加底線或直接將標點符號劃掉，兩者在視覺上容易混淆，所以編輯經常
會將整個單字或片語刪除，並且重新打上附有正確標點符號的字詞。如果要替單字加上連
字號，例如secondrate，請直接將它劃掉並加上有連字號的單字。若要將連字號改為短破折
號（1914–18）——或將雙連字號改為
長破折號——編輯只要直接把它們打
上去就好。字體編排設計的樣式，例
如斜體字、粗體字、和小型大寫字，可
以直接加以更改。

雖然「劃紅線」是一種流暢又直
接的方法，但它可能帶有 一些危險性。
編輯必須在將檔案提供給設計師與排
版師之前，小心翼翼地去除編輯過程
中的所有記錄。否則可能造成的災難
除了連字、缺漏字之外，或許還會有你
忘了自己曾經寫給作者的評語〔妳的
母愛上哪兒去了？〕。

Editing an electronic file and allowing the author to see the changes is
called *redlining* (also referred to as "editing online"). Basic housekeeping
includes removing all double spaces and converting hatches (a.k.a. "dumb
quotes") to quotation marks and apostrophes (a.k.a. "smart quotes"). The
editor need not point out these changes to the author.

Changes to the structure and wording of the text must be
communicated to the author. A visual convention is needed for showing
deleted and added material. ~~Words to be removed~~ are typically struck out,
and words added or substituted can be underlined, highlighted, or rendered
in color. A line in the margin indicates that a change has been recommended.
[Queries to the author are set off with brackets.]6

Underlining, or striking out; punctuation is visually confusing, so the
editor often strikes out an entire word, or phrase, or phrase—and types
in the freshly punctuated passage as an addition. To hyphenate a word such
as ~~secondrate~~ second-rate, strike it out and add the hyphenated form. When
converting hyphens to en dashes (1914–18)—or changing double hyphens to
em dashes—the editor simply keys them in. Typographic styles such as *italic*,
**boldface**, and small capitals can also be changed directly.

Although redlining is wonderfully fluid and direct, it can be dangerous.
The editor must scrupulously remove all traces of the editing process before
releasing the file for design and typesetting. Potential disasters include words
that are stucktogether, a missing , or a forgotten comment to the author [Are
you out of your mother-loving mind?].

A. Queries to the author can also take the form of footnotes. Identify these notes with
letters, so they are not confused with footnotes that belong to the text.

5 對作者提出的疑問也可以是註腳的形
式，以字母標示這些註腳，這樣才不會
與內文的註腳互相混淆。

# PROOFREADING
## 校稿

校稿在原稿經過編輯、設計、排版之後進行。在處理文件的過程中，任何時間點都可能會出現新的錯誤，而之前沒有被發現的舊錯誤也可能會在文字以排版後的樣貌呈現時被辨識出來。校稿者會就拼字、文法、與事實等明顯的錯誤進行訂正，但要避免更動樣式與內容。這個階段的變更不但代價昂貴，而且可能會影響頁面的設計並製造新的問題。

雖然編輯可能會與作者或客戶共同或分別參與校稿，但實際上校稿是不同於編輯的工作。設計師或排版師[6]不應該被賦予校稿者的角色，然而設計者必須在將稿件交回給編輯、作者、或客戶之前仔細檢查其中是否有錯誤。

PROOFREADING takes place *after* an edited manuscript has been designed and typeset. New errrors can appear at any time during the handling of a document, and old errors—previously unrecognized—can leap to the eye once the text has been set in type. The proofreader corrects gross errors in spelling, grammar, and fact, but avoid changes in style and content. Changes at this stage are not only expensive but they can affect the page design and introduce new problems.

Proofreading is different task from editing, although the editor may play a role in it, along with or in addition to the author or client. Although the *designer or typesetter*[1] should not be given the role of proof reader, designers must nonetheless inspect their work carefully for errors before sending it back to the editor, author, or client.

Mark all corrections in the margin of the proof, and indicate the position of changes within the text. Don't write between the lines. Many of the same interline symbols are used in proofreading and in copy editing, but proofreaders use an additional set of flags for marginal notes.

Don't obliterate what is being crossed out and deleted, so the typesetter can read it.

Mark all changes on one master proof. If several copies of the proof are circulated for approval, one person (usually the editor) is responsible for transferring corrections to a master copy.

Don't give the designer a proof with conflicting or indecisive comments.

TYPES OF *proofs* Depending on how a project is organized and produced, some or all of the following proofs may be involved.

*Galley proofs* are typically supplied in a book-length project. They consist of text that has been typeset but not paginated and do not yet include illustrations.

*Page proofs* are broken into pages and include illustrations, page numbers, running heads, and other details.

*Revised proofs* include changes that have been recommended  by the proofreader and input by the designer or typesetter.

*Printer's proofs* are generated by the printer. At this phase, changes become increasingly costly, complex, and ill-advised. In theory, one is only looking for printers' errors—not errors in design or verbal style—at this stage. Printer's proofs might include blue lines (one color only) and/or color proofs.

1. The designer and typesetter may be the same person. In a design studio, as opposed to a publishing house, designers are generally responsible for typesetting.

將更正記號作在樣稿的邊界上，並且在內文中標示出更正處的位置。不要在行與行之間書寫。校稿與文字編輯會使用到許多相同的行間符號，但校稿者另有一套在邊界作註記的方式。

不要將原先劃掉與刪除的筆跡擦去，這樣排版師才有辦法看到。

將所有變更註記在一張主要的樣稿上。假使同時有好幾份樣稿供傳閱審核，需要有人（通常是編輯）負責將更正的部分全數註記到一份主要的樣稿上。

不要將一份註記內容有衝突或不明確的樣稿交給設計師。

樣稿的類型：根據企劃案組織與產出的方式，期間可能會使用到以下數種或全部的樣稿類型。

初校校樣（galley proofs）通常會於書本規模的企劃當中提供。校樣內容是已經排版但尚未編定頁碼、也還未搭配插圖的內文。

排版校樣（page proofs）會分頁，並包括有插圖、頁碼、逐頁標題、與其它細節。

修訂校樣（revised proofs）包括校稿者建議的更正、以及設計者或排版者提出的意見。

印刷校樣（printer's proofs）是由印刷商製作提供。在這個階段，更正所付出的代價變得更昂貴、更複雜，而且不智。理論上，這個階段應該只要檢查是否有印刷上——而不是設計或文字風格上——的錯誤。印刷校樣可能會包括有藍線圖（只有單色）和／或彩色樣稿。

6 設計師與排版師或許會是同一個人。相對於出版社，設計工作室裡通常是由設計師負責排版的工作。

| 編輯修改 | 內文裡的記號 | 邊界上的記號 | 編輯修改 | 內文裡的記號 | 邊界上的記號 |
|---|---|---|---|---|---|
| 刪除 | delete | (刪除記號) | 調整字距 | letterspace | ls |
| 刪除並靠攏 | delete and close up | (記號) | 靠攏 | clo se up | (記號) |
| 保留原樣 | let it stand | stet | 插入空格 | insert space | # |
| 插入文字或字母 | insert | text | 縮減空格 | reduce space | less # |
| 段落接排 | run in paragraph | run in | 對調 | pose trans | tr |
| 另起一段 | start new paragraph | (記號) | 靠右對齊 | flush right | fr |
| 插入標點符號 | insert punctuation | (記號) | 靠左對齊 | flush left | fl |
| 更改標點符號 | change punctuation | (記號) | 縮排一個em寬度 | indent 1 em | (記號) |
| 插入連字號 | insert hyphen | (記號) | 移至下一行 | move to next line | T.O. |
| 插入圓括號 | insert parentheses | (記號) | 上標 | superscript 1 | 1 |
| 插入短或長破折號 | insert en dash | N  M | 垂直對齊 | align vertically | (記號) |
| 插入引號 | insert quotes | (記號) | 水平對齊 | align horizontally | (記號) |
| 大寫 | capitalize | cap | 完整拼出縮寫 | spell out abbrev. | SP |
| 改為小寫 | LOWERCASE | lc | 使用連字 | use ligature (flour) | fl |
| 改為小型大寫字 | small caps | sc | 校稿者無法解決的疑問 | query | ? |
| 改為粗體字 | bold | bf |  |  |  |
| 改為正體字 | roman | rom |  |  |  |
| 字型錯誤 | wrong font | wf |  |  |  |

校稿者使用的記號，來自《芝加哥格式手冊》與大衛·朱利的著作《向後轉：字體編排設計規則的復興》（About Face: Reviving the Rules of Typography, East Sussex: Rotovision, 2001）。各家所使用的記號慣例的確會有些許不同。

# FREE ADVICE
## 免費的建議

**思考多一點，設計少一點。**

當設計裡缺少強烈的概念，就會出現許多不顧後果的設計行為（包括漸層、陰影、與莫名其妙的透明）。一個好的概念可以為設計決策提供架構，引導作品的發展方向。

**多說一點，少寫一點。**

就如同設計師要避免在空間裡自顧自地填滿各種視覺效果，作家也應該記住別人不會像他們那樣熱愛自己所寫的文字。

**買貴一點，買少一點。**

便宜的東西之所以便宜，與它們的製作方法、材質、以及製造者有關。買品質好一點的產品，但不要常常買。

**願你思慮深，傷口淺。**

務必使用鋒利的刀片。雖然平面設計不是極度危險的職業，但鈍化的X-Acto刀片已經導致許多深夜意外發生。請保護你的輸出成品不要受到濺血的無端波及。

**緊密是新的留白方式。**

在市郊無限擴張的時代，緊密交織的社區展現了面貌一新的吸睛魅力。因此在頁面與螢幕上也是如此，大量的資訊文本會比貧乏冷清的內容發揮更好的效果。

**不要削足適履。**

與其將內容硬塞進死板的容器當中，不如打造一個靈活有彈性、對於它們要容納的素材能夠有所回應的系統。

**做大一點。** （寶拉·雪兒贈言）

業餘字體編排設計師會把他們的字體做得太大。一般預設的12 pt大小字型——在螢幕上看起來還可以——在頁面上看起來往往顯得太大。然而設計老手卻常常把字體做得太小：像是這裡所顯示的，7-pt。

## 說要比聽來得容易。

傾聽你的客戶、使用者、讀者、和朋友的聲音。一旦你傾聽他人的聲音，你便會做出更好的設計。

## 設計是一種情境的藝術。

設計師會對世界上所發生的需求、問題、與環境作出反應。最棒的作品會因應有趣的情境——心胸開放的客戶、美好的動機、或出色的內容——而誕生。

## 沒有什麼工作是微不足道的。

平面設計師每次設計一張名片也足以改變這個世界——只要這張名片是屬於一個真正有趣的傢伙。

## 介面在失靈的時候才會引人注意。

設計會幫助日常生活系統順暢運作，使用者與讀者往往會忽略這些事物是如何被擺放在一起的。設計有時候也應該自我宣告，顯露它的結構、認同、個性、與政治見解，好讓系統的存在被清楚呈現出來。

## 概念是製造藝術的機器。 （索爾·勒維特〔Sol Lewitt〕贈言）

強而有力的概念可以影響色彩、版面、字體、形式等等的決策，避免產生莫名其妙的愚蠢行為。（但另一方面，莫名其妙的愚蠢行為有時候會導出強而有力的概念。）

## 早起的鳥兒勤做工。

你的最佳思考時間可能是在大清早、三更半夜、或甚有少數情況是在課堂中或九點到五點之間的上班時間。不論你的最佳時間是發生在淋浴間、健身房、或在火車上，就善用這段時間努力思考吧。

## 建立對話的機會。

設計是社交性的。它存在於社會之中，它創造社會，也需要屬於自己的社會——一個致力於提昇並討論共同期待與渴望的設計師社群。盡你所能地閱讀、寫作、與談論關於設計的一切。

## 讓它生生不息下去吧。

# BIBLIOGRAPHY
參考書目

## LETTER

Bartram, Alan. *Five Hundred Years of Book Design.* London: British Library, 2001.

Benjamin, Walter. *One Way Street and Other Writings.* London: Verso, 1978.

Blackwell, Lewis. *Twentieth-Century Type.* New Haven: Yale University Press, 2004.

Boyarski, Dan, Christine Neuwirth, Jodi Forlizzi, and Susan Harkness Regli. "A Study of Fonts Designed for Screen Display." *CHI 98* (April 1998): 18–23.

Broos, Kees, and Paul Hefting. *Dutch Graphic Design: A Century.* Cambridge: MIT Press, 1993.

Burke, Christopher. *Paul Renner: The Art of Typography.* New York: Princeton Architectural Press, 1998.

Clouse, Doug and Angela Voulangas. *The Handy Book of Artistic Printing.* New York: Princeton Architectural Press, 2009.

Christin, Anne-Marie. *A History of Writing, from Hieroglyph to Multimedia.* Paris: Flammarion, 2002.

Crouwel, Wim. *New Alphabet: An Introduction for a Programmed Typography.* Amsterdam: Wim Crouwel/Total Design, 1967.

———, Kees Broos, and David Quay. *Wim Crouwel: Alphabets.* Amsterdam: BIS Publishers, 2003.

Cruz, Andy, Ken Barber, and Rich Roat. *House Industries.* Berlin: Die Gestalten Verlag, 2004.

De Jong, Cees, Alston W. Purvis, and Jan Tholenaar, eds. *Type: A Visual History of Typefaces, Volume I, 1628–1900.* Cologne: Taschen, 2009.

Eason, Ron, and Sarah Rookledge. *Rookledge's International Directory of Type Designers: A Biographical Handbook.* New York: Sarabande Press, 1994.

Gray, Nicolete. *A History of Lettering.* Oxford: Phaidon Press, 1986.

Heller, Steven, and Philip B. Meggs, eds. *Texts on Type: Critical Writings on Typography.* New York: Allworth Press, 2001.

Johnston, Edward. *Writing & Illuminating & Lettering.* London: Sir Isaac Pitman & Sons, 1932.

Kelly, Rob Roy. *American Wood Type: 1828–1900.* New York: Da Capo Press, 1969.

Kinross, Robin. *Unjustified Texts: Perspectives on Typography.* London: Hyphen Press, 2002.

Lawson, Alexander. *Anatomy of a Typeface.* Boston: David R. Godine, 1990.

Lewis, John. *Anatomy of Printing: The Influences of Art and History on its Design.* New York: Watson-Guptill Publications, 1970.

———. *Typography: Basic Principles, Influences and Trends Since the Nineteenth Century.* New York: Reinhold Publishing, 1963.

McMurtrie, Douglas. *The Book: The Story of Printing and Bookmaking.* New York: Dorset Press, 1943.

Morison, Stanley. *Letter Forms.* London: Nattali & Maurice, 1968.

Noordzij, Gerrit. *Letterletter: An Inconsistent Collection of Tentative Theories That Do Not Claim Any Authority Other Than That of Common Sense.* Vancouver: Hartley and Marks, 2000.

Pardoe, F. E. *John Baskerville of Birmingham: Letter-Founder and Printer.* London: Frederick Muller Limited, 1975.

Perry, Michael. *Hand Job: A Catalog of Type.* New York: Princeton Architectural Press, 2007.

Shelley, Mary. *Frankenstein.* New York: The Modern Library, 1999. First published 1831.

Re, Margaret. *Typographically Speaking: The Art of Matthew Carter.* New York: Princeton Architectural Press, 2002.

Triggs, Teal. *The Typographic Experiment: Radical Innovation in Contemporary Type Design.* London: Thames & Hudson, 2003.

Updike, Daniel. *Printing Types: Their History, Forms, and Use, Volumes I and II.* New York: Dover Publications, 1980.

VanderLans, Rudy, and Zuzana Licko. *Emigre: Graphic Design into the Digital Realm.* New York: Van Nostrand Reinhold, 1993.

Vanderlans, Rudy. *Emigre No. 70: The Look Back Issue, Selections from Emigre Magazine, 1984–2009.* Berkeley, CA: Gingko Press, 2009.

Willen, Bruce and Nolen Strals. *Lettering & Type: Creating Letters and Designing Typefaces.* New York: Princeton Architectural Press, 2009.

## TEXT

Armstrong, Helen. *Graphic Design Theory: Readings from the Field.* New York: Princeton Architectural Press, 2009.

Barthes, Roland. *Image/Music/Text.* Trans. Stephen Heath. New York: Hill and Wang, 1977.

———. *Mythologies.* Trans. Annette Lavers. New York: Hill and Wang, 1977.

Baudrillard, Jean. *For a Critique of the Political Economy of the Sign.* St. Louis, MO: Telos Press, 1981.

Benjamin, Walter. *Reflections.* Ed. Peter Demetz. New York: Schocken Books, 1978.

Bierut, Michael. *Forty Posters for the Yale School of Architecture.* Cohoes, NY: Mohawk Fine Papers, 2007.

Bolter, Jay David. *Writing Space: Computers, Hypertext, and the Remediation of Print.* Mahwah, NJ: Lawrence Erlbaum Associates, 2001.

Derrida, Jacques. *Of Grammatology.* Trans. Gayatri Chakravorty Spivak. Baltimore: Johns Hopkins University Press, 1976.

Diamond, Jared. *Guns, Germs, and Steel: The Fates of Human Societies.* New York: W. W. Norton, 1997.

Kaplan, Nancy. "Blake's Problem and Ours: Some Reflections on the Image and the Word." *Readerly/Writerly Texts*, 3.2 (Spring/Summer 1996): 115–33.

Gould, John D. *et al.* "Reading from CRT Displays Can Be as Fast as Reading from Paper." *Human Factors* 29, 5 (1987): 497–517.

Helfand, Jessica. *Screen: Essays on Graphic Design, New Media, and Visual Culture.* New York: Princeton Architectural Press, 2001.

Lessig, Lawrence. *Free Culture: How Big Media Uses Technology and the Law to Lock Down Culture and Control Creativity.* New York: Penguin, 2004.

Laurel, Brenda. *Utopian Entrepreneur.* Cambridge: MIT Press, 2001.

Lunenfeld, Peter. *Snap to Grid: A User's Guide to Digital Arts, Media, and Cultures.* Cambridge: MIT Press, 2001.

Manovich, Lev. *The Language of New Media.* Cambridge: MIT Press, 2002.

McCoy, Katherine and Michael McCoy. *Cranbrook Design: The New Discourse.* New York: Rizzoli, 1990.

———. "American Graphic Design Expression." *Design Quarterly* 148 (1990): 4–22.

McLuhan, Marshall. *The Gutenberg Galaxy*. Toronto: University of Toronto Press, 1962.

Millman, Debbie. *The Essential Principles of Graphic Design*. Cincinnati: How, 2008.

Moulthrop, Stuart. "You Say You Want a Revolution? Hypertext and the Laws of Media" in *The New Media Reader*. Noah Wardrip-Fruin and Nick Monfort, eds. Cambridge: MIT Press, 2003. 691–703.

Nielsen, Jakob. *Designing Web Usability*. Indianapolis: New Riders, 2000.

Ong, Walter. *Orality and Literacy: The Technologizing of the Word*. New York: Methuen, 1982.

Raskin, Jef. *The Human Interface: New Directions for Designing Interactive Systems*. Reading, MA: Addison-Wesley, 2000.

Ronell, Avital. *The Telephone Book: Technology, Schizophrenia, Electric Speech*. Lincoln, NE: University of Nebraska Press, 1989.

### GRID

Berners-Lee, Tim. *Weaving the Web: The Original Design and Ultimate Destiny of the World Wide Web*. New York: HarperCollins, 1999.

Bosshard, Hans Rudolf. *Der Typografische Raster/The Typographic Grid*. Sulgen, Switzerland: Verlag Niggli, 2000.

Cantz, Hatje. *Karl Gerstner: Review of 5 x 10 Years of Graphic Design etc*. Ostfildern-Ruit, Germany: Hatje Cantz Verlag, 2001.

Elam, Kimberly. *Geometry of Design*. New York: Princeton Architectural Press, 2001.

Gerstner, Karl. *Designing Programmes*. Sulgen, Switzerland: Arthur Niggli Ltd., 1964.

Gibson, William. *Neuromancer*. New York: Ace Books, 1984.

Higgins, Hannah P. *The Grid Book*. Cambridge: MIT Press, 2009.

Hochuli, Jost, and Robin Kinross. *Designing Books: Practice and Theory*. London: Hyphen Press, 1996.

Krauss, Rosalind. "Grids" in *The Originality of the Avant-Garde and Other Modernist Myths*. Cambridge: MIT Press, 1985. 9–22.

Küsters, Christian and Emily King. *Restart: New Systems in Graphic Design*. London: Thames and Hudson, 2002.

Lidwell, William, Kritina Holden, and Jill Butler. *Universal Principles of Design*. Gloucester, MA: Rockport Publishers, 2003.

Müller-Brockmann, Josef. *The Graphic Artist and his Design Problems*. Sulgen, Switzerland: Arthur Niggli Ltd., 1961.

———. *Grid Systems in Graphic Design*. Santa Monica: Ram Publications, 1996. First published in 1961.

———. *A History of Graphic Communication*. Sulgen, Switzerland: Arthur Niggli Ltd., 1971.

Nicolai, Carsten. *Grid Index*. Berlin: Die Gestalten, 2009.

Roberts, Lucienne, and Julia Shrift. *The Designer and the Grid*. East Sussex, UK: RotoVision, 2002.

Rothschild, Deborah, Ellen Lupton, and Darra Goldstein. *Graphic Design in the Mechanical Age: Selections from the Merrill C. Berman Collection*. New Haven: Yale University Press, 1999.

Ruder, Emil. *Typography*. Sulgen, Switzerland: Arthur Niggli Ltd., New York: Hastings House, 1981. First published in 1967.

Rüegg, Ruedi. *Basic Typography: Design with Letters*. New York: Van Nostrand Reinhold, 1989.

Samara, Timothy. *Making and Breaking the Grid: A Graphic Design Layout Workshop*. Gloucester, MA: Rockport Publishers, 2002.

Tufte, Edward R. *Envisioning Information*. Cheshire, CT: Graphics Press, 1990.

———. *The Cognitive Style of PowerPoint*. Cheshire, CT: Graphics Press, 2003.

Zeldman, Jeffrey with Ethan Marcotte. *Designing with Web Standards*, Third Edition. Berkeley, CA: New Riders, 2009.

### MANUALS AND MONOGRAPHS

Baines, Phil, and Andrew Haslam. *Type and Typography*. New York: Watson-Guptill Publications, 2002.

Bringhurst, Robert. *The Elements of Typographic Style*. Vancouver: Hartley and Marks, 1992, 1997.

*The Chicago Manual of Style, 15th Edition*. Chicago: University of Chicago Press, 2003.

Dwiggins, W. A. *Layout in Advertising*. New York: Harper and Brothers Publishers, 1928.

Eckersley, Richard *et al. Glossary of Typesetting Terms*. Chicago: University of Chicago Press, 1994.

Felton, Paul. *Type Heresy: Breaking the Ten Commandments of Typography*. London: Merrell, 2006.

French, Nigel. *InDesign Type: Professional Typography with Adobe InDesign CS2*. Berkeley, CA: Peachpit Press, 2006.

Jardi, Enric. *Twenty-Two Tips on Typography (That Some Designers Will Never Reveal)*. Barcelona: Actar, 2007.

Jury, David. *About Face: Reviving the Rules of Typography*. East Sussex, UK: RotoVision, 2001.

Kane, John. *A Type Primer*. London: Laurence King, 2002.

Kunz, Willi. *Typography: Macro- and Micro-Aesthetics*. Sulgen, Switzerland: Verlag Arthur Niggli, 1998.

Lupton, Ellen and J. Abbott Miller. *Design Writing Research: Writing on Graphic Design*. London: Phaidon, 1999.

Lupton, Ellen and Jennifer Cole Phillips. *Graphic Design: The New Basics*. New York: Princeton Architectural Press, 2008.

Lynch, Patrick, and Sarah Horton. *Web Style Guide: Basic Design Principles for Creating Web Sites*. New Haven: Yale University Press, 2001.

Millman, Debbie. *The Essential Principles of Graphic Design*. Cincinnati: How, 2008.

Rosendorf, Theodore. *The Typographic Desk Reference*. New Castle: Oak Knoll, 2008.

Samara, Timothy. *Typography Workbook: A Real-World Guide to Using Type in Graphic Design*. Beverly, MA: Rockport, 2004.

Scher, Paula. *Make It Bigger*. New York: Princeton Architectural Press, 2002.

Spiekermann, Erik, and E. M. Ginger. *Stop Stealing Sheep and Find Out How Type Works*. Mountain View, CA: Adobe Press, 1993.

Strizver, Ilene. *Type Rules: The Designer's Guide to Professional Typography*. Cincinnati: North Light Books, 2001.

Strunk, William Jr. and E. B. White. *The Elements of Style*. Illustrated by Maira Kalman. New York: Penguin Press, 2005.

Tschichold, Jan. *The Form of the Book: Essays on the Morality of Good Design*. Point Roberts, WA: Hartley & Marks, 1991.

中英對照